Flower Painting in Oil

Flower Painting in Oil

BY CHARLES REID

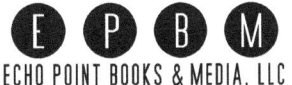

ECHO POINT BOOKS & MEDIA, LLC

Published by Echo Point Books & Media
Brattleboro, Vermont
www.EchoPointBooks.com

All rights reserved.
Neither this work nor any portions thereof may be reproduced, stored in a retrieval system, or transmitted in any capacity without written permission from the publisher.

Copyright © 1976 by Watson-Guptill Publications
Copyright © 2016 by Charles Reid

Flower Painting in Oil
ISBN: 978-1-62654-380-5 (paperback)
978-1-62654-381-2 (casebound)

Interior design by Bob Fillie

Cover design by Adrienne Núñez
Editorial and proofreading assistance by Ian Straus,
Echo Point Books & Media

Printed and bound in the United States of America

This book is for Sam.

CONTENTS

Acknowledgments, 8
Preface, 9

Materials, 11

Brushes, 11
Canvas, 12
Panels, 13
Paper, 13
Easels, 13
Paintboxes, 15
Palettes, 15
Paints, 15
Colors, 15
The Reds, 15
Orange, 15
Yellow, 15
The Greens, 16
The Blues, 16
The Earth Colors, 16
Black, 16
White, 16
Mediums, 16
Gesso, 18
Accessories, 18

Learning About Flowers, 21

Drawing a Bouquet, 21
Individual Flower Shapes, 21

Project 1 Using the Brush, 27

Washy, 27
Regular, 28
Drybrush, 28
Controlled, 32
Pointillist-Type, 32
Scumbled, 32

Project 2 Broad Leaf Forms, 35

Practice Exercises, 35

Project 3 Slender Leaf Forms, 39

Project 4 Compact Forms, 43

Project 5 Diffused Forms, 49

Project 6 Massed Forms, 55

Project 7 Open Forms, 61

Project 8 See-Through Forms, 67

Color Demonstrations, 73

Dried Flowers, 81
Daisies and Brushes, 84
Kitchen Flowers, 86
Anemones, 88
Sigrid's Flowers, 90
Persian Rug and Daisies, 92
Orchids, 94

Project 9 Glossy Opaque Container, 97

Project 10 Glossy Transparent Container, 101

Project 11 Flowers and Backgrounds, 107

Close-Value Painting, 107
High-Contrast Painting, 107

Project 12 Color Mixing, 111

Darkening Colors, 111
Lightening Colors, 112
Pointers on Mixing Color, 121
Mixing Greens, 121
Cool Greens, 121
Warm Greens, 124
Mixing Grays, 124
Complementary Colors, 124
Earth Colors and Blue, 125
Black and White, 125

Project 13 Composition, 127

Boundaries, 127
Horizon, 127
Placement, 127
Background, 127
Background as Subject, 127
Positioning Flowers, 130
Viewfinder, 130
Overlapping Objects, 130
Compositional Direction, 132
Cutting Off Objects, 132
Some Final Thoughts, 135

Project 14 Values, 137

Values are Relative, 137
Values in Diffused Light, 137
Values in Strong Light, 139
Values in Shadow, 139
Accents, 140
Highlights, 140
Reflected Light, 140

Project 15 Pattern, 143

Abstract Design, 143
Pattern in Old Master Paintings, 143
Value Studies, 143
Directing the Eye, 149
Poor Pattern, 149
Correcting Poor Pattern, 150

Project 16 Lighting, 153

Lighting for Form, 153
Lighting for Composition, 153

Project 17 Edges, 159

Combine Hard and Soft Edges, 159
Making a Hard Edge, 159
Making a Soft Edge, 159
Edges for Emphasis and Form, 163

Index, 165

Acknowledgments

My appreciation and thanks to Fairfield Porter, who helped me to see. Also my heartfelt thanks to Peggy, who encouraged and typed.

PREFACE

I must admit that I don't know much about flowers. I don't know any of their Latin names. I'm not even sure of the names of some of the fairly common ones. In my defense, since starting to paint them I've learned more about flowers. More important, I've learned to appreciate them. Henry Miller said, "To paint is to love again." This seems especially true of flowers. They never seem so beautiful as when they're in front of my easel on a table or in a field in the spring sunlight. The purpose of this book is not to teach you about flowers but to help you see them and, once seeing them, to help you to draw and paint what you see.

As in every other area of painting, you must see well and clearly but you mustn't see too much. You must see very specifically, but at the same time very generally. You must see specific shapes, catching the exact line, curve, or angle; yet at the same time, you must see large forms, dismissing the unimportant, the noncritical details. This business of seeing the essential and dismissing the unimportant is the first step all of us must make if we wish to paint a face, a barn, or a flower. Understanding this idea doesn't make us artists but it makes it possible to put what we see down on a piece of paper or canvas. The "art" part is a different ballgame. I really don't feel that anyone can teach you to be an artist, but I hope this book will help you understand and practice the craft of drawing and painting flowers. The art is up to you.

My feeling is that you don't have to be a botanist or even become very involved with the particulars of flowers in order to paint them sensitively and well. I'm writing to those people who are interested in flowers as objects to paint. The flowers I paint are rarely "correct," but I'm not as concerned with "correctness" as I am with the quality, the feeling, the spirit of the flowers. On the other hand, accurate flower studies can be very beautiful, just as Audubon's bird prints are beautiful. The way I happen to paint flowers is my way and is quite incidental. I hope that the principles I'll be discussing will allow you to paint flowers in your own way, whether broadly and exuberantly or accurately and exquisitely.

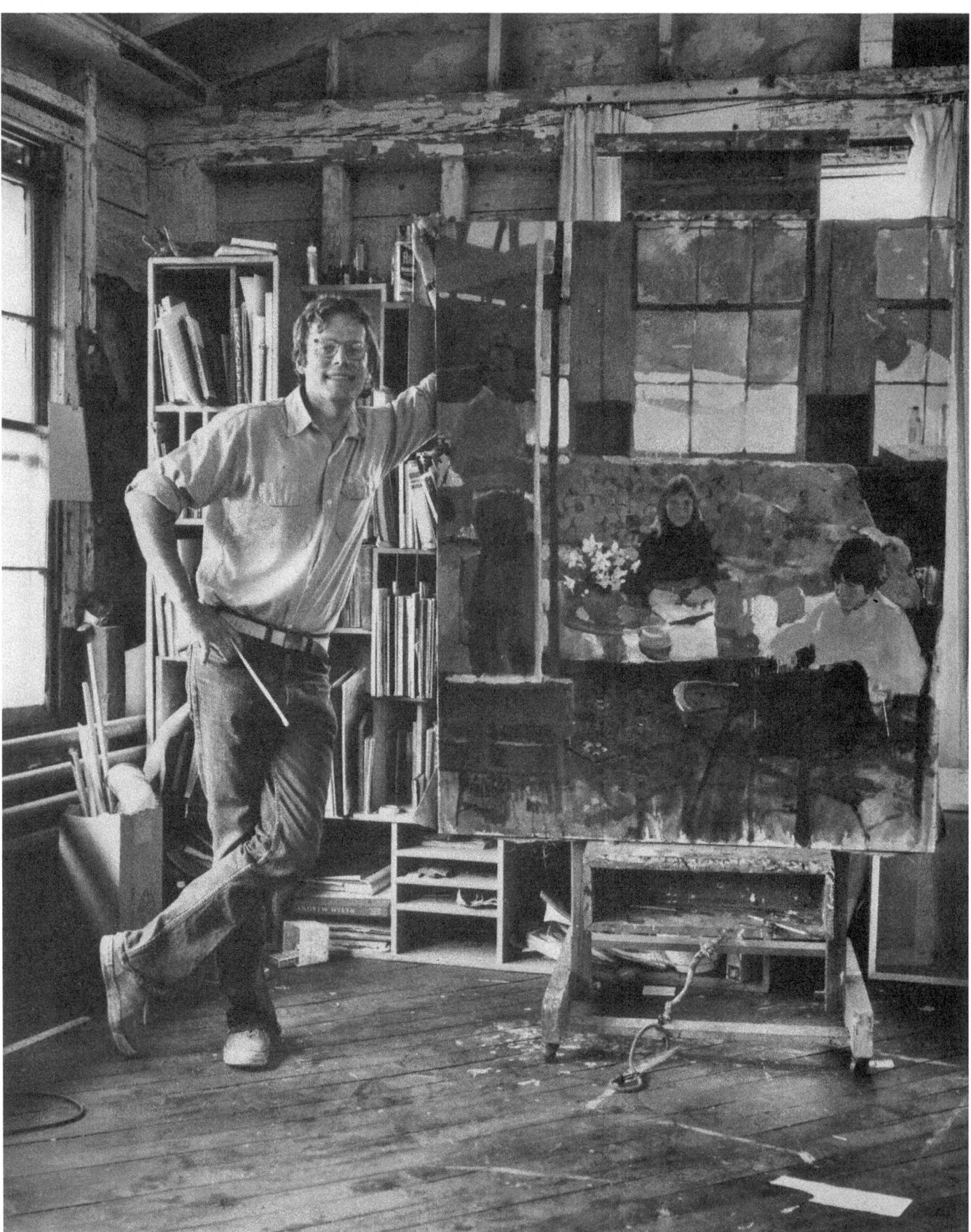

MATERIALS

What do you need to paint an oil painting? Many of you probably have brushes, paints, etc. Some will have favorite brushes and colors. That's fine! Don't throw out what you have just because your colors or brushes aren't the ones I suggest.

It's impossible to cover all the possible colors, mediums, varnishes, and types of canvas available. However, I would strongly suggest reading a book like Ralph Mayer's *The Artist's Handbook of Materials and Techniques* or one of the other books devoted to the craft of painting. These books cover in detail everything you will need to know about paints, materials, etc. But this chapter will be a broad outline to get you started. The colors, brushes, and mediums are the ones I'm personally familiar with and use every day. This doesn't mean they'll be right for you. Read this chapter, but be sure to explore the subject further.

Brushes. Always buy the best brush you can afford. You can buy cheaper paints or work on inexpensive canvas, but painting with cheap brushes is like trying to model a figure in clay with mittens on. Good oil painting brushes are made out of bristle or red sable in two forms, flats or rounds (Figure 1). Don't use a synthetic brush with plastic bristles—these are meant for acrylic painting rather than oil.

Bristles. Bristle brushes are generally made from hog's hair and are fairly stiff. They come in a size range from #1 to #10 (even larger in some brands). In your flats, I think you should have #4, #6, and #10. Always use the largest bristles for the broadest area. These brushes aren't that expensive, so please have at least these four. Again, buy good ones. If you're buying long flats, make sure that the bristles curve in at the corners (Figure 2). This is very important! Never buy long flats that are square-tipped or they'll splay out and cause you trouble. I like the longer flats as opposed to the shorter bristles, called "brights." The long flats are much more limber and suit my particular approach.

Round bristles were used a great deal in the nineteenth and early twentieth centuries, but artists rarely use them now. I suspect this is a question of fashion. Apparently, the round bristles are excellent. I've always wanted to get a bunch of them and do a painting, but I haven't, so I can't really give you an opinion on them. There's also a shape called "filbert," but I haven't used this either. They look like worn long flats and, since I have plenty of worn long flats, it seems pointless to buy a filbert.

Since bristle brushes are stiffer than sables, you can put much more paint on the canvas, covering broader areas more easily. Because of this, I feel you should use bristle brushes for *alla prima* painting. (*Alla prima* means aiming for the final result from the very first stroke.)

Sables. Sable brushes are soft and pliable. If you like the feeling of a sable brush, I'd suggest you buy the smaller size, no larger than a #6 or #8. After this, the cost is so high you really have to be in love with

The author in his studio.

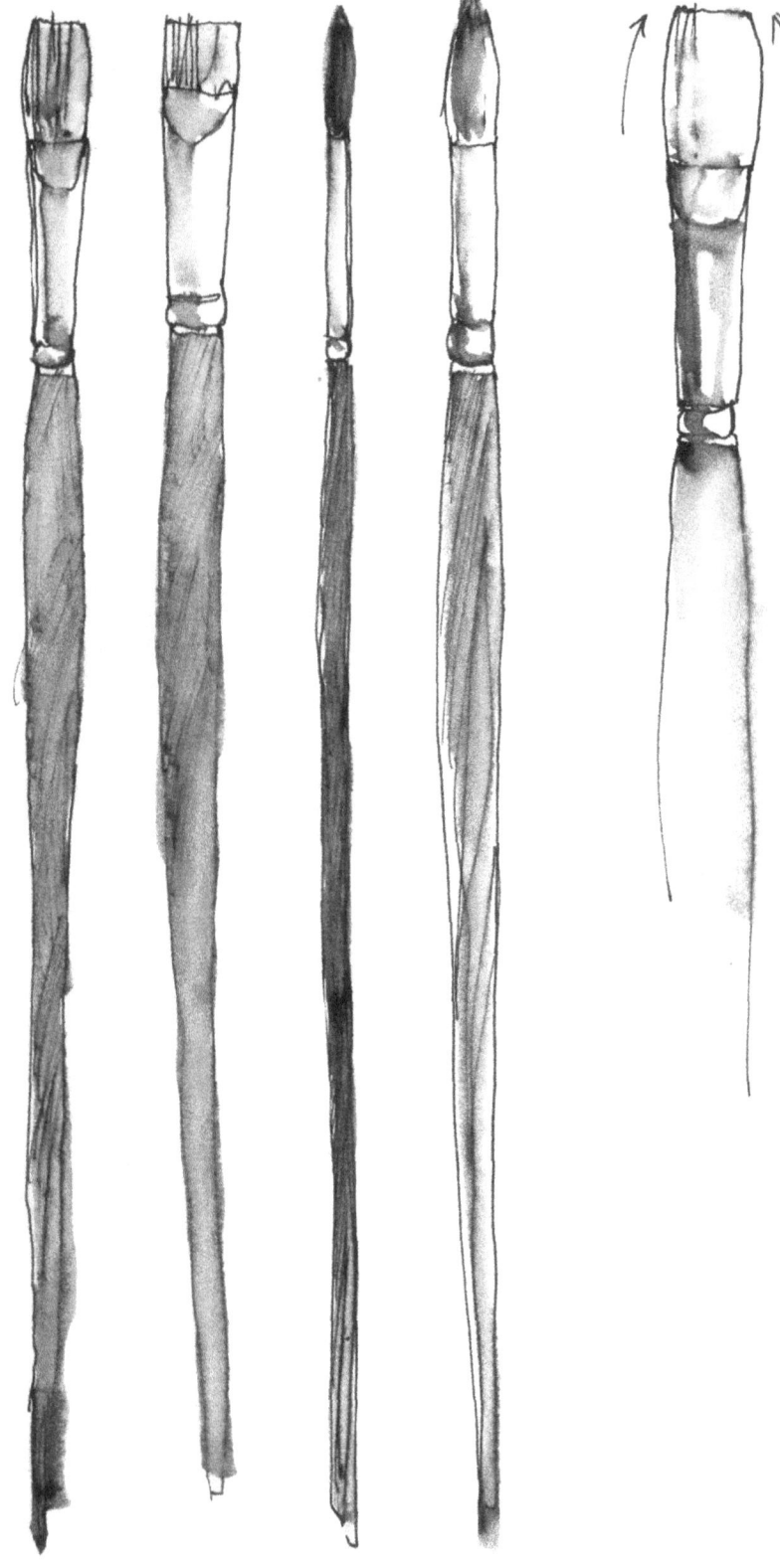

Figure 1. *(Left) Here are the four basic types of brushes. Left to right, they are a long flat, a bright, a round sable, and a round bristle.*

Figure 2. *(Right) Be sure you use long flat brushes that curve in at the corners. The square-tipped ones splay out with use.*

sable to want it.

I always come up with a rather slick, slippery looking result when painting *alla prima* with sable flats. It seems to me sable flats are best for glazing, and also they're much more expensive than hog's hair. I use the round sable, however, especially for delicate, fine detail work.

I'd suggest having several round sables—sizes #3 to #6. They wear out fast and aren't that expensive. The size here isn't that important; however, anything smaller than #3 is small for my needs, and above #6 you might just as well use a small bristle brush.

Canvas. Canvas is made of two materials, cotton and linen.

Cotton. Cotton canvas is difficult to stretch. The surface tends to be smooth and gets clogged with paint quickly, making overpainting a very difficult and unpleasant business. In a word, cotton is not recommended for anything other than quick sketches and exercises.

Linen. Linen is by far superior. It comes in various weights and textures. The weight depends on the number of threads per square inch. The texture depends on the size of the weave. If you buy prepared canvas, you won't have to worry about this, since most prepared canvas seems to come in a standard medium texture. I will say that buying prestretched, preprimed canvas is a luxury. It's expensive, and if you plan to do much painting, I'd suggest you buy your linen in rolls and stretch your own canvases. It's not only much cheaper, but you'll also have a choice of textures. An even better choice, but more of a bother, is to buy "raw" linen. This means that the linen comes without the white priming. It's simply linen cloth. I always buy my canvas this way. It's the least expensive, and sometimes I think the priming on the preprimed canvas isn't all it should be. You can get the widest possible choice of textures when you buy unprimed linen. To start, I'd suggest a medium

texture. You can always experiment with other textures later. I suggest sending for an illustrated catalog from Utrecht Linens, Inc. (33 Thirty-Fifth Street, Brooklyn, N.Y. 11232). They have a wide range of linens from which to choose, they're very pleasant to deal with, and prompt in their delivery.

Panels. I've always disliked canvas panels and don't recommend them. I only use them for practice exercises. Masonite panels are much better than canvas. They're cheap and make an excellent surface when given a couple of coats of Liquitex acrylic gesso. Always get the untempered panels. Tempered Masonite contains oil that doesn't form a good surface for the gesso. Remember, you can't put plastic paint over an oil surface like an old oil painting. The gesso will flake right off. You can only put oil paint over plastic paint.

Paper. Many artists have used paper and cardboard for oil painting. I've always been under the impression that oil attacks paper and eventually the paper will break down. Toulouse-Lautrec did many paintings on cardboard, and they're still holding up. I've been told, however, that cardboard isn't what it used to be; so I can't recommend it as a painting surface. I think your best bet would be vellum. Vellum has oil in it already, so it's compatible with oil paint.

Easels. The type of easel you choose depends on where you plan to do most of your painting. If you're going to work in your house or outside you should have a portable easel. There are aluminum ones that work fairly well. But portable easels just aren't as satisfactory as studio easels made to stay in one place. While it's important to use an easel that's fairly steady, I'd rather see you spend your painting money on good brushes. You can manage with a cheaper easel, but you can't manage with cheaper brushes.

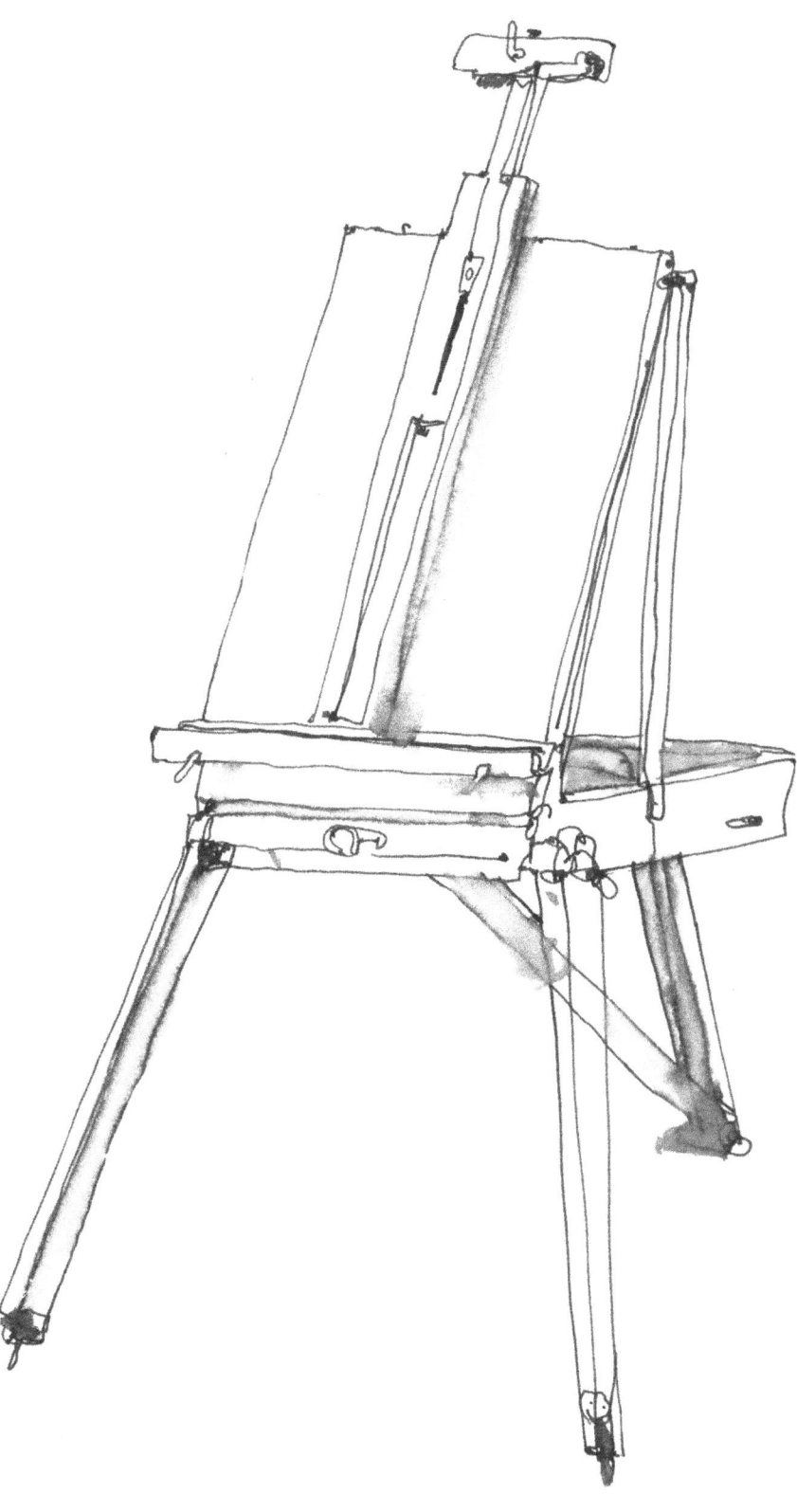

Figure 3. *This is a French easel. It's very expensive, but it contains a wonderful built-in paintbox that's great for painting outdoors or in the studio.*

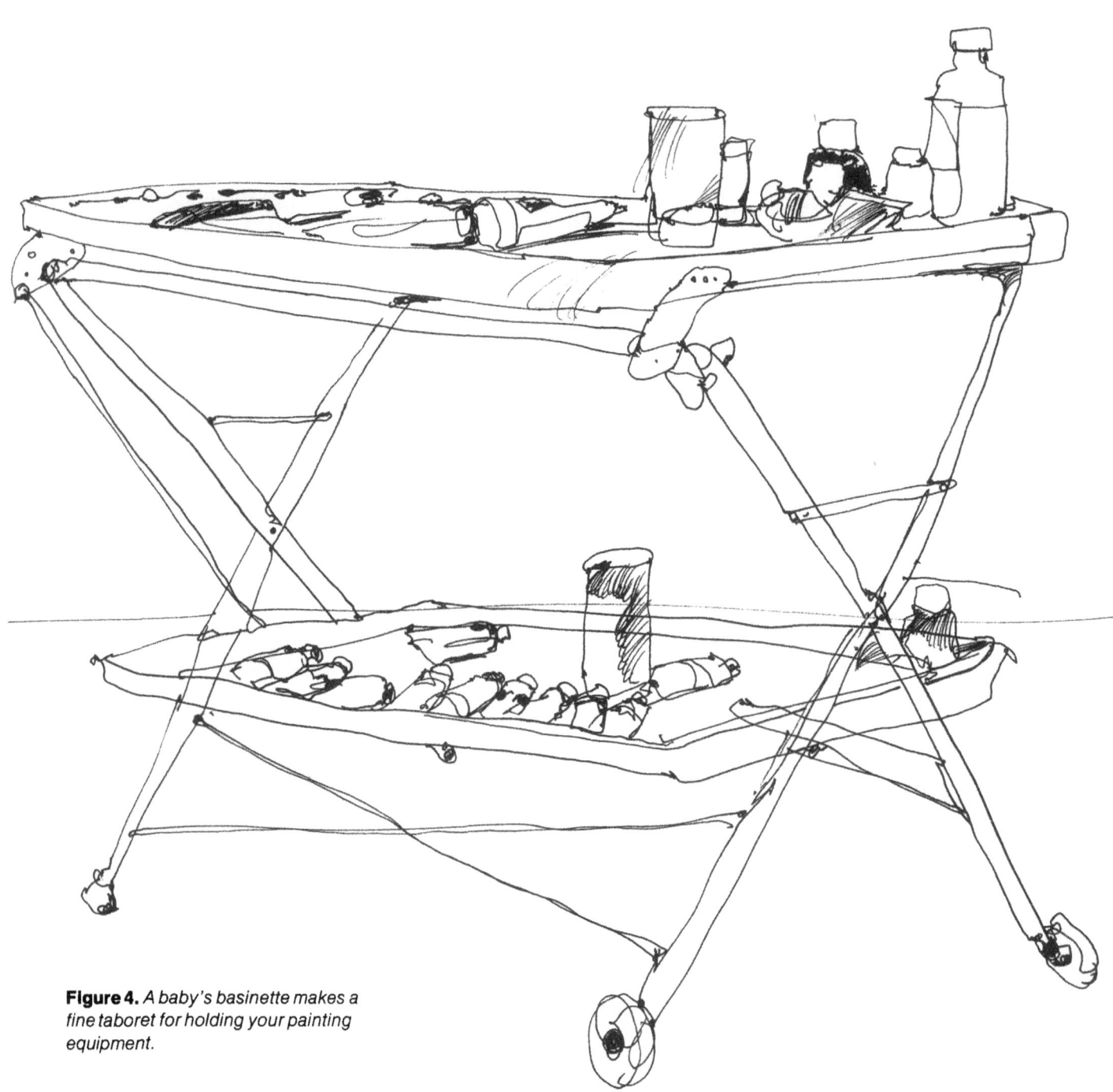

Figure 4. *A baby's basinette makes a fine taboret for holding your painting equipment.*

Paintboxes. An official paintbox isn't necessary, but it's handy. You can carry your paint tubes, brushes, and palette in one container. This type of box even allows you to carry a palette with paint squeezed out, which saves you from having to scrape your palette each time you want to move. If you don't want to invest in a paintbox, any container will do. My students arrive with an assortment of paintboxes, cartons, canvas bags, briefcases, and tool boxes. A paintbox is one item that doesn't matter, as long as it carries what you want.

My favorite kind of paintbox is a French Easel (see Figure 3). This is a paintbox and folding easel combined. It's a marvelous invention, but very expensive. Spend your money on more critical materials. In the studio, a baby's basinette is excellent for holding your equipment (see Figure 4).

Palettes. This is a simple one. I wish you wouldn't use paper palettes; but you probably will, no matter what I say. Students insist that paper palettes are easier. I suppose this is true if you only paint occasionally—you can tear off your paper and discard it. But this wastes paint, and it's very hard to mix paint properly on a paper palette.

If you paint often, please use a regular wooden or Masonite palette. If you work mostly in a studio, a glass palette is excellent. I use both: a wooden palette (which I fit into my portable box), and a glass palette in my studio. Never use a plastic palette for oil paint. Turpentine melts the plastic. (The only exception would be Plexiglas, which seems to work better.) Glass palettes are not handy to carry, but they're good for a studio because they're easy to clean. A razor blade in a holder from your hardware store does the job. But you can't use it on wooden or Masonite palettes because it will tear up the surface. Instead, a painting knife and Kleenex, or a paint rag and some turpentine will clean a wooden or Masonite palette nicely.

Paints. There are four large and reputable manufacturers whose paints I use. Artists seem to vary as to their favorite brands. You'll probably find at least one of them in your art supply store. The only European paint I've really used is Winsor & Newton. (I haven't tried French or Italian colors simply because they're not readily available.)

Winsor & Newton paints are very fine, but also very expensive because their ingredients are of the highest quality, and therefore costly. Grumbacher, Shiva, and Bocour also make fine paints, and I've used all three brands. Each company's paints vary slightly in hue. For example, a Winsor & Newton cadmium yellow pale is warmer than a Grumbacher cadmium yellow pale. You'll find many colors the same, but do be prepared for some differences.

Manufacturers often add filler to their paints. Filler is a substance added to the pure pigment and oil when a color is tubed to extend shelflife and add to the paint's workability. It doesn't hurt the pigment, but, obviously, the more filler in a tube, the less pigment (and therefore tinting power) in that tube. This doesn't mean you can't get as brilliant a color. It just means that you'll have to use a bit more paint when using colors with a lot of fillers. Some manufacturers also use more oil than others in their paints. This has nothing to do with the quality of the pigment itself, and since some people like more fluid paint, they may actually prefer this. But it might be better to add oil (or other mediums) to your paint yourself, so you can control the amount.

Colors. I'll list some colors which are fairly basic. Although they serve me well, this should not be considered a definitive list. Every painter should find his or her own favorites. Try these colors, but experiment with others, too. I see no reason, however, to go into exotic colors. If you like particular hues that are a bit unusual, I'd check a book like Mayer's on their permanency.

My own palette changes constantly. I recently added Indian red, a color that is not at all necessary. But I'm in a "warm-earthy" period and, for the time being, enjoy using this color. You, too, will find colors you like which aren't mentioned here. Don't worry. I'm just listing a palette that might form a basis for you.

The Reds. There are five colors that I consider part of this family:

Alizarin Crimson. This color is necessary and considered permanent. It's a slow drier. It's been said that it might fade when exposed to light, but I never noticed it fading and have always used this color. It's a very strong dye. (You'll realize this if you ever get some on a clean dress or shirt.) Alizarin is wonderful for mixing those purples, lavenders, and pinks so necessary in painting flowers. You'll need it also for darkening reds and for mixing other rich darks. I often mix it with ultramarine blue or viridian to make my darkest darks, or with cerulean or phthalo blues for making purple.

Cadmium Red Light. I've always had this color on my palette. It's not as strong in tinting power as alizarin, but it's still very strong. This color is a good basic red. I find it much more useful than either cadmium red medium or cadmium red dark. The darker cadmiums can be used for particular mixtures, but cadmium red light seems the most versatile of the reds, and one that you should at least start with on your palette.

Vermilion. This is a slightly cooler version of cadmium red light. The difference between these two reds is very slight and I often find myself interchanging them without really noticing.

Orange. While you can mix yellow and red to make an orange, the orange you mix won't be as nice as cadmium orange. I consider this a necessary color and one you should

have on your palette. Remember, cadmiums are strong, so always start with a little, especially if you are mixing it with a light color or a white. A touch of cadmium orange can be added to a white to give it warmth and strength.

Yellow. You might like to include cadmium yellow pale in your palette. This is a color that varies in hue considerably from one manufacturer to another. Also try lemon yellow and cadmium yellow light. You'll find these three yellows similar in value, but varying in warmth and coolness.

The Greens. I have three colors that I use to produce greens:

Viridian. This is the most useful green, and if you are going to have just one, this should be it.

Phthalo Green. The only other green that comes out of the tube as dark as viridian is phthalo green. Phthalo (short for phthalocyanine) can be a fine color, but I find it too strong and dominant, and I rarely use it.

Permanent Green Light. This is a good light green, a bit warmer than viridian. This color would never knock your eye out, but it's wonderful for subtle areas.

There are other greens, but you really don't need them. I'd rather see you experiment mixing various combinations of yellow ochre, yellow, and raw sienna with your various blues. Your best greens will be made up of mixtures of various colors; so never expect an "instant" green right out of the tube.

The Blues. There are four blue colors on my palette:

Ultramarine Blue. This is an old standby. It has good tinting power without being as strong as phthalo blue. Ultramarine is very dark out of the tube and is a good mixer.

Phthalo Blue. I don't use phthalo blue in my oil painting, but you may prefer it to ultramarine. Phthalo is very strong and tends to dominate any mixture. It makes beautiful dark purples when mixed with alizarin crimson.

Cobalt Blue. This is a lovely color, much more gentle and subtle than ultramarine and phthalo blues. It's a middle-value blue, a bit darker and richer than cerulean blue.

Cerulean Blue. This is a soft light blue, useful for mixing subtle grays. If I could have only two blues, I'd choose cerulean and ultramarine.

The Earth Colors. I consider the following six colors to be part of the "earth" group:

Yellow Ochre. This is a subtle, unobtrusive color, and therein lies its advantage. When you want a soft, quiet yellow, this color is excellent. You can get a soft yellow using a small amount of one of the cadmiums, but you have to be careful since the cadmiums are much stronger in tinting power than yellow ochre. Yellow ochre, however, can be a bit chalky when used in mixing greens.

Raw Sienna. This is a darker version of yellow ochre and I find it more useful than ochre. For mixing greens, the raw sienna works beautifully. Because it's lower in value (darker), it tends to make richer and deeper greens.

Burnt Sienna. This is one of those colors (like viridian) which is necessary on your palette, but not a good color when used alone. It needs company. Many students overuse burnt sienna, and the results are often raw and harsh. Try using burnt sienna as a substitute for red when mixing. Use a bit in your green mixtures and try mixing it with ultramarine, phthalo blue, or viridian to make rich darks.

Burnt Umber. This is your darkest brown. It's warmer and more reddish than raw umber. Burnt umber is good for dark darks, when you don't wish to use black. But don't rely on burnt umber alone. I prefer to make darks with a mixture of burnt sienna and blue or green. This is a personal opinion, but mixtures seem to be better than any single color right out of a tube. Also, burnt umber when mixed with blue and a bit of white makes a fine gray.

Raw Umber. This color is cooler than burnt umber and tends more toward the green. I often leave it off my palette. But you should try both raw and burnt umber. You might well find both necessary.

Black. The only black I normally use is ivory black. Many teachers discourage the use of black because students overuse it. However, black is a fine color and can be used with yellows to make beautiful greens. The problem with black is that it's not the best way to darken a color. (We'll discuss the alternatives to black as a darkener in a later chapter on color mixing.)

White. I generally use Permalba white (Weber), but any titanium white will do.

Mediums. A medium is used to make oil paint more fluid and "buttery." Unfortunately, mediums cause many of our permanency difficulties. The safest mediums are prepared combinations such as Taubes' copal painting medium or Winsor & Newton's "Winton" painting medium. You also can make your own medium using one-third linseed oil, one-third turpentine, and one-third damar varnish. I feel that this homemade medium is just as good as the prepared ones. (Turpentine alone is not a good binder, so I don't recommend using it alone as a medium. Linseed oil alone tends to yellow. It, too, must be used in combination with other mediums.)

Gel. Several companies put out gel mediums which work well and seem to be safe in terms of permanency. Weber's "Res-in-gel" has a particularly nice consistency. Each brand

Sony with Narcissus. 8" x 10". This painting was done in my studio at night. The light was harsh, and I was working on cotton canvas, which I don't like to use. Linen is much more pleasant to paint on. I pushed the flowers up into the right-hand corner, letting the borders of the canvas crop off part of the bouquet. Notice how the shadow of the vase blends into the background. Compare this soft "lost" edge with the edge of the vase that faces the light. Also look at the edges within the flowers: some are hard and definite, others are softer and blurred.

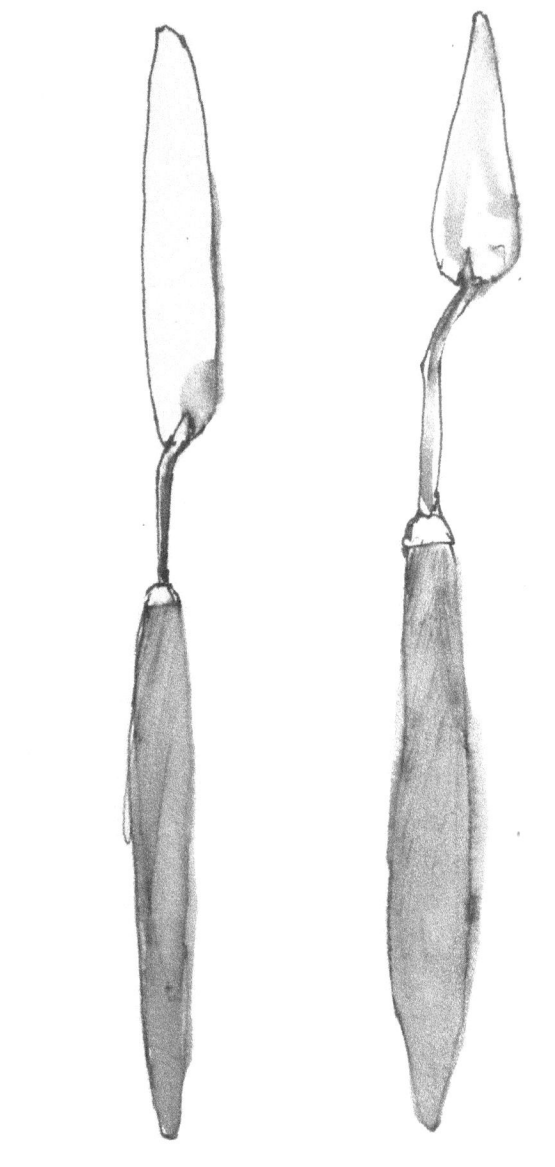

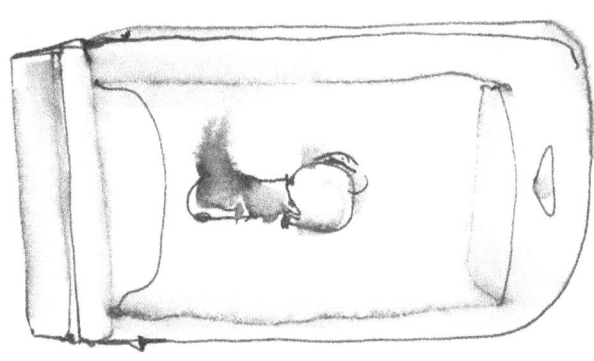

Figure 5. *The knives pictured here do double duty: they can both apply paint and clean your palette. Left to right, they are: a palette knife, a painting knife; and a razor blade in a holder, which is good for cleaning off a glass palette.*

is a bit different in consistency, so you'll have to experiment with several to find the one you like best.

Gesso. Artists always used to prepare their own gesso, and I believe many still do. I came along in the era of plastic paints and plastic gesso. Although I stayed with oil and watercolor paints, I've always used synthetic gesso as a ground for my oil paintings. Since I've never heard of any trouble as far as permanency is concerned, and because it's so handy, I see no reason to go through the trouble of preparing the rather complicated traditional gesso. There are several synthetic gessos available, all equally good. However, as with paint, I'm sure you'll find the consistency of the gesso differs with each manufacturer. You'll probably have to add some water before applying the gesso to your canvas or panel. It's better to put on two or three thin coats rather than a single thick one. Buy a nice wide nylon or bristle brush, a 3" or 4" housepainter's brush will do nicely, to apply your gesso to the canvas. After each coat has dried, give it a light sanding with fine sandpaper to smooth the surface of any deep brush grooves.

Accessories. Besides the materials discussed, there are a few other items:

Rags, Kleenex, etc. First of all, you'll need something to wipe your brushes. Most rags are unsatisfactory, since they're not absorbent enough. Cloth diapers are great, but hard to come by. I find Kleenex or toilet paper excellent. (Paper towels work well, too.)

Palette Knives. You'll also need a palette knife to clean your palette. I prefer what is usually called a painting knife (see Figure 5). The blade of a painting knife is small and flexible. If you use a glass palette, you'll need a razor blade and holder, available at any hardware store. This scraper works very well on glass, and it's probably the easiest combination for a tidy, clean palette.

Turpentine, Brush Cleaner, and Mineral Spirits. These are necessary for cleaning your brushes. You can buy a special cleaning jar at your art store, but I make my own out of two cans. I illustrate how I do it in Figure 6. First I take a coffee can, and find a smaller can that fits inside it. Next, I cut out the top of the smaller can and turn it upside down. Then I drive a nail into its bottom to make holes. I then place the smaller can with the holes upside down in the larger coffee can and fill it with turpentine or brush cleaner. When you clean your brush, the sludge will drop to the bottom, and you'll always have fairly clean turpentine or brush cleaner.

To hold your medium, you can use small oil cups from the art store or, cheaper still, try catfood cans. After each painting session, clean your brushes in turpentine, brush cleaner, or mineral spirits, followed with a bath in Ivory Soap and water. Clean brushes are a joy to work with, but just as important, cleaning them in mild soap and water will assure them of a long and happy life.

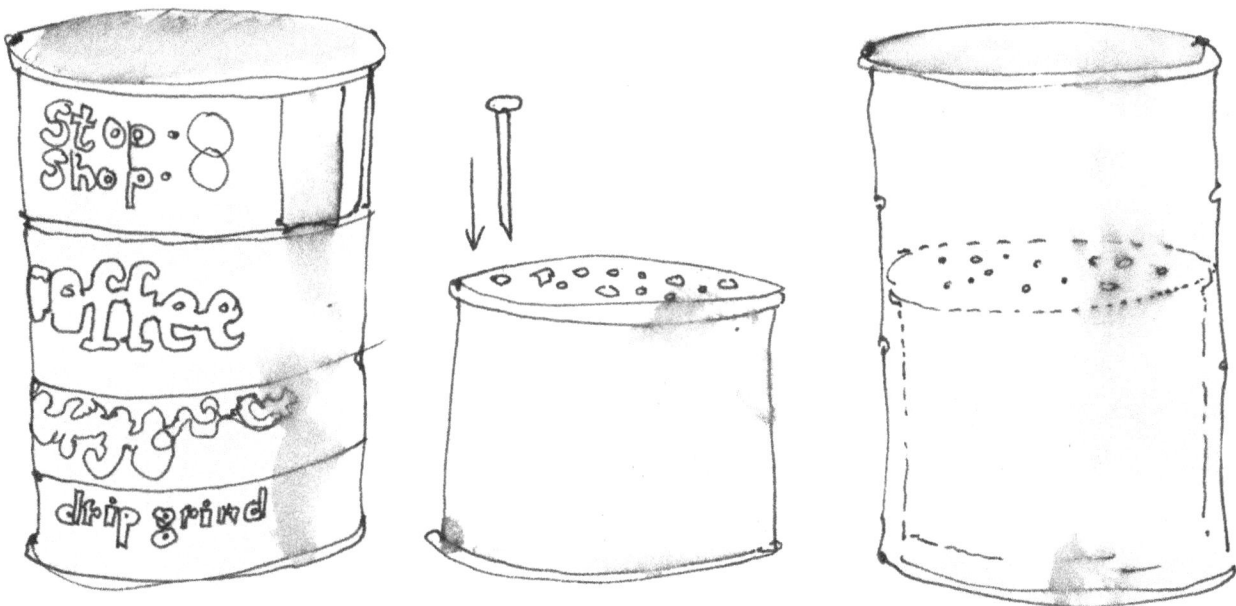

Figure 6. *Here are the three steps I take in making my own special cleaning jar for brushes. First I find a clean coffee can (left). Then I take a smaller can, cut off its top, and punch holes in its bottom (center). Finally, I place the smaller can upside down in the larger can and fill the latter with turpentine (right).*

LEARNING ABOUT FLOWERS

Christy with Flowers. *40" x 40". Private collection. This is not really a flower painting. I included in this book several pictures that contain flowers but are actually interiors with figures, because I was interested in using flowers as part of a larger composition. My place of work usually has flowers around. Ann, one of the artists I work with, brings them in regularly, so that flowers have become part of our everyday surroundings. In this case, I put in all the flowers and plants I could. I started out with Christy sitting at the table with only the ashtray and other objects, but the lower left-hand corner seemed so empty that I added the flowers.*

Some wildflowers are on my studio table: Queen Anne's lace, goldenrod, some thistles and pine boughs, and Joe Pye weed. They were picked last week by a friend, and now the flowers are dry and the leaves wilted and drooping. Can it be possible to paint something this delicate and involved? There must be thousands of tiny buds and minute stems. The only possible way to approach an arrangement like this is to simplify the tiny forms into larger masses.

Drawing a Bouquet. I'll start with a wildflower bouquet in the drawings that follow (Figures 7–9), and see how the entire bouquet and container can be treated in different media.

I set my bouquet in front of a window so I can really concentrate on the flat outside shape. For these exercises, I suggest using a medium like ink or watercolor, but you might also use charcoal, as I do in Figure 9. (Magic markers are handy, but too mechanical.) I hope the exercises shown here will help you simplify complicated small forms into larger simpler shapes. This is *very* important. You should set up some flowers against the light, so you can see the silhouette easily. Don't use a spotlight or it will blind you to subtle relationships. During the day, a window works well, and at night a fairly soft incandescent light is good.

Individual Flower Shapes. Now let's take a closer look at several different varieties of flowers and see how to simplify them.

Delphinium. This flower is made up of tightly packed, small flowers, clustered together in a tall mass. First look at the outside shape (Figure 10A). Notice the variety on each side of the form. (Nature is varied; she never repeats herself.) Train yourself to observe and describe the variety you find in whatever you draw or paint.

The next step is to look within the outside shape and place the light and dark masses without destroying the feeling of the large form (Figure 10B). Don't break the delphinium into an unconnected scattering of small buds.

Evening Primrose. Here the individual blossoms are still found in rather close groupings. The outside shape (Figure 11A) is much more descriptive, and the silhouette is much more obvious than the delphinium's. Notice that the shadows on the primrose are fairly light; you're still aware of a lighter overall shape on a darker background (Figure 11B). I'm keepng the individual flowers as subtle as possible. This is the secret of retaining the large shape, which is so important.

Rose. The last silhouette is a rose (Figure 12), a single large bud, broken up into petals. (You'd have the same situation with peonies, marigolds, etc.) The dark shape is lightened slightly in some places, and darkened in others, to suggest the small, but very involved, structure of its petals.

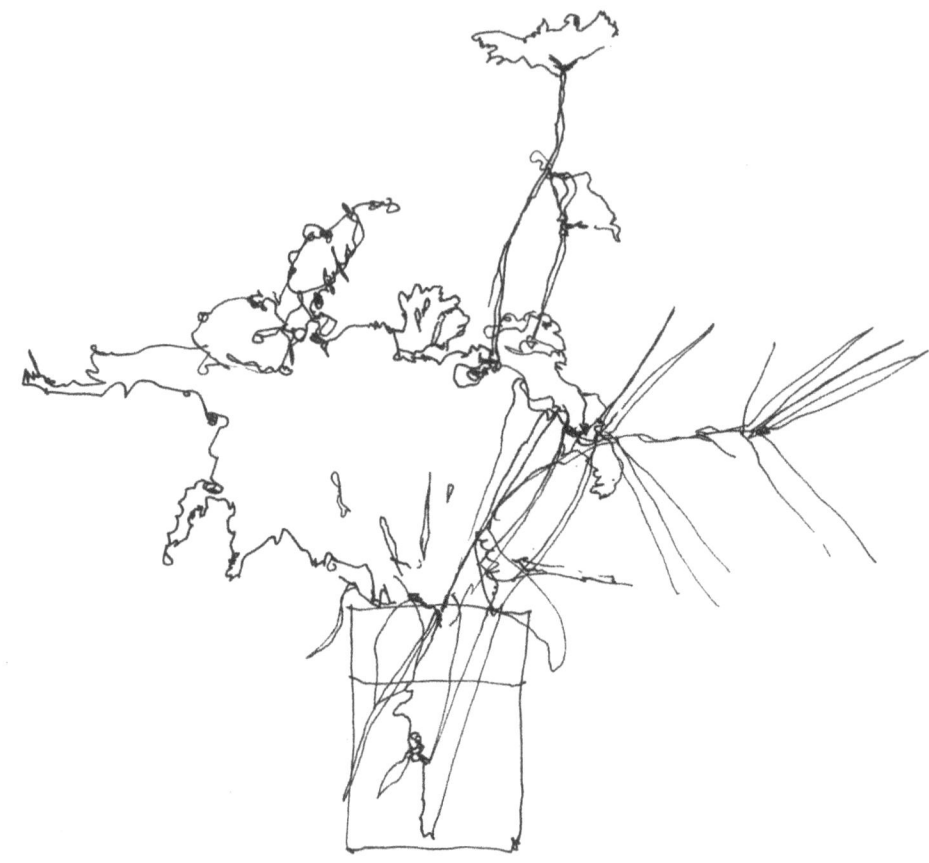

Figure 7. This line drawing of the outside shape of the flowers is what I actually see as I edit out almost all of the details within the mass.

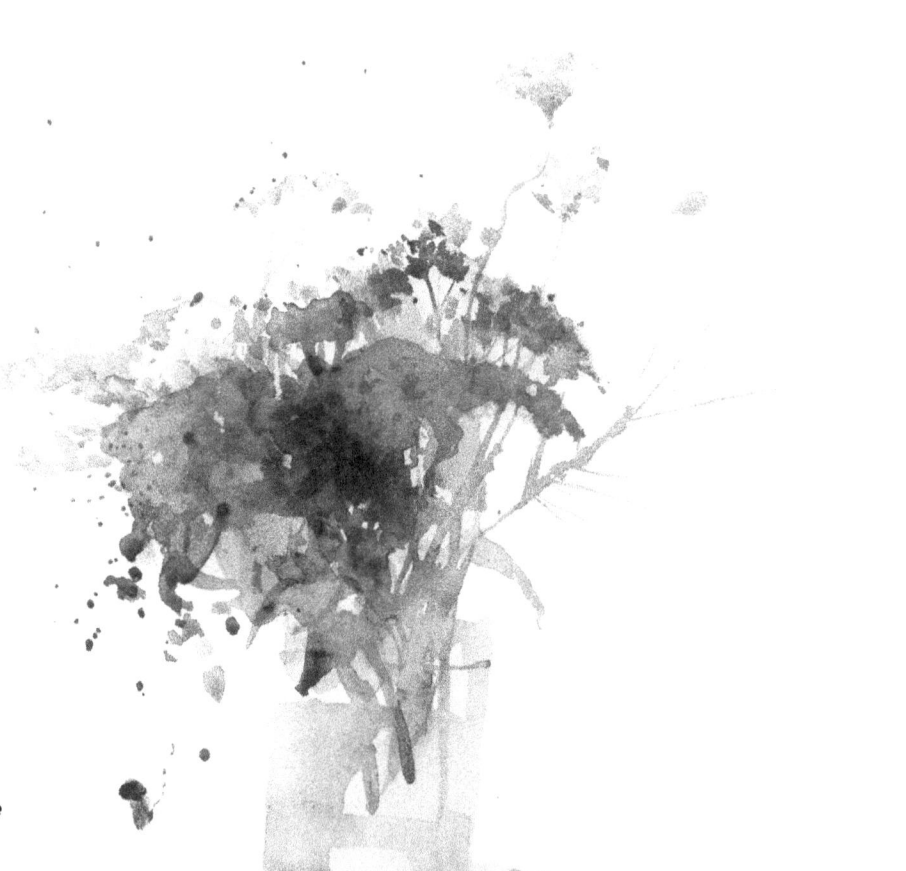

Figure 8. This wash drawing has a bit more detail, but still so much is left unsaid. For a wash drawing, you could use ink, watercolor, or oil diluted with turpentine. I used watercolor here.

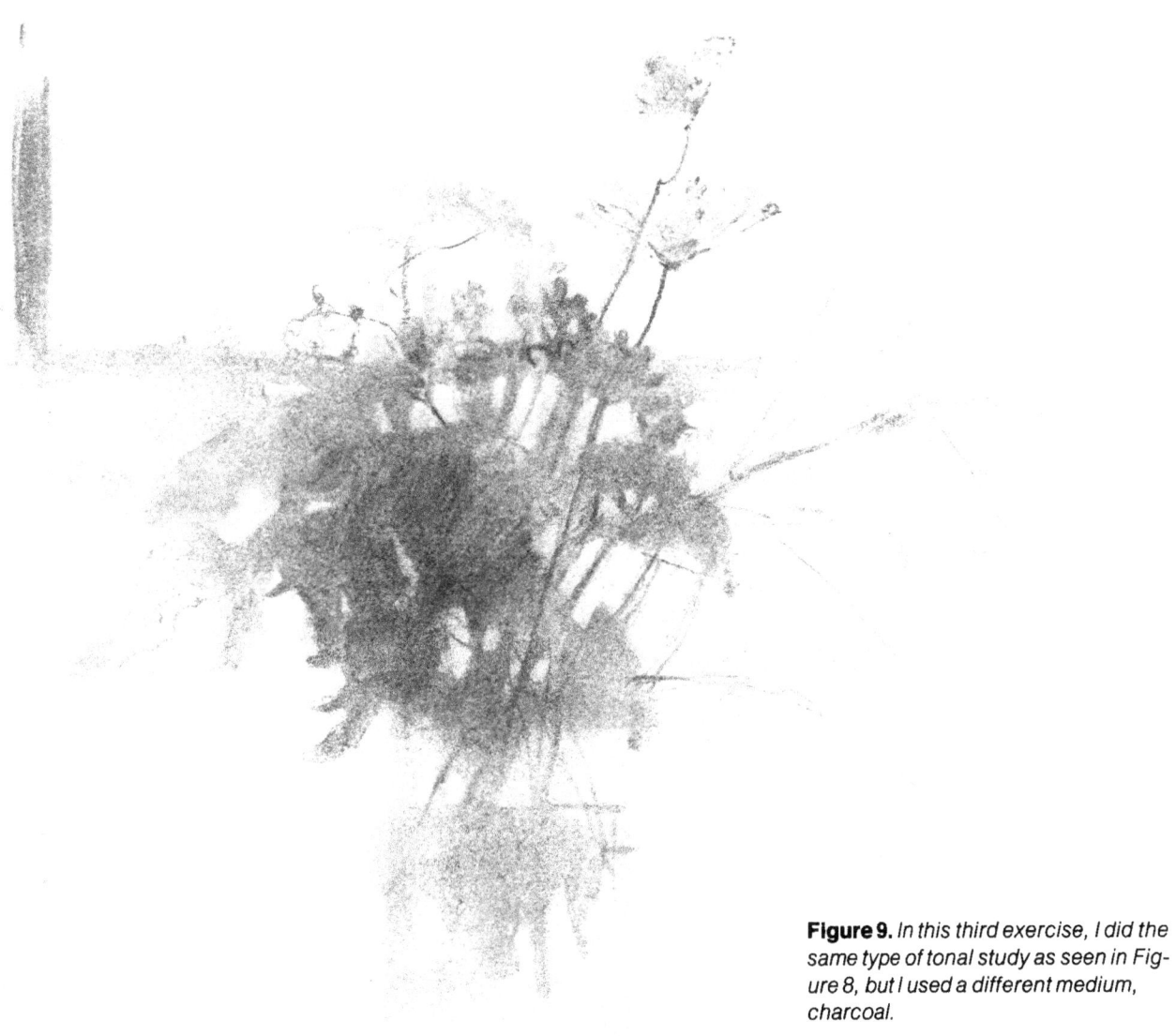

Figure 9. In this third exercise, I did the same type of tonal study as seen in Figure 8, but I used a different medium, charcoal.

Figure 10. With the delphinium, or any flower form for that matter, most students forget to consider the outside shape and begin by looking within the shape for all the details. In Sketch A (left) I concentrated on the outside shape of the delphinium. In Sketch B (right) I used the darker background to set off the lighter side of the delphinium, while suggesting the presence of smaller forms within.

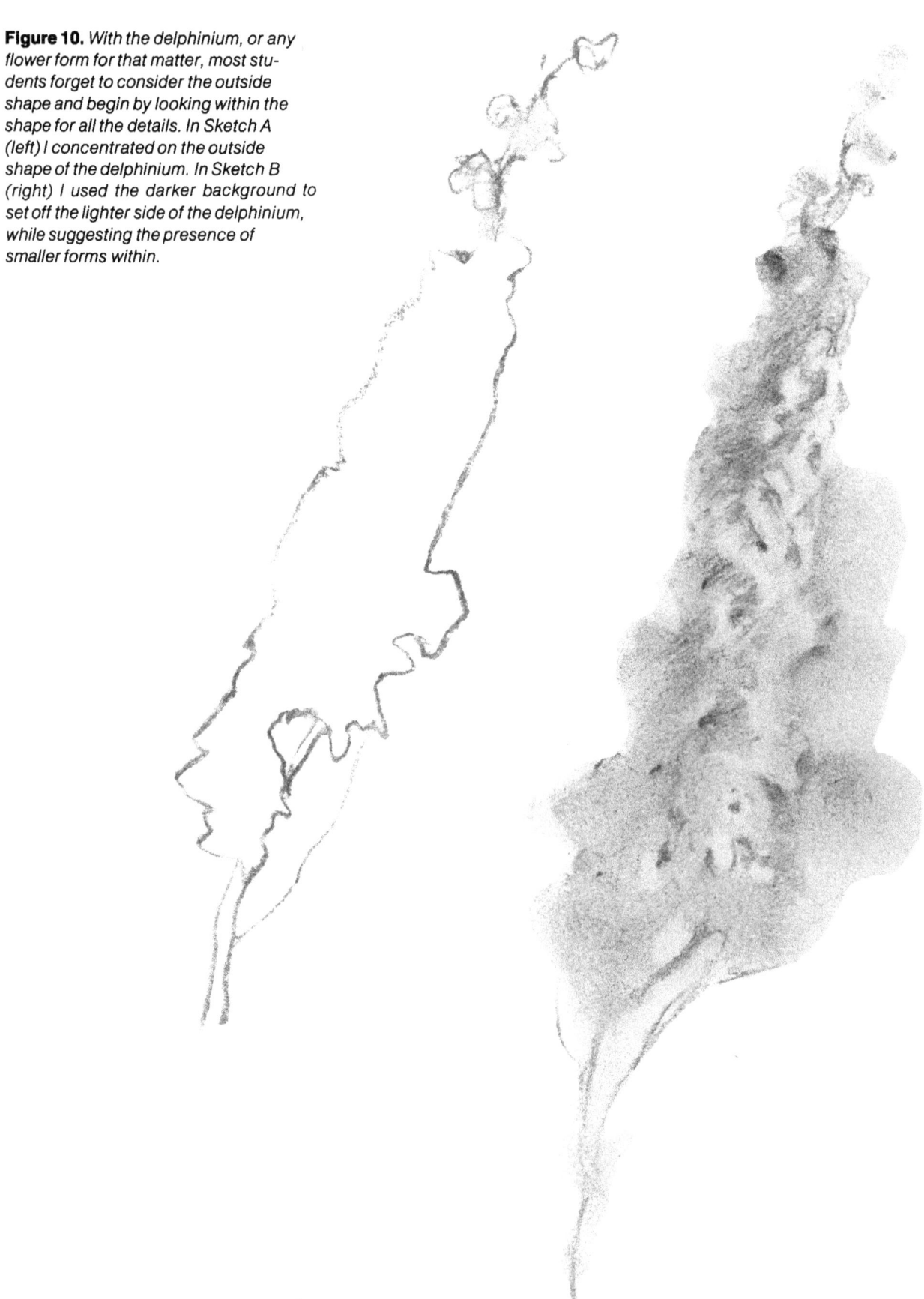

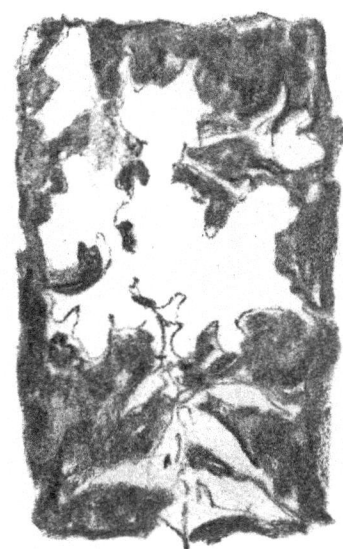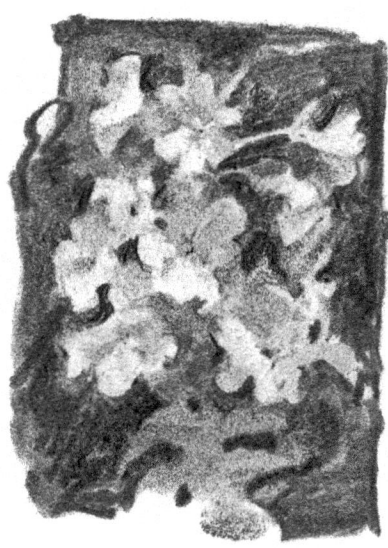

Figure 11. *In Sketch A (left) I used the negative shape of the background to show the positive shape of the primroses. I actually drew the background rather than the flower itself. In Sketch B (right) light and shade was added to the primroses.*

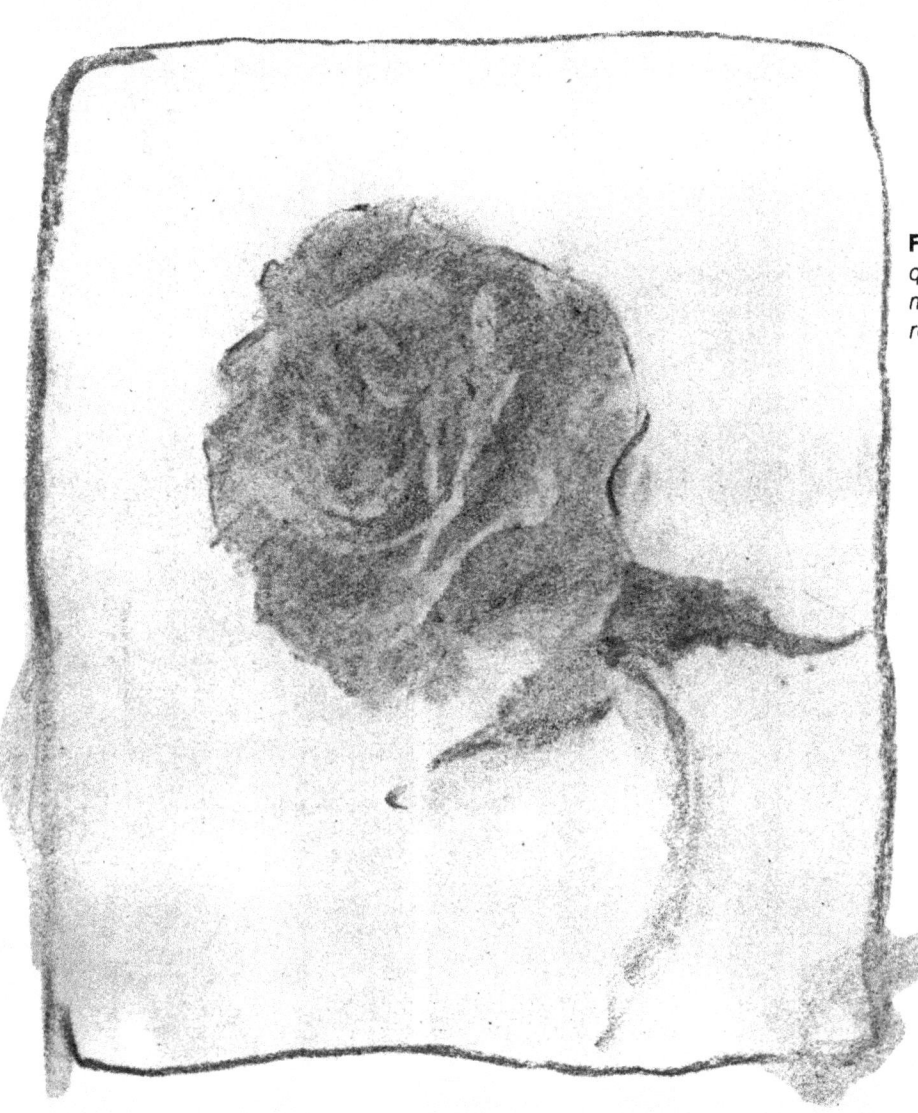

Figure 12. *If you look at the sketch quickly, or squint at it, you should still be more aware of the overall shape of the rose than the small forms.*

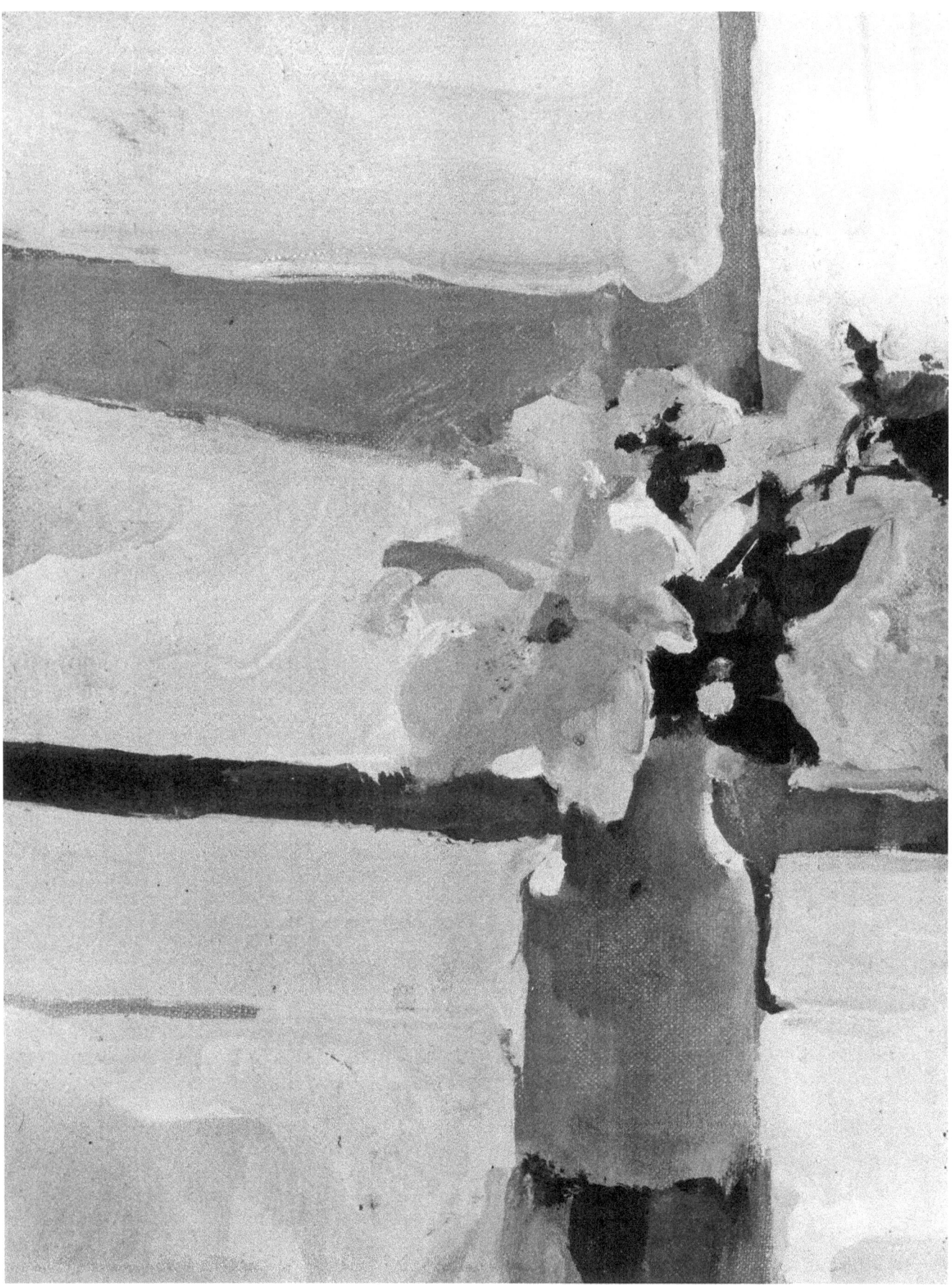

PROJECT 1
USING THE BRUSH

How you hold your brush depends on what kind of brushstroke you're going to make. Broad areas and detailed areas demand different treatments. As you paint more and become accustomed to holding your brush in various ways, you'll develop your own favorite brushwork. Some artists use dry, smudging brushstrokes, while others use fluid, flowing strokes. Some even paint pictures with thousands of little dots of color instead of actual strokes. Your brushwork is your handwriting in paint. If possible, don't worry too much about it. Concentrate on the subject of your painting and your brushwork will take care of itself.

The main thing to remember when holding your brush is that it's a friend, not an enemy. Don't strangle it in a vicelike grip. The brush should be a natural extension of your hand, wrist, and arm. If you're working on detailed areas where control is important, hold your brush down by the ferrule. If you're working on a broad area with freedom and verve, hold your brush back toward the end of the handle. *Never* hold the brush only one way.

Many students dab at paintings with little strokes. Only once in a while are little dabs necessary. Usually what's needed is a bolder stroke executed with a bigger brush held back toward the end of the handle, and some courage. Here are six types of brushstrokes I use (illustrated in Figure 13) and my methods of holding the brush in each case (Figure 14).

Washy. With an oxhair brush, apply the paint almost like watercolor (Figure 13A). Use lots of turpentine or painting medium with a small amount of pigment. (Keep your turpentine and your painting medium in separate containers.) Never use this diluted brushwork over an old painting or try to work it into areas you've just painted. Only use this approach when starting a new canvas. Naturally you'll do most of your mixing on the palette, but if some pigment starts to build up, a brush dipped in turpentine can be worked directly into the canvas. Finally, don't use white (opaque) pigment to lighten your wash-in areas. The turpentine will act as your lightener. Just as water is used to lighten watercolor, the more turpentine you use, the lighter and more transparent your wash will be on the canvas. This method is excellent for your early lay-in stage, when you want to cover large areas of your canvas quickly. When various colors are mixed and worked together on the canvas, lovely effects result. Some contemporary artists use this method from beginning to end, never using impasto.

For your broad, washy strokes, hold the brush back toward the end of the handle (Figure 14A). Control isn't the object here; the aim is spontaneity. If you're just beginning a painting, this is the time to have fun and get some color going. You're all set, as long as you don't let the paint build up too soon. Allow some outrageous color to happen in your washes; swirl and scrub with your brush.

Narcissus. *Oil on canvas, 8" x 10". Collection Dr. and Mrs. Gordon Reid. I painted these flowers in strong sunlight, placing them so that they were anchored by the window frames. Notice that the composition is basically a cross. This can be a static arrangement if you don't vary the sizes and shapes of the negative spaces around the subject. Not only did I try to avoid boredom in the surrounding shapes, but I also changed values in the various rectangles and varied the textures.*

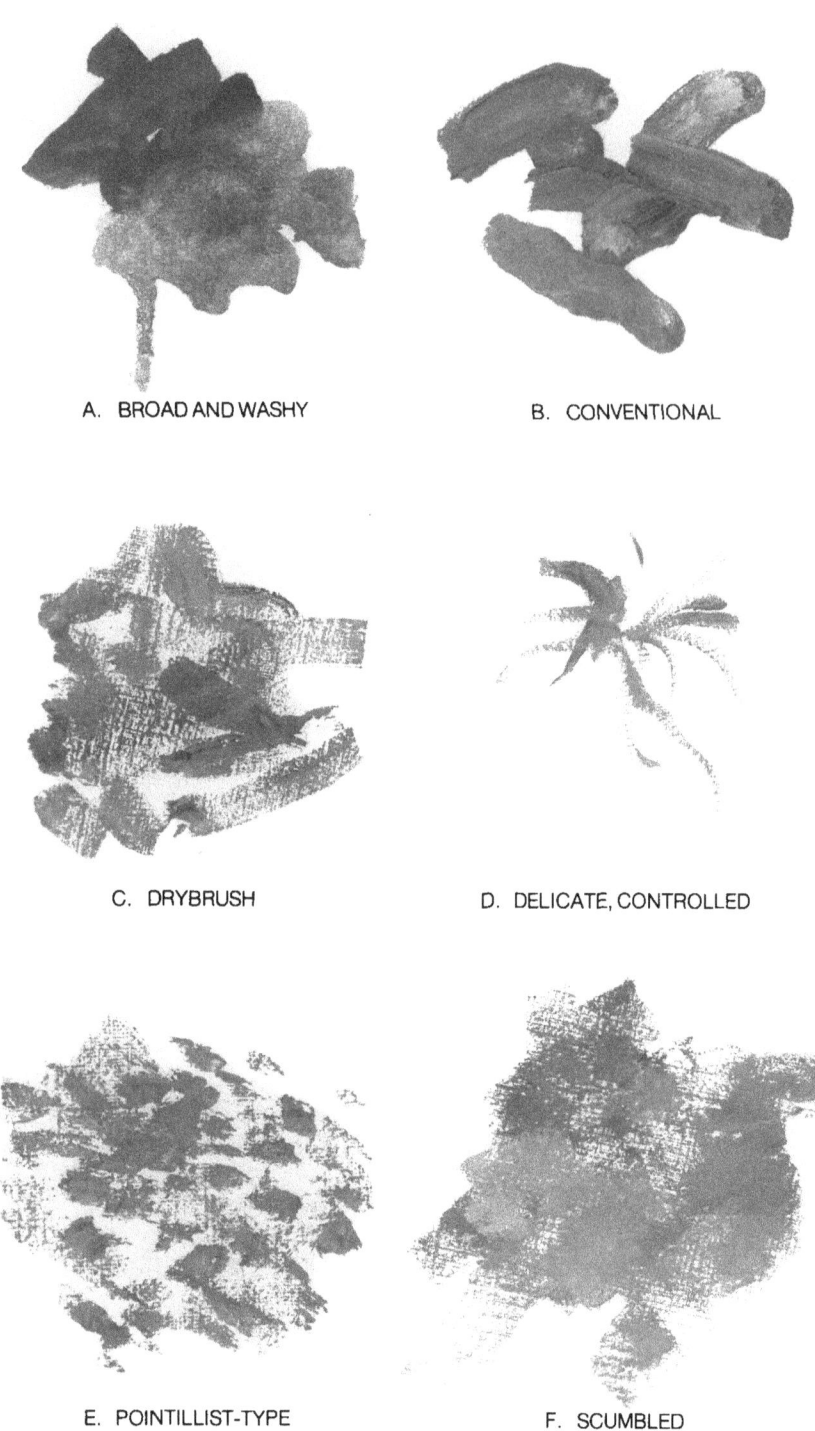

Figure 13. *In these swatches, you can see a variety of brushstrokes.*

Regular. For most conventional brushstrokes, where you want freedom with some control, mix paint on the palette with just enough medium to make it fluid (Figure 13B). Some artists use turpentine as their medium, but it really doesn't have enough body. I suggest you use a prepared painting medium, or better still, mix your own (see the section on painting mediums in the Materials chapter). Pick up a generous glob of paint from the mixture of pigment and medium on the palette. Use just the tip of the bristle brush to paint with. To see this type of painting, take a look at some late Rembrandts. This marvelous artist describes beautifully areas that seem to have detail, but actually are painted with a single gorgeous stroke loaded with paint.

For these strokes, you can either hold the brush about halfway up the handle in the conventional way (Figure 14B), or you may prefer to hold the brush with the handle under the palm (Figure 14C). How you hold it isn't as important as *where* you hold it. Try to keep yourself from going more than two-thirds of the way up the handle toward the tip. It would be best if you made yourself hold it at the halfway point, at least sometimes. You'd be surprised at the amount of control you'll actually have.

Drybrush. This is called "broken color" in oil painting and "drybrush" in watercolor (Figure 13C). "Drybrush" seems to describe it best: little, if any, medium is used, and very dry pigment is dragged across the textured surface of the canvas. I suggest you use an oxhair brush here. The limp sable brush is really too soft for this technique. As I've also mentioned in the Materials chapter, the amount of oil mixed into the pigment varies with each brand of paint. However, most colors without medium added will be dry enough to use for drybrush.

This approach is excellent for painting one color over another

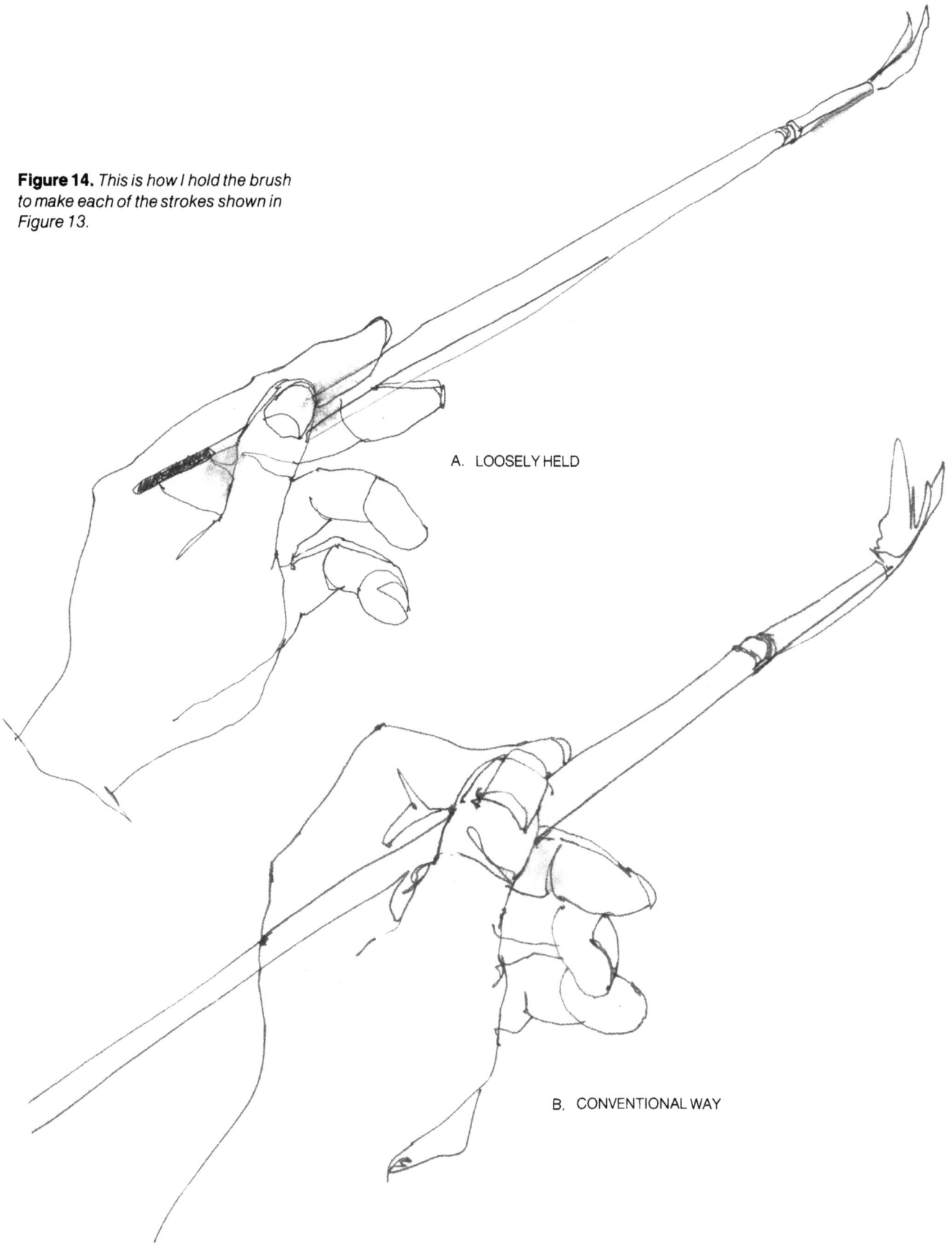

Figure 14. *This is how I hold the brush to make each of the stokes shown in Figure 13.*

A. LOOSELY HELD

B. CONVENTIONAL WAY

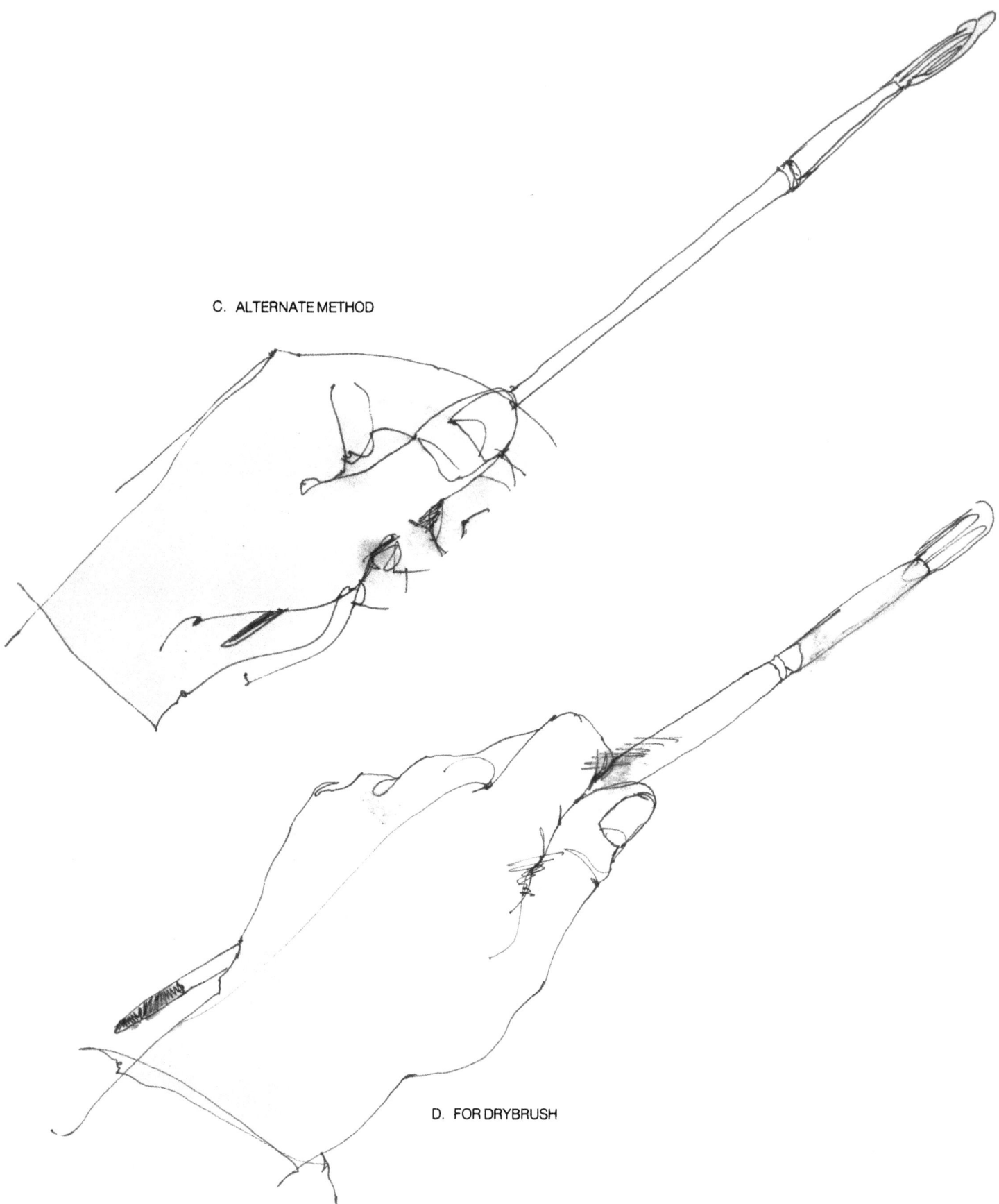

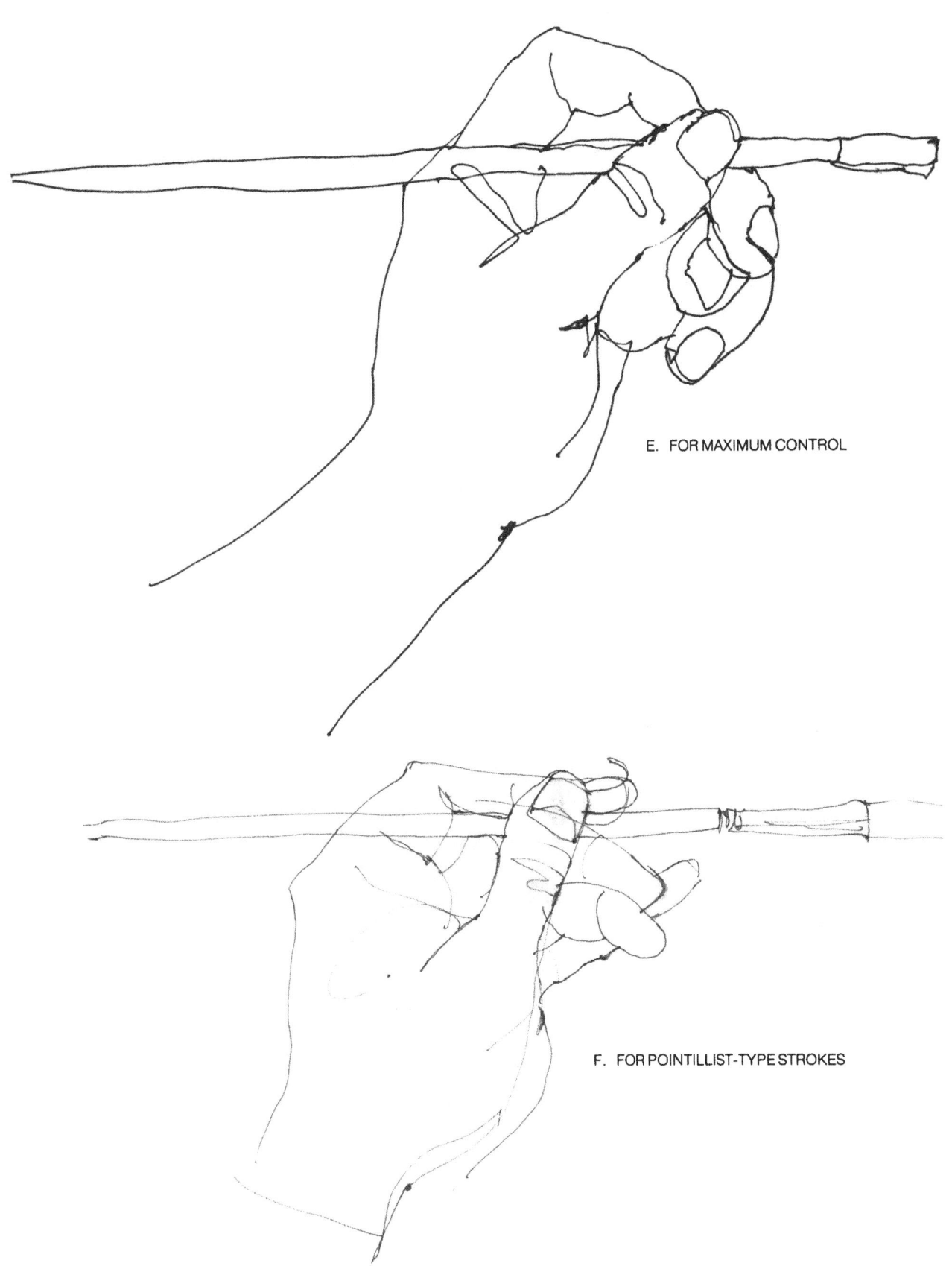

E. FOR MAXIMUM CONTROL

F. FOR POINTILLIST-TYPE STROKES

that's already dry. It's possible to suggest detail and texture as well as light without laboring over the passage. The Russian painter Nicholi Fechin used this very dry paint beautifully. He apparently found the commercial colors we use too moist, and so he squeezed his paint onto paper towels in order to remove excess oil.

About the same amount of control is needed to produce the drybrush strokes shown in Figure 13C as the conventional strokes. Use the side of the brush rather than the tip (Figure 14D), and hold the brush with the handle under the palm or projecting out between thumb and forefinger, again about halfway up the handle. Since you're using the side of the bristles, the brush handle is almost parallel to the canvas as you make your stroke.

Controlled. Impasto as well as broken color is illustrated in Figure 13D. This approach is excellent for delicate, detailed areas. One stroke can suggest the stem of a plant or the petal of a wildflower. I used a #8 sable oil painting brush here, which I prefer, for thin, fine strokes, but you could also use a bristle brush.

Delicate, controlled brushwork demands the most control, so the hand must be closer to the ferrule than with the other strokes (Figure 14E). If you're making free but delicate strokes, then you may grip the brush farther from the ferrule.

Pointillist-Type. In Figure 13E the paint is plopped down with the end of an oxhair or sable brush. The paint isn't "pulled" through a stroke; it's simply dropped onto the canvas. I use this stroke for texture in such flowers as Queen Anne's lace, goldenrod, or any bud that's tiny and contained. Your paint can be fluid or dry, depending on the texture you're after.

In order to make this stroke, the brush may be held either almost parallel with the canvas or at right angles, depending on the particular effect you want (Figure 14F). The placement of the hand on the brush handle influences the amount of control you'll have.

Scumbled. I've always called the stroke illustrated in Figure 13F "scumbling," but other artists don't agree. Anyway, the name doesn't matter. You'll notice that the paint is quite dry in this example, but thicker paint could be used. The paint can be applied in a scrubbing motion, either with a single value or with a lighter value worked into a darker one.

It's important to realize that the brush is a very versatile tool. You can work with flowing strokes, using only the tips of the hairs, or, just as effectively, use the edge or side. In Figure 14G, the side of the brush was used, with the handle held under the palm. If control is not a problem and, instead, more pressure is needed, the brush can be gripped fairly close to the ferrule.

Don't be afraid to abuse your brushes when you're painting. That's what they're made for. The time to take care of your brushes is after you finished painting—a rinse in turpentine or brush cleaner, then a nice bath in Ivory soap and water.

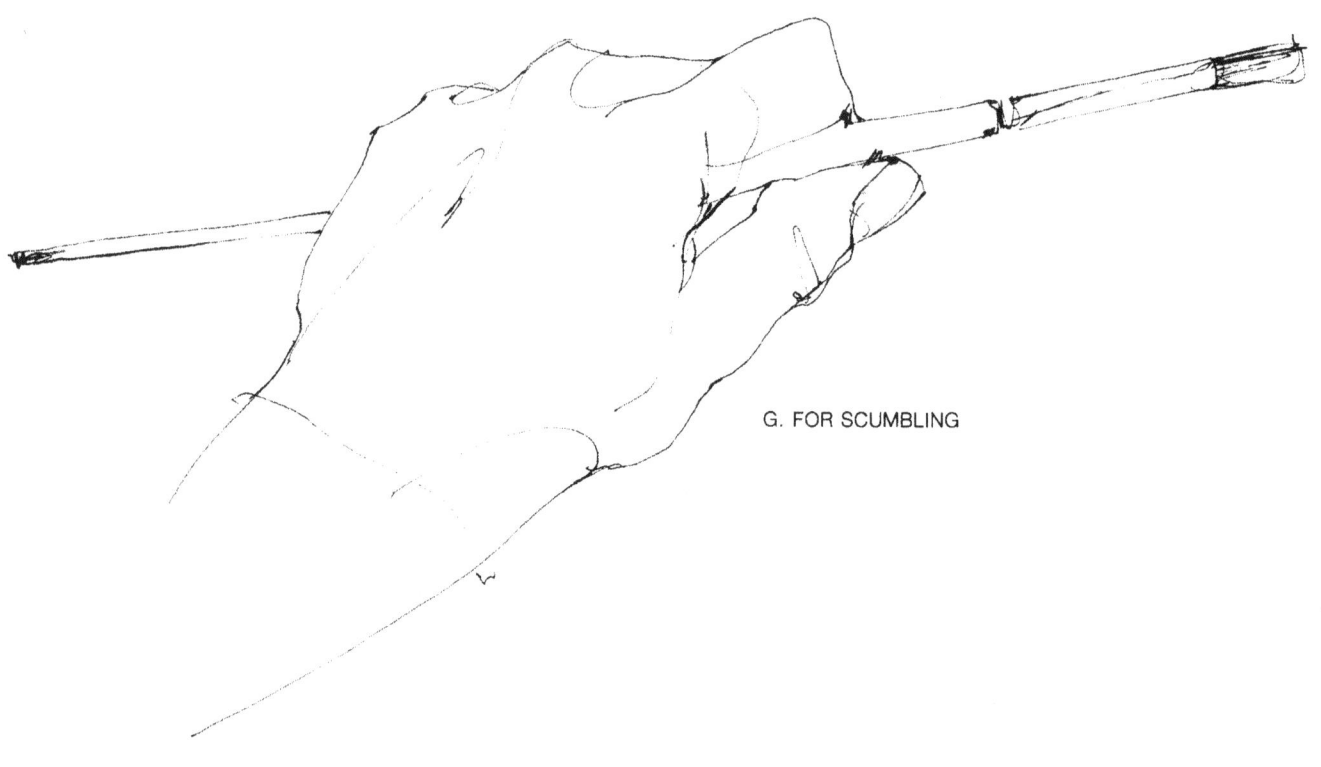

G. FOR SCUMBLING

32 FLOWER PAINTING IN OIL

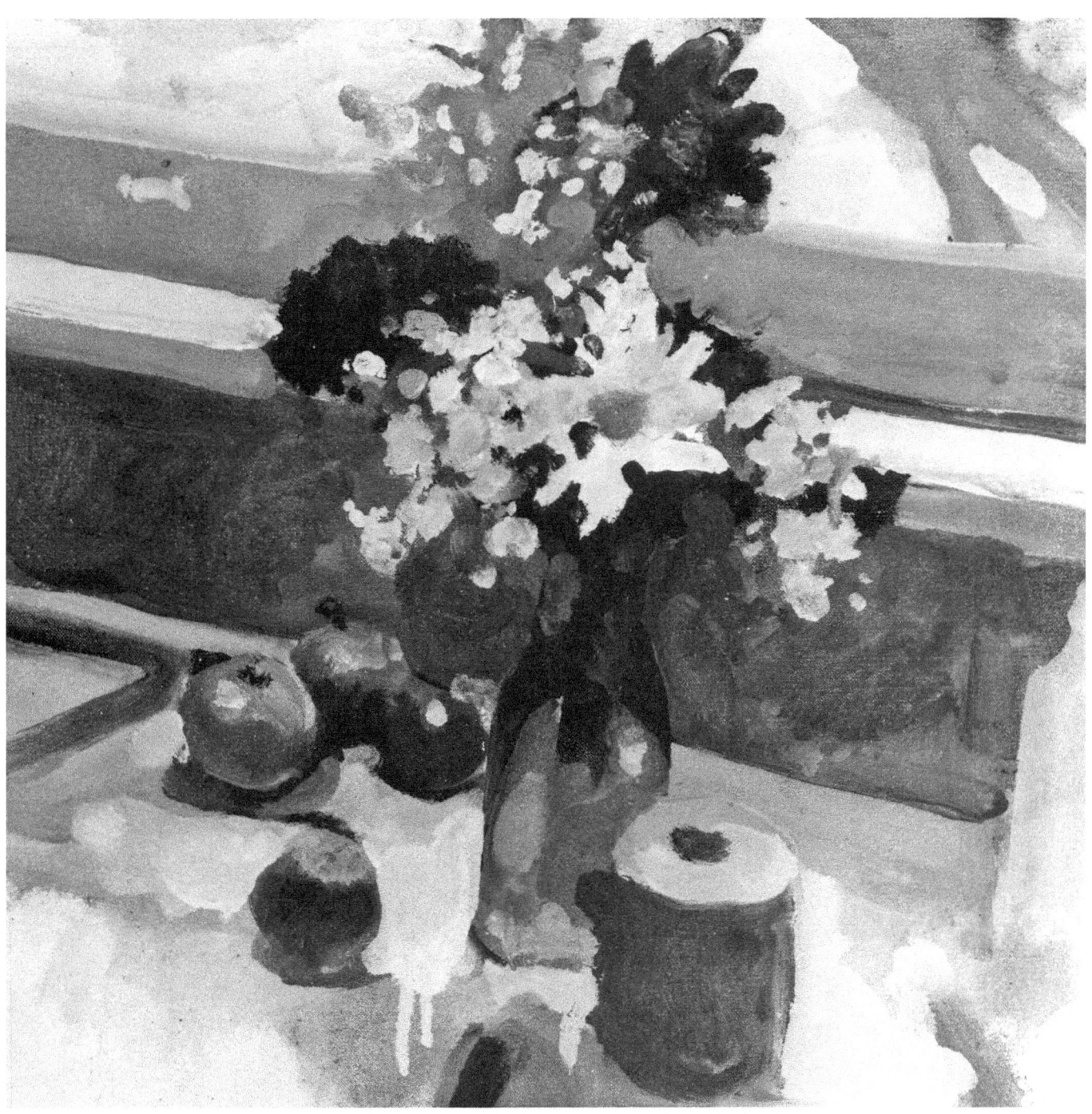

Tomatoes and Flowers. *14" x 14". This painting isn't actually finished, but I included it to show the countertop and the "drips." You can see how much medium I used. Many artists don't like the paint to be this fluid. I suppose I like this consistency because of my experience with watercolor. I handle the two media, watercolors and oils, in a very similar way.*

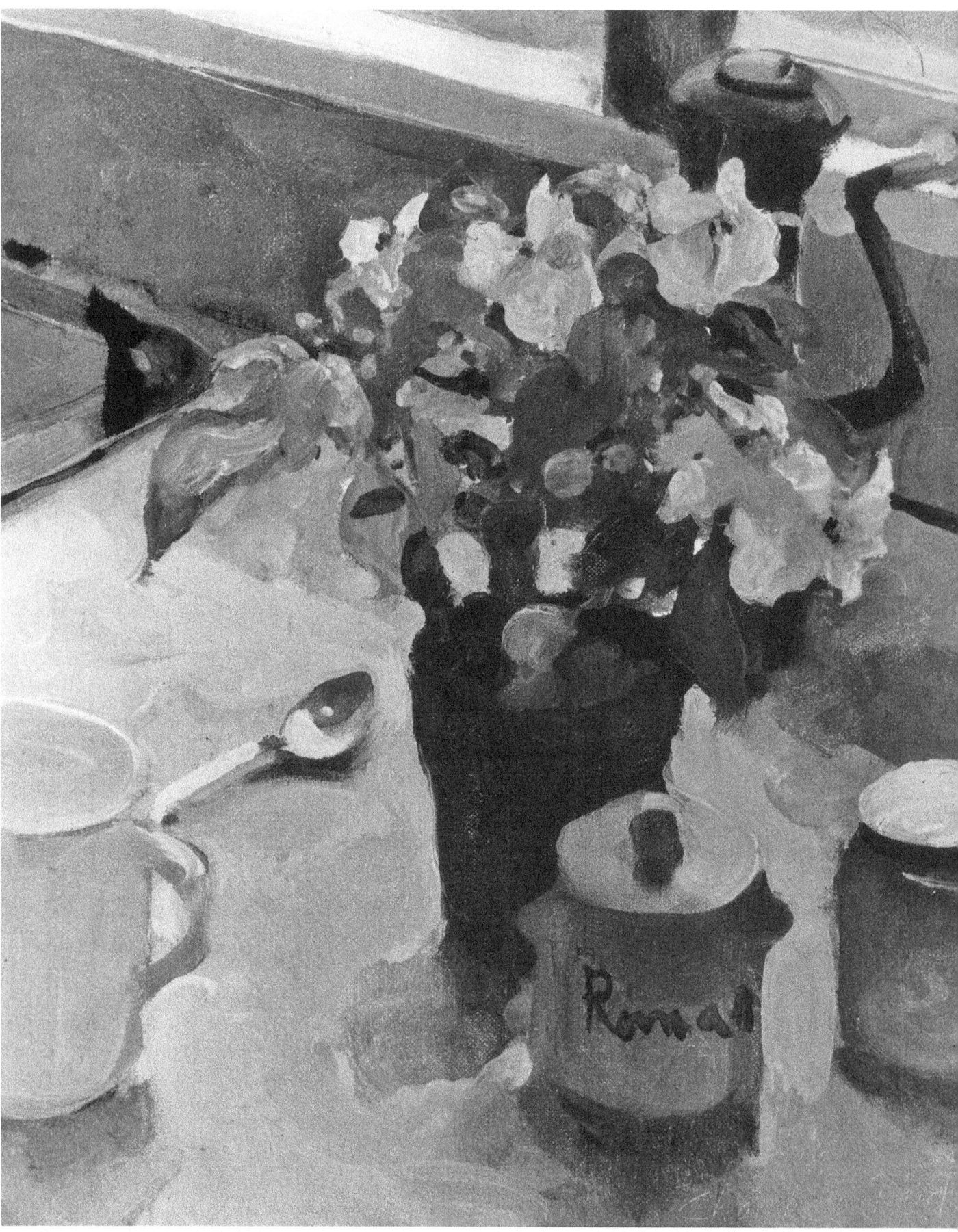

PROJECT 2
BROAD LEAF FORMS

Now that we've discussed the various brushstrokes and how to hold the brush, I'd like you to follow along with the exercises in this project and actually make some practice strokes. Notice in my examples that I've made no attempt to do well-formed, nicely painted leaves. What I've tried to do is make strokes you can easily master. Some of them are simple marks with paint, while others attempt to follow particular contours. And although some are lighter than others, still, each stroke is essentially one value. As you do these exercises, don't make any preliminary drawing; you're just getting your feet wet here, making only the most general indications.

Practice Exercises. To start, mix a little black and a bit of white on your palette, using your brush. (I've grown used to mixing all my paint with a brush rather than a palette knife. It's much easier to make the value and color changes that are constantly necessary.) As you mix, dip your brush in some painting medium. The consistency of your paint (the proportion of medium to pigment) depends on you. At any rate, the paint should be fluid enough to be easily manipulated.

Impatience Plant. *9" x 12". I enjoy painting kitchen objects. Here, I set the plant on the kitchen counter next to the herb container, with the dark mass of the flowerpot dominating the picture. The cast shadows of the objects help tie the flowers in with the borders of the picture. The salt cellar ties the flowers to the top of the picture. Always try to see your objects in terms of the picture boundaries.*

Figure 15. *The brushstrokes shown in these swatches can be used to suggest broad leaves of plants.*

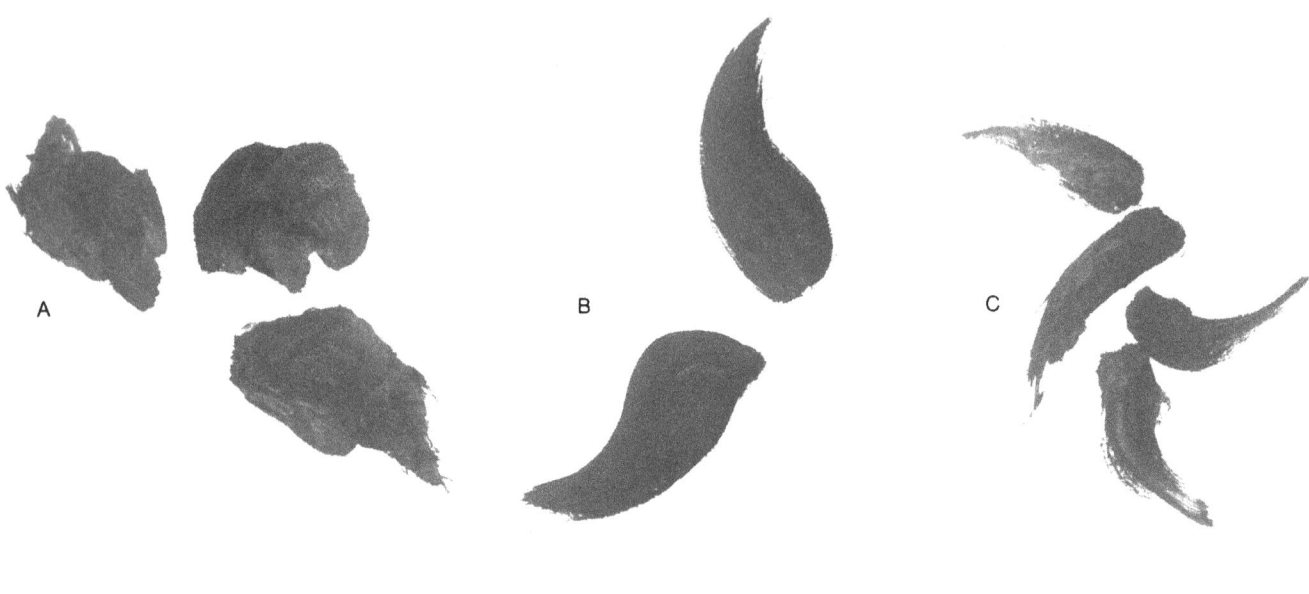

Short, Abrupt Strokes. The first exercise (Figure 15A) is very simple. Make some short, quick strokes, just to see what happens. Try twisting the brush, moving it sideways. Simply make strokes. Then see if they look anything like leaves.

Short, Feathered Strokes. In the second exercise (Figure 15B), again make simple strokes, but with the boundaries slightly more specific. Notice how several of the boundaries in my example are "feathered." This is done by lifting the brush off the canvas during the course of a stroke. Don't worry too much if you have trouble with this particular stroke. It's not easy to vary pressure on your brush at just the right time. Just be patient and willing to practice.

Thinner Strokes. Thinner leaf forms (Figure 15C) are done with a single stroke of the brush, lifting the brush off the canvas as you complete the stroke. Just as in Figure 15B, this stroke takes practice. As you can see, my examples are far from perfect. Your only object in these early stages should be to get acquainted with the basic brush manipulations. No one expects you to paint museum-quality leaves yet!

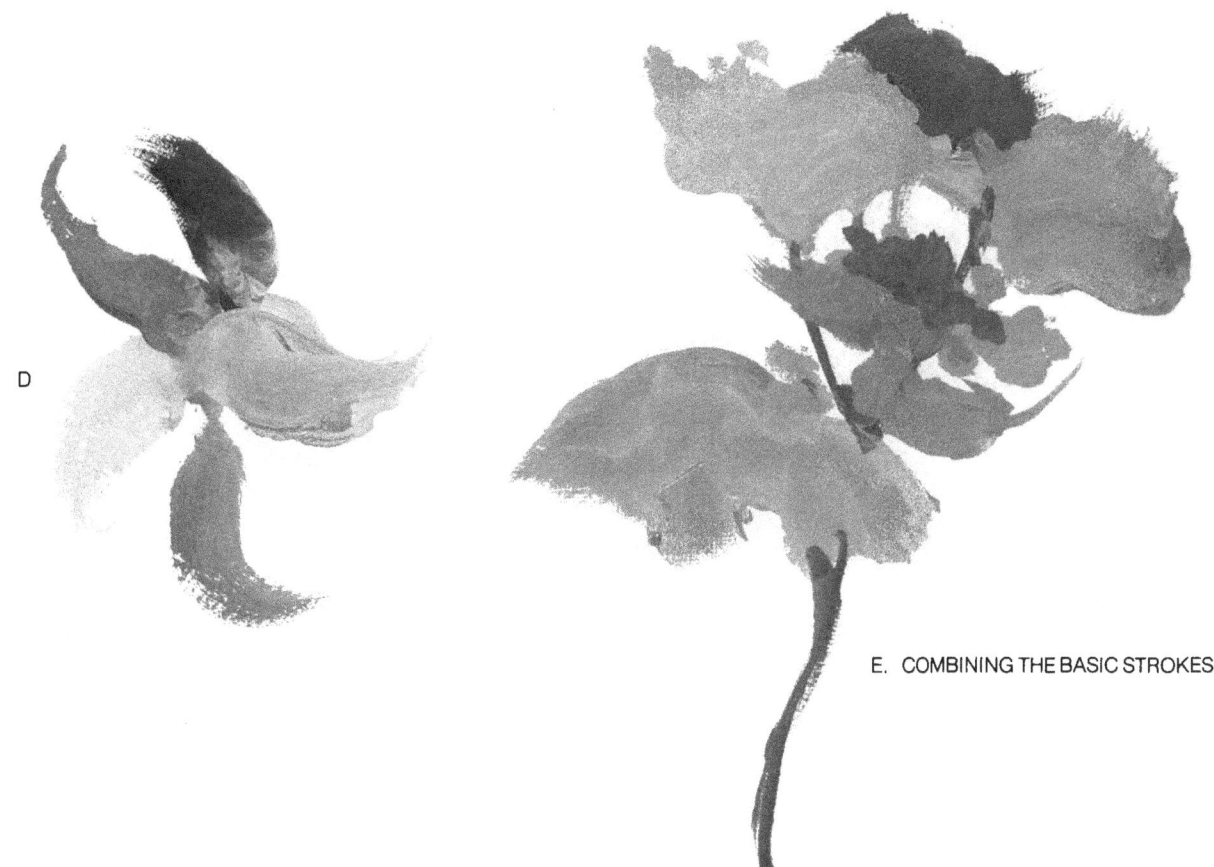

E. COMBINING THE BASIC STROKES

Light and Dark Strokes. Now try to get different values in the same single strokes (Figure 15D). Don't worry about getting the exact values I use in my example. Just try to make some of your leaf strokes darker or lighter than others.

The Complete Plant. Finally, do a complete section of a broad-leaf plant (Figure 15E). I used a geranium as a basis for my example, but it's a rather free interpretation. I used the basic strokes discussed in this section, and I varied the values in the leaves as well.

Start by making broad strokes, leaving spaces between some strokes, grouping others together. Don't labor. Just do simple basic strokes, using several values. If they don't look in the least like leaves, that's okay too. Now, with a thin sable oil brush, say a #8, make single, thin strokes to indicate stems. You can do all this out of your head. Or use my example. Or use an actual plant. If you do use an actual plant, don't get involved with value changes within single leaves. Keep it simple and broad!

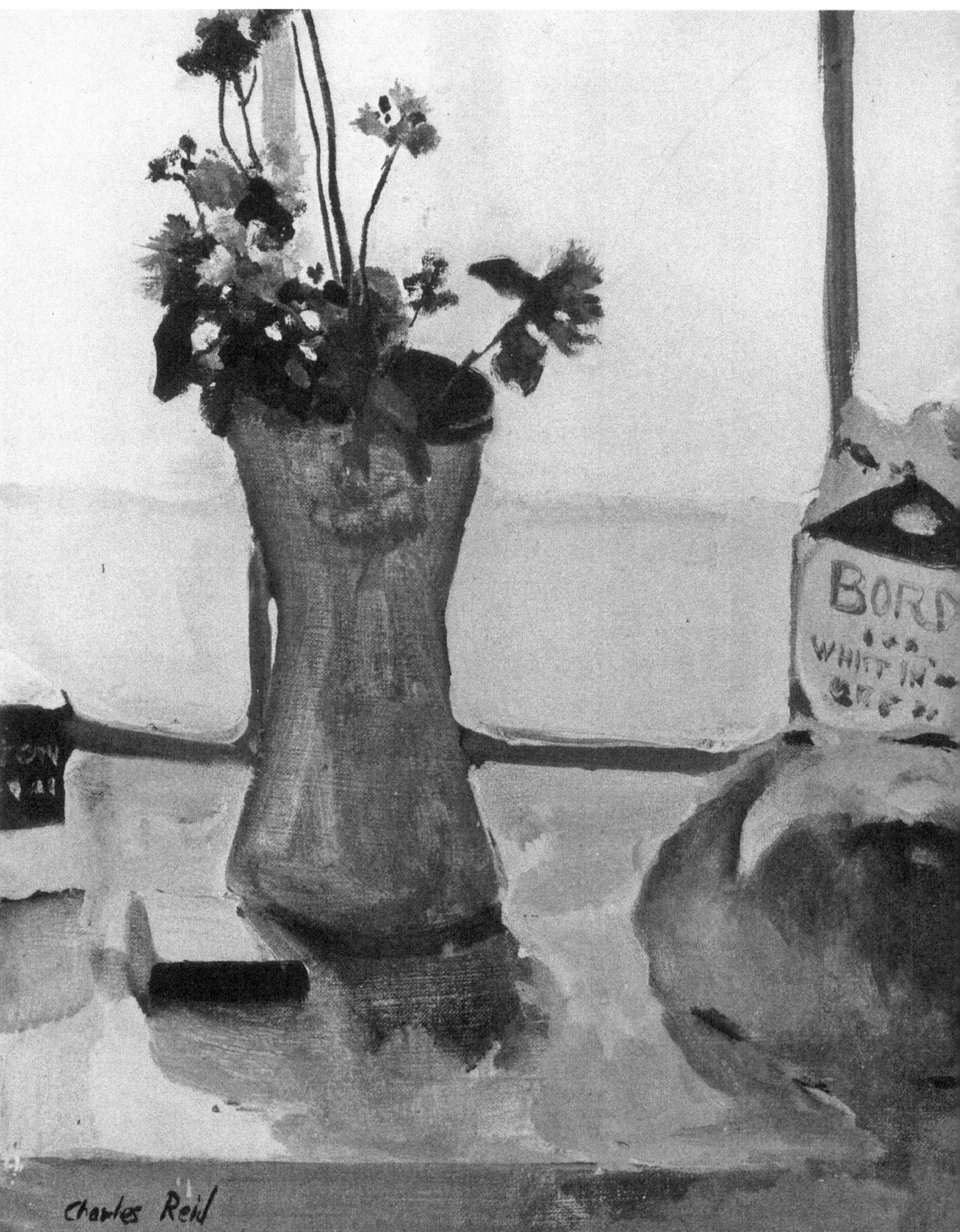

PROJECT 3
SLENDER LEAF FORMS

For this project, we'll paint delicate leaves with interesting, involved shapes. Don't worry too much if the shapes you paint aren't just like the ones you see in the actual plant. The main thing is to develop interesting and varied shapes, whether they're the actual shapes you see or your own interpretation of them. Please note that as I progress I constantly change shapes, trying to refine them. Never paint an image and then paint background around it. You'll see what I mean if you compare the sketches in this project.

I haven't made any boundaries or outlines in my examples because I want you to get in the habit of painting back and forth between the image and the background. I actually pull the background color into a section of the leaf to correct its shape. Then, if the shape still isn't right, I repaint the leaf, this time painting the leaf color on top of the background. Painting in this manner keeps the images from looking cut out and pasted on.

If you simply fill in a drawing, you obviously have more control over the flower's shape. But that really isn't painting! Don't get frustrated if your leaves don't look like leaves. One of your greatest hurdles will simply be learning how to move paint around—and you'll never learn that if you keep filling in outlines.

One final word. Be sure to keep your paint fairly thin, especially in your darker background. The more paint you have on the canvas, the more trouble you can get into. You'll have to experiment. One rule of thumb is to use enough pigment to cover the canvas easily without getting too much of a buildup.

Milk Carton. *12" x 14". This is an old painting, and one of my first flower paintings. I think the vase is too big and the wildflowers too sparse. If I had it to do over, I wouldn't be as stingy with the bouquet.*

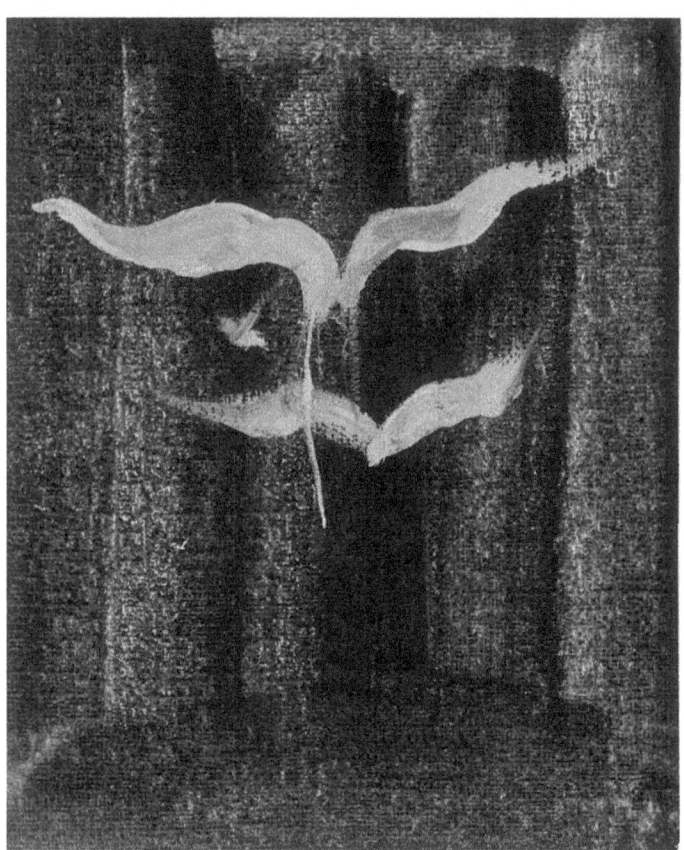 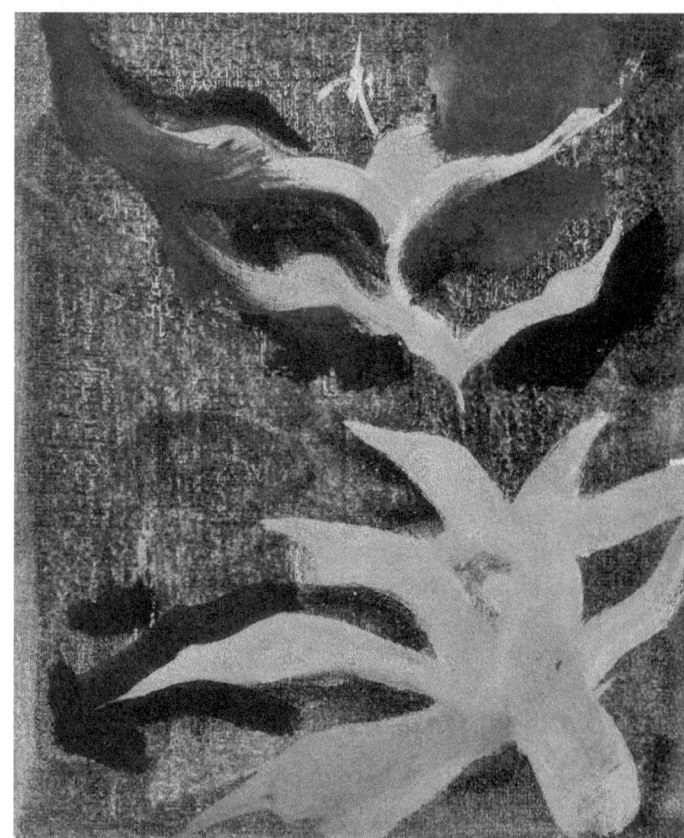

Step 1. Here, I wash in black using lots of turpentine so it will dry quickly. I don't use any white; I keep the wash transparent. When the wash-in is dry, I start the leaves, using a #3 long, flat bristle brush. I start at the base of the leaf where it meets the stem, then brush out, moving the brush in a curved, almost zigzag, manner. I vary the pressure on the brush, bearing down where I want a wider section, lifting up slightly where I want a thinner area. As I get to the end of the leaf, I lift up on my brush, still continuing the stroke. ·

Step 2. I continue the stroke down to a cluster of overlapping leaves. Notice that I'm involved with a silhouette of light forms against a darker background. Always simplify at this stage. Don't worry about small value changes on the individual leaves. Instead, work for the basic differences in value between your positive shapes (leaves) and the negative shapes (background). I start working into the background with slightly thicker paint, using my background color to refine my leaf shapes. As I mentioned in my introduction, I paint background color right into the still-wet paint used in the leaves. If I make a mistake (and I usually do), I clean my brush in turpentine or get a new brush and restate the leaf, painting the leaf back over the background until I get the shape I want.

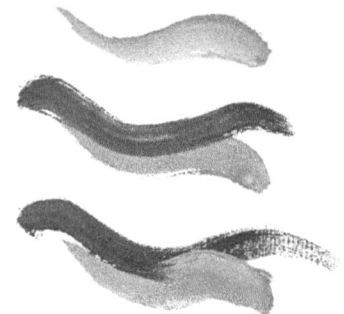

I hope this diagram will help show you what I mean. First, the leaf shape is painted with a single stroke. Next, the background color is brushed along and into the top boundary of the leaf. It's still not right, so I take my "leaf" brush and restate, brushing leaf color back out over the still-wet background color. I've left the stroke unfinished to help show what I've done.

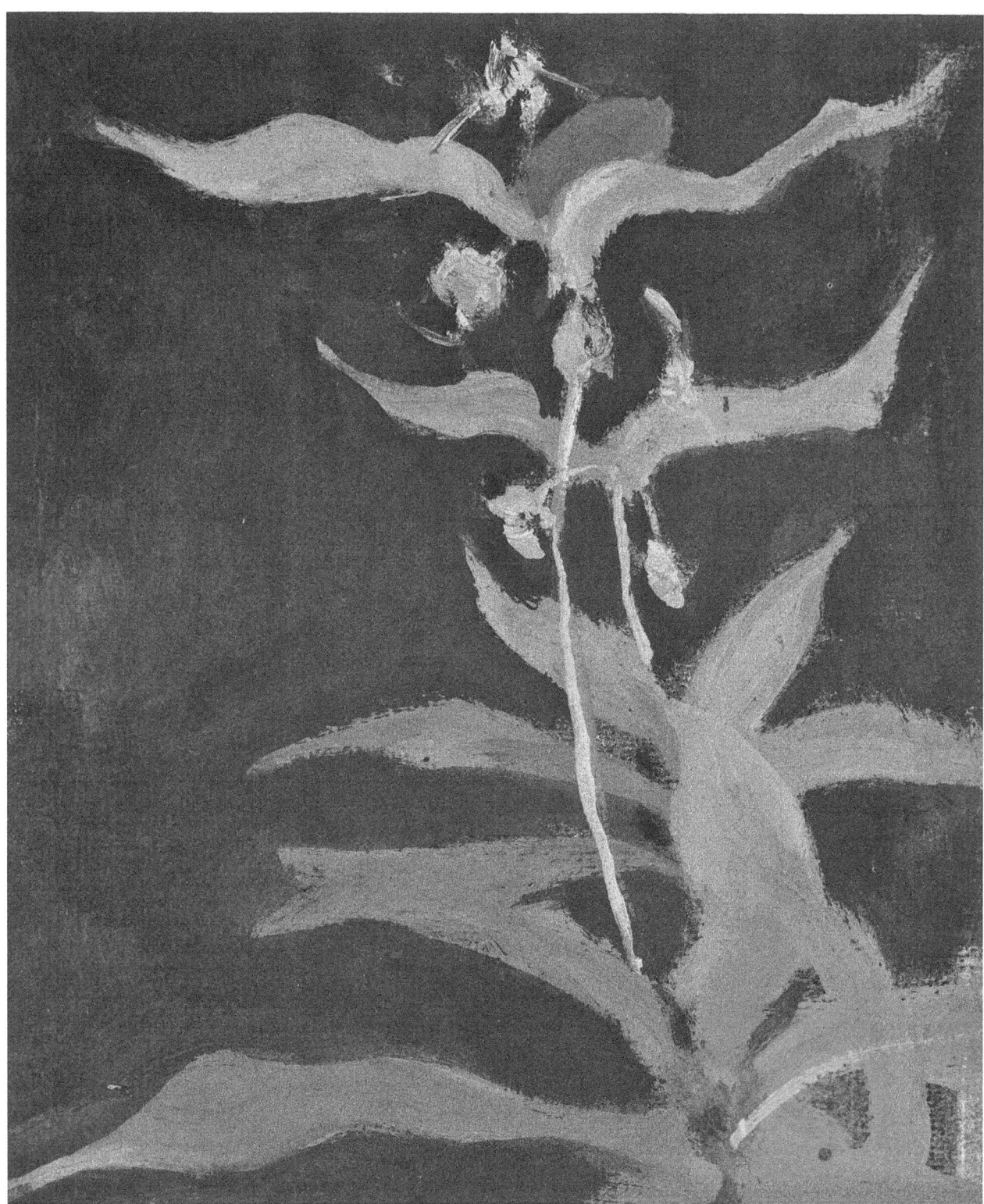

Step 3. I repaint the background. In this case, I want darker values to set off the leaves. Notice that I repaint all the lower leaves, making them a bit darker. I also make the leaf shapes a bit longer and more graceful. When I paint the background into the leaf, I don't necessarily paint out the whole leaf. I might just change an edge. The stems and buds come last. For these delicate forms, I use a #9 sable oil brush. I try to make the stems with a long, flowing stroke. If you have trouble doing this, simply take your background brush, paint out the stem, and try again. To succeed, you must make an easy, fairly rapid stroke, not lifting your brush until you come to the end of the stem.

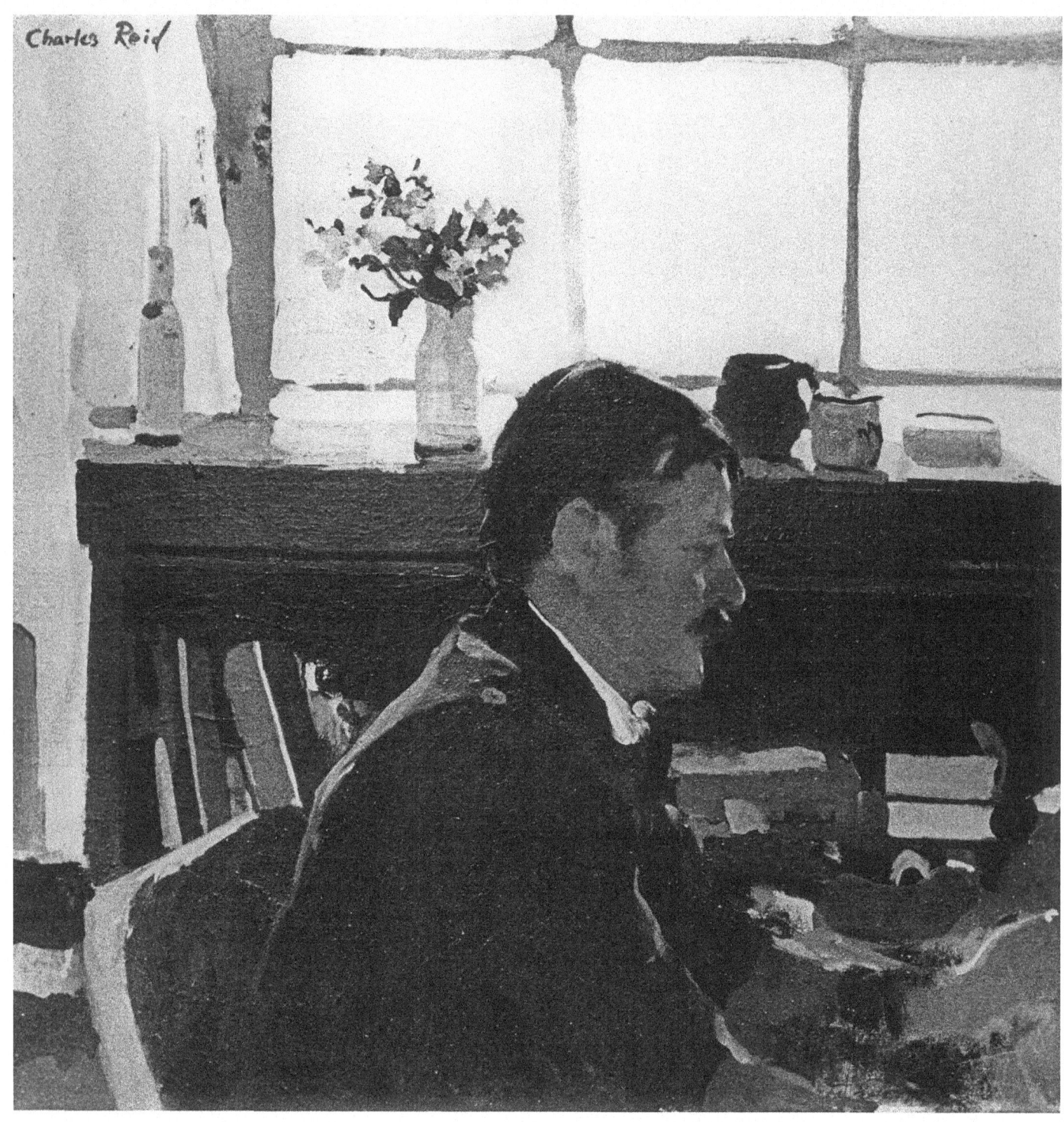

Chip. *36" x 36". Collection Mr. and Mrs. Allen Cramer. I set a small bouquet of wildflowers on Chip's bookcase. Notice that the bookcase top is quite shiny, so that where the light hits its surface, the local color is washed out. But where the cast shadows from the vase, window frame, and other objects block the strong light, the local color of the bookcase is retained.*

PROJECT 4
COMPACT FORMS

It's difficult to incorporate details into the overall mass of any object. You tend to see only the details and *nothing more*; if you do see the mass, you still give the details the starring role. This is not to say that painting details is wrong. Some of our very best artists have been involved with small forms. The point is this: the large areas of lights and darks in any painting must dominate the small forms.

The two sketches in Figure 16 illustrate what I mean. In Figure 16A I've tried to draw as many small forms as possible. I haven't done anything with larger areas of lights and darks. In Figure 16B I've left out some detail and have tried to show the flower as an overall shape on a darker background. I think it's fairly obvious which sketch "reads" best.

Unfortunately, you don't always have such an obvious situation as a light flower on a dark background. Sometimes it's hard to see the differences between lighter and darker areas. You may have to look harder, but please look!

Getting to the problem at hand, a compact flower like a rose, tulip, daffodil, or water lily is made up of many small petals. These many petals are gathered together to make a whole flower. The problem is how to indicate that there are many petals and show the entire flower at the same time. The key is to suggest the individual petals without losing the feeling of bulk and form of the whole flower. The easiest way to understand the bulk of an object is to cast a single strong light on that object. A single light causes a single shadow shape; that shadow shape is the key to showing bulk in the simplest, most obvious fashion.

For this project I used a photograph as reference. Normally, I paint my flowers from life because I find it easiest. However, I found an excellent photograph with good, simple light and shade and decided to use it. In my step-by-step painting of this one flower, I'll try to explain how to show bulk and two-dimensional form while showing enough detail to clearly identify a particular flower.

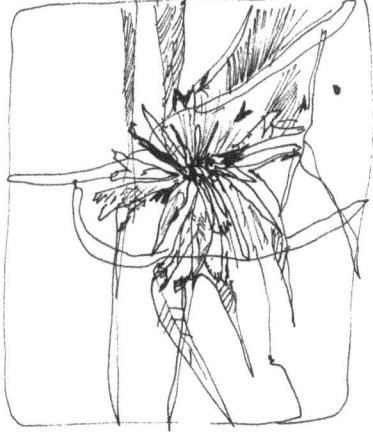
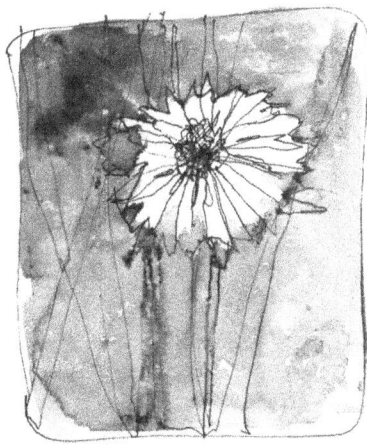

Figure 16. *In Sketch A (left) there are too many small forms; in Sketch B (right) I've left out details and concentrated on the overall pattern.*

Step 1. I normally start right on the white canvas. There's something fresh and vibrant in these first strokes on a white canvas that really grabs me. I sketch in with my #9 round sable oil brush. In this case, I'm using viridian mixed with quite a lot of turpentine. I never use any particular color for my sketch—sometimes an umber or black; other times, burnt sienna or a blue or green. It really doesn't matter. You may even use red if you wish. Starting off with a stronger color like red or blue might get you off on the right foot and keep you from being too timid in color. Just make sure whatever color you do choose is well diluted with turpentine. Otherwise it won't dry, and will "pick up" when you paint over it. Note that my sketch also includes some very quick indications out to the border of the canvas. I'm already thinking about placement. Never think only of the subject; always think of the background and all that bothersome area around the edges of your canvas.

Step 2. I want to get some darks in quickly. You can't relate a light color successfully to the white canvas alone. You need the comparison of some darks. *Always* start with middle or dark values in your first strokes. Notice that I don't move my brush in just one direction. The brush is moved horizontally, diagonally, and vertically, all in quick succession. I rarely make more than two or three strokes before changing directions.

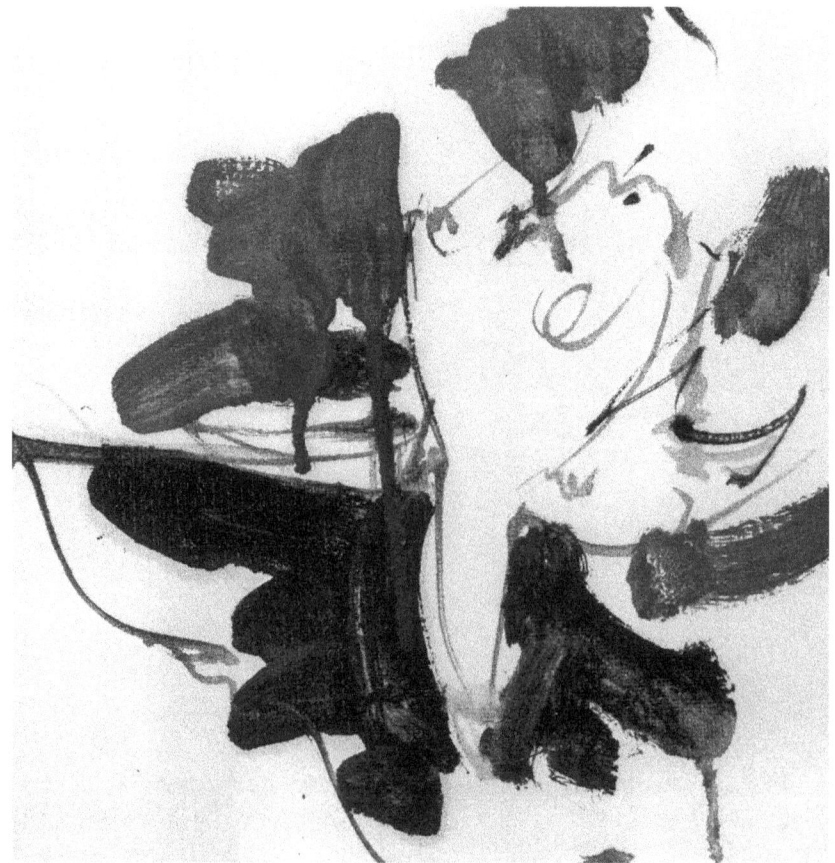

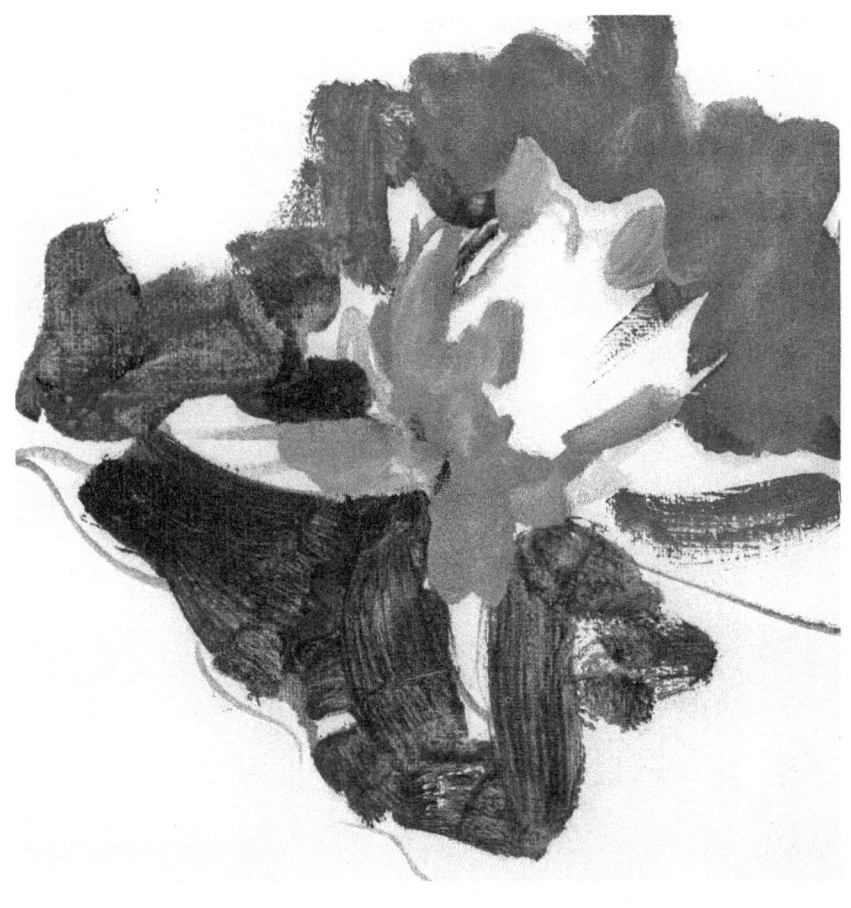

Step 3. If you're working with flowers that fade quickly, you may have to paint them before anything else in the painting. But this really isn't good practice, so if your flowers are holding up, I strongly suggest you keep the *whole* picture going at the same time. This means that the background will be at the same stage of "finish" as the subject of your painting.

There's some strong sunlight shining on the water lily, creating a definite shadow shape. I block in the shadow shapes first. Shadows act as the foundation of your picture, so get them in simply and broadly. Try to connect them into one single shape. There'll always be one or two isolated bits. But keep them at a minimum. What you should be after is one large, simple single-value shadow area. Notice that the shadow shapes are broadly, yet quite carefully, painted in terms of shape. *The shadow shape must describe the structure of the form on which it lies.*

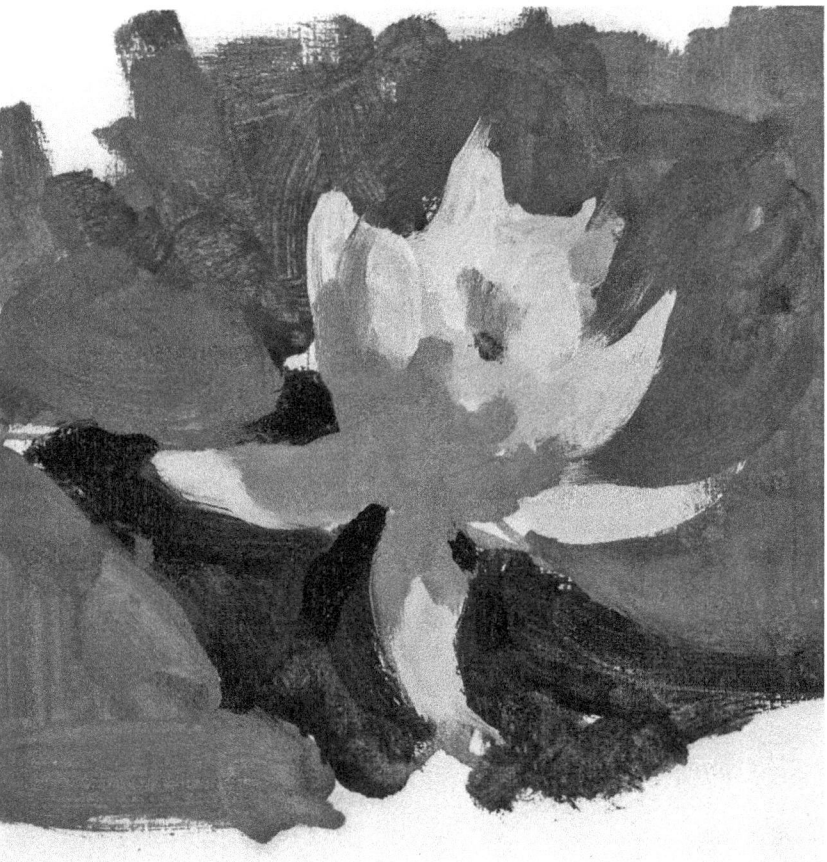

Step 4. Now I start massing in my lights. The hardest part of this step is to avoid destroying the simple shadow shape I've just blocked in. It would be easy if you could just paint your light area carefully around the shadow. The trouble with this method is that you'd have a hard-edged flower that looks like a paint-by-the-numbers picture. If you feel you lack sufficient control to paint your lights right up to and into the darks, at least isolate the light areas from the darks. You won't make a great-looking flower, but at least you'll have a good simple statement of light and shade. If you do mess up the boundaries of your shadows, you can always restate the shadow. However, don't get light paint into the shadows, and don't allow the shadows to build up with thick paint. Keep them fairly thin. Notice that all my light areas on the lily are fairly light. Don't allow small dark values to get into your big light shape and don't allow lights to get into your big shadow shape.

COMPACT FORMS 45

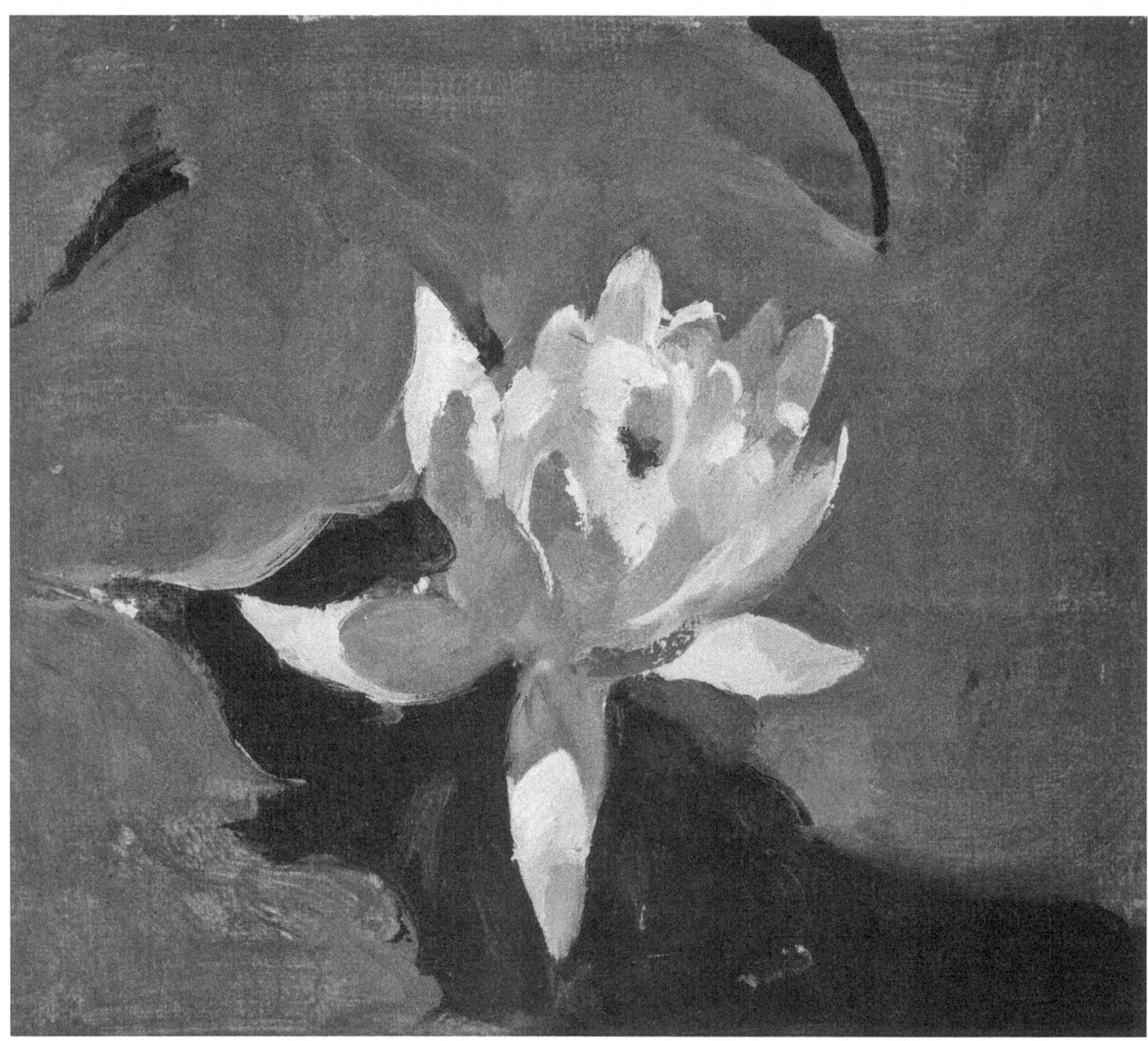

Step 5. Now comes the confusing part. I add some small shadows out in my big light area and I place some reflected light in my shadow. This is where you could get into trouble, so be careful! All your good simple shapes will be destroyed if you make those small darks in the light area too dark. Conversely, your shadow will be destroyed if you make reflected light too light. *Reflected light should never be as light as your main light.* Please note that this flower still has a dominant shadow area and a dominant light area. If you find your small forms taking over, then you know they're wrong. Take a big brush and restate the whole light or shadow area and try again with the smaller forms. Put in only those small forms that are absolutely necessary. If a small form isn't necessary, it has no business being in the picture. Remember that you're painting a whole flower, not a bunch of individual petals. There's a big difference between the two!

Marmalade Jar. *(Right) 16" x 12". This was one of my first still lifes. It's very stark. The window dividers seem to be too dark (part of the problem is in the black and white photo, which tends to generalize darks in value that are differentiated when seen in color). In the actual still life, there was a very dark cast shadow, even darker than I painted it. If the cast shadow were actually painted the same value as the darks in the flowers, it would distract from the flowers, resulting in a divided painting with two focal points.*

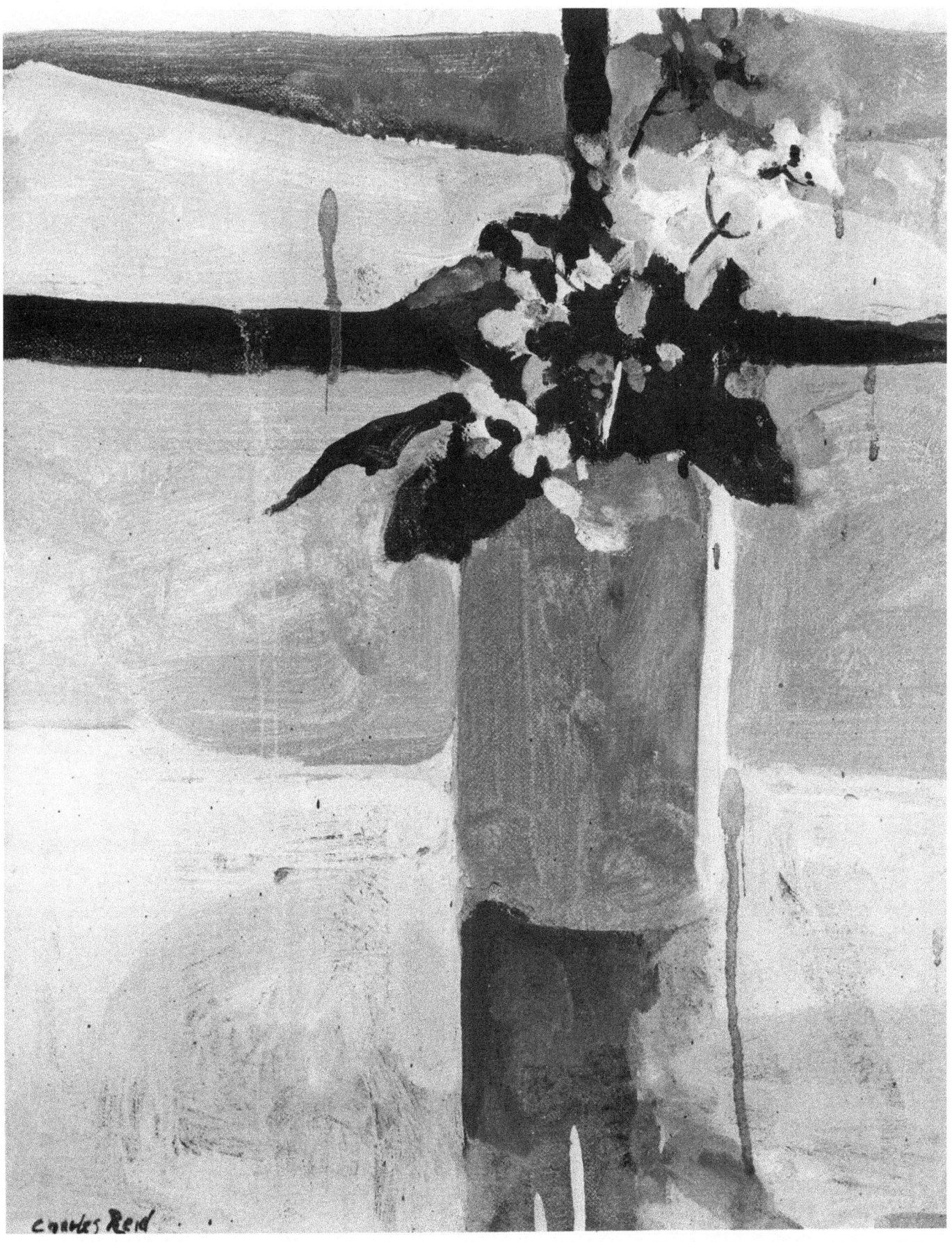

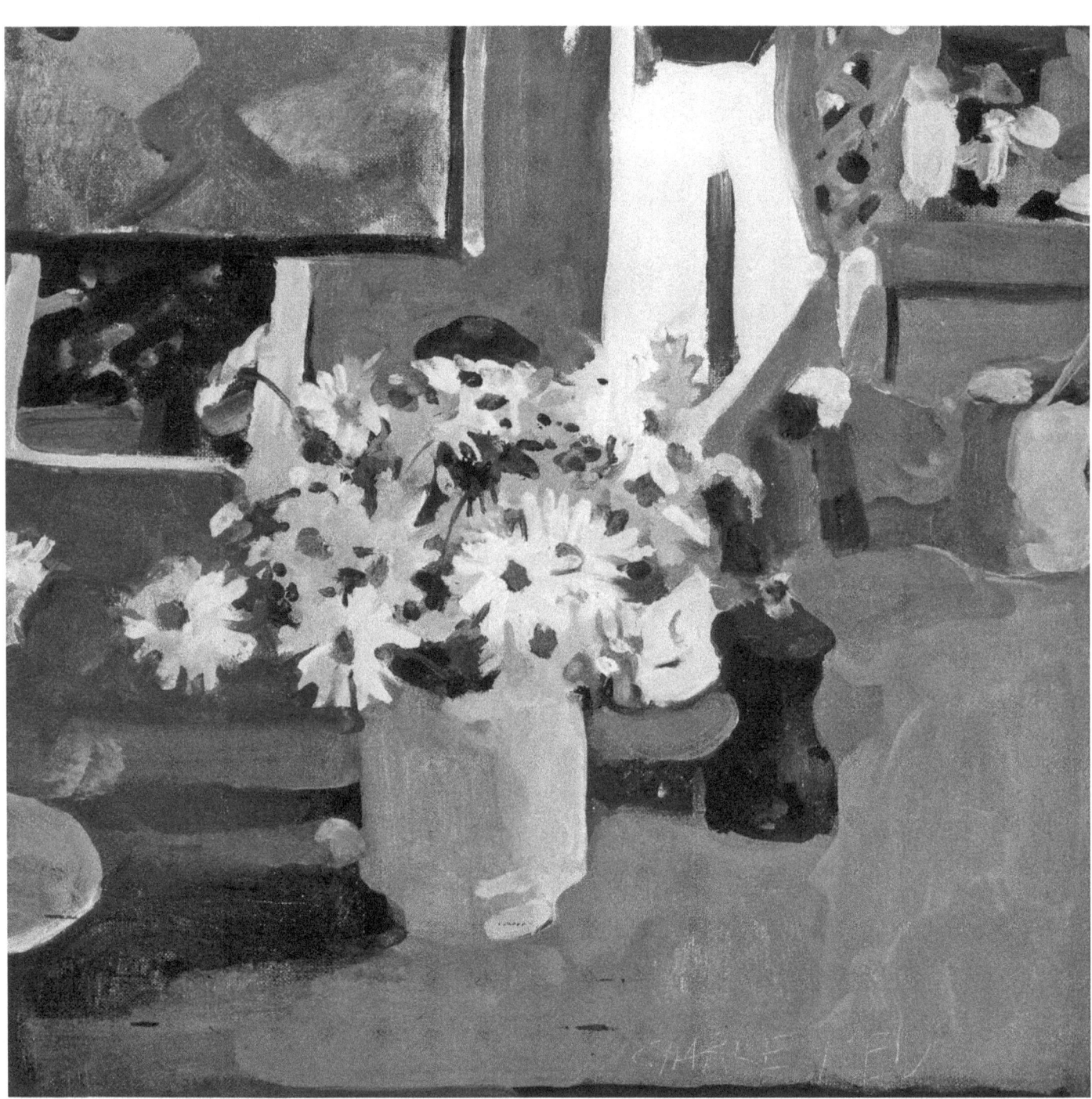

PROJECT 5
DIFFUSED FORMS

I love to paint wildflowers; I like their subtle, understated colors. Even when the colors are bright, they seem beautifully modulated. One of the great disadvantages of many wildflowers is their short life after being cut; some only last a few minutes. More important, many wildflowers are endangered species and shouldn't be cut at all. Be sure and pick only the most abundant varieties. It would be much better to paint the rarer wildflowers where they grow and live.

For this project, I chose wood anemones and I painted them in their natural surroundings. I enjoy painting diffused plant forms like daisies or anemones, since they give me a good opportunity for some delicate brushwork and some fine, intricate passages. Remember that variety and contrast are an important part of any painting. In this case, you can contrast the small, fragile anemones with the broader leaf forms.

Kitchen Daisies. *12" x 14". This was a painting that more or less painted itself. Once I got started, everything went along pleasantly and things seemed to fall into place, so that I didn't have to change any objects around. This doesn't necessarily mean that it's a better painting than one created with a struggle. But painting a subject in this way, not worrying, just putting things down simply and directly, can be a marvelous experience.*

Step 1. I first tone my picture surface. As a rule, I like to work directly on white canvas, but I choose to tone the canvas in this case, since most of the painting is going to be dark. As a general rule, I tone a canvas to a middle value. It can be lighter than this, but I wouldn't suggest making your tone much darker than a middle value. Just as it's difficult to compare light values when working on a white canvas, it's also difficult to judge light values against a very dark canvas.

For toning I use turpentine, raw umber, and some viridian—you can use a dark color for toning, but always use plenty of turpentine so the paint will dry quickly. Work the very thin paint directly on the canvas, and allow it to dry before resuming work.

Step 2. Now that the tone is dry, I start on the petals. The anemones are a very simple flower, and each petal will be painted with a single stroke of the brush. You may use a #8 or #9 sable brush, if you wish. If you decide to use a sable, keep a small long, flat bristle (a #3 or #4) handy. Painting with sables alone can cause slick work. When I feel this happening, I switch to a bristle.

You may start at the narrow tip of the petal and work toward the fatter base, or you may start at the base and work out. Try both ways. The trick will be to vary the pressure on your brush so you can get the thin tip widening to the fatter base. This will take some practice, but if you've done the brush exercises, you shouldn't have too much trouble.

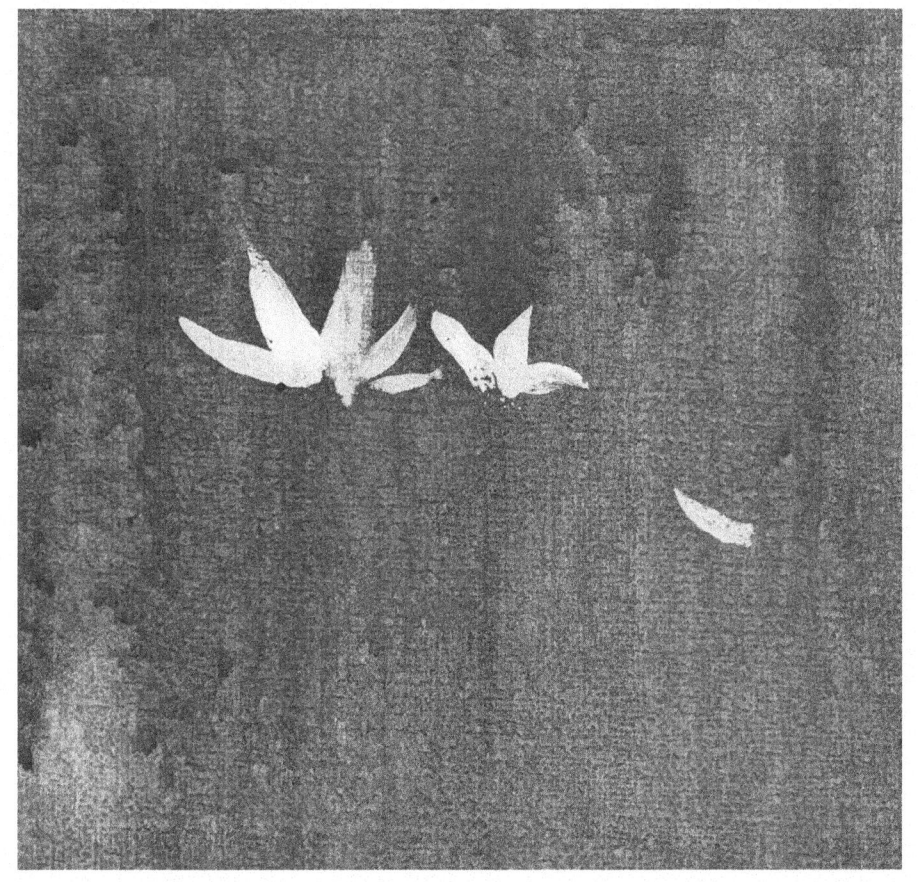

Step 3. Now I add more petals to the one I did in Step 2. Notice that you're not looking directly down at each flower. Don't paint these petals like the spokes of a wheel. Nature is definitely not mechanical! Look for variety in shape. It's not as important to be factual as it is to give each flower you paint the unique quality of its particular variety.

Finally, spend more time looking and less time putting on paint. I often see students paint a figure, still life, or landscape without really looking at the subject. Never paint from previous knowledge. Each painting should be a new experience. Just pretend you've never seen a flower before. See that flower with a fresh vision and, hopefully, your painting will reflect that feeling.

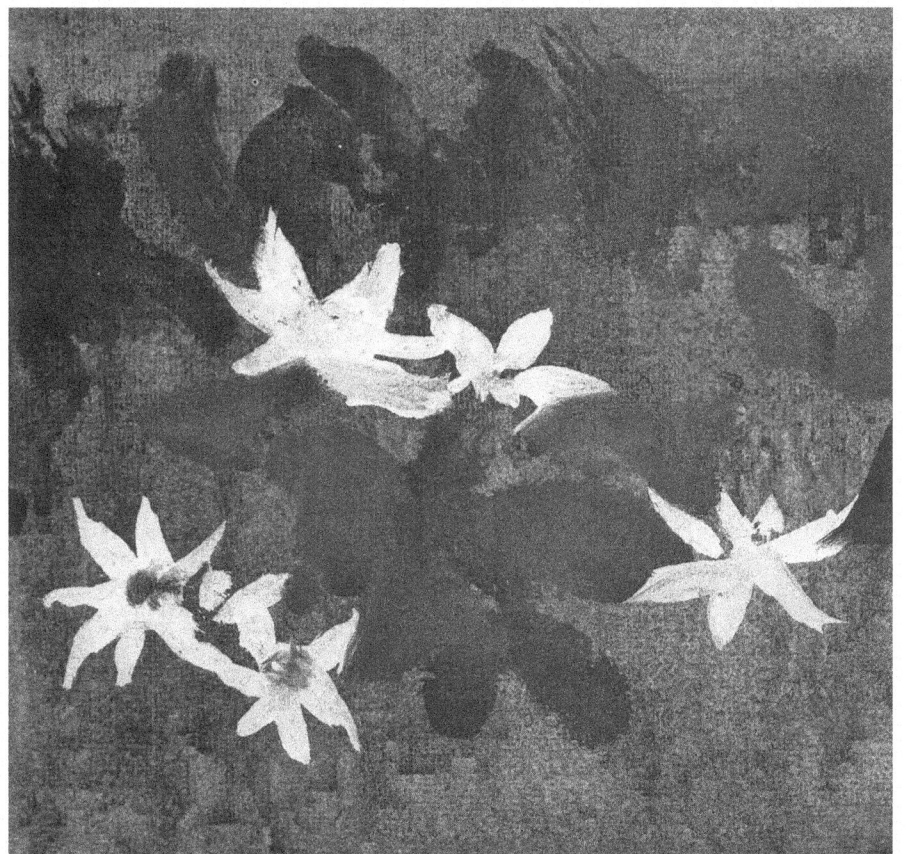

Step 4. Never work on any one part of a painting too long. In this case, don't paint too many petals without getting into the leaf areas around those petals. There always should be a feeling of connection between any subject and its background. So far, I just have a middle value and light flower petals. Now I add some darker darks.

Notice how I "spot" pieces of paint, using single strokes. These single strokes will all eventually converge; but, for now, I want to keep as many areas of the painting going as possible. I paint with the idea that my first tone might well show through; so I don't carefully cover each area of the painting. (However, if you're working on a white canvas, you cover the white fairly quickly. Bits and pieces of white canvas can be distracting.)

DIFFUSED FORMS 51

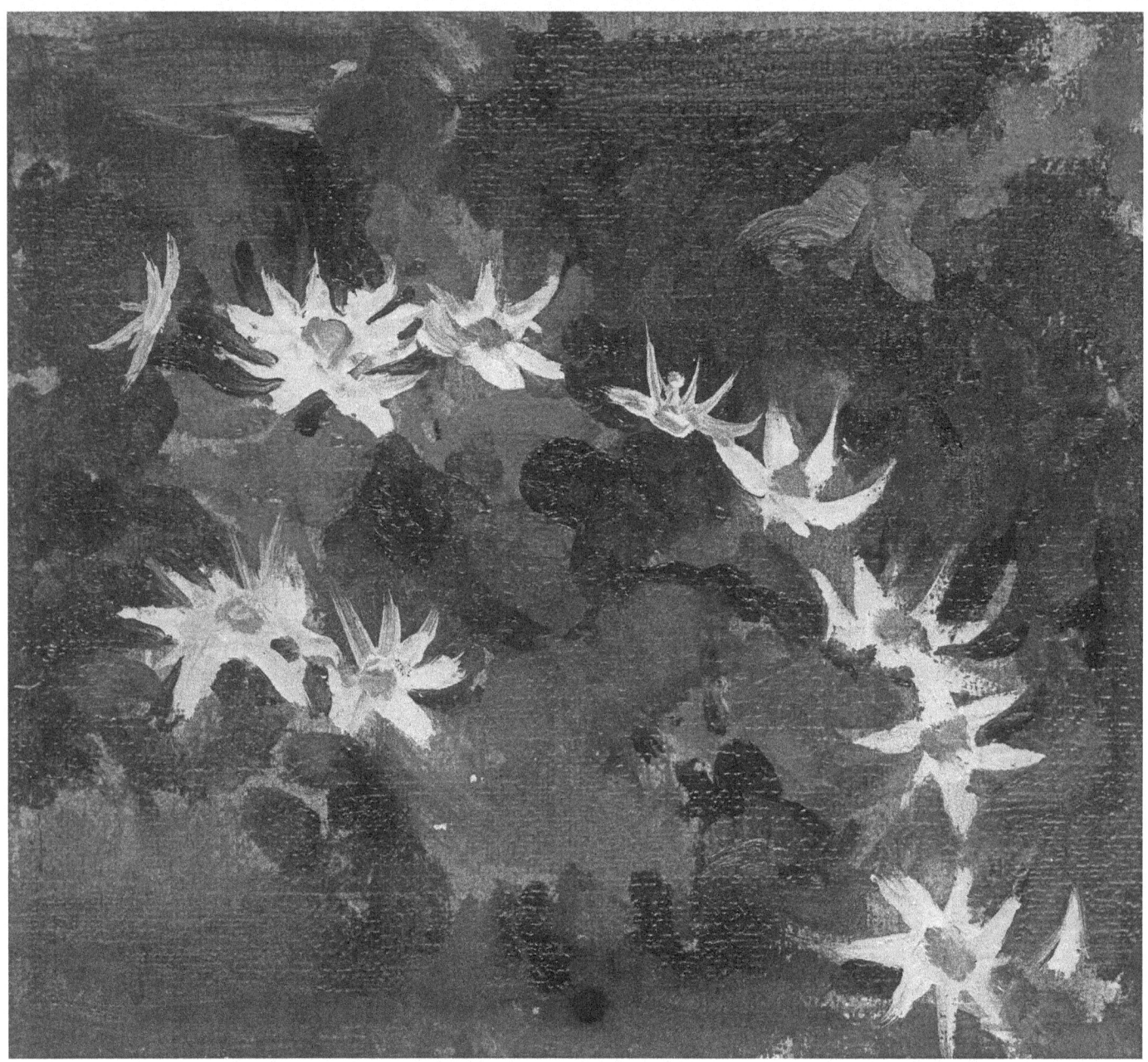

Step 5. I continue working back and forth, developing the flowers, then switching to the background. It's very important to keep the flowers from looking brittle and hard. Notice the many soft, indistinct edges on the flower petals. Never outline a light flower by painting around its contour with very dark paint. Notice the variety in value around the anemones. Dark darks are "spotted" in some places, lighter darks "spotted" in others.

Make sure you vary your brushwork. If you're edges are getting too hard, try working with a bristle instead of your round sable. If the sable is the problem, switch to a bristle. Perhaps you are getting tight because your brush is too small. Try using a bigger brush to avoid getting rigid too early.

Finally, notice that the anemones are placed to form a design. The flowers lead the eye through the picture in an arc from the upper left down to the lower right. Always think of design and composition, even when doing the simplest sketch.

Christy with Flowers. *(Detail) Here the vase is more important than the flowers. Normally this wouldn't be a good idea, but these flowers are used to fill an empty area in a large painting, so the prominent vase is excusable. The flowers, and especially the vase, are light shapes surrounded by darks. Notice that I used mostly middle values around these light shapes. Only where the vase meets the light did I really aim for a strong contrast by using dark background values right behind it. Don't isolate the light areas. Transitional values help them "breathe" and connect with surrounding values.*

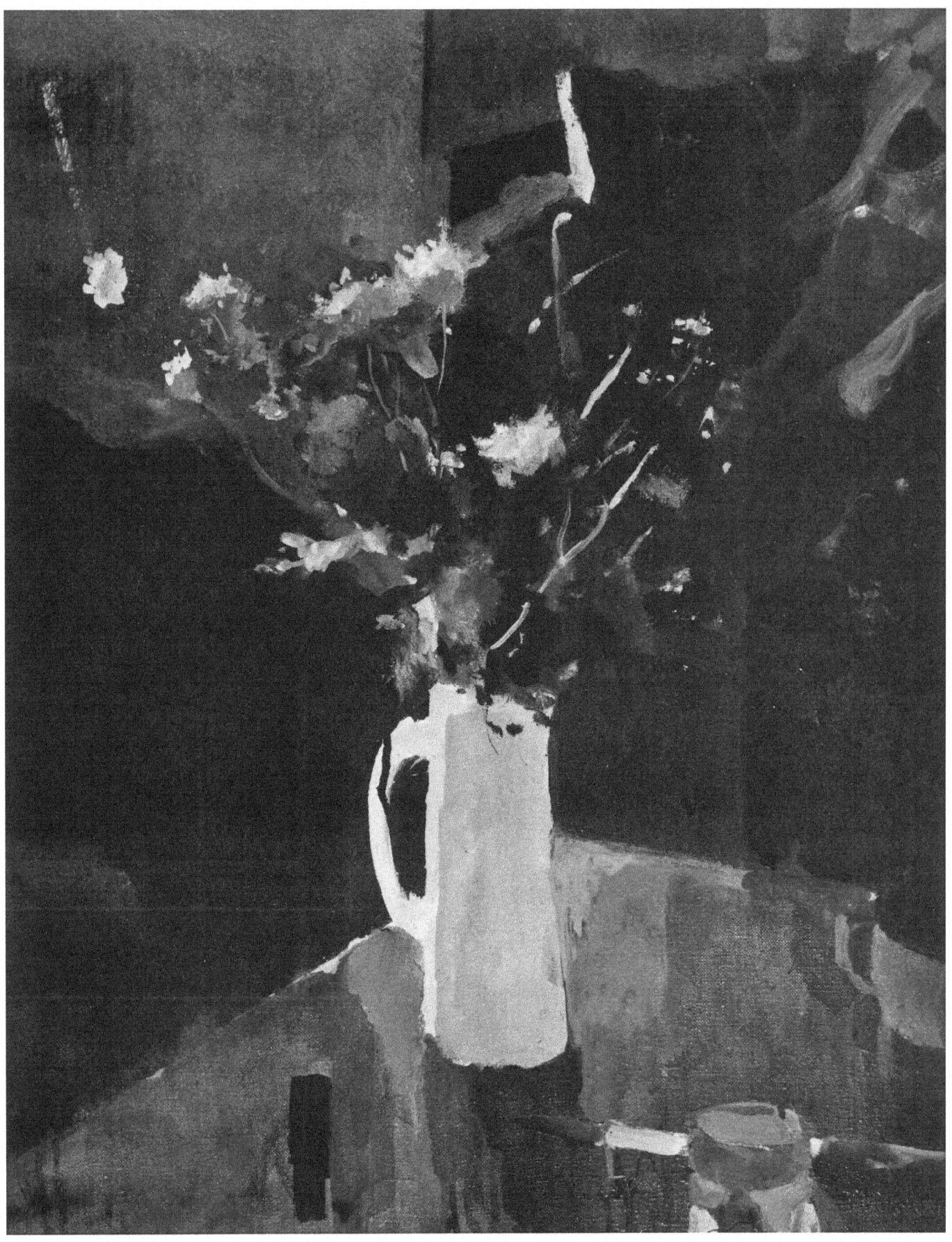

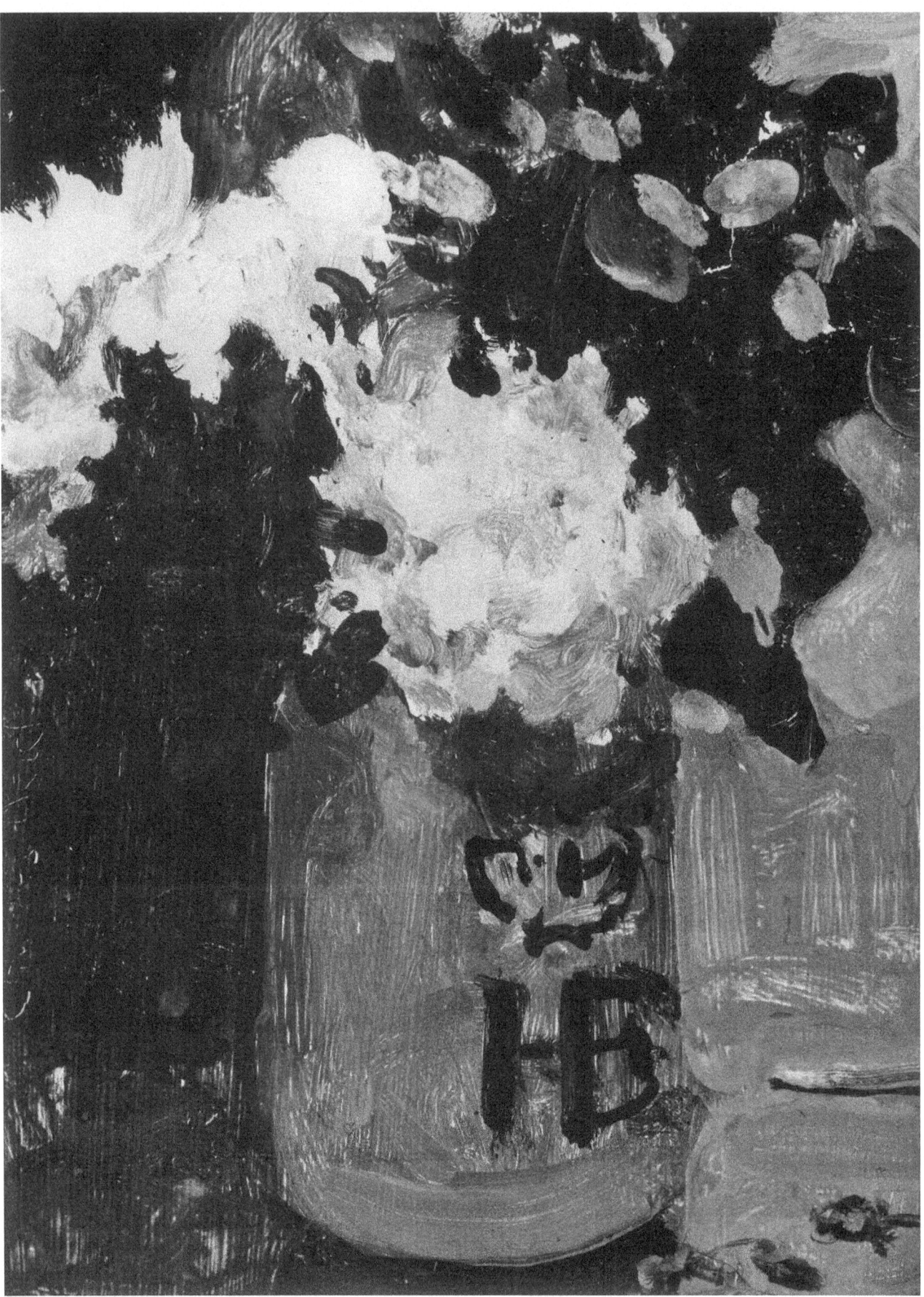

PROJECT 6
MASSED FORMS

The trick to painting massed plant forms like zinnias or chrysanthemums is first to see the flowers as an overall mass, then to see the value changes within that mass, without losing the feeling of the whole form. For this project I've chosen zinnias, flowers that I find difficult to paint. I guess the colors are a bit too brilliant for me. At any rate, a nice neighbor picked some and presented them to me, so here they are.

As I looked at the zinnias, squinting hard, I could see that all the flowers were darker than the background. That was my first decision. After this major value relationship of flowers to background was firmly anchored in my brain, I noted the different values of the individual flowers themselves. In this project, I'd like you to just concentrate on how much darker or lighter each flower is in relation to its neighbor.

Beer Mug. *6" x 8". I painted this on a little piece of Masonite with a Liquitex gesso ground. I tried to arrange the flowers so they'd lead the eye diagonally across the painting. Notice the massing of large areas of light against dark areas, and the more subtle massing of smaller areas of lights within light areas, and vice versa. Always work for the greatest contrast first, then the lesser ones, or you'll lost sight of the effect of the painting as a whole.*

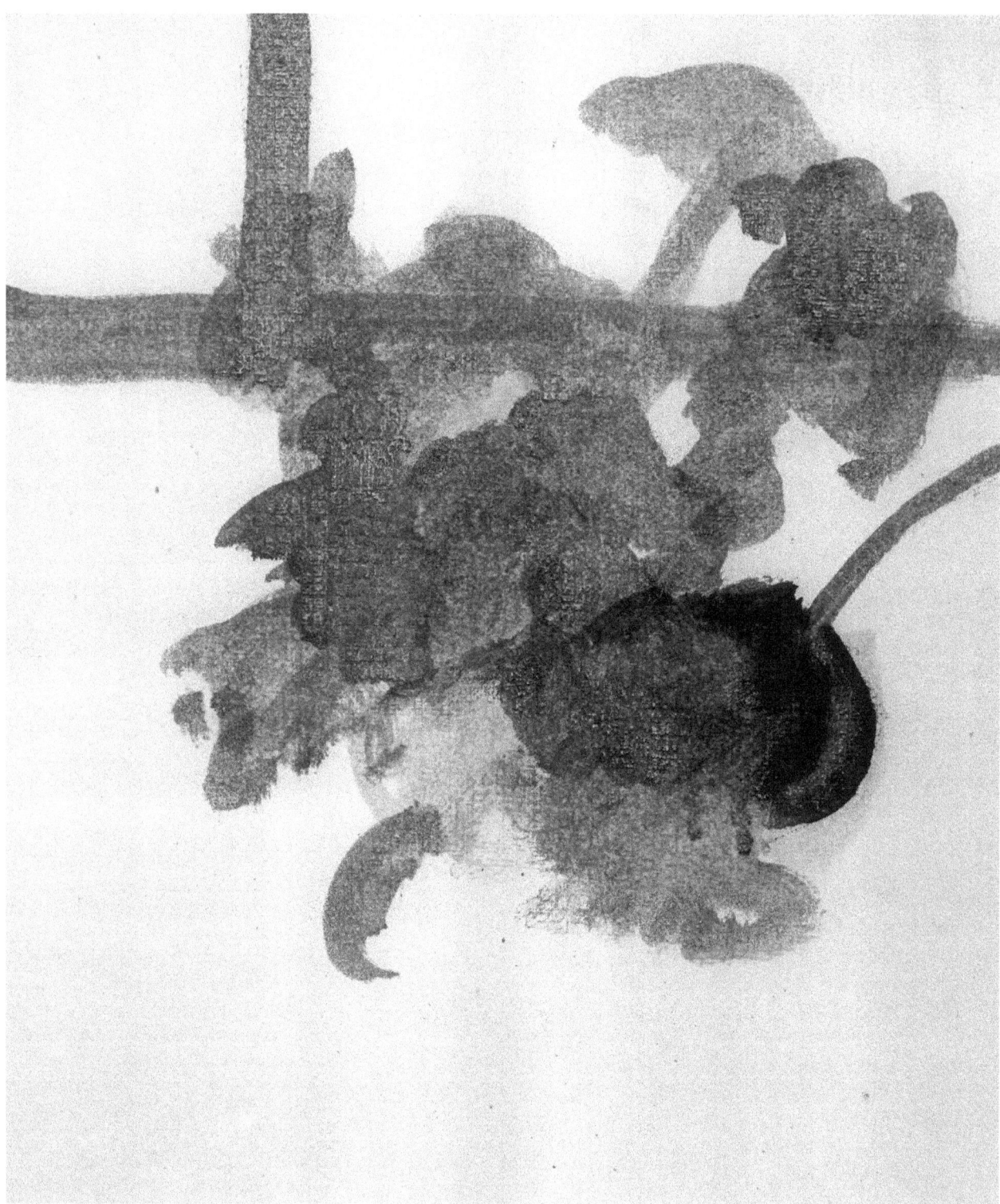

Step 1. I start by massing in the dark silhouette of the bouquet. I'm using a fairly big bristle brush, a #8 or #10. As I've said earlier, I usually mix quite a bit of turpentine with my colors at this stage right on the palette. You might prefer to sketch in the flowers, but be sure you don't get involved with individual flower forms. All I really want now is the silhouette of the whole bouquet.

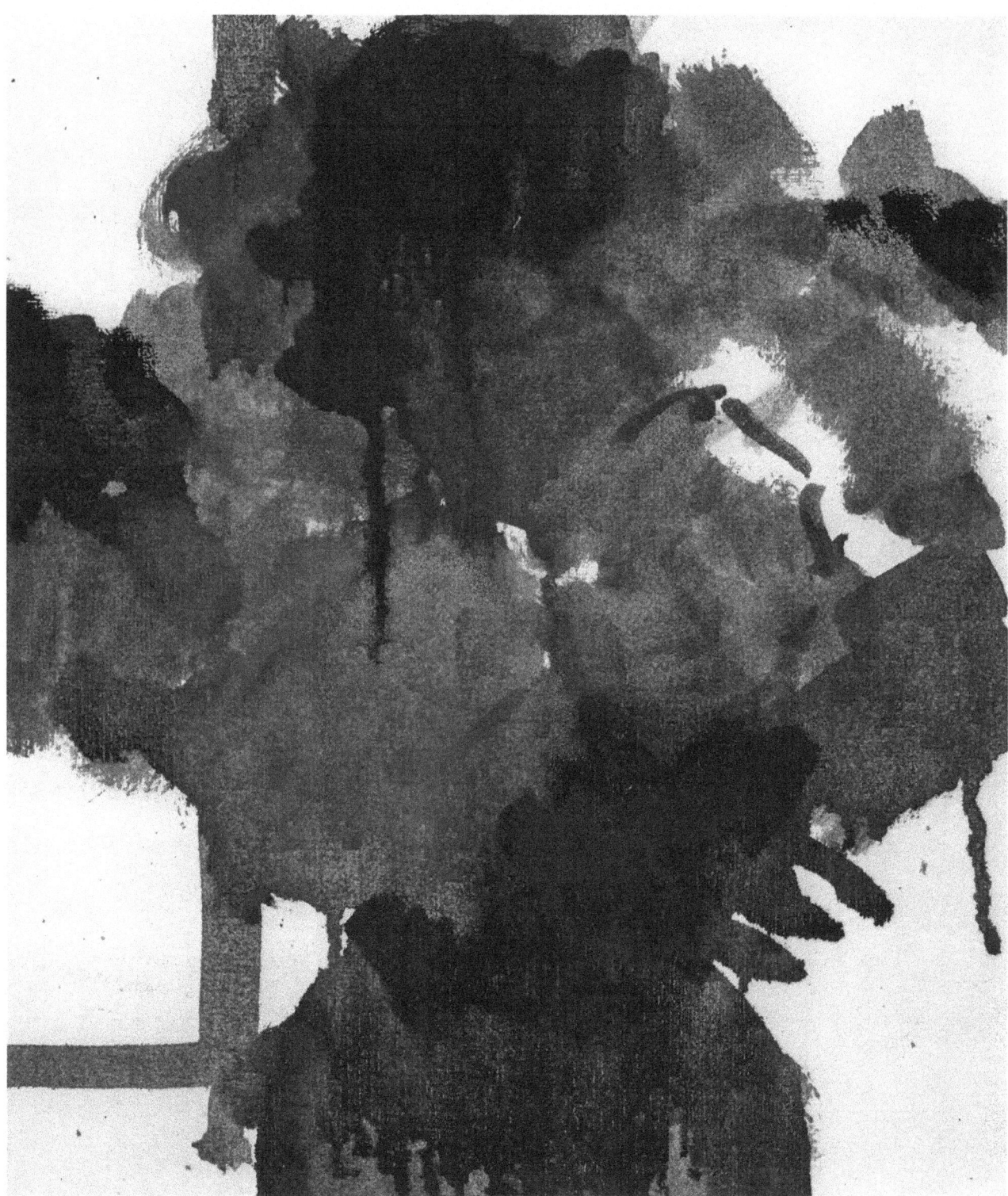

Step 2. Here I continue working very thinly, still just massing in the silhouette of the bouquet. Notice that the darkest darks are stressed. It's important to get your darks established early because you'll be relating your other values to them.

It's usually impossible to get exactly the right value at this lay-in stage. Later, when you have the canvas covered, you can go back and make more subtle value corrections. But in the early stages, make some courageous decisions. (Many students make their paintings too pale and timid.) Don't be afraid to exaggerate your lights and darks in this lay-in stage. You might well wish to modify these values later, but, in the beginning, they'll give you the foundation to work around. Once your big contrasts are there, the middle values will follow.

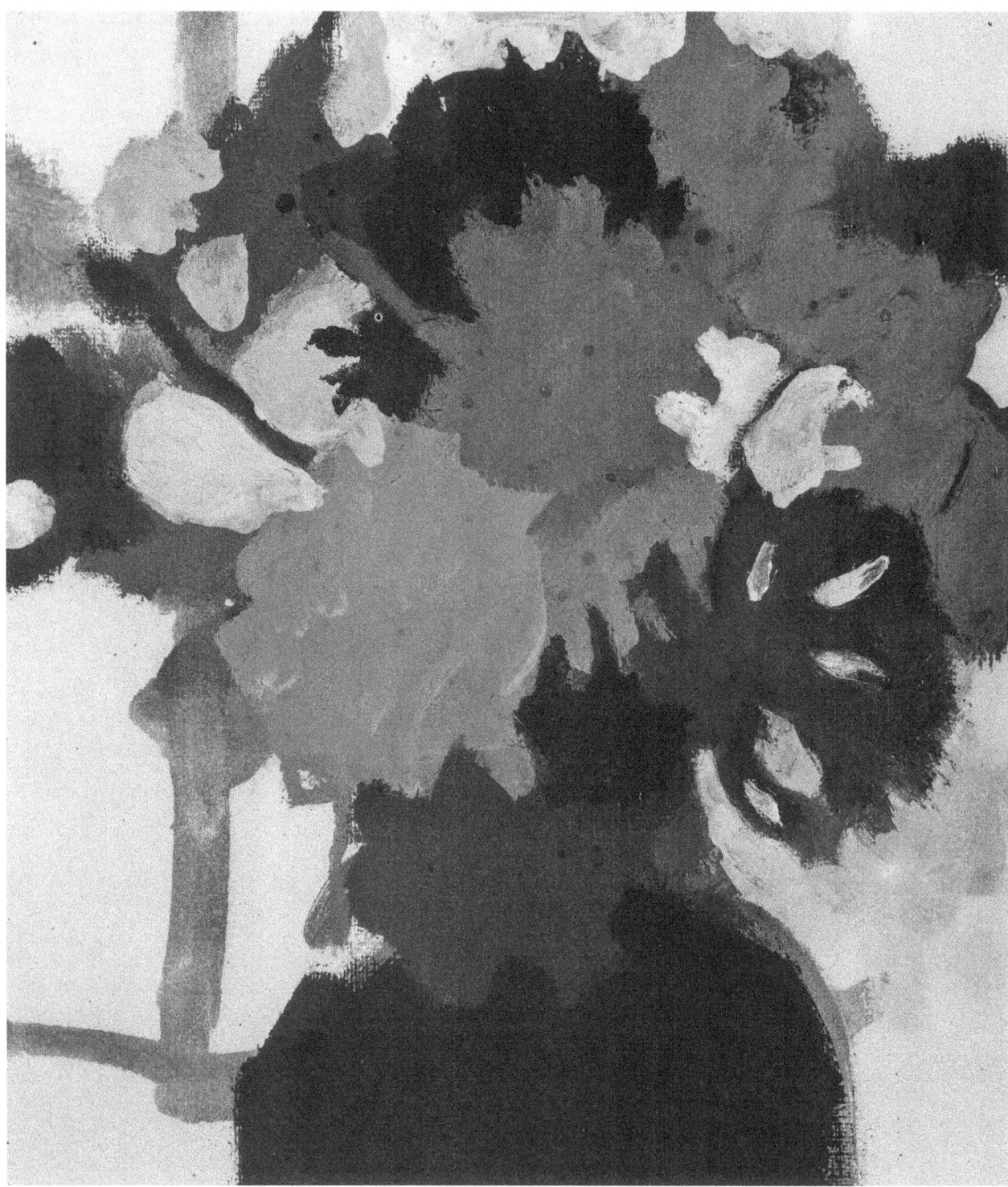

Step 3. Now that I establish the major shapes and important contrasts, it's time to add some middle values. At this point, I substitute a painting medium for turpentine. I can use thicker paint—but not too thick—as I develop these middle values. This is where you may get into trouble. You'll probably start seeing small forms as you begin to work for your middle values.

Notice in my sketch that even though I lightened some of the values within the bouquet, I still keep the feeling of a dark shape against a lighter background. Nothing within the bouquet is as light as the background. Keep squinting as you develop the individual flower shapes; keep thinking of the big forms. I use the background to develop better silhouettes. Since the paint in the flowers is fairly thin, it's easy to work into the bouquet with my thicker light paint.

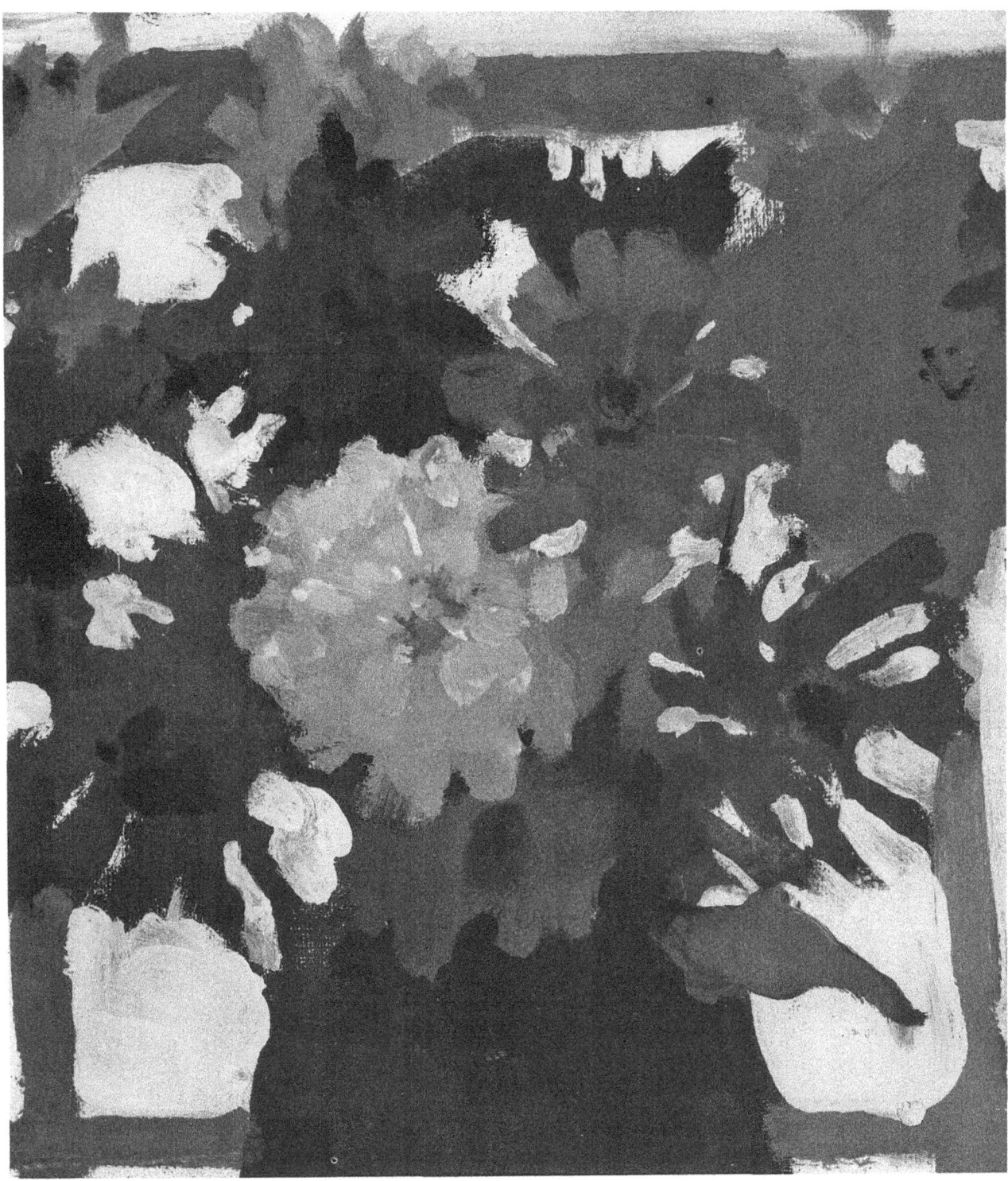

Step 4. Notice how different this final step is from earlier ones. The main reason is that I keep changing shapes and patterns as well as values as I paint. The painting itself should be taking over at this point. It should suggest what is needed to finish.

I try to do this final sketch in five values, running from white in the background to black in the vase and one or two of the flowers. You don't have to limit your value range; but, for now, it might be simpler to use black, white, and a few middle tones.

Please notice that I rely a great deal on outside shapes to make the picture interesting. I don't want you to get into painting individual petals on the zinnias at this stage. If you just get a simplified generalization, you'll be doing fine. Only in the lightest flower, do I make any attempt to show individual petals. You may later carry your flowers to any degree of detail you wish, but not now. Keep it simple.

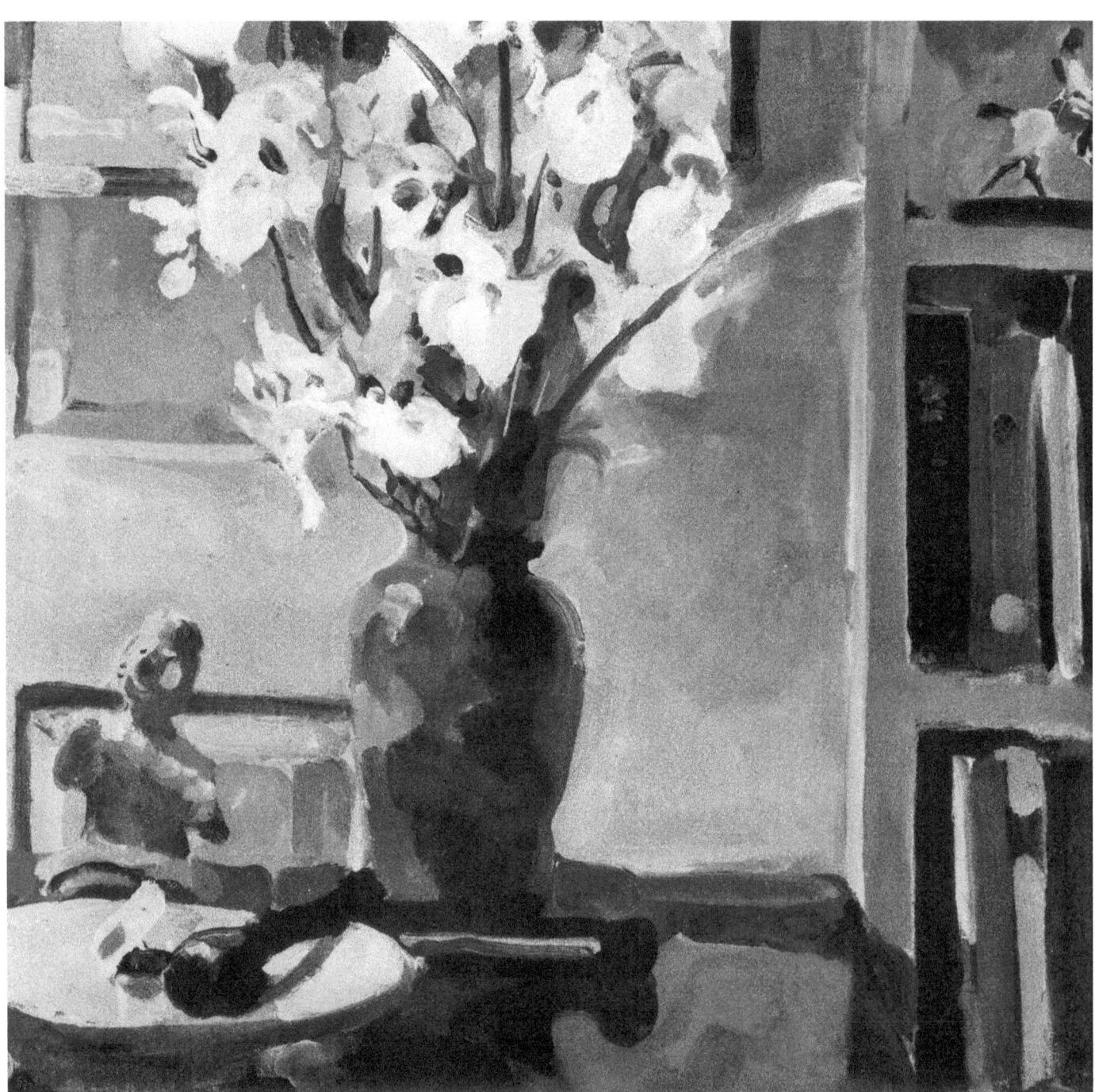

PROJECT 7
OPEN FORMS

Open plant forms like irises or dogwood are fun to paint. The brush is given more freedom, flowing out with longer strokes without your having to worry about small forms.

In this project, there's a fairly complicated background, but the flowers themselves are quite simple. The dogwood, which are light in value, are set against a darker background. But as I've mentioned, the background is quite complicated, with many stems and leaves. So even though the background is basically dark, there are lots of light values that seem as light as the petals. This makes it hard to establish a strong light-and-dark pattern. If I'd made the greens in the background as light as I really saw them, the flowers would not have stood out. Therefore, I selected just a few lights and surrounded them with darks so those few areas would seem very important. You must always decide where you want to put your center of interest and place your greatest contrasts (value, color, and intensity) there in order to direct the eye to this area.

Iris. 20" x 20". I cut these flowers off at the top, but I'm not sure it was a good idea. The vase isn't that attractive and it takes up too much space. I didn't take advantage of the flowers because I was trying to make something out of the objects on the table. I really didn't succeed.

Step 1. Again I start with my round sable brush, using ultramarine blue diluted with turpentine. You can see that, although I do use some lines, I also use dark masses to set off the light flowers. I'm always so eager to get to the painting that I don't take enough pains with my drawing. Gear the extent of your drawing to your own personal needs. Some artists don't draw at all; they start right in with light and dark masses. Others spend a lot of time and make a very careful drawing. Decide what suits you best.

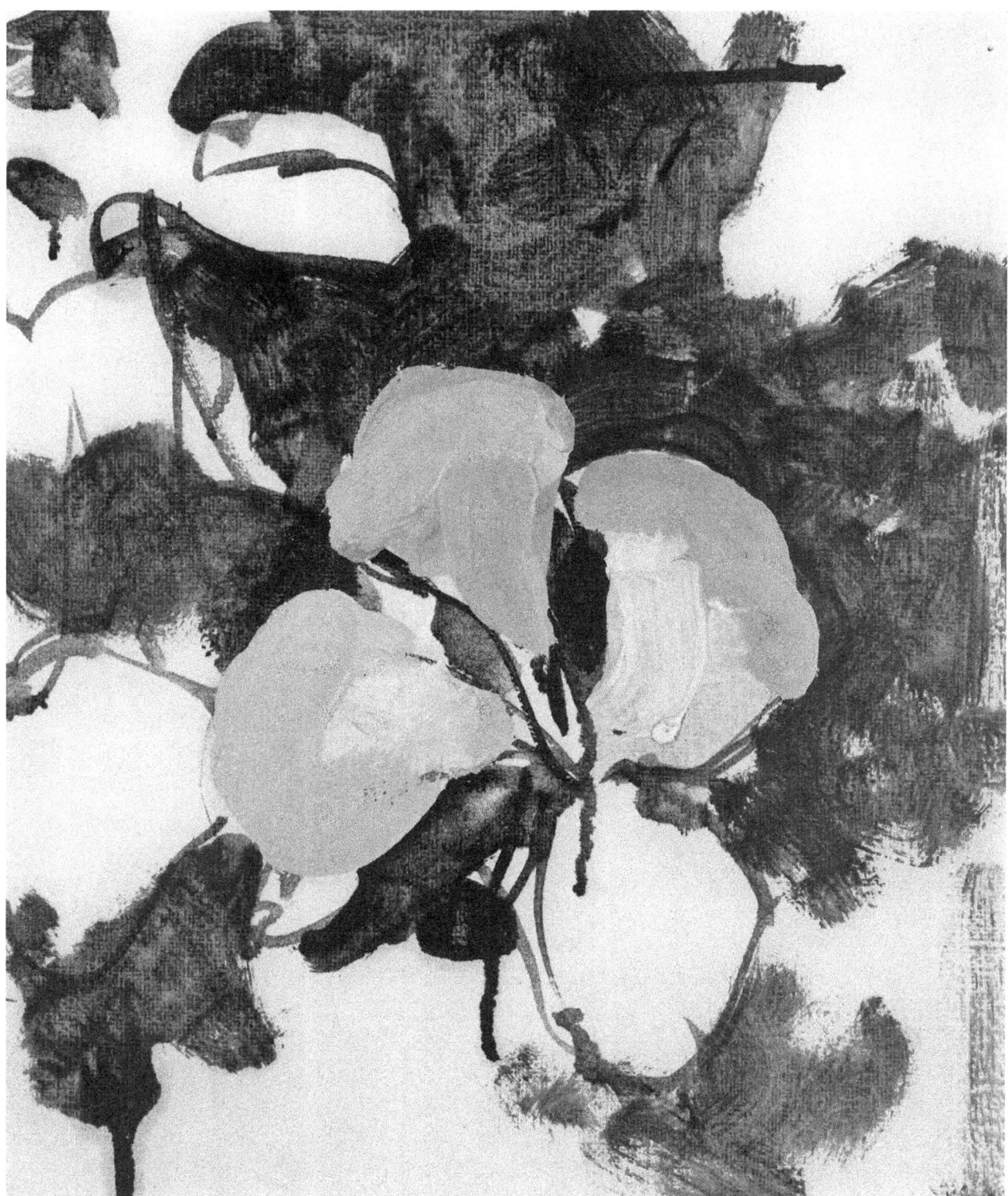

Step 2. I've worked a bit more on the background. I'm using a middle value—lighter than many areas I see in the background, but darker than many other background areas. I'm not putting in any stems or leaves; that will come later. For now, I only want a middle value to set off the light flowers. I start working into the flowers, trying to keep the whole picture going at the same pace. Notice how broadly I paint the leaves of the flowers. Everyone has a different method of painting. I'd hate to say that you must all use a big brush and make broad, long strokes, but I *would* say that you must think on a broad scale. You must always think of the whole flower, even if you put paint down in small individual strokes.

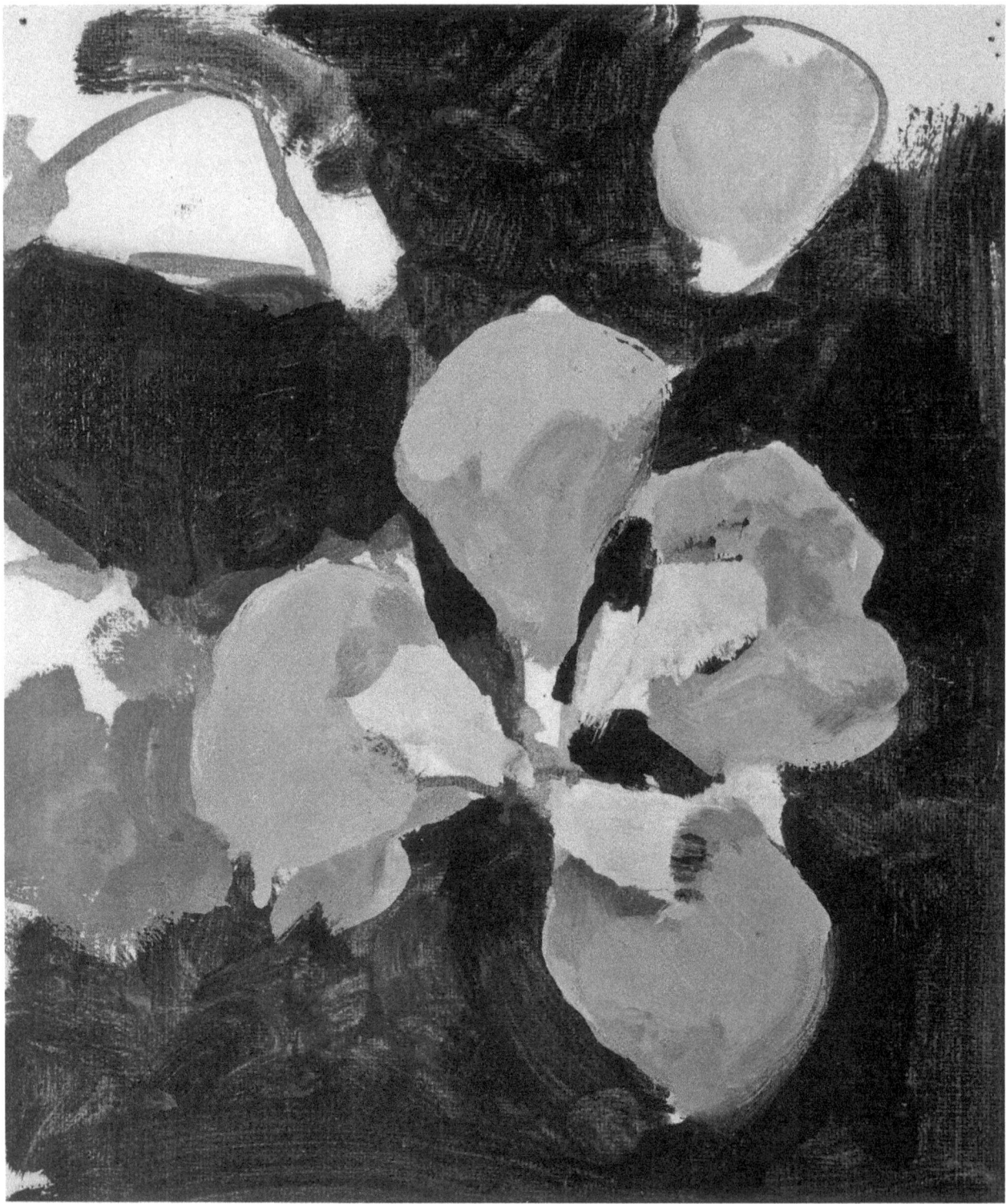

Step 3. I add some darker areas in the background, but notice that I still haven't gone into individual leaves or stems. As I work back into the petals, I begin to think about some of the minor value changes that will give the individual petals form. Remember that, basically, the petals will be a light form; so don't let any values within the petals get too dark. In this step, I will more or less bring the whole painting to the same degree of finish as the main flower grouping in the center of the picture. When all of the white areas you see will be covered, only then will I be able to take another look at the values and decide how well they work together. It's very difficult to get the values right the first time around. So now is the time to check them, before adding your details and small forms.

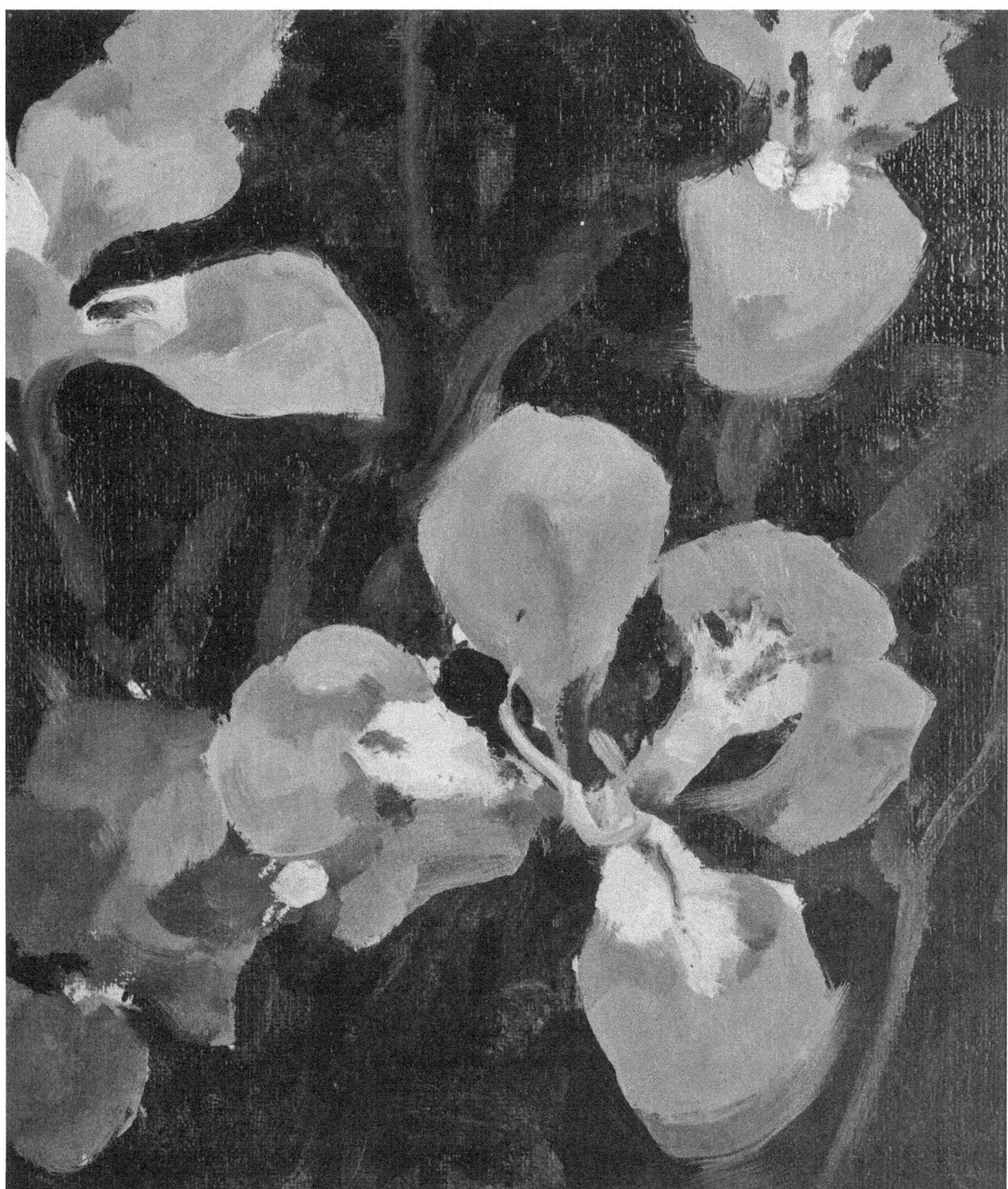

Step 4. I try to get in some of the background detail. As long as I keep the background, in general, darker than the flowers, I can put in as much detail as I want. If I let some of those leaves and stems get too light, there'll be confusion. In this case, I won't carry either the background or the flowers to a really finished state.

Once you get to this point, it's up to you just how much further you'll want to carry the painting. If you do go further, you must constantly make sure you're not losing the theme of the painting: light flowers, dark background. Stand back from your work, squint, take a walk, and come back to see the picture with a fresh eye. However you do it, make sure you don't let the small details take over the big value differences.

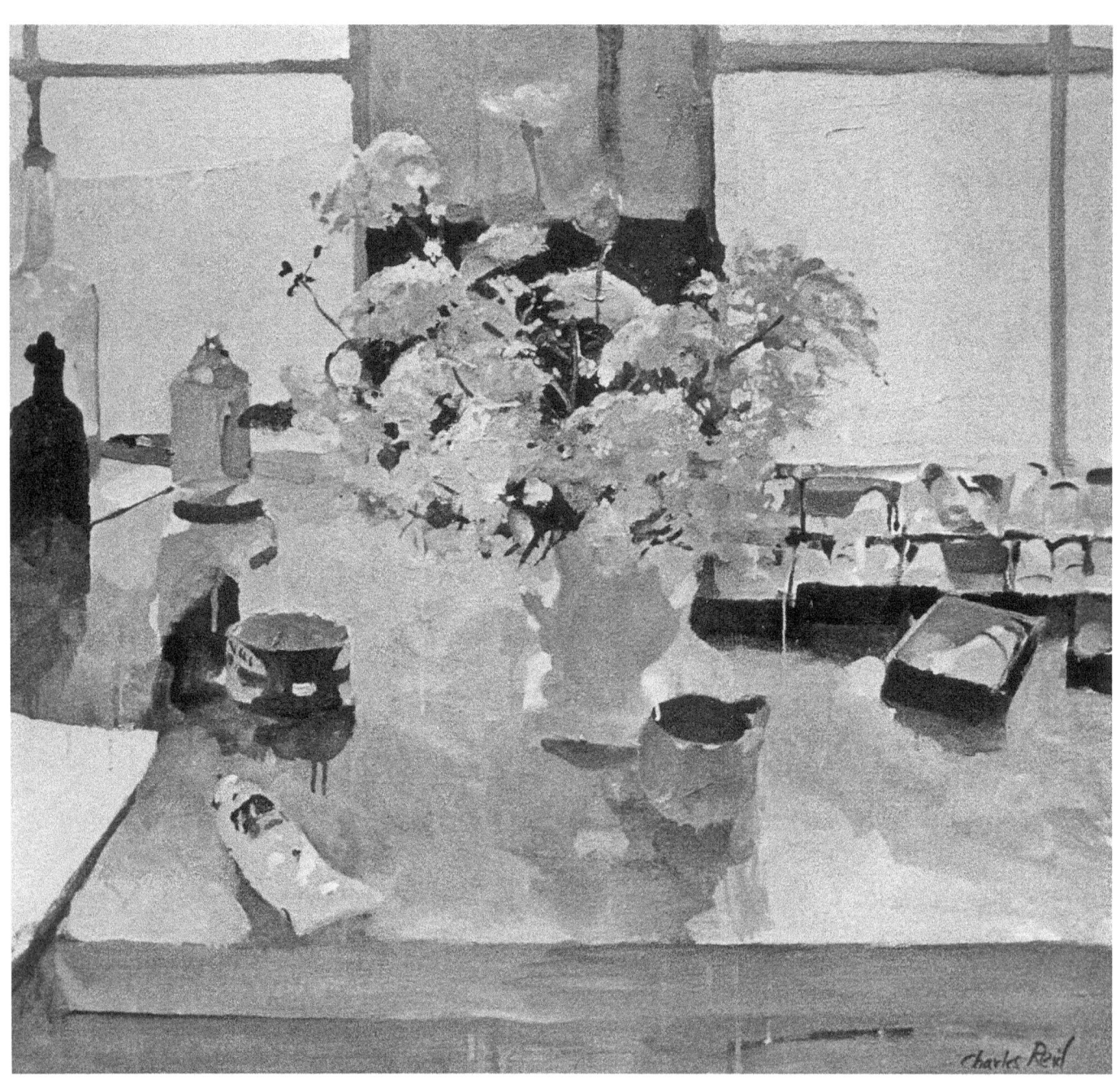

PROJECT 8
SEE-THROUGH FORMS

Painting very detailed flowers is difficult. You tend to see the detail and nothing else. I've mentioned this before, and will again. It seems to me that if we could just see the big shapes before we see the small ones, everything would be much simpler.

For this project, I used a wild form of Queen Anne's lace. The bouquet isn't very interesting, but I'd like to concentrate on the flowers.

The flowers are made up of many tiny blooms, all massed together. You won't have too much trouble seeing these flowers as a mass, even though there are quite a few small, separated blooms where we can see through to areas beyond. The secret is to squint. Stop squinting only when you have the painting massed in nicely, with big shapes of lights and darks.

Queen Anne's Lace. *20" x 30". This started out to be a geranium painting. The geranium was already painted and I was almost finished with the surroundings, when I decided that some Queen Anne's lace in the studio would look better. The geranium was almost dry; I scraped off the parts that were thicker and still wet. I could have also taken a rag, put some turpentine on it, and wiped it over the section I wanted to change. However, I don't recommend this approach unless the paint is perfectly dry. At any rate, I had the urge to change the flowers—and so I did!*

Step 1. I'm working directly on white canvas, using no tone. This is my normal approach. (At other times, I use a toned canvas. You must decide for yourself which you prefer and when.) I need some darker values on the white canvas to set off my light flowers. These darks go first. I use thin paint with lots of turpentine. You don't want thick paint in your darks, especially at this early stage.

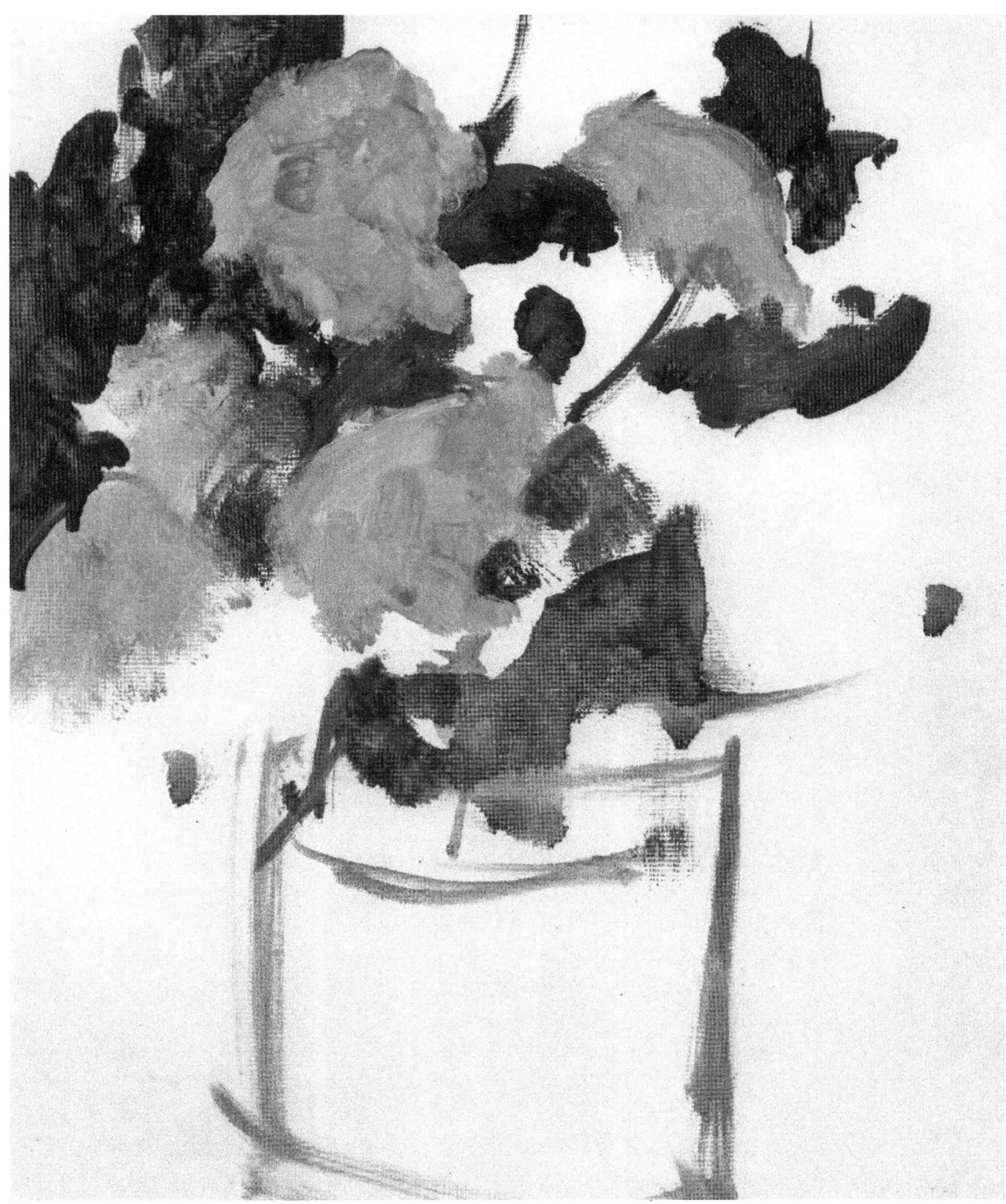

Step 2. Before adding many more darks, I start using white. Although you can't see my colors in these black and white demonstrations, I mix the white with a little cerulean blue and cadmium orange, and perhaps some yellow ochre and a touch of alizarin. Plain white paint is too cold and dull. These colors make the white richer. Be sure to add only very small amounts of color to a fairly small amount of white—the color should still look white when you're done. The exact proportions will come with experiment and practice. And don't use a palette knife—use your brush. Notice that although I use less medium with the white, the lights I add are still fairly thin. I've brushed them into and over the darker values. As long as the darks in Step 1 are thin, you can't get into too much trouble.

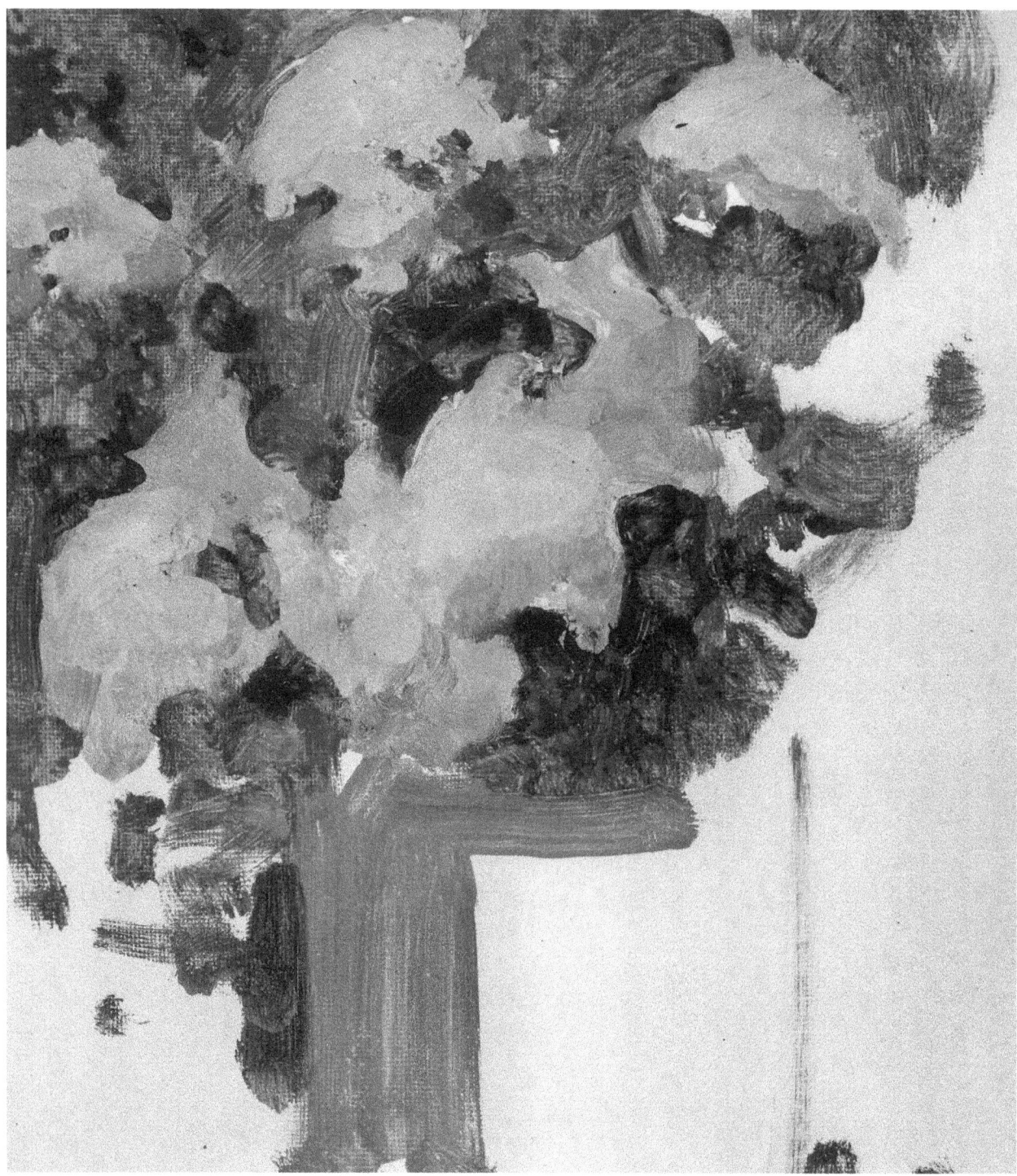

Step 3. I look for form. These flowers are complicated with lots of small forms and confusing halftones and middle lights. Forget about the middle lights at this stage, and decide which areas are actually in the light, and which are in shadow. I think of the flowers as I would a ball with a light shining on it. Don't make any area in the flowers *too* dark. Remember, if you make a shadow too dark, the flowers won't look white anymore. I'm also working on the boundaries of the flowers, trying to get their shapes and edges right. When I paint the white into the surrounding darks, some soft edges happen. As I'll discuss in detail in a later project, edges are vital. Soft edges make things "go back." Hard edges make things come forward. Aside from this, flowers *are* soft; they're not made of metal. Blurred edges are one way of showing this.

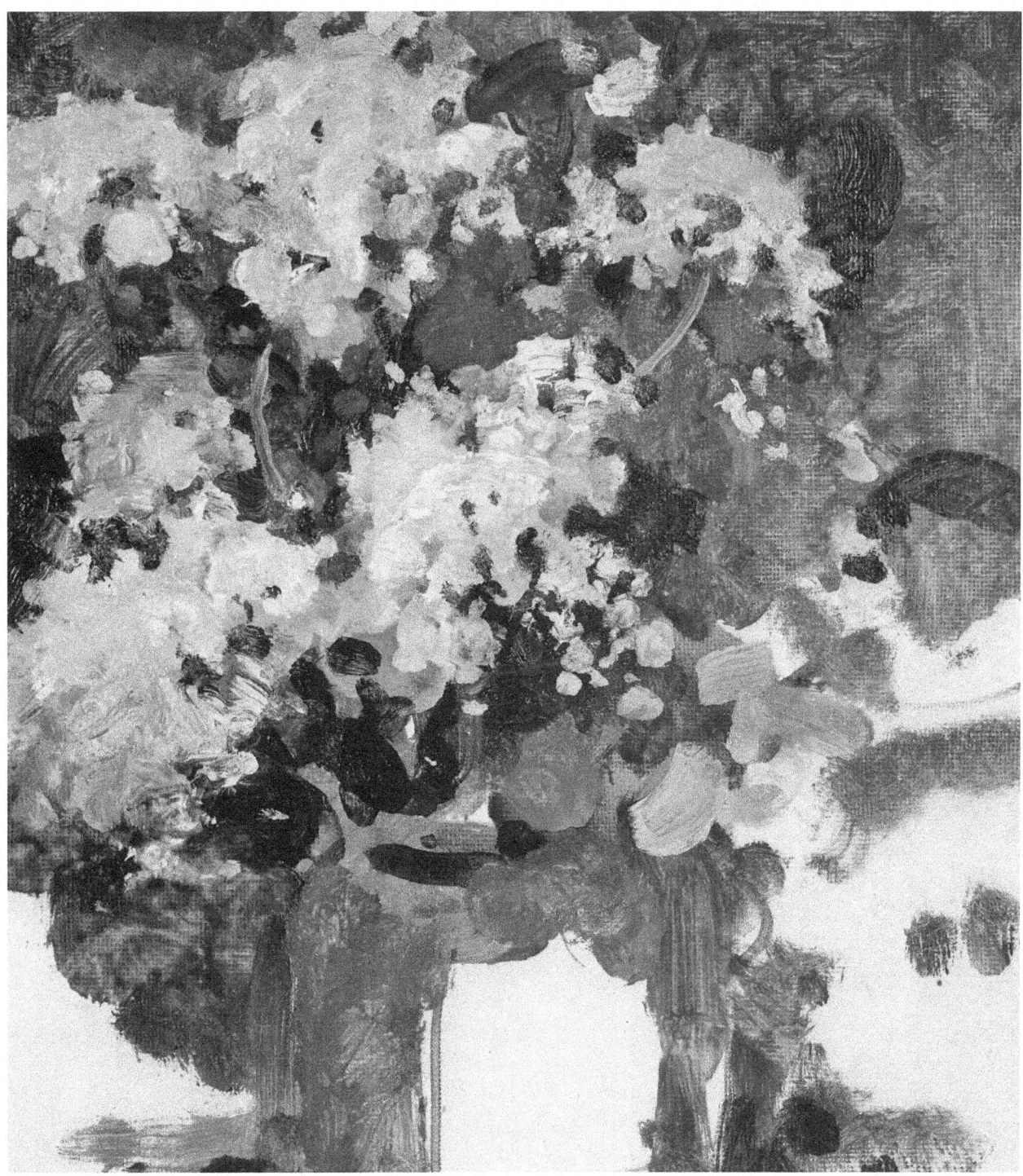

Step 4. There are several potential problems. As you begin to show details, you may add too many middle values. Middle values often confuse the area in question. No value in the flowers can be as dark as the leaves surrounding the flowers—so be careful. I now add some darks with the flowers. You can see through many sections of the Queen Anne's Lace, but only add the more obvious darks, or you'll create confusion. Although I'm still keeping my darks thin, I'm using heavier paint in the flowers now. The thicker paint gives a suggestion of detail where none actually exists. I've held off on putting in my darkest darks, but now I add a few to the lower center. I've also added a lot of small white spots there. Choose one area for your darkest dark and your greatest amount of detail to give the whole painting a sense of completeness and finish. Notice how many directions the brushstrokes take. Never paint all your strokes all in the same direction. Paint in a crisscross fashion—don't just "fill in."

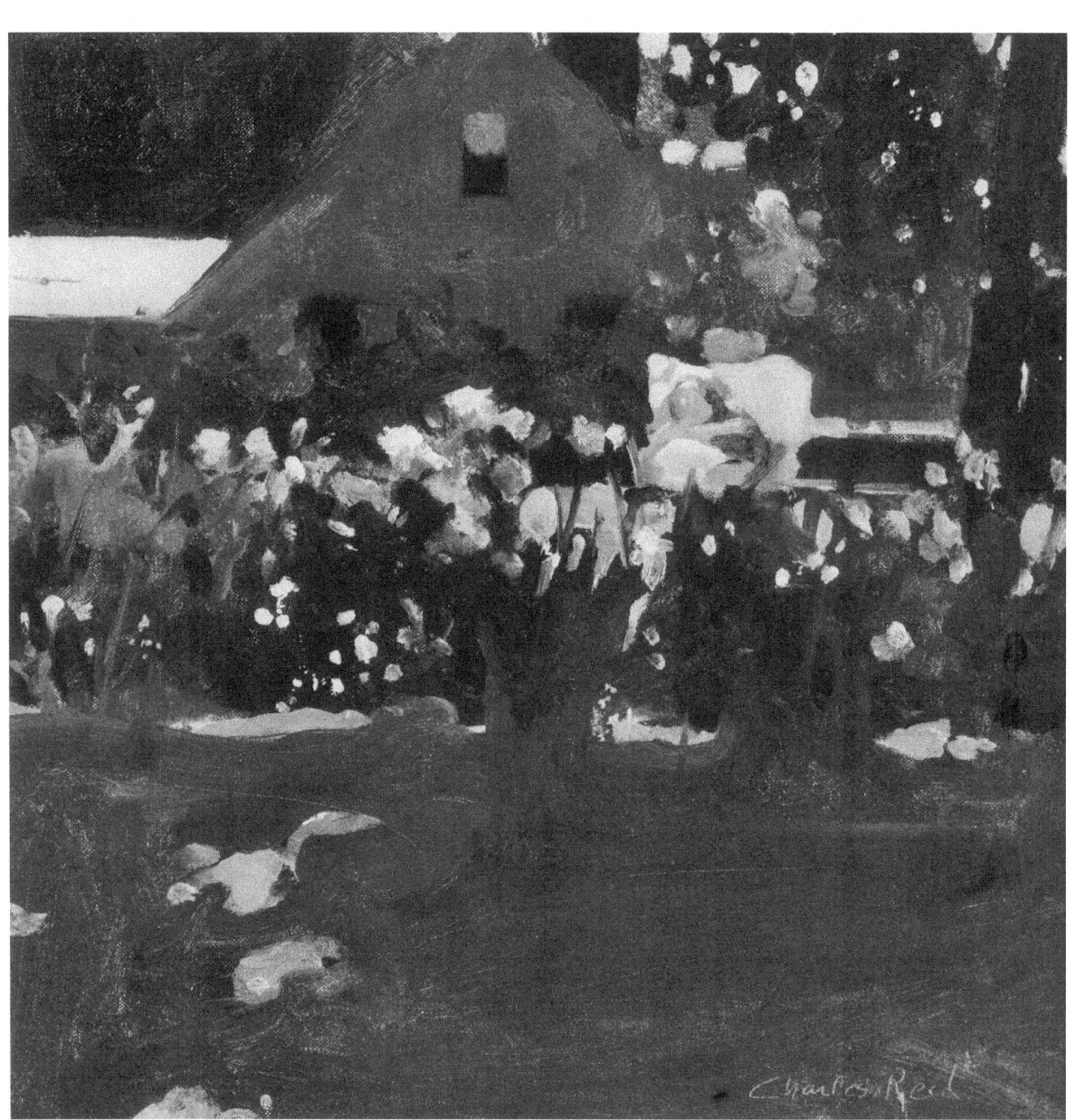

COLOR DEMONSTRATIONS

On the pages that follow, I'll demonstrate much of what I try to explain in my black and white steps. Because the demonstrations are in color, you'll be able to see the subtle changes that can occur in hue or intensity when the value remains the same. Also, while the black and white demonstrations are more in the nature of studies, many of these are actual paintings. Notice as I describe the stages of my painting that I loosely follow a certain order of procedure: planning the composition; positioning the objects to lead the eye through the painting; toning the canvas or filling in the white canvas; massing in adjoining areas similar in value; placing my darks first, then my lights and middle values; correcting and adjusting my color values and my drawing; adding highlights and accents; and finally, firming selected edges.

Notice when I describe my palette that the colors I use to paint the same object are not fixed but vary from one demonstration to another. You must experiment. You don't always have to paint objects the exact color they appear. Sometimes it's more exciting to exaggerate the colors you see in order to get a certain effect. You should certainly never paint them a single flat color, as a housepainter would paint a wall. Aim for visual excitement—make your objects come alive!

Sarah in the Yard. *11" x 14". Private collection. My daughter was home from school with a cold when I had her sit out in the sun and pose. She tired of the idea, and I really didn't get very far with her part of the picture. I wanted the flowers to stand out, so I simplified the foreground, showing only a few lightstruck spots. My composition is triangular: the eye moves from the lightstruck roof, to the light in Sarah's chair, then back across and down to the light spots in the foreground.*

Dried Flowers

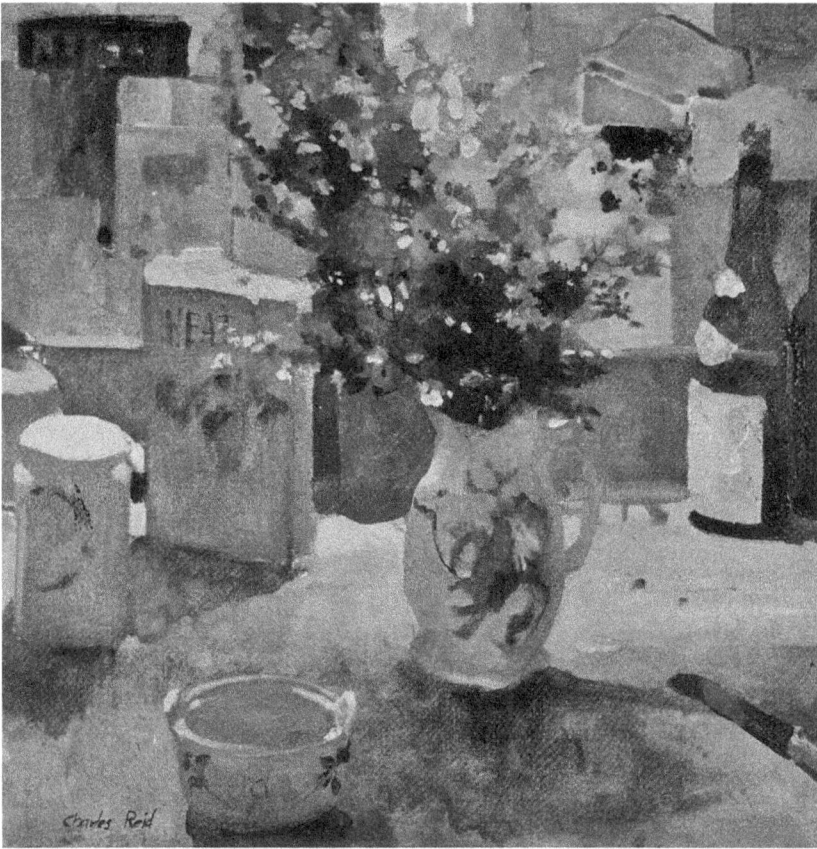

Dried flowers offer a chance to paint flowers without fear of them fading. This, of course, is an advantage; you can skip a painting day or two, knowing that they'll be just as you left them. Dried flowers are complicated, with many small and subtle things happening. I imagine many people might find mustard yellow and quiet grays unexciting, but it's important to see how much color you can squeeze out of a subject like this.

Aside from color, the major problem here is to simplify the many small buds by painting them as a mass. It's important to see things as color masses rather than as objects. As I squint at my setup, I try to see the wine labels as patches of warm and cool color. I don't see (or try to paint) the lettering! If you find yourself seeing too many small details, like the lettering, then you're not squinting enough. This same principle applies to the flowers. Squint until you see them as a dark mass against a light background, as a light mass against a dark background, or as the same value. In this case, some sections of the wildflowers are darker than the adjacent background, while other parts of the bouquet are lighter. This is a very important point. Always compare adjacent value areas.

For this demonstration, I set up the flowers on my kitchen counter, with fluorescent light coming from above. The objects (except for the wine bottles) were left over from breakfast. The wall behind the flowers was covered with wine labels I've collected. These labels look fine in the kitchen, but they make a difficult background to paint. As I struggle with a still life, I sometimes wish I hadn't put them up!

Here, I wanted to capture the feeling of flowers, without showing every bud. Before even beginning this demonstration, I repainted the flowers five times, and each time I found them getting too busy and cluttered. The final result looks dashed off, but actually it was a real struggle. I'm still not too happy with the flowers, and I feel other parts of the painting are more successful. This is often the case. The parts you fight with aren't always as good as the parts you give less attention to.

Palette

The Browns. There are many browns in this setup—in the flowers, the tabletop, the cereal box, and the table. But earth colors like raw umber, burnt umber, and burnt sienna don't look their best as they come from the tube. So, here I mixed raw sienna with cadmium orange and some cerulean blue for the lighter yellow browns, to which I added a small amount of cadmium yellow light and cadmium yellow medium. For my other browns, I used cobalt blue with burnt sienna and raw umber.

The Vase and the Jars. The grays on the shadow sides were made with cerulean blue and cadmium orange mixed with white. Purple, made with phthalo and cobalt blues to which a little alizarin is added, appears in the pattern and in the shadow sections of the vase.

The Flowers. Basically, the flowers are splashes of cadmium yellow pale, raw sienna, cadmium red light, alizarin crimson, phthalo blue, raw umber, and burnt umber. The greens were made with ivory black mixed with cadmium yellow light; also a mixture of ultramarine blue, burnt umber, burnt and raw sienna, and cadmium yellow medium and light.

The Bottle. The bottle was underpainted in permanent green light, with a mixture of ivory black and cadmium yellow light painted over it.

Daisies and Brushes

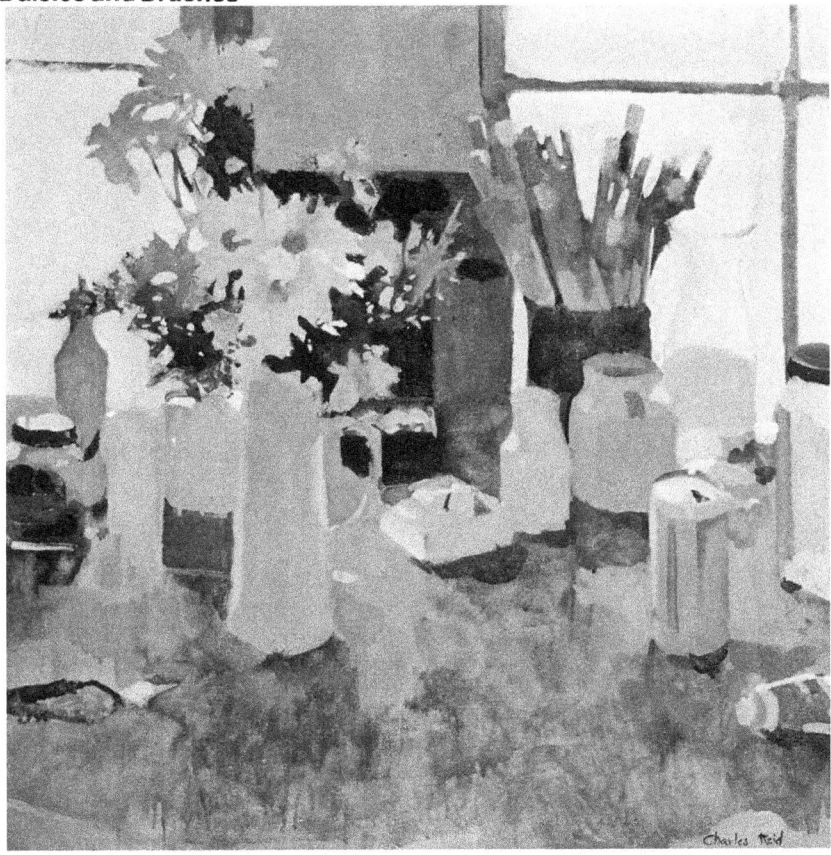

I like to put the things around me into my paintings rather than "create" environments for a still life. There are subjects everywhere, but for me, my brushes and paint tubes are a more natural background than, let's say, a drapery. I'm also happy painting mustard jars, milk cartons, and paint tubes; others would perhaps rather paint something more elegant.

I remember reading somewhere that to Degas beauty was the Opéra, while to Toulouse-Lautrec, it was the Moulin Rouge. Both are wonderful artists and it didn't matter what they painted. What is important is their excitement in what they saw.

Palette

The Daisies. For the daisies out in the light, I used cadmium yellow and a touch of cadmium orange. This warmed and strengthened the whites. For the shadow side of the daisies, grays were mixed essentially from three combinations: cerulean blue, cadmium orange, and white; raw or burnt umber, cerulean or cobalt blue, and white; and finally, alizarin crimson with cobalt or cerulean blue (which makes purple) and its complement, cadmium yellow, raw sienna, and yellow ochre, plus some white. The rest of the grays, in the vases, window frames, brushes, etc., were mixed with the same three combinations of colors.

The Tabletop. I tried to create variety and interest in the tabletop, while at the same time relating it to the rest of my painting. Therefore, I selected several appropriate transparent colors used elsewhere—burnt umber, yellow ochre, raw sienna, viridian, and alizarin crimson—and mixed them with lots of turpentine. However, I avoided adding white to my colors because its opacity would destroy the transparent quality of the washes.

Kitchen Flowers

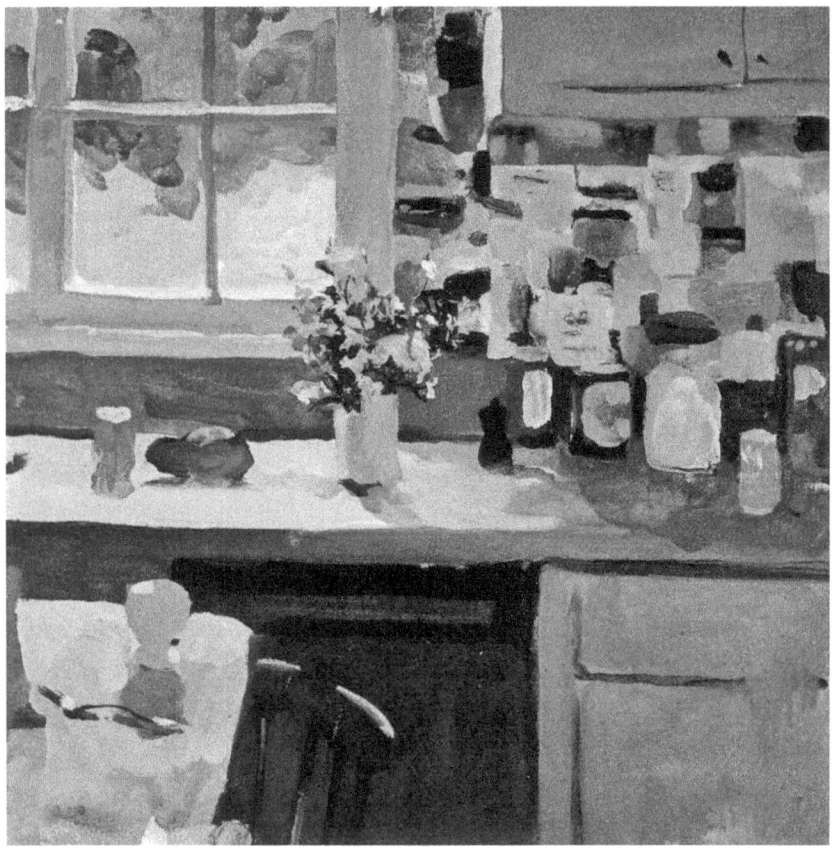

I was going to paint a closeup of this bouquet, but as I walked through the kitchen door, sunlight was flooding over the counter, the cucumber, and my flowers. It wasn't strong sunlight, but the soft winter light of a sun low in the sky. I knew that what I was looking at wouldn't stay the same. The sun would be coming through other windows, and the light I saw at 9:00 A.M. would be very different at noon, as anyone who has ever painted a landscape on a sunny day knows.

I think many paintings are ruined by artists who want to put in a full day's work, rather than stop when the light changes. A few moments of confused brushing in a changed light can ruin hours of good work. I suggest you paint on a small canvas or panel if you're trying to catch a changing light (save your large paintings for a subject with a constant light). Or, if you must tackle a larger painting, work on the critical areas when the light is right and on the areas that aren't directly affected by the sun when the light has changed. I myself have trouble with changing light, as you'll see in Step 3 of this demonstration.

Palette

The Countertop. The colors I used in the countertop were mostly white, yellow ochre, burnt sienna, cadmium orange, alizarin crimson, and cerulean blue. Cadmium red light was also spotted in areas on the right-hand side of the painting.

The Flowers. The pink flowers were made with a mixture of alizarin crimson and white. The yellow flowers were yellow ochre and cadmium yellow pale.

The Greens. I mixed greens here in two of my favorite ways: with viridian or permanent green light, a small amount of cadmium red light, and white; and with cadmium yellow pale, cadmium yellow medium, black, plus white added to lighten the mixture.

Anemones

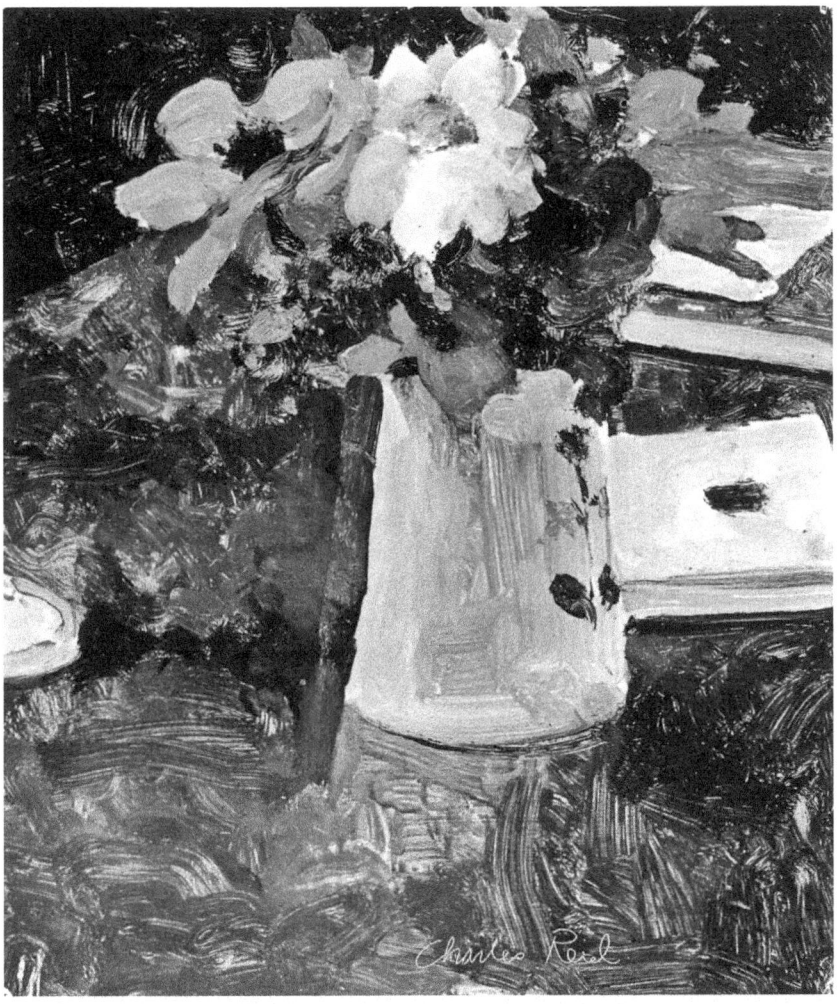

I sometimes struggle on a small still life for days, while at other times I spend only a morning. It has nothing to do with the flowers themselves. I usually have trouble with the surroundings and getting just the right value and color relationship between the background and the flowers. On the other hand, I often think I ruin paintings because I get too fussy. The picture becomes an exercise in value relationships rather than simply a painting. It's marvelous just to paint your subject directly and simply, and then, when done, to put down your brushes and call the picture finished. To grow as an artist, of course, you need both the fussiness and the spontaneity.

In this case, I was fortunate to have fairly dark surroundings and obvious lights and darks within the flowers. A painting like this, with strong value contrasts, is easier to do than a close-value painting with little contrast. I also find it easier to do closeups. Backgrounds are difficult (at least for me), so when I can paint a head, a bowl of flowers, or a building without much background, my painting goes more easily.

Since these are pretty, bright flowers, I was glad to have some good gray-browns in the surroundings. Remember, a colorful painting is not necessarily filled with pure color. Some artists, like Matisse and Bonnard, can get away with using pure color in their pictures; but both of these artists are marvelous painters who could truly handle color. For most of us, it's easier to get the impression of strong color if we use limited areas of intense color, contrasted against and surrounded by larger, more grayed sections.

Palette

The Anemones. The only pure color here is in the red anemones. The pink anemones are grayer than they actually are. I just couldn't mix a pink that bright. To mix them, I started out with a glob of white and add small touches of alizarin crimson and phthalo blue. The dark purple anemones were made with alizarin crimson and ultramarine blue, grayed with a touch of raw sienna. (Remember, the complement of purple is yellow.) You might also try using yellow ochre.

The Leaves. For my greens, I used black and cadmium yellow as well as viridian and a touch of raw sienna and cadmium red light and/or alizarin. There can be no definite formula as to proportions. You must experiment.

The Vase. The colors in the vase are white, yellow ochre, and/or raw sienna mixed with cadmium red light and alizarin crimson. To gray it, I added some cerulean blue (you could also use cobalt) mixed with cadmium orange and white, and a bit of permanent green light mixed with cadmium red light and white. Again you must experiment.

Sigrid's Flowers

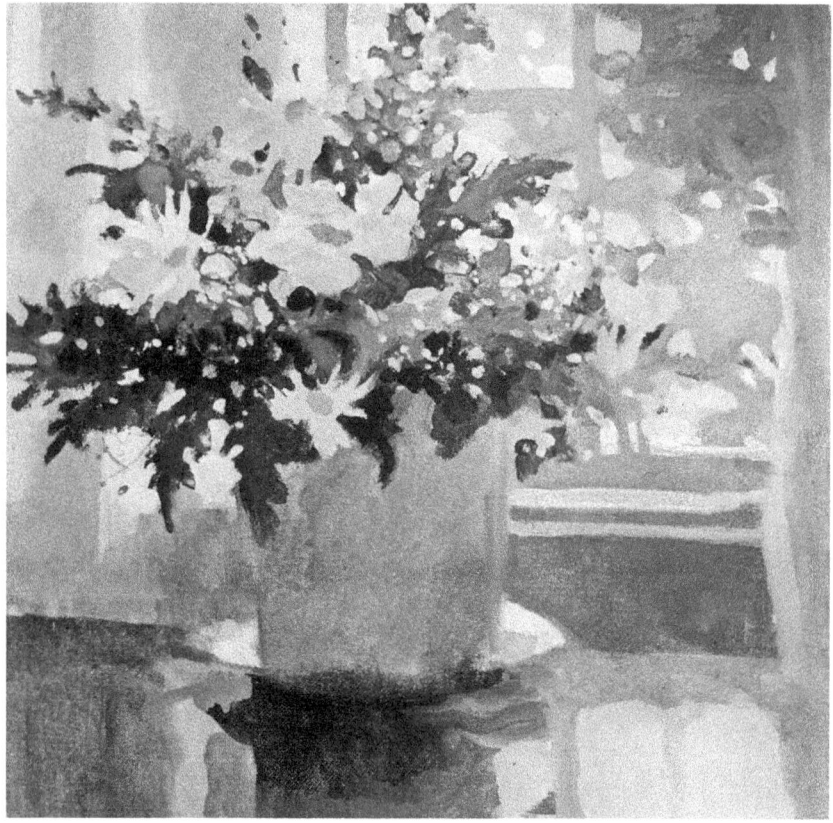

Sigrid Schultz is eighty-two and a good friend. She was a correspondent in Berlin before World War II and helped quite a few people escape from Germany before Hitler closed the door. One friend who escaped sent these flowers to Sigrid. I saw them and quickly snatched them up. It was really too kind of Sigrid, for by the time I returned her flowers, two days later, they were quite tired and faded. At any rate, she was a good sport, hoping, no doubt, that the sacrifice was for the sake of Art. It's marvelous to paint things you love to look at. The subject needn't be literally beautiful but it must stir the artist's soul.

Recently I saw an Impressionist exhibit at The Metropolitan Museum of Art in New York City. I studied the greens in various paintings and was impressed by how many "greens" weren't actually green at all. I saw blues, browns, and blacks. It seems that pure green has to be carefully balanced. Where there were pure greens, I saw how gray-blues or browns were used as balancing agents. Some artists don't even have viridian or permanent green light on their palettes, preferring to mix all their greens with blue and yellow or black and yellow. Winslow Homer used lots of purple blacks in his Adirondack Mountain watercolors. It's true that the pines up there do look black, but even in his Florida and Caribbean paintings, Homer used lots of red-browns, blues, and blacks. Try using reds to "cut" your greens. Experiment with earth colors like raw sienna or burnt sienna. Whatever you do, don't squeeze viridian out of a tube and consider it sufficient.

Palette. Let me go over the greens I use in this project. They're important here and were mixed several ways.

The Bouquet. The dark greens in the bouquet are a combination of viridian, black, cadmium yellow light, raw sienna, and cadmium red light. Tubed greens like viridian are fine as long as you mix them with something else; they need to be mellowed. In this case I used a bit of alizarin crimson and cadmium red light along with raw sienna. Some cerulean blue flowers were worked into the greens to soften them.

The Trees and Bushes. For the trees and bushes outside the window, I mixed viridian and cerulean blue (again, you could use cobalt) with cadmium yellow light and/or yellow ochre. Some alizarin crimson or cadmium red light was added to gray these greens, and naturally, a good deal of white was needed to lighten them. Be very careful when you add white to a green not to get it chalky. Some of the other greens here are a mixture of cadmium yellow and ivory black—with a lot of black in them.

Persian Rug and Daisies

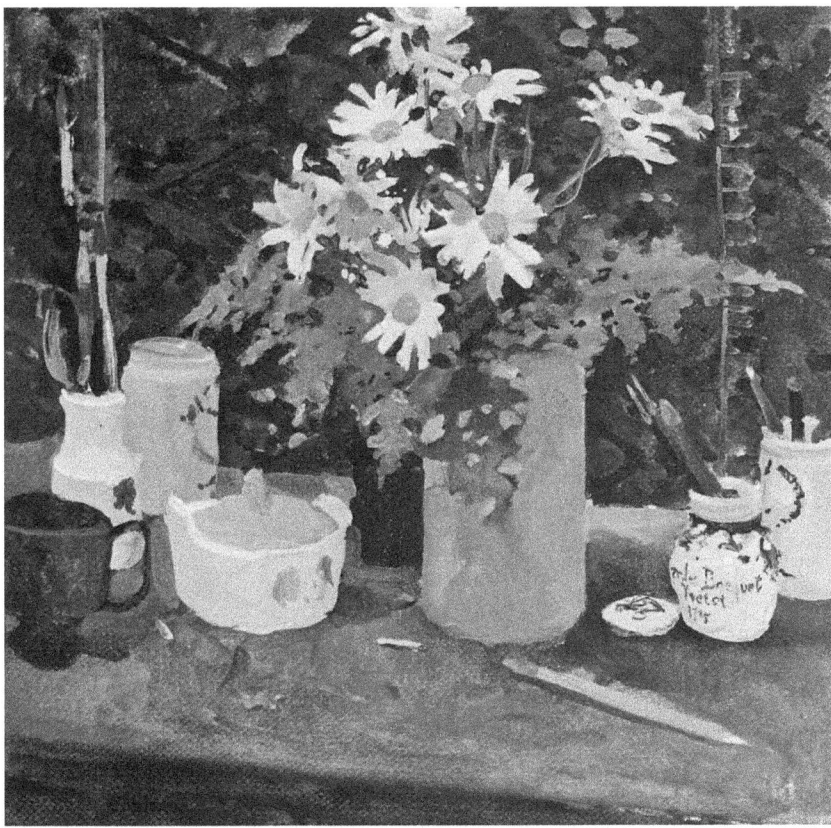

The background you see in this demonstration is for warmth—warmth in the studio rather than warmth in the painting. I pinned a rug over my studio window to stop the draft. I still have lots of cold air circulating in the studio, but the rug looks nice and makes a good backdrop. The objects on the table are at home; I like to use mustard and marmalade jars to hold my pencils and brushes. The light comes from a skylight above the flowers and is fairly soft.

Palette.

The Rug. My palette for the Persian rug in the background is mostly burnt sienna, Indian red softened with permanent green light, raw sienna, and yellow ochre. I spotted some black mixed with burnt umber and raw sienna in the black lines and dots of the pattern. The other colors don't lighten the black much, but they make it less harsh. I used a generally dark, earthy red (Indian red) in this background.

The Ferns. Ferns make up the greens in this bouquet and they are very cool. They seem pale, almost washed out, in the light sections. For these lights, I tried black with cadmium yellow light. This combination makes a less intense green than the usual viridian, permanent green light, or just a mixture of blue and yellow. (I do add some of these colors I mention when I want to enrich my ferns or create a more intense green.) In the ferns, I also combined lots of cerulean blue with white, plus cadmium yellow light, permanent green, and a bit of black and yellow ochre. For the darks, I used burnt sienna mixed with raw sienna. *Not black!* Too dark a dot or line and you make a hole in your canvas. Notice the softness where the fern's boundaries meet the background. Flowers and plants aren't made of steel; make sure your edges have softness in some places.

The Jars. The mustard jar on the right appears obviously cool, so I used lots of cerulean blue, a bit of cadmium orange and alizarin crimson, and a good deal of white. The jar with the yellow top to the left of the vase is warmer than the mustard jar. For this, I tried alizarin crimson, cerulean blue, and yellow ochre, experimenting with the proportions of these colors until it was the proper degree of warmth in relation to the mustard jar.

The Table. Never settle for burnt or raw umber for a brown tabletop. Look again. In this case, I saw cerulean blue, white, alizarin crimson, burnt sienna, burnt umber, and raw sienna—all in one table! You must never say to yourself, "That's a brown table, and brown means burnt umber." Brown means a good deal more than burnt umber! The table was painted very thinly. Sometimes I used the side of my brush; other times, the tip. Sometimes I squished the bristles down on the canvas. Never use the same strokes or hold the brush in the same way. Contrast is the key in painting, so you must contrast directions of strokes. Paint in a crosshatch manner, some strokes up and down, some across, and some diagonal, all in a small area. In this case, I used the side of my brush, scrubbing the cerulean blue, white, and alizarin crimson into the burnt sienna, burnt umber, and raw sienna. As in the background, I used a drybrush or broken-color method of painting, and very little paint.

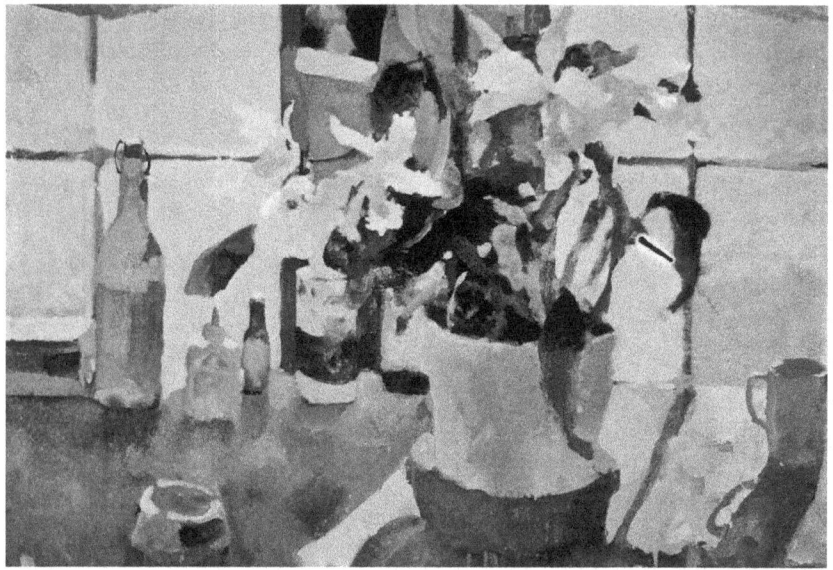

Painting anything in strong sunlight is tricky because the shadow pattern is constantly changing. I started this painting in early afternoon, establishing a definite shadow pattern. This painting is quite large, 30" x 36", so in order to finish it (which took about five days), I had to paint in the morning and on several overcast days. This meant that whenever I worked in the mornings or on the cloudy days, I tried to stick to areas that seemed to remain fairly constant, such as the divider between the windows, the greens, and the flowerpot. I moved objects around so they'd be in sunlight or shadow just to see how they'd look. In the course of painting, I also cheated a bit and added some lights that happened later in the day (the sunlight to the left of the vase occurred around 2:30 while the lightstruck areas to the right of the vase were correct for 1:30). I did this to break up what I thought was a boring area.

Palette. For this painting, I used cerulean blue, alizarin crimson, cadmium orange, cadmium red light, cadmium yellow light, yellow ochre, raw sienna, viridian, burnt umber, raw umber, burnt sienna, black, and white. As I list these colors, it sounds like a lot; but let's go over individual areas to see just how much repetition there was. The windows, flowers, flowerpot, glue container, jars behind the pot, and the light tabletop were all painted with the same basic combination: white, alizarin crimson, cerulean blue, viridian, yellow ochre, cadmium yellow light, and cadmium orange. A bit of cadmium red light might have sneaked in, but I prefer alizarin crimson to cadmium red light for mixing purples and purple grays. Notice that I mixed viridian with a little white, which in turn was mixed with orange and white. This makes a nice, subtle gray. You'll have to practice mixing white with these various colors.

The Light Areas. The tabletop in sunlight is warm, so warm colors predominate (yellow, yellow ochre, and orange). Naturally, I used lots of white. On the right-hand side of the painting, where it's cooler, I started using more alizarin and cerulean blue, and a bit less yellow and orange. As I moved into the flowers, which have both warm and cool areas, you can see some obvious yellow as well as obvious purples and blues. At the windows on the left there are lots of cool colors—mostly white, alizarin, and cerulean blue.

The Dark Areas. In darker areas, like in the flowerpot, I used the same combination of alizarin and cerulean, but much less white. (I could also have used raw sienna, a darker version of yellow ochre.) The divider between the windows was again made up of the same combination. Here the colors tend toward the warm, so raw sienna, yellows, and orange dominate the purple of my alizarin-cerulean combination. Again, very little white was used in these darker areas. As I got into other darker areas, such as the leaves, the darker sections of the tabletop, and the clay saucer, I started using burnt sienna and more cadmium red light. I used very little cadmium yellow and white. In painting the table in shadow, I used the same combination of alizarin and cerulean, although I could have also moved into the darker blues such as cobalt, ultramarine, or phthalo blue.

The Windows. Painting windows is always a problem. In this case, I looked out past the lovely flowers at a not-so-lovely asphalt roof. I had to forget about the roof itself and concentrate on the shadow patterns that would enhance my picture. I experimented with the grays in the roof area (I often spend hours just trying to get exactly the right color). I tried bluish, pinkish, and brownish grays: purple mixed with a little cadmium yellow, yellow ochre, or raw sienna, and lots of white. I also tried cerulean blue and cadmium orange, and also a little cerulean blue and burnt umber, adding lots of white to both mixtures. I felt it was important to get some variety in the individual roof sections segmented by the window dividers.

The Leaves. For the leaves, I used quite a bit of cadmium red and raw sienna with viridian. I could also have used cadmium yellow light and yellow ochre mixed with black.

The Bottle. I usually use blues for my cooler greens, rather than viridian, so the bottle was painted with cerulean blue, cadmium yellow light, and white.

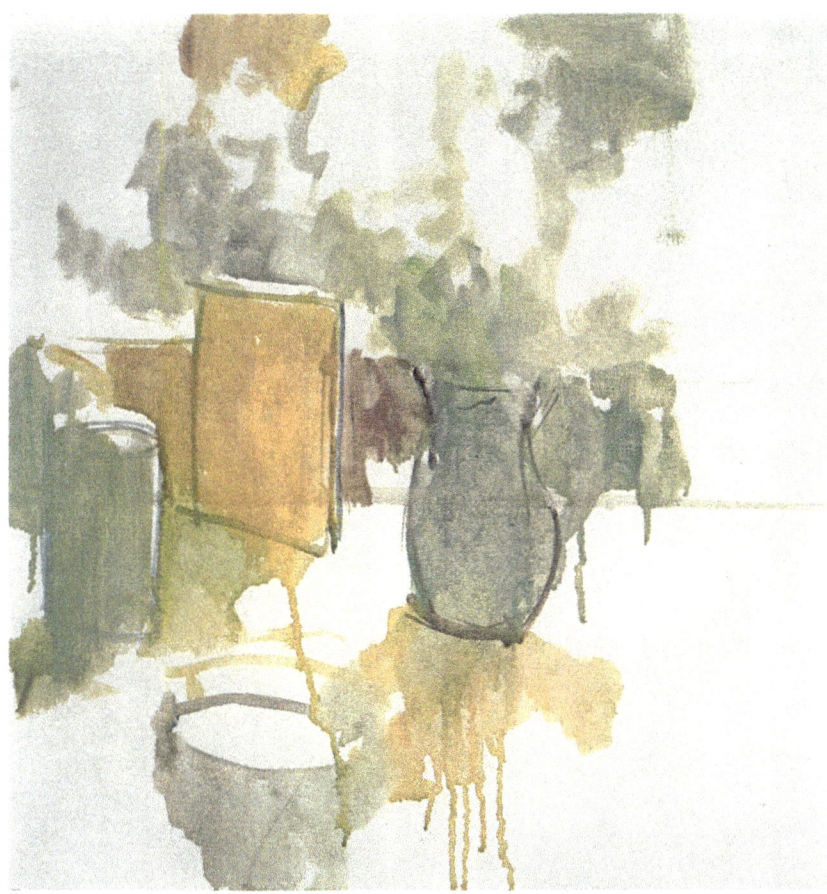

DRIED FLOWERS

Step 1. For this project, I make only a few lines to indicate the relative positions of my objects. Next I start laying in large masses of color. I'm using only turpentine as a medium here; the oil paint is practically the consistency of watercolor. I make color changes as I go, but you'll notice that the values are pretty much the same. I concentrate on putting in my middle values, not lights or darks. These middle values will dominate this painting.

Because I'm working on white canvas, I try to get as much of the white covered as soon as possible. Notice that all areas so far are practically the same in terms of finish. I don't develop any one area; I try to keep the whole painting going at the same pace. If I were painting flowers that might fade quickly, I'd probably concentrate on them—but only after I'd massed in a good part of the surrounding areas.

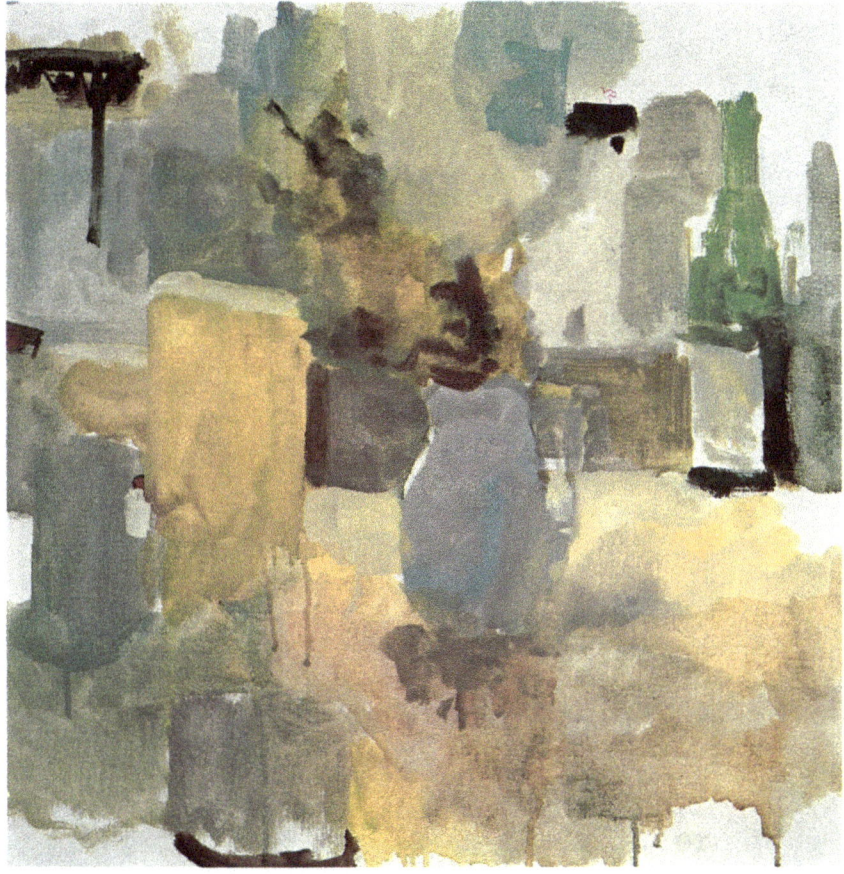

Step 2. Almost all the canvas is covered now. It's time to develop individual areas. I switch to my regular painting medium, because I want the paint to have a heavier, more buttery consistency. (Be sure not to let your paint get too thick. The more paint you have, the harder it is to handle.) At this stage, I usually exaggerate my color. Notice how much yellow I've used for the countertop. The white pitcher, which is in shadow, I paint a very cool gray. It's best not to use black and white to mix gray. Get in the habit of using complementary colors instead. Notice that I keep areas of similar value connected and massed, without hard divisions. The bouquet and the background, as well as the cast shadow below the pitcher and the pitcher itself, are painted in practically the same color and value.

COLOR DEMONSTRATIONS 81

Step 3. I'm now bringing my objects into focus. I begin to separate individual areas, but I try to lose my edges in areas where the value is the same. For example, notice how the flowers flow into the background to the left of the vase, and the yellow cereal box and its cast shadow are painted with almost the same value and color. I start massing in the hundreds of complicated stems and buds as two or three large areas. It's naturally much easier to see larger areas of lights and darks if you have a single light shining on your flowers. In this case, the main light comes from above and behind the flowers, so most of the flowers are actually in shadow. I can see that the lightest area is in the goldenrod at the top of the bouquet. The dried flowers to the left of the goldenrod are also affected by the single light source, but they have a darker local value than the goldenrod.

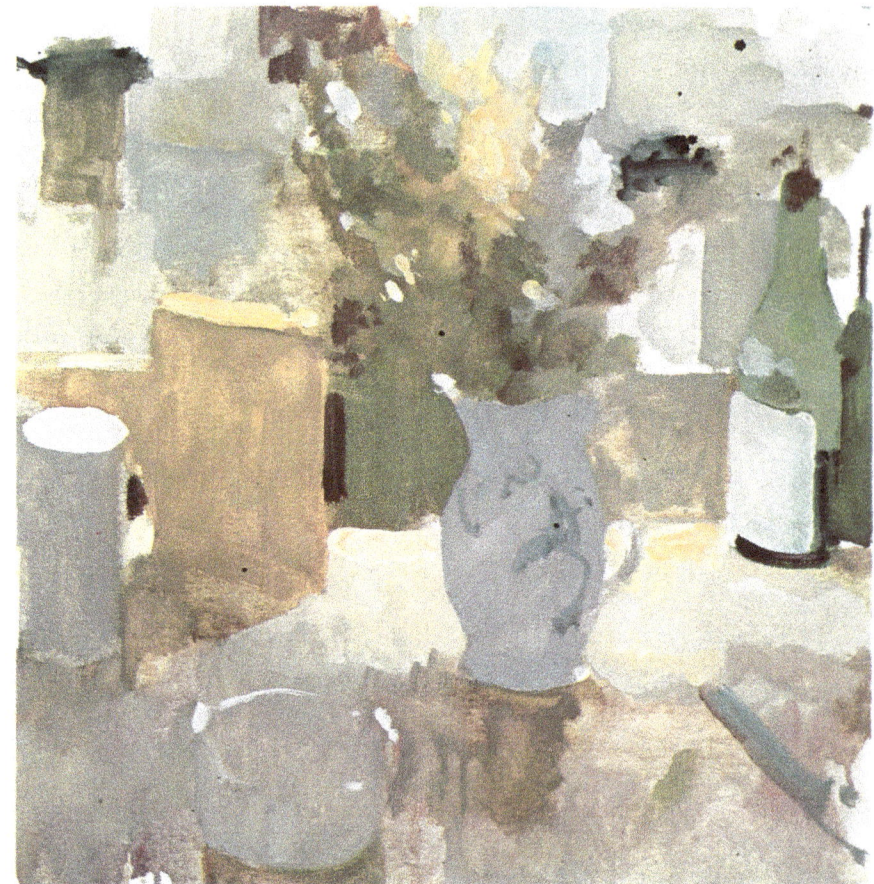

Step 4. There's more tightening up here. I add more details; I deepen contrasts between areas; I suggest sections for future work—where I'll be placing highlights, reflected lights, and additional detail. I work more color and shapes into the background and into the objects on the table. I add more lights and darks to the flowers and add a hard edge to the base where it meets the dark leaves—the center of interest of the painting. However, despite the addition of small forms, the basic value areas remain relative to each other.

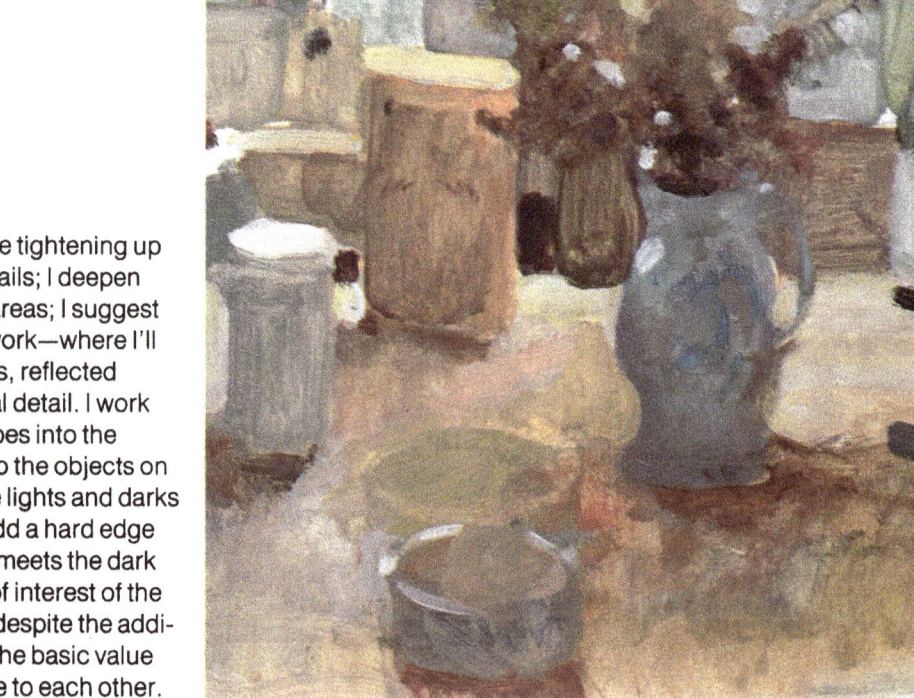

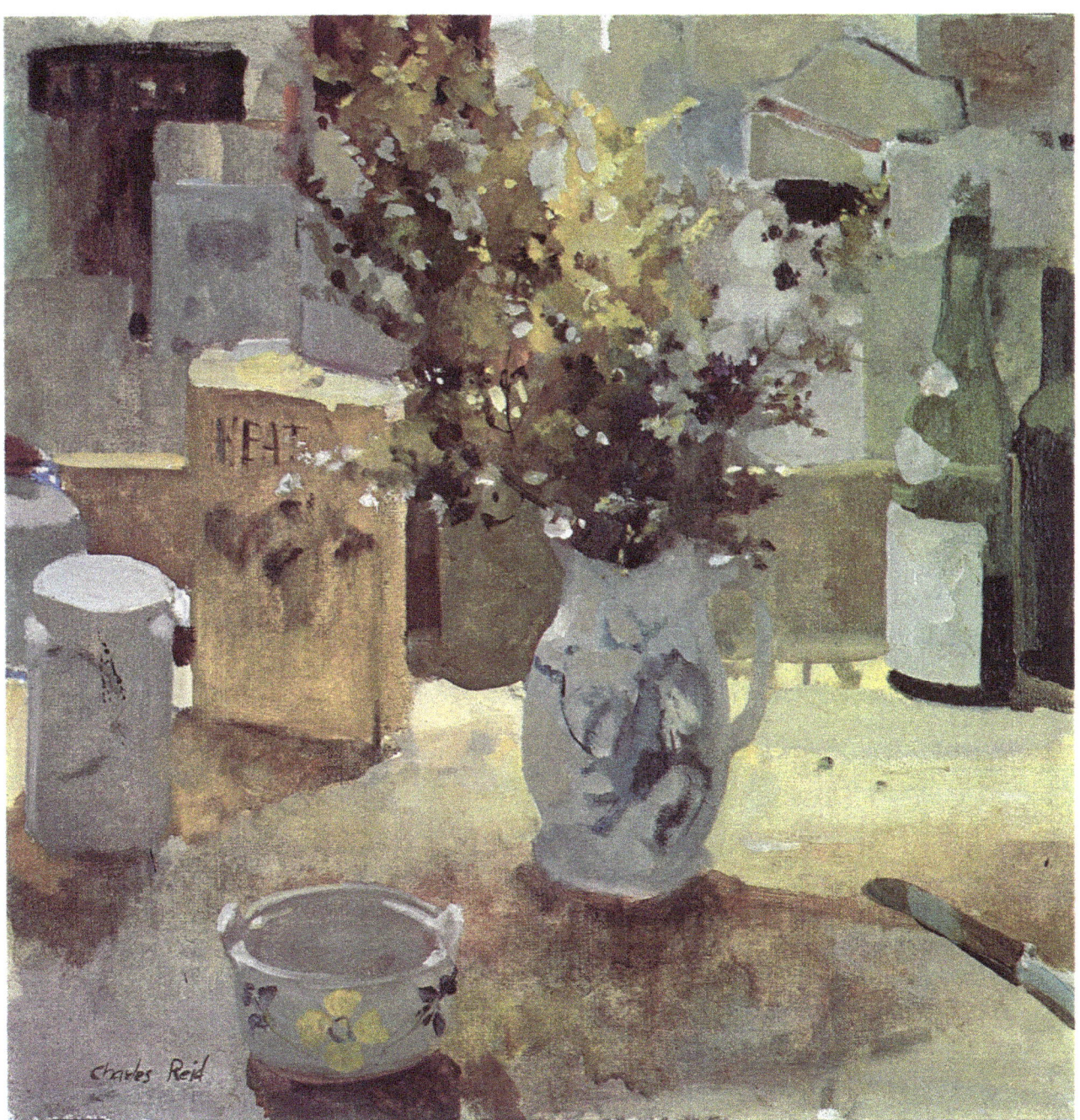

Step 5. I now finish the painting. I carefully place my darkest darks where they'll be most effective in terms of my composition. Their placement is very important, since they will give the painting depth and emphasis and will direct the eye through the picture. For example, the black label above and to the right of the flowers helps to make the white flowers stand out and also strengthen this area. More darks are found at the top left and in the bottles. Then, hopefully, the eye will go on to the vase and its design and then on to the small container in the foreground.

Up to this point, I've been concentrating on the structure of the picture, dealing with shapes of color and value rather than painting individual objects. Some artists will want to carry their painting to a highly finished state, while others might want only a spontaneous, "loose" impression of a still life. This is the stage when each artist's style should take over.

DAISIES AND BRUSHES

Step 1. In this case, I use only a few lines for placement. Since I'm interested in the design of the picture rather than the rendering of single objects, I immediately start massing in large shapes of lights and darks. (Turpentine is my only medium at this stage.) It's important to think in terms of silhouettes of dark areas against light and light areas against dark. The trouble with this approach is the fear of "losing" the drawing. Although I know this fear, I feel that most student pictures suffer from making each object an individual form. You must always think of the still life as a whole while you're trying to draw or paint each piece.

Step 2. The composition is established. I'm usually relieved when I get a painting to this point. I know I won't have to make any more major changes. Notice how "fluid" the picture is at this stage. My paint is still very thin. If I did want to make a major change, it would still be possible.

I add a tube of paint on the left and on the right-hand sides of the painting—something more had to be happening in the rather large, empty foreground.

84 FLOWER PAINTING IN OIL

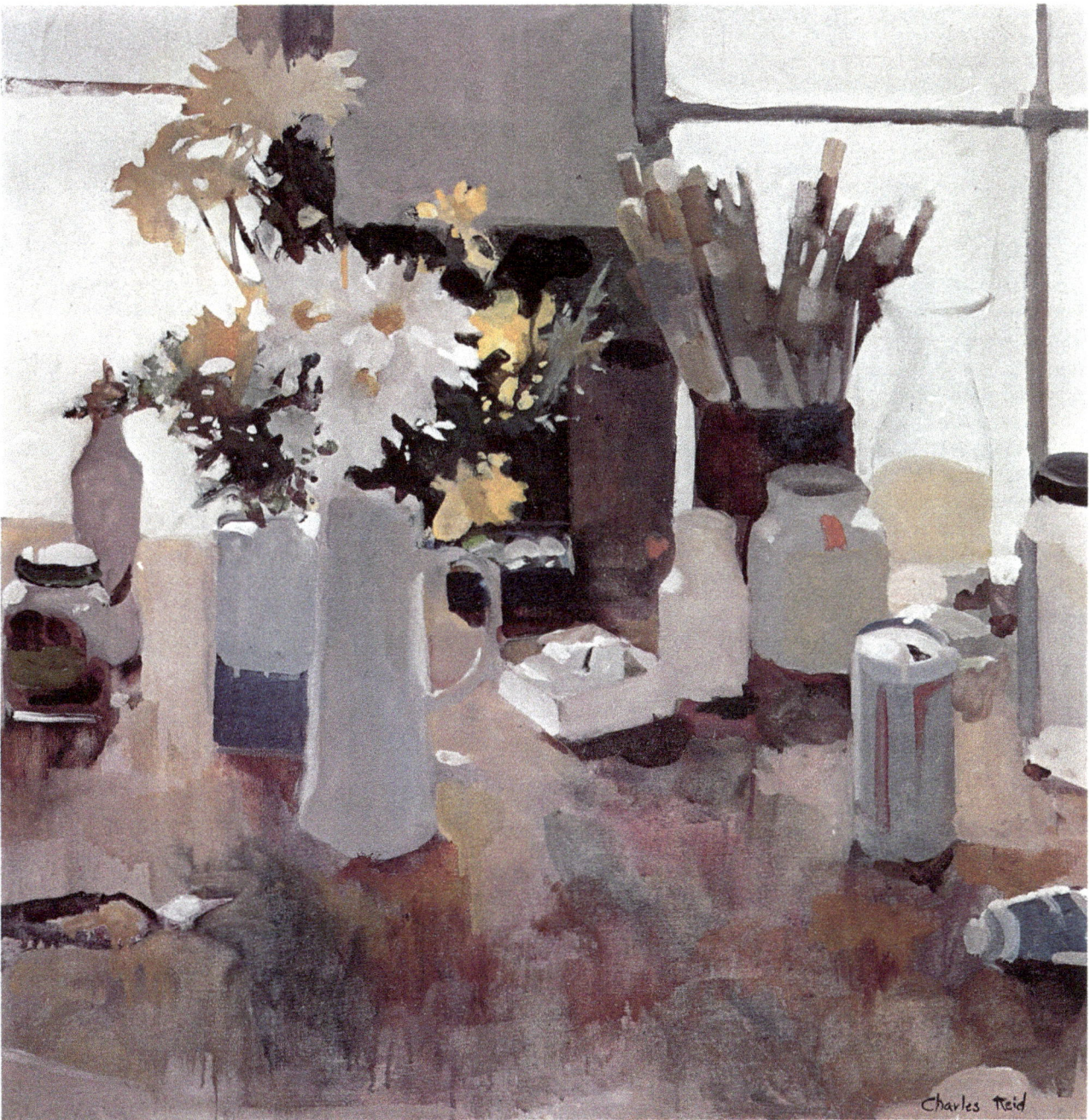

Step 3. The final stage of a painting is difficult. The painting must be drawn together, edges firmed, the subject drawn into focus. Now is the time to work on color changes. Just a minor color change between two adjoining objects can make a huge difference.

Notice the warm and cool grays in the mustard jars, paint tubes, carton, and beer can. I might spend a whole morning finding just the right combination of grays in these objects. The tabletop is an unexciting brown at first glance, but actually there are some lovely yellows, reds, purples, and blues there.

KITCHEN FLOWERS

Step 1. I look at my subject in a purely abstract way: how to make large masses of lights and darks balance each other. This is what makes a composition. Where you place individual objects is not as important as the placement of your big masses of lights and darks.

Notice how everything is connected. The window on the upper left ties in with the cupboard over the counter. They form a large middle dark along the top of the picture. Diagonally across and below the window is another area of dark: the cupboard under the counter. I leave my lights untouched, concentrating on blocking in my darker areas.

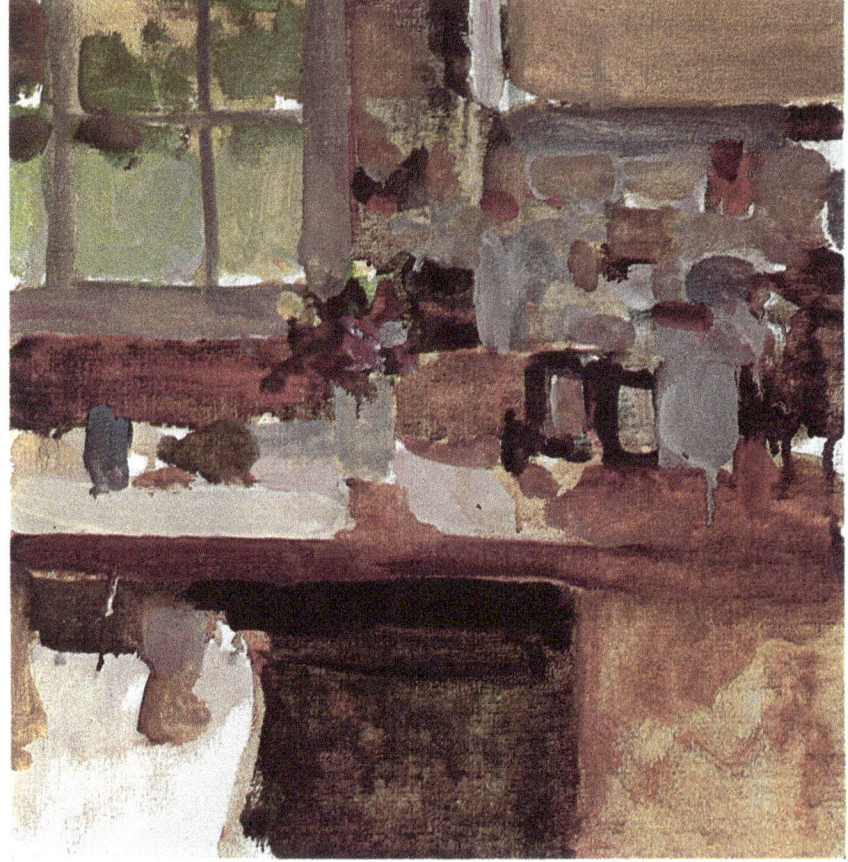

Step 2. Now that the canvas is covered, there are some big differences from Step 1. As you've seen before, it's almost impossible to judge your values in the beginning. In this case, in addition, I have the tricky problem of painting the window and the landscape outside as well as my interior. The window area is very light, but the lightstruck counter is even lighter.

It's vital to squint most of the time at this stage, and to compare one section with another to find that area's color or value. You can't just look at the wall of wine labels to come up with the correct value or color. You must compare it to the window.

86 FLOWER PAINTING IN OIL

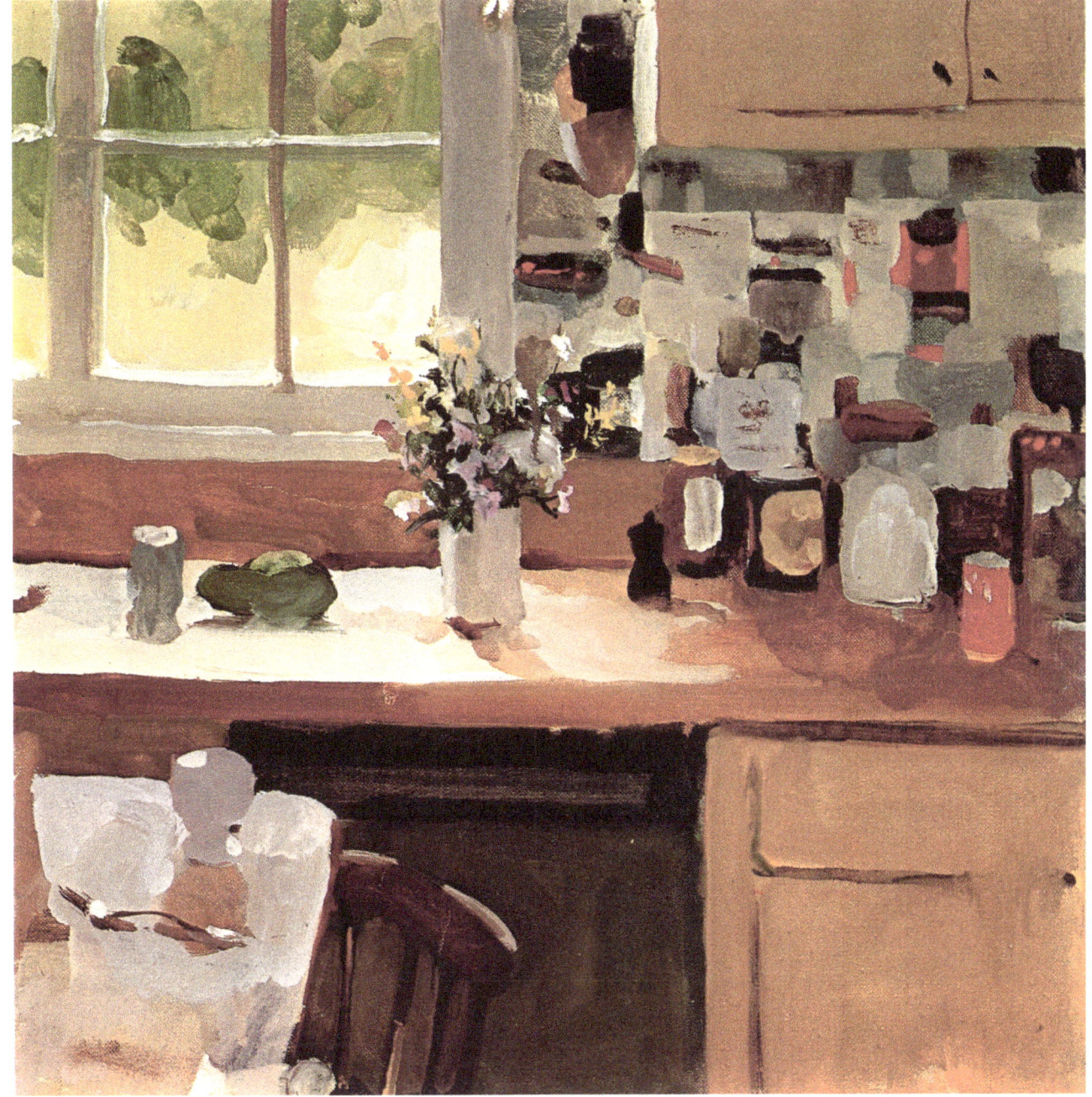

Step 3. Looking at Step 2, I feel the darkness invading my painting. This is when coming back to the picture after a trip to the supermarket can be a real eye-opener.

It's important to realize that to show light, you must also show dark. In this case, I lighten the window and the counter in front of the window. This fairly limited amount of very light area seems to suggest that the whole painting is "light." (However, too much light in a picture often only succeeds in making it look washed out.)

To finish the rest of the picture, I merely firm certain edges, especially those out in the light. Notice how generally I paint the wine labels. I want the wall to look like a whole wall, not a bunch of wine labels. (I'm not sure I succeeded.) Keep yourself from getting too hard-edged, too specific. Try to see the wall out of focus (squint). Also, try painting the wall while you're actually looking at the flowers next to it.

ANEMONES

Step 1. The white anemone really stands out—I start my painting with the hope that I'll be able to put its shape in the right place. However, I start off with my darks first, keeping them fairly thin. Never try to paint a light value against a light tone on white canvas or panel. Always place some darks first.

Notice the shadow shape on the vase. There are also reflected lights and textures on this vase, but I ignore them and paint only this simple, one-value shadow. It's vital that you see only the obvious at this early stage. Notice the lines that contact the flowers with the border on one side and the vase with the border on the other side. Always think of the whole picture. I'm thinking now of what I'll try to do with all that white emptiness around my vase of anemones.

Step 2. I'm painting very thinly on a Masonite panel primed with Liquitex gesso. Masonite presents a slippery surface to work on. You might like it or hate it. I'm using a gel medium that comes from a tube called Win-Gel (put out by Winsor & Newton). It seems to me the gel works better on Masonite than an oil medium because it gives a bit more control.

As I work on my palette, some of the burnt sienna, raw umber, and burnt umber may get into the purples and greens of the flowers, but it doesn't worry me. It's important to develop color themes in your pictures. The easiest way to do this is to have some of the same colors in adjoining areas.

88 FLOWER PAINTING IN OIL

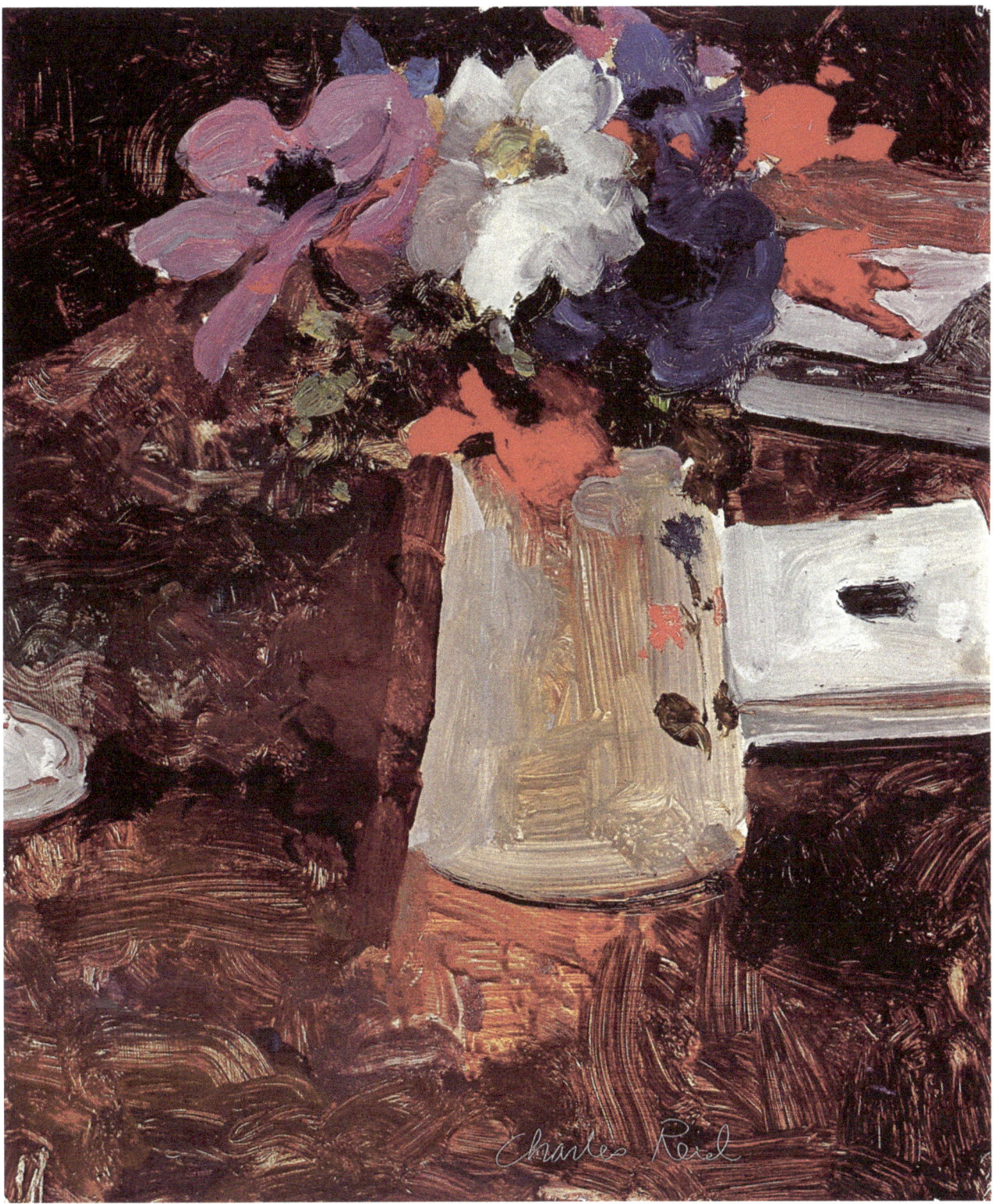

Step 3. All areas are covered. I add reflected light to the vase carefully, making certain that the reflected light never gets as light as the main light on the vase. As the table recedes the brown goes toward purple in some areas, toward green in other areas. The value also changes slightly. But don't overdo these color and value changes or you'll break up the overall tone.

I'm not too pleased with the white book, but I decide not to fuss with the painting anymore. I'm never completely happy with what I paint; there's always something I'd like to change. Another thing that's probably wrong is the placement of the flowers. They're too crowded into the top of the picture. But I like to try getting away with things like this.

SIGRID'S FLOWERS

Step 1. These flowers are busy with small blooms of various colors and shapes. I put them against a window so that the back lighting helps simplify the darker colors, making a mass. The flowers are so lovely, it seems natural to do a closeup. Since they're complicated, I decide not to put anything else in the picture.

The composition is very simple. I merge the fairly dark mass of the vase with the similar value and color of the windowsill. Next I squint and see the large mass of dark which makes up most of the bouquet. I'll worry about details later.

Step 2. The background outside is very important here. I want to tie it into the flowers. It's hard to decide how dark or light to make the trees outside. As I look through the window, it seems that they're fairly dark. Yet, when I look at the flowers, the window area looks light. I think the answer lies in the composition. I must adjust the values in both the flowers and the background so the design works well for me. At one point, I may want to make the trees outside darker.

I connect the white flowers at the top of the bouquet to the curtain by making both curtain and flowers the same value. The vase and the wall to the left are also the same value. The windowsill is drawn up into the window area and connects with the trees beyond.

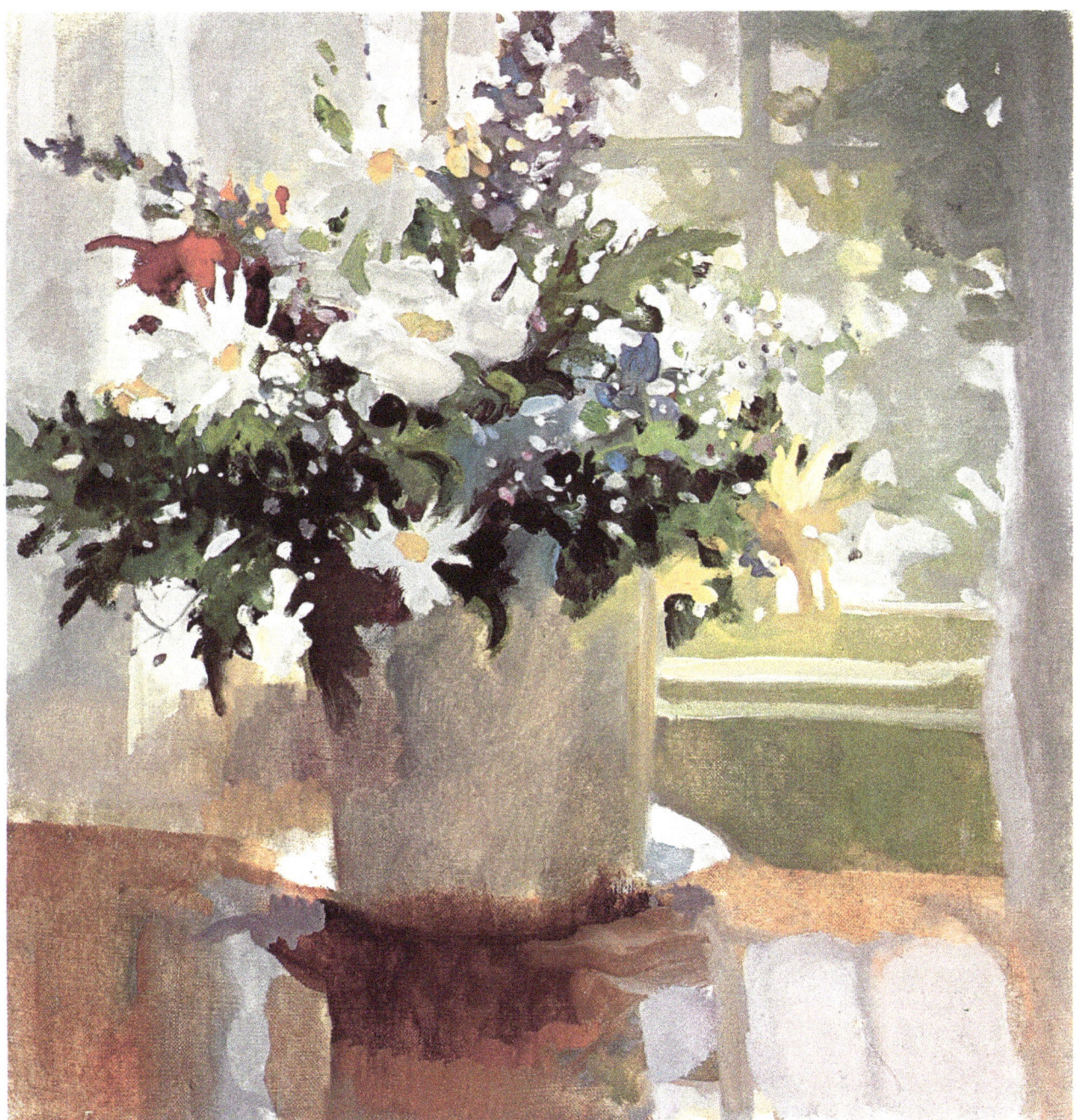

Step 3. Now I refine the painting, changing many values in this final stage. The windowsill seems too dark, so I lighten it. Hopefully, it will make the picture more luminous. I add small buds—but I must be careful. One or two buds might look great, but I have to fight a tendency to keep on adding too many little dots of color. If you can control your values well (that is, not make the dots too light), you can probably add as many as you like. However, I think that the big mass of dark in the bouquet is important. I feel it "carries" this busy arrangement. So I try to control my urge to flick spots of lights all over.

PERSIAN RUG AND DAISIES

Step 1. I'm dealing with a Persian rug—this means lots of pattern. I could either fill in the pattern, actually sketching in the light and dark parts, or else I can squint, generalizing the pattern into a dark background to set off my daisies. I decide on the latter course. I work the background around the parts that will be the daisies. I use lots of turpentine for my medium, painting thinly, as if I were doing a watercolor.

I leave white canvas about where the daisies should be, but I don't carefully plan or sketch in the outlines for the flowers. If you make your dark background fairly thin, you'll be able to paint the thicker light flowers over it without much trouble. The general plan of the painting is now made. I spot lights and darks in almost all areas of the canvas.

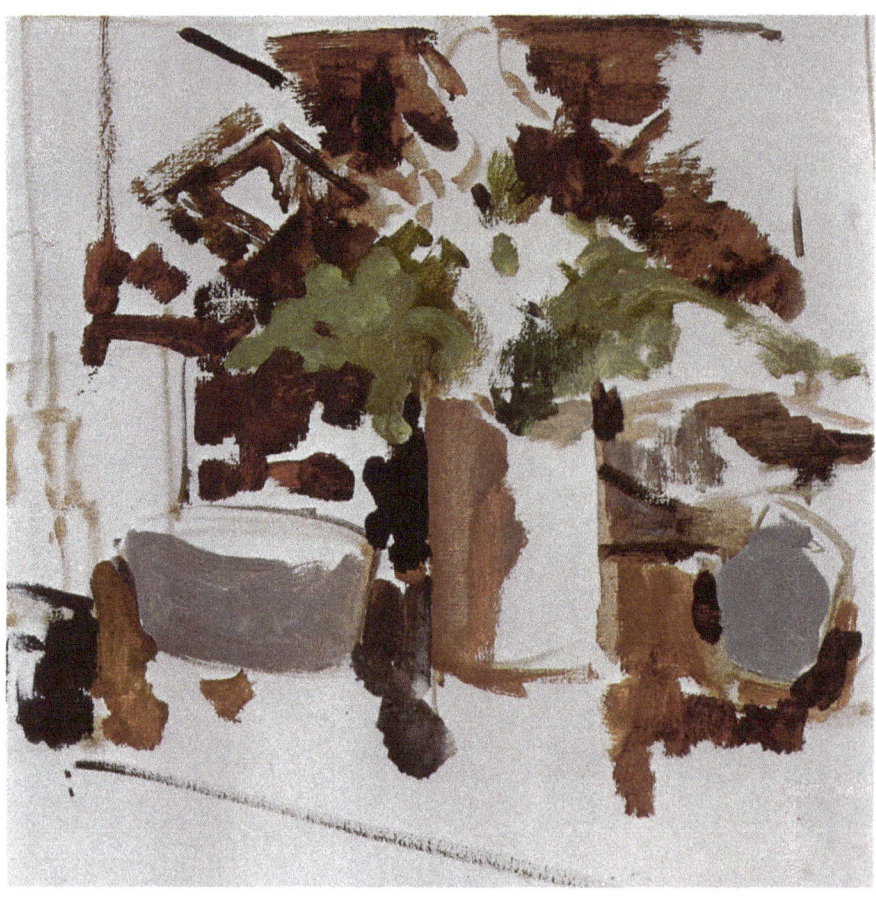

Step 2. I add more background color, being careful not to let too much dark get in. I then add more daisy color. Squinting, I see that many of the daisies, though very light, are actually in shadow. So I add cerulean blue and orange to my white to make these very light shadows. The daisies are painted out into the background and into the greens of the bouquet—easily done as the background and the greens are fairly thin.

I treat the ferns as a mass—later, I'll add some details. I place a dark dark beside the vase. It's helpful to state one good definite dark in every picture. It acts as a rich contrast for all of the middle and light values. At this stage, I don't worry too much about getting the exact intensity or hue.

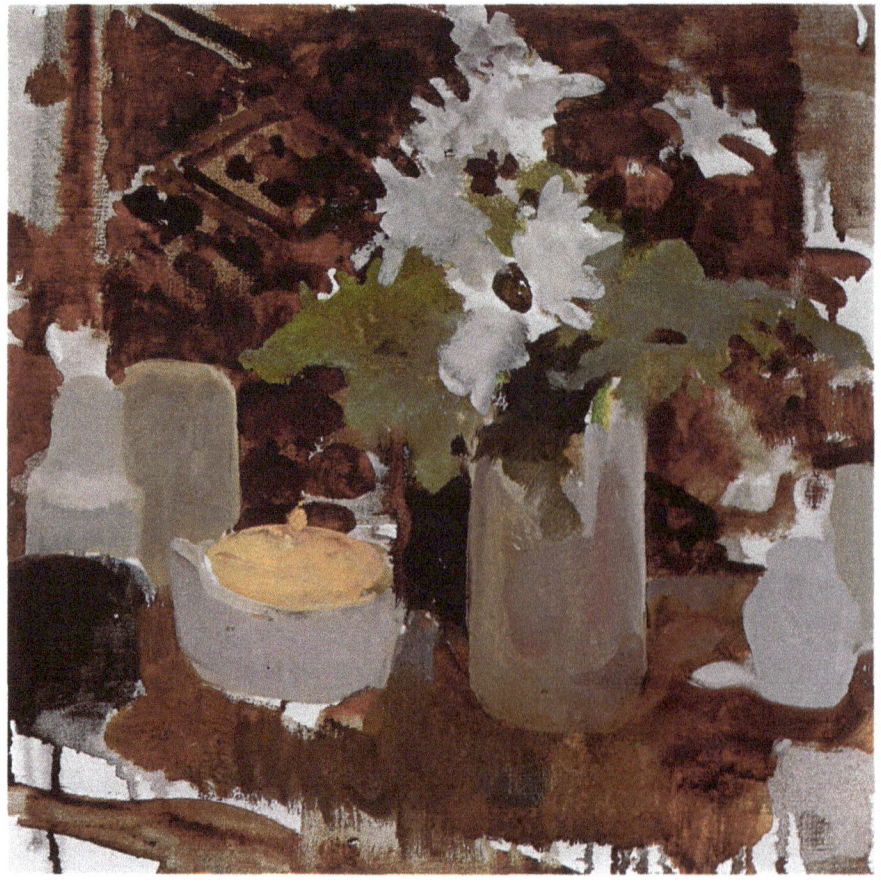

92 FLOWER PAINTING IN OIL

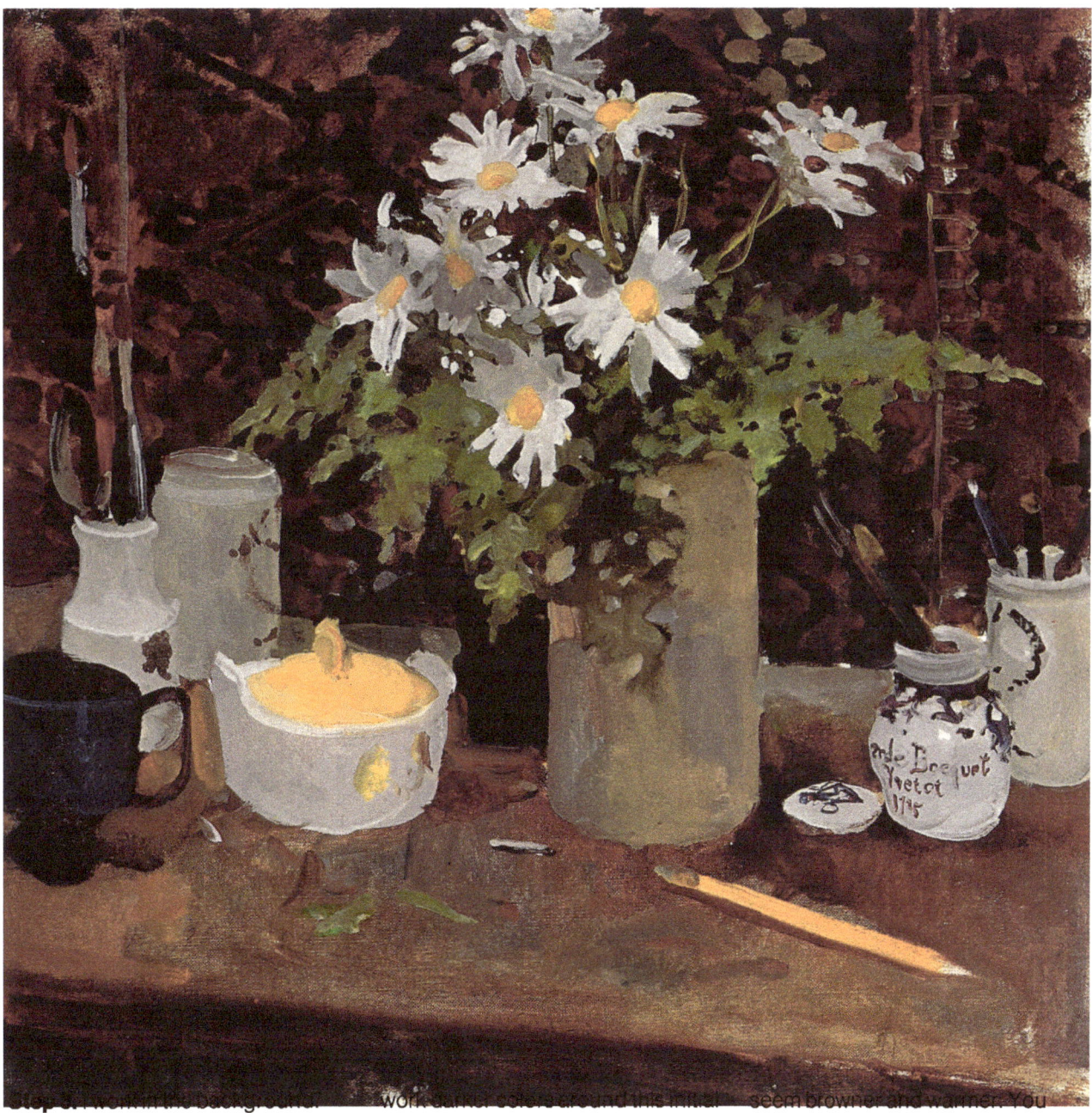

It's hard to tell from the photograph, but the background is painted with fairly dry paint. I use very little medium. Remember in Step 1 when I used lots of turpentine and washed in the background? That color now acts as an undertone and will stand for some of the middle and lighter tones. I don't repaint these areas. I work darker colors around this initial tone.

One of the most difficult tasks is to suggest the detail of the delicate ferns. I'm not sure I am doing that well, but I keep putting in dark dots and lines then painting them out with "fern color." Finishing the jars on the table is really a matter of getting the right gray. Some jars are cooler, with more blue in them; other jars seem browner and warmer. You might have trouble getting just the right shape, but that's a drawing problem that needs practice. I'm more interested in your seeing color and value changes here.

I look at the daisies on the table and then compare them to my painting. Daisies are very white, but that's the best I can do; so I stop painting.

ORCHIDS

Step 1. Normally I sketch in with a brush (usually a #4 or #6 long-handled, flat bristle brush). This time I use a pencil, a 2B. You can also try using charcoal to establish your drawing. If you do use charcoal, though, be sure to dust your painting with a chamois or cloth to get rid of excess charcoal. Leave just the vague drawing as your guide.

I'm very interested in design, so I immediately start blocking in my big dark shapes. (Don't be afraid to lose your drawing.) I really squint to the point where I can hardly see, and all the big dark shapes seem to merge into a large, simple mass. This is what I paint.

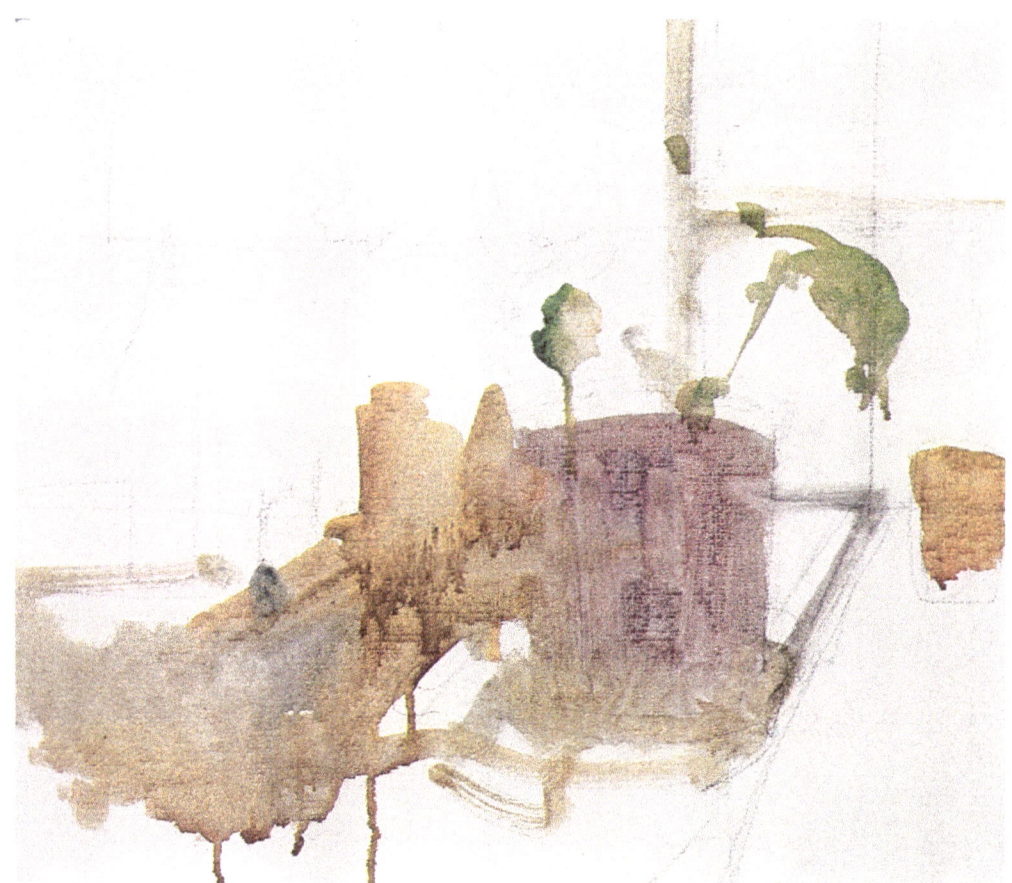

Step 2. I try to connect my darks with adjoining darks; my lights, with adjoining lights. Notice, for example, that the flowers are painted the same value and color as the window. As the painting develops, I'll make some separations; but, for now, I try to avoid all small differences and minor value changes. Notice, too, how thinly the paint is applied.

In massing my values, I allow adjoining colors of similar value to mix. Here, some of the earthy reds of the clay saucer mix with the cooler colors of the flowerpot. The main thing is to merge adjoining color areas, such as the cool bluish pot and the warm reddish saucer, without making a value change.

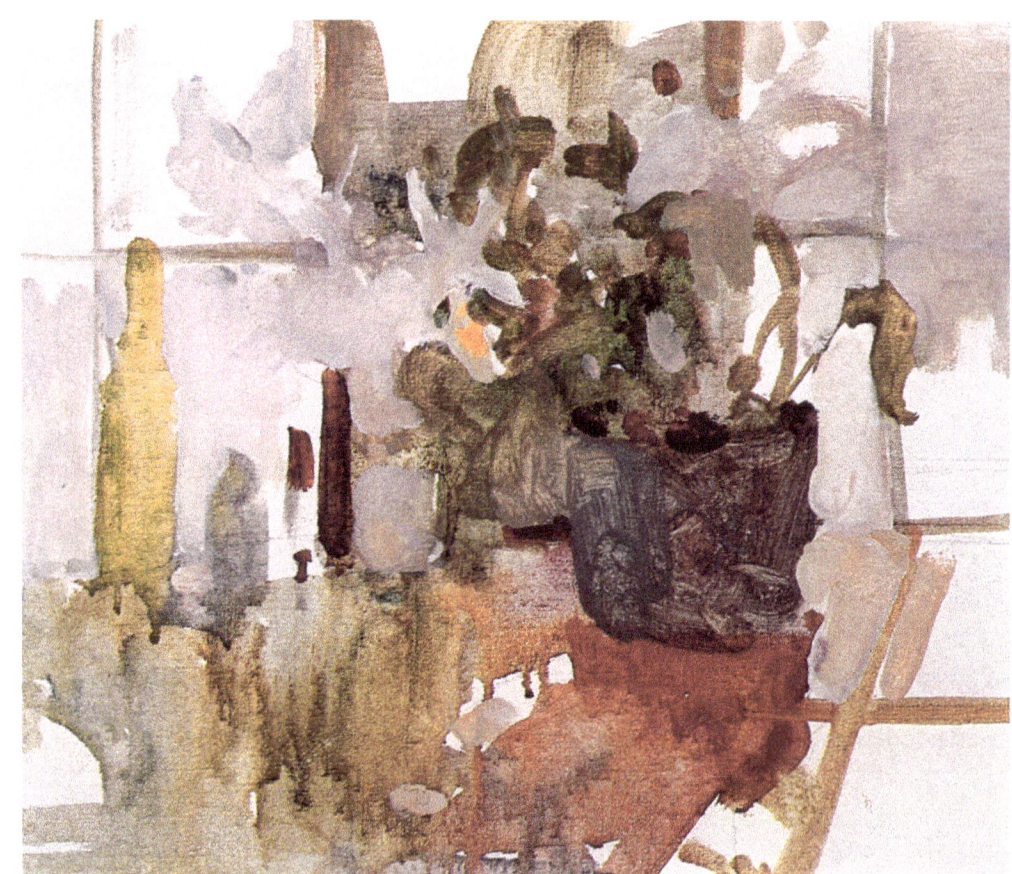

94 FLOWER PAINTING IN OIL

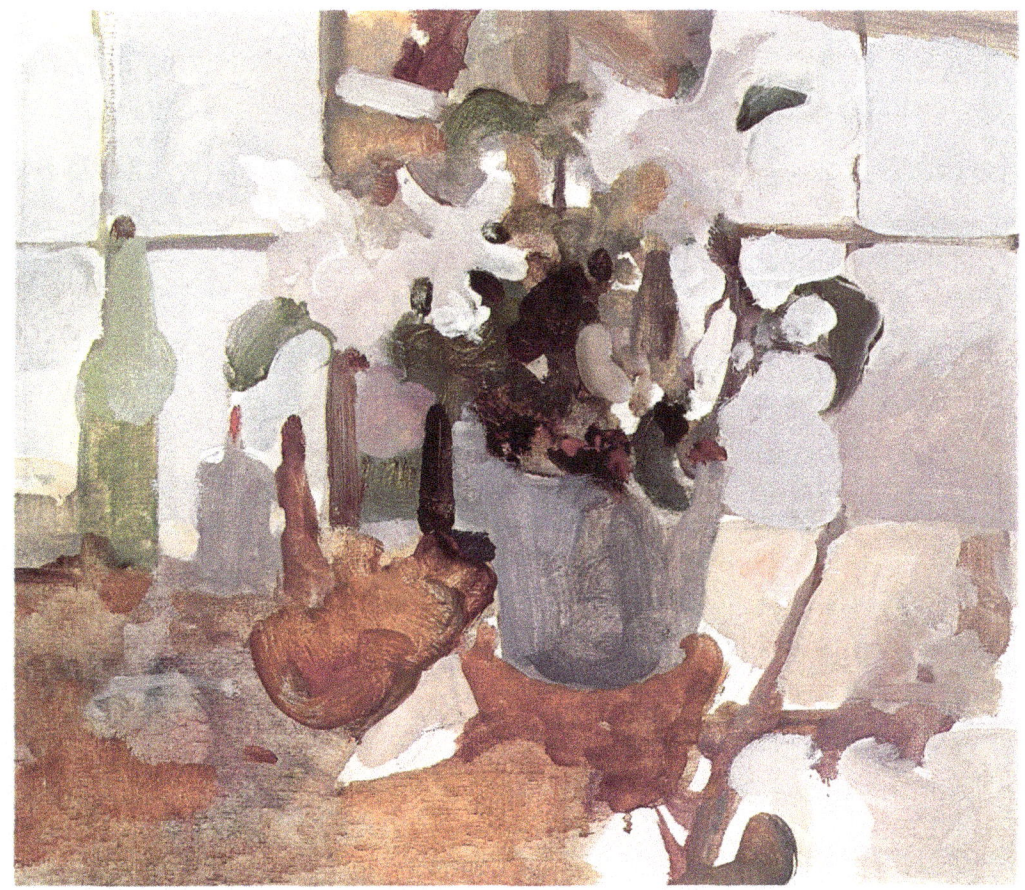

Step 3. Many changes are made here from Step 2. Painting, for me, is a growing process. I constantly adjust and modify. For example, the flowerpot in this step is much lighter than in Step 2, and the cool greens in the table of Step 2 have here become darker, warmer browns. As you paint, always keep several areas in mind. As you make color and value changes in one area, you must constantly adjust colors and values in other areas. For example, if you change color or value in the flowerpot, you must check other areas—especially the surrounding ones—to see if they need adjustment.

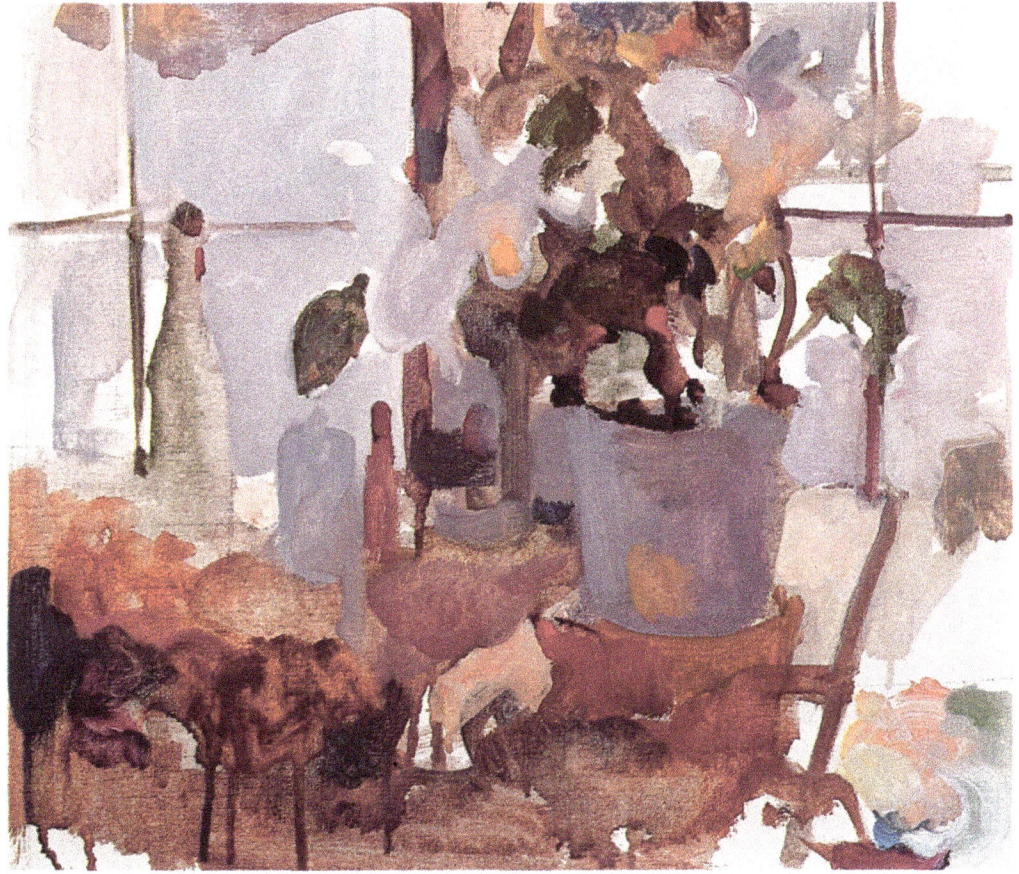

Step 4. This is a color diagram to help you see the color combinations I use to reach my final painting. The point is that I use the same colors over and over. I vary the ratio of one color with another, but the same colors are found throughout. A color swatch in the lower right-hand corner of this step shows my basic color combinations. (For a detailed description of my palette, please see the introduction to this demonstration.)

COLOR DEMONSTRATIONS 95

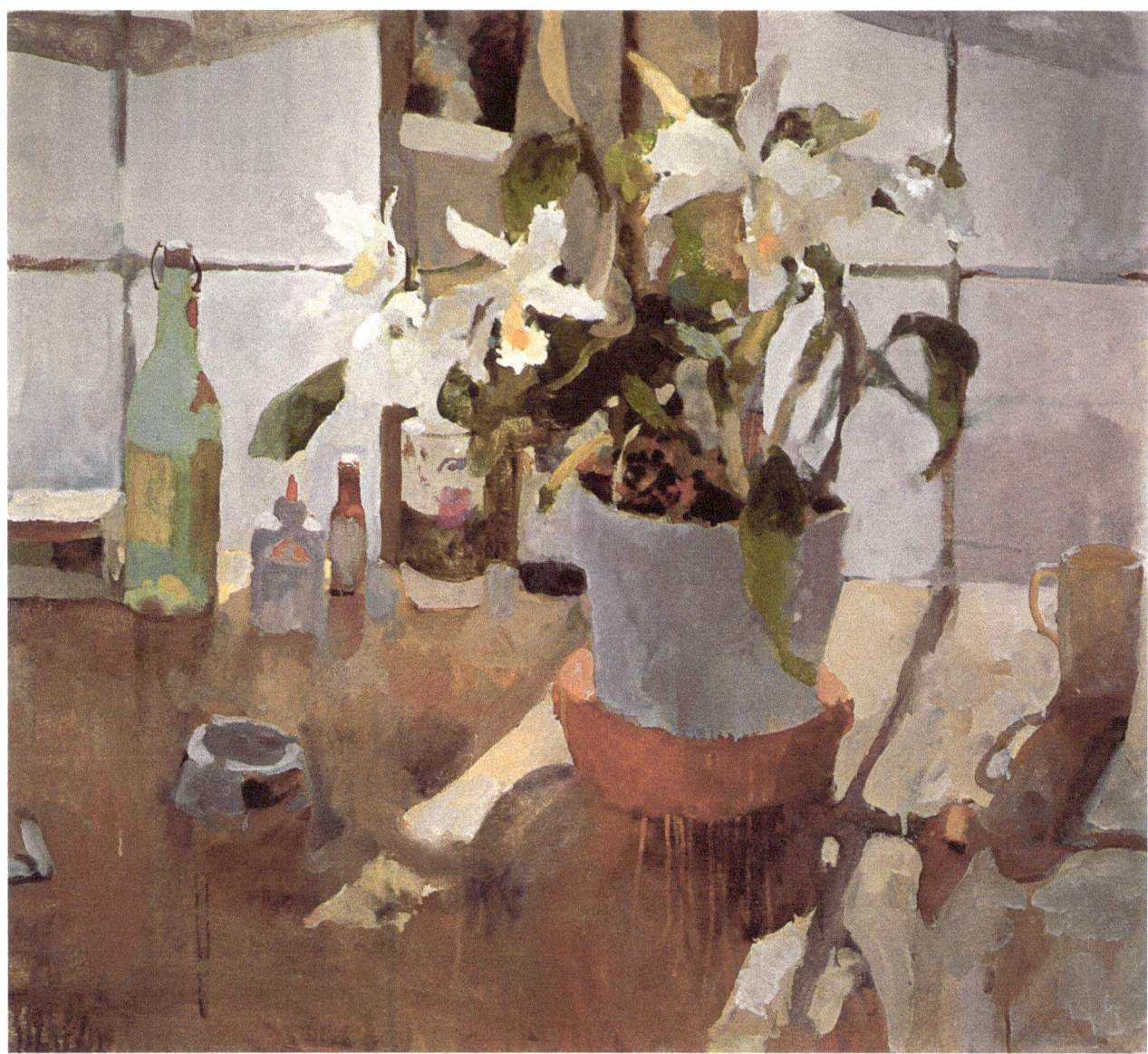

Step 5. As you compare my finished painting to Step 4, you can see that quite a bit has been done to tighten it up. I try to keep my painting fluid as long as possible, although, by Step 4, most of my big color and value relationships are established, and only minor adjustments remain to be made. As I approach Step 5, where I make final changes, I fix boundaries and harden edges as I bring various objects into focus.

Again, comparing this step with Step 4, look at individual areas and try to see where I use the warmer side of my basic color combination. Note where I go cooler. Observe that I place a coffee cup on the right-hand side, since I find the area to the right of the flowers too empty. I also add an ashtray. The window divider behind the bottle is moved in order to break up the window area more.

One of the hardest things to do is maintain a balance between defining the flowers enough, but not too much. If you define too much, you'll lose the soft texture that's so necessary in flower painting. You might want to refine the flowers more than I have, but be careful not to go overboard. Too many hard, defined edges will make the blossoms and leaves look like metal.

PROJECT 9
GLOSSY OPAQUE CONTAINER

Opaque, glossy objects are difficult to paint because the values are confusing. They don't have the simple light and shade you find in matte surfaces. Matte surfaces aren't shiny, so they don't reflect the lights, darks, and colors around them. They have a simple light-and-shade pattern. Very glossy surfaces don't have a definite value. A particular, fixed value is there, but it's confused by all the surrounding lights and darks of various colors bouncing off the shiny object. The problem is especially pronounced when you're painting metal objects like silver or brass.

In this project, I used a porcelain container. Although my subject is glossy, it's certainly less shiny than a metal object. In a sense, porcelain is probably halfway between a matte surface and something made of silver, brass, or copper.

This particular container is one of my favorite things to paint. It has a pattern, but since pattern only confuses the issue, I left it out. (I'll discuss pattern in Project 15.)

Step 1. I'm painting directly on the white canvas. I'm not using a tone. With a #4 long bristle brush and fairly thin paint, I start to draw. The only medium I'm using is turpentine; I use quite a lot, so the paint has no real body. There should be no pigment buildup here; my paint is almost as thin as watercolor. Notice that I sketch in my picture boundaries. Even though this is just a study of a single object, I still place the object carefully within the picture area.

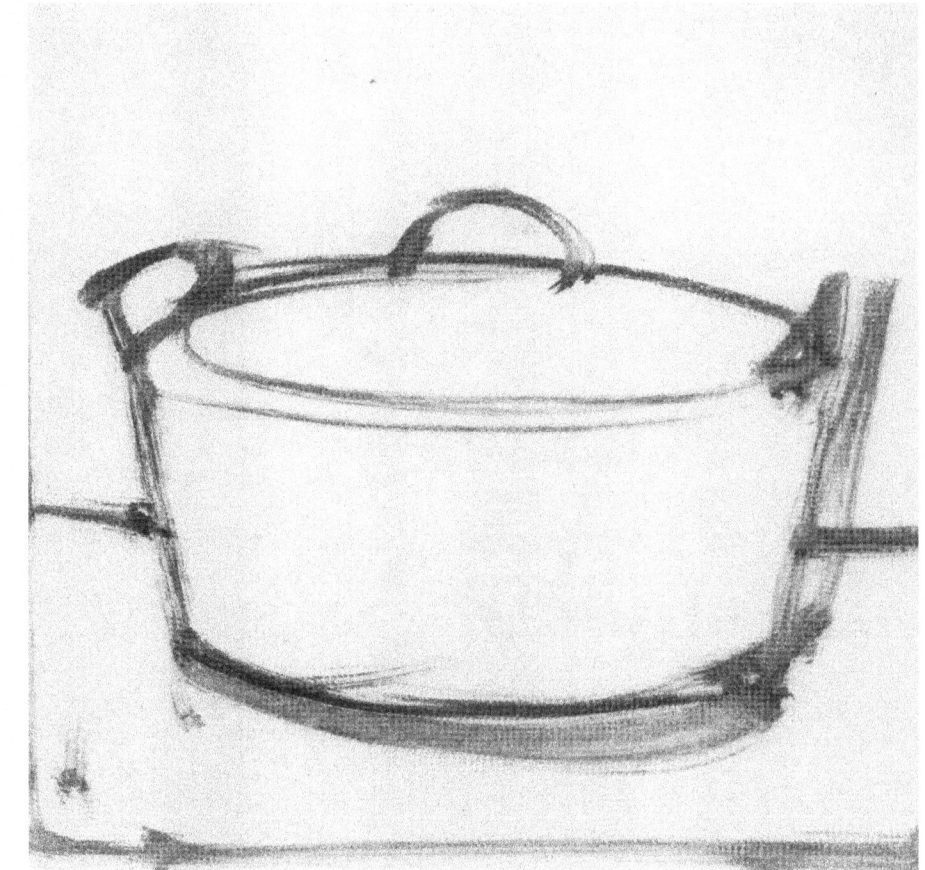

Step 2. Still using only turpentine as my medium, I begin to block in my value masses. I have a very dark background and fairly dark table. It's hard to judge values against a white canvas, so I don't worry if I don't get just the right value at first. The important thing is to quickly get enough paint on to cover the white canvas. I start to suggest some pattern in the bowl, but decide it would complicate matters. I make no attempt to finish or develop any particular area. I'm painting very broadly with a fairly large brush: a #6 long flat bristle. I work in the background on both sides of my subject, as well as within the subject. Never try to finish the thing you're painting and then go on to the background. Always paint the subject and the background at the same time.

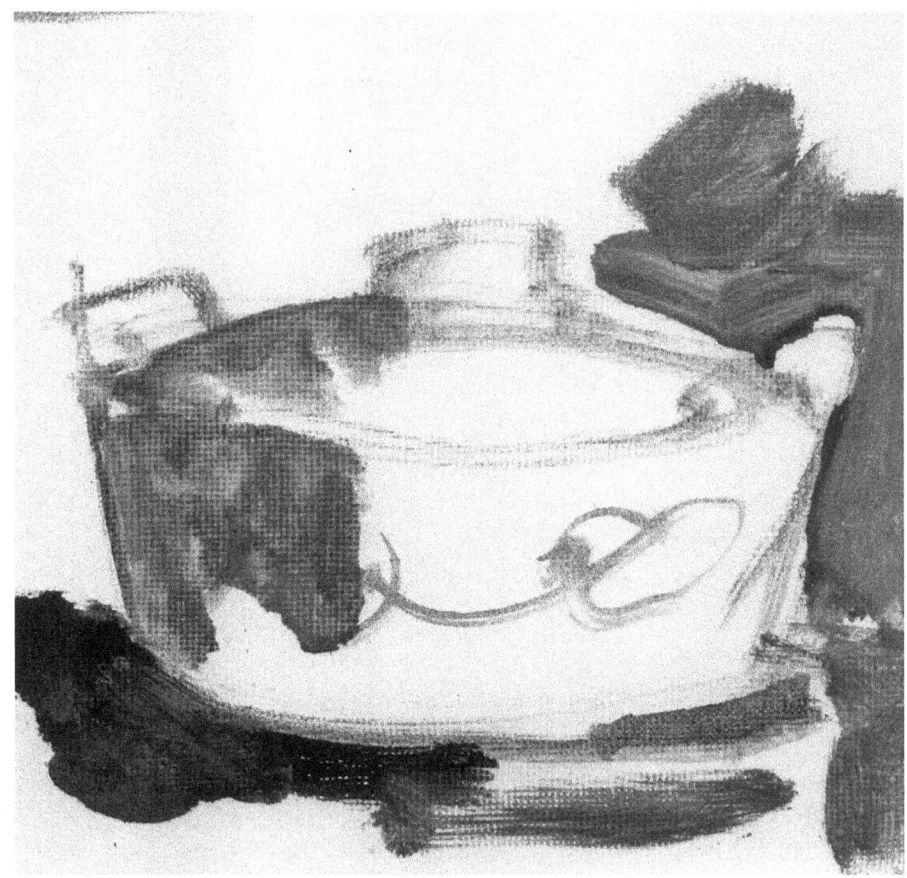

98 FLOWER PAINTING IN OIL

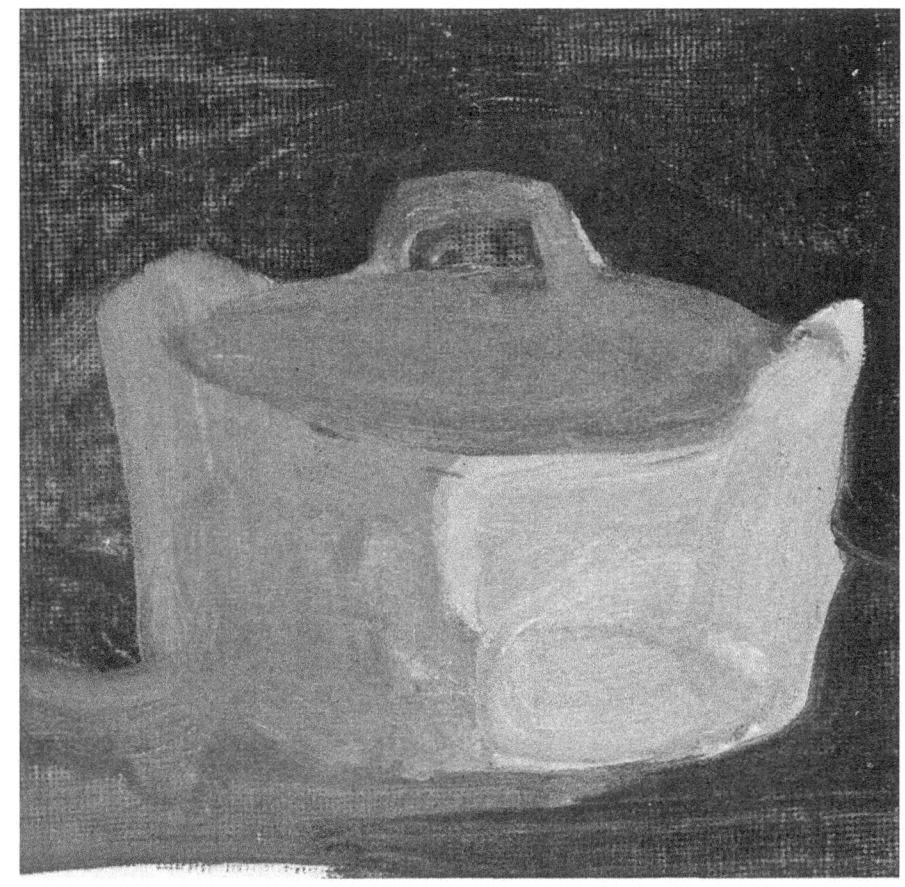

Step 3. Now the canvas is completely covered. I haven't developed any particular area; many areas run together. I try hard not to be confined by my boundary lines. Notice that both light and shadow are put down with a single value for each. This particular lighting (a side light) divides the bowl in half. I start with the shadow first. I see that the shadow side of the bowl merges with the table. (Keep your edges hard, or separated from the background, out in the light, but don't be afraid to lose your boundaries in the shadow.) I paint the top of the container at the same time—I see and think of them both together. I see many values of light on the bowl, but paint only one—an average value that's light, but not as light as my highlight. Don't worry how you put the paint on.

The values I have now are about right for an object with a matte surface. If the container weren't shiny, I'd just have to soften some edges, stress the highlight, and call it quits. The only difference between a glossy and a matte surface is that a glossy one has lights and highlights.

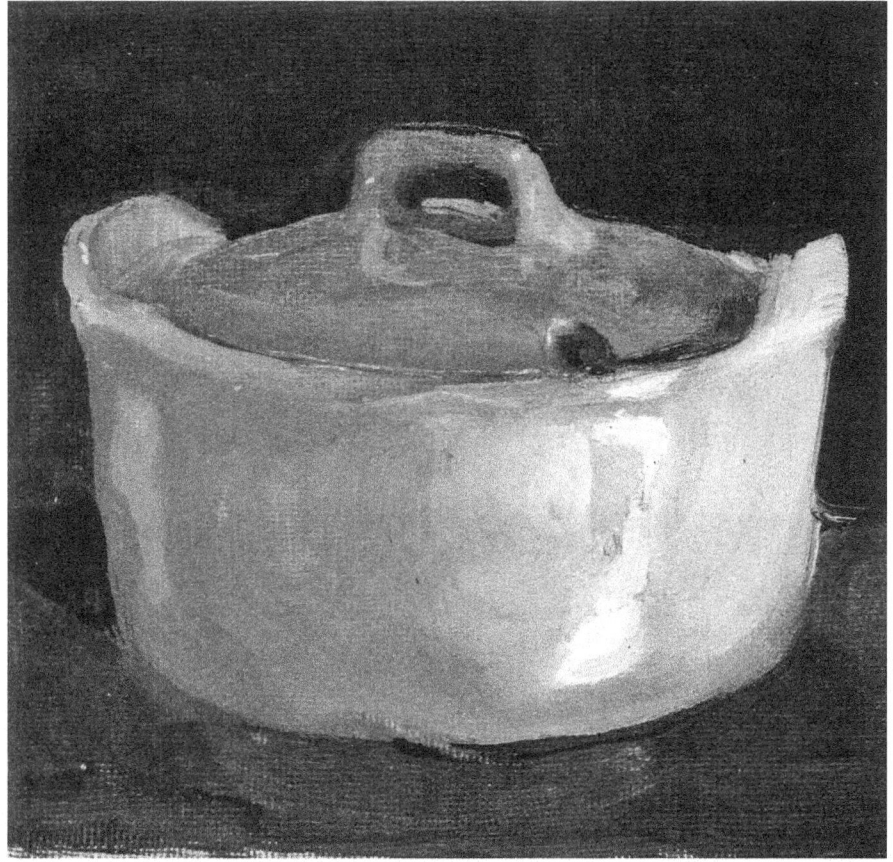

Step 4. The real work is done. All the important decisions have been made. Now it's time to add the highlights. Glossy surfaces have very definite highlights; without them, the bowl wouldn't look shiny!

I add pure white paint to the major light area on the container. Notice that the edges on both sides of the white highlight are different. Where the highlight faces the light source, the edge is hard; where it moves toward the shadow side, the edge is soft and blurry. There's a fairly strong reflected light in the shadow, but it's not as light as the main light, although it probably would be, if this were a shiny metal. In that case, the bowl might even have a highlight in the shadow.

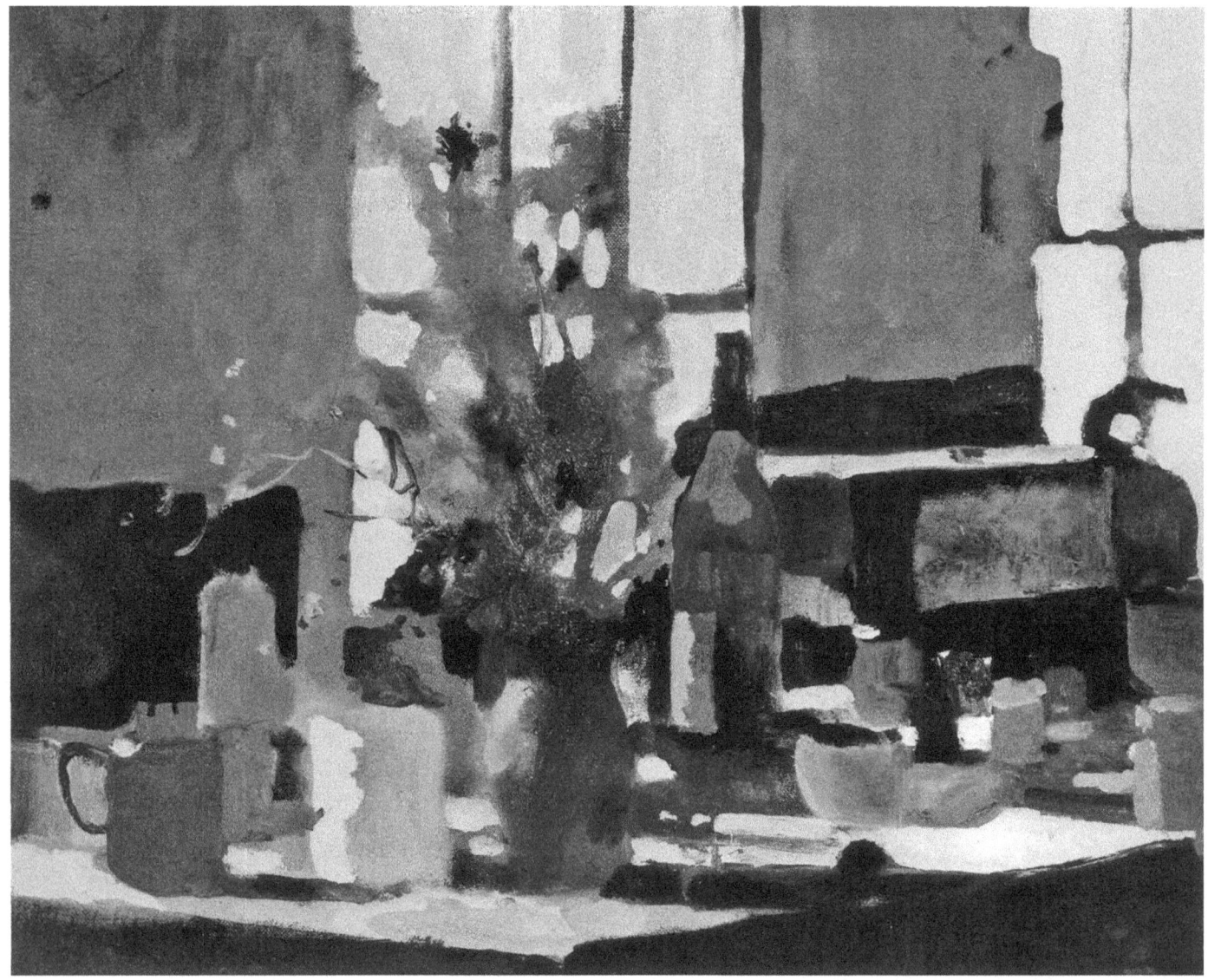

Christy with Flowers. *(Detail) This bouquet contains dried flowers: browns and soft siennas and ochres. The dried flowers are generally the same value as the walls and window dividers. I allowed the overlapping values to merge, using the whites in the window to create a silhouette of the darker flowers. I painted the whites of the window at the same time as the flowers. After I finished, I repainted the window with thicker paint and redefined the boundaries around and within the flowers. I think you can see how much thicker the paint is in the window and flowers, while the walls and window dividers are fairly thin.*

PROJECT 10
GLOSSY TRANSPARENT CONTAINER

I painted two bottles from this project: one fairly light, the other darker. Rendering shiny bottles is not easy for me—I don't have the patience. However, some of you will really enjoy painting textures. Painting specific textures takes time, interest, and patience. My feeling is that you can paint anything once you get your basic values right.

Step 1. The bottles are placed on my drawing table in front of a window. I start to sketch one of them with a #4 long bristle brush, my paint diluted only with turpentine. Notice the corrections in my drawing. Because I didn't get it tall enough the first time, I had to add a bit on the top and bottom. I sketch quite freely, but use a vertical plumb line to help with my proportions.

102 FLOWER PAINTING IN OIL

Step 2. I start to paint. (Always start with your darker values first.) I try to simplify values—actually, I use the same value both in the bottle and the windowframe. I add a darker value in the bottletop. It's good to have one definite dark to "key" the rest of your values to.

Step 3. I want to get the white canvas covered, so I don't finish any one area. At this stage, you should have a general idea of the value pattern of the picture. But, remember, you can't really establish correct values this early. You'll have to make changes as the painting develops. I hope you'll notice the connections between various areas. I separate them only when there's an obvious value contrast. If this were in color, you'd see color changes even though the values are the same. (Please refer to the color demonstrations.) Notice that the eye travels from the table on the left up through the taller bottle, and on up to the right-hand wall.

I add another bottle on the right, massing it in as a simple shape. I'm really using only one value, except where the label shows through the bottle. My paint is thin—if I used thick paint, the bottle would look heavy.

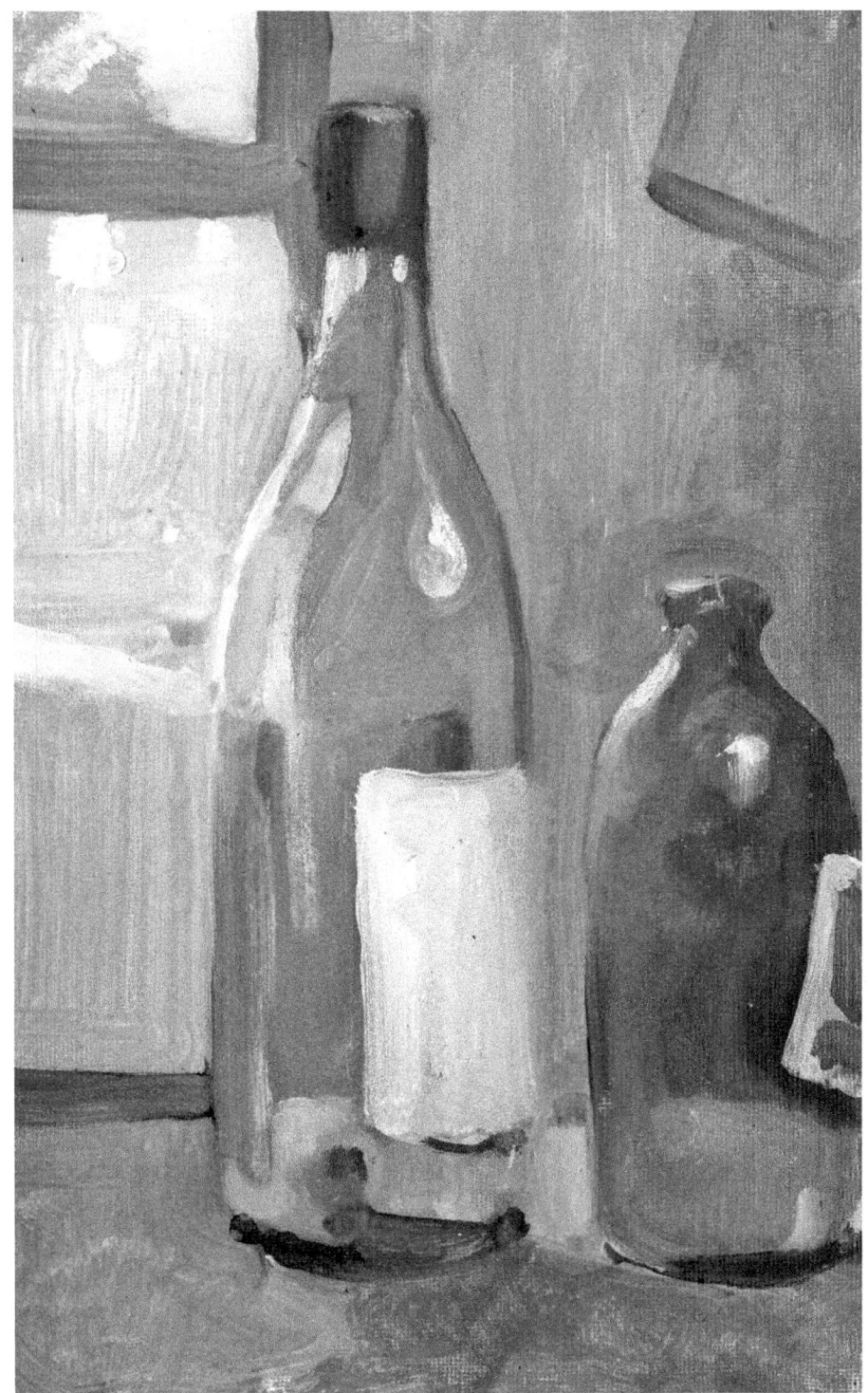

Step 4. I modify values: I lighten the bottle on the left-hand side and darken the lower window area. You really can't be definite about values until you try using them. I'm still not sure about the value of that bottle; maybe it would have been better if left darker. What looks good in the setup may not look right on canvas. You must put it down in paint, then decide if it's what you want.

The most important thing I do in this step is add highlights. Highlights make things look glossy. If I added some white dots now to Step 3, I'd have shiny looking bottles.

I try to see the value changes in the label of the lighter bottle. Notice that it's darker at the end and gets lighter as it goes around the bottle. This may sound unimportant, but it's necessary to see the little things once the big things are established.

Notice the variety of edges I use. You can see soft edges inside both bottles when you look through the transparent glass; you can find hard edges in the labels. Compare these two different areas. If the situation were reversed, and the labels facing you were painted soft while the labels seen through the glass are hard, would the bottles look transparent?

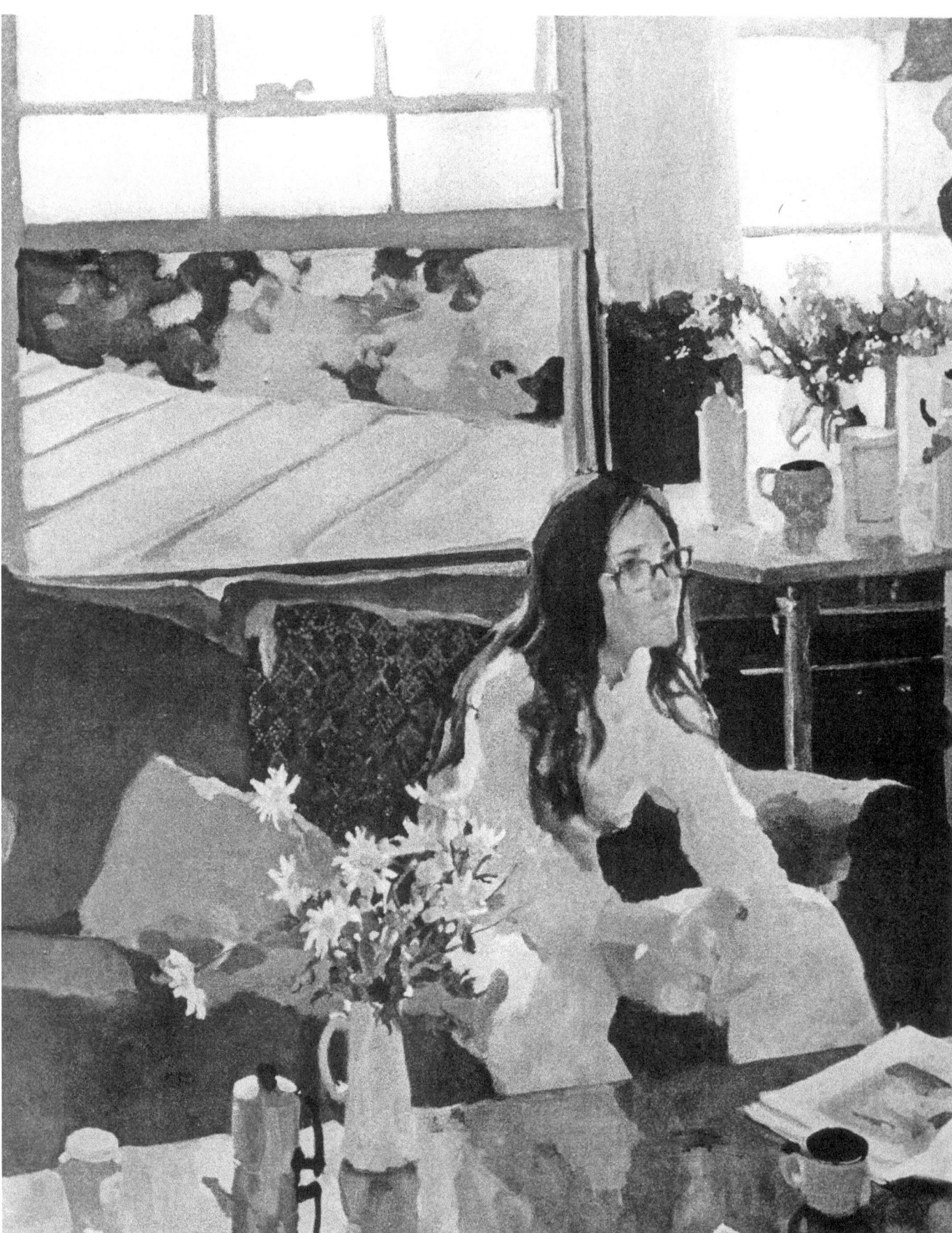

PROJECT 11
FORMS AND CONTRAST

The easiest way to paint almost anything is to put something dark against something light, or something light against something dark. The stronger the contrast, the easier it is to show form. Also, simple light and dark shapes always have the most drama and impact. This doesn't mean that highly contrasted pictures are better than subtle, close-value pictures. Sometimes the subtle ones are best. The point is that subtle paintings are more difficult to do well. The four rough sketches in Figure 17 illustrate the problems of painting flowers against backgrounds both in a high-contrast composition and a subtle, close-value composition.

Close-Value Painting. In Figure 17A I placed a small bunch of very light flowers against a light wall. Because the illustration is in black and white, it's hard to see where the flowers end and the wall begins. But in the actual painting, or course, the color contrasts help define the forms. Just the same, it's harder to get any real definition of form when your flowers and walls are close in value. The only thing to do is to look for and take advantage of any definite darks in the arrangement. In this case, the leaves are quite dark compared with the walls and flowers.

In Figure 17B I repeated my first sketch without stressing the darks and you can see what a "washed-out" and weak picture I have. You don't need to go as dark as I did in the first sketch, but you must have some relatively dark values if you're going to paint light flowers on a light background. This is not to say that this high-keyed approach can't work. It can work beautifully, but I feel you must be a fairly experienced painter to carry if off well.

High-Contrast Painting. In Figure 17C I went to the opposite extreme—light flowers against a very dark background. Indeed, the sketch looks "heavy" and rather unappealing. Yet you can't argue with the clarity that results from highly contrasted paintings.

In Figure 17D I found the most satisfying solution. The background is of medium value: I've avoided the heaviness of a very dark background, and the definition problems of a very light background. If you're just starting out, I'd suggest you use a middle-value background. Naturally, you won't always stick to this value range—you'll want to try both very light and very dark backgrounds. But a medium-value background makes a good starting point.

Afternoon. *40" x 50". Collection Mr. and Mrs. J.D. Miller. You can create emphasis by placing your darkest dark and lightest light where you want a center of interest. Here, I tried to make Christy's head the area of greatest contrast. Note how her head is anchored first by the cross of the window frame and then by the legs of the table. I deliberately placed the darkest dark in her hair as well as in the wall above and to her right. There's a strong value contrast in the foreground coffee pot, but this area is so small it can't really compete with the larger areas of value contrast around Christy.*

A. CLOSE-VALUE PAINTING NEEDS CONTRAST...

B. ...OR PICTURE LOOKS WASHED-OUT

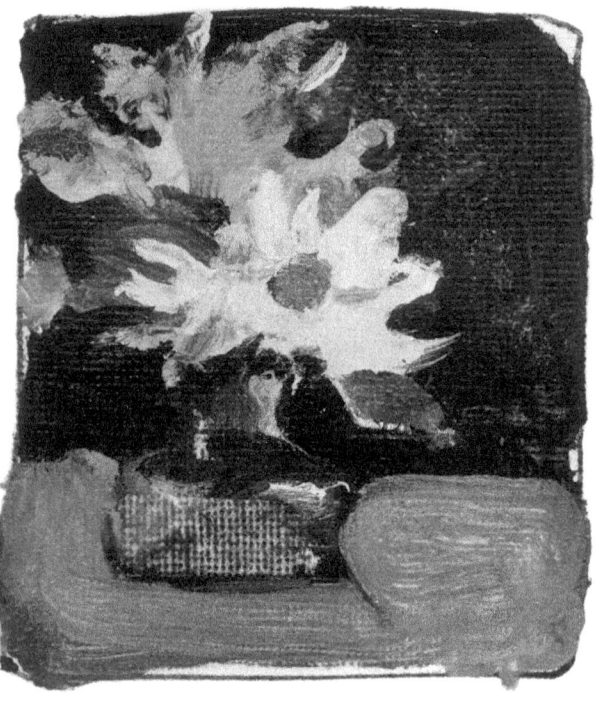

C. HIGH CONTRAST, BUT WRONG MOOD

D. COMPROMISE: A MIDDLE-VALUE BACKGROUND

Figure 17. *Selecting the right background for your flower paintings can be an important step.*

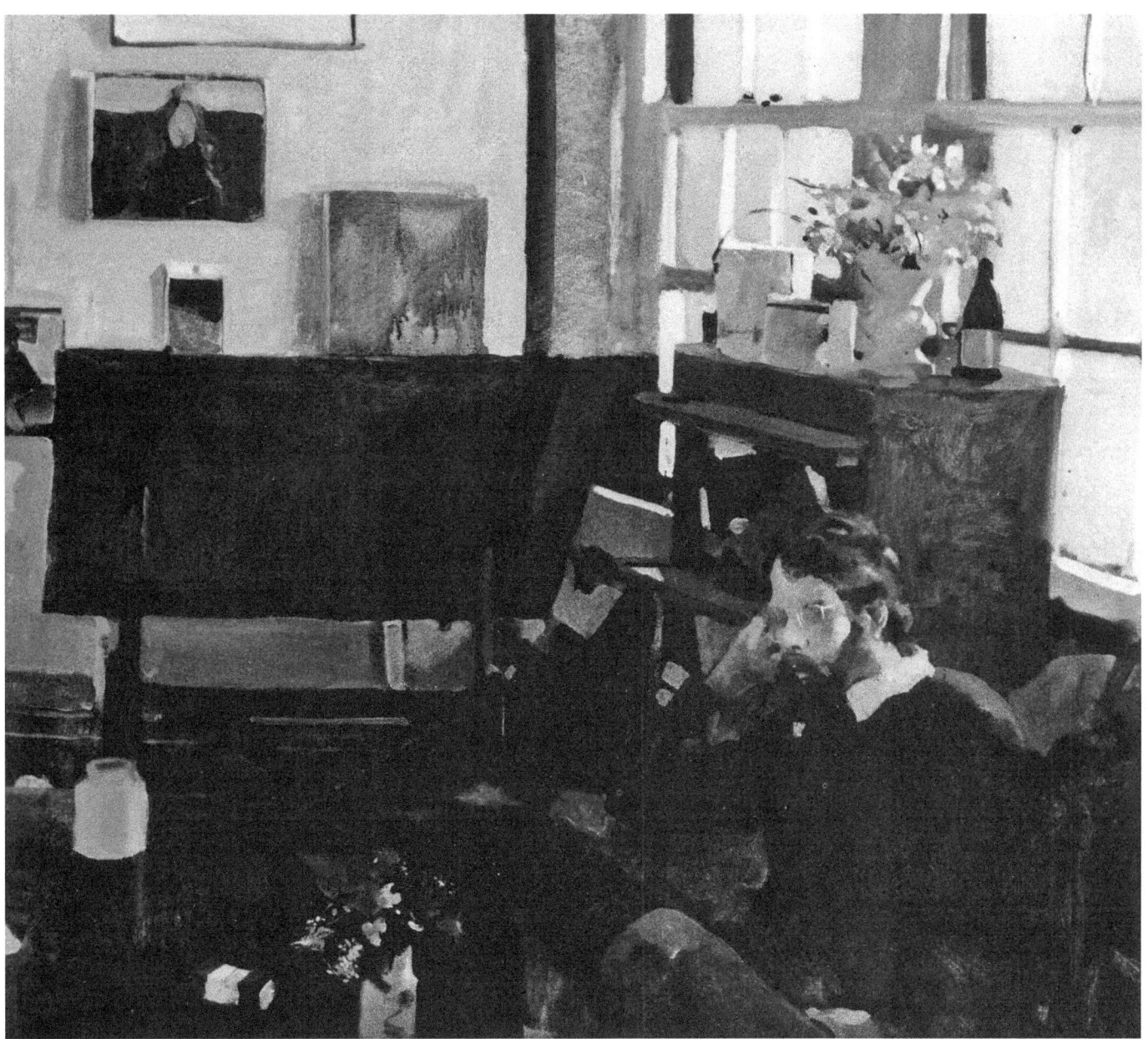

Allen. *30" x 40".* *This is another painting of a person where flowers play a large part in the composition. Notice that both bouquets are in line, with Allen in the middle and that I used the flowers to draw a diagonal across the painting. Ordinarily you are not supposed to do this, since it makes for a static composition. However, the big mass of dark below and the light above really dominate, so lining up objects within this simple pattern doesn't do much damage.*

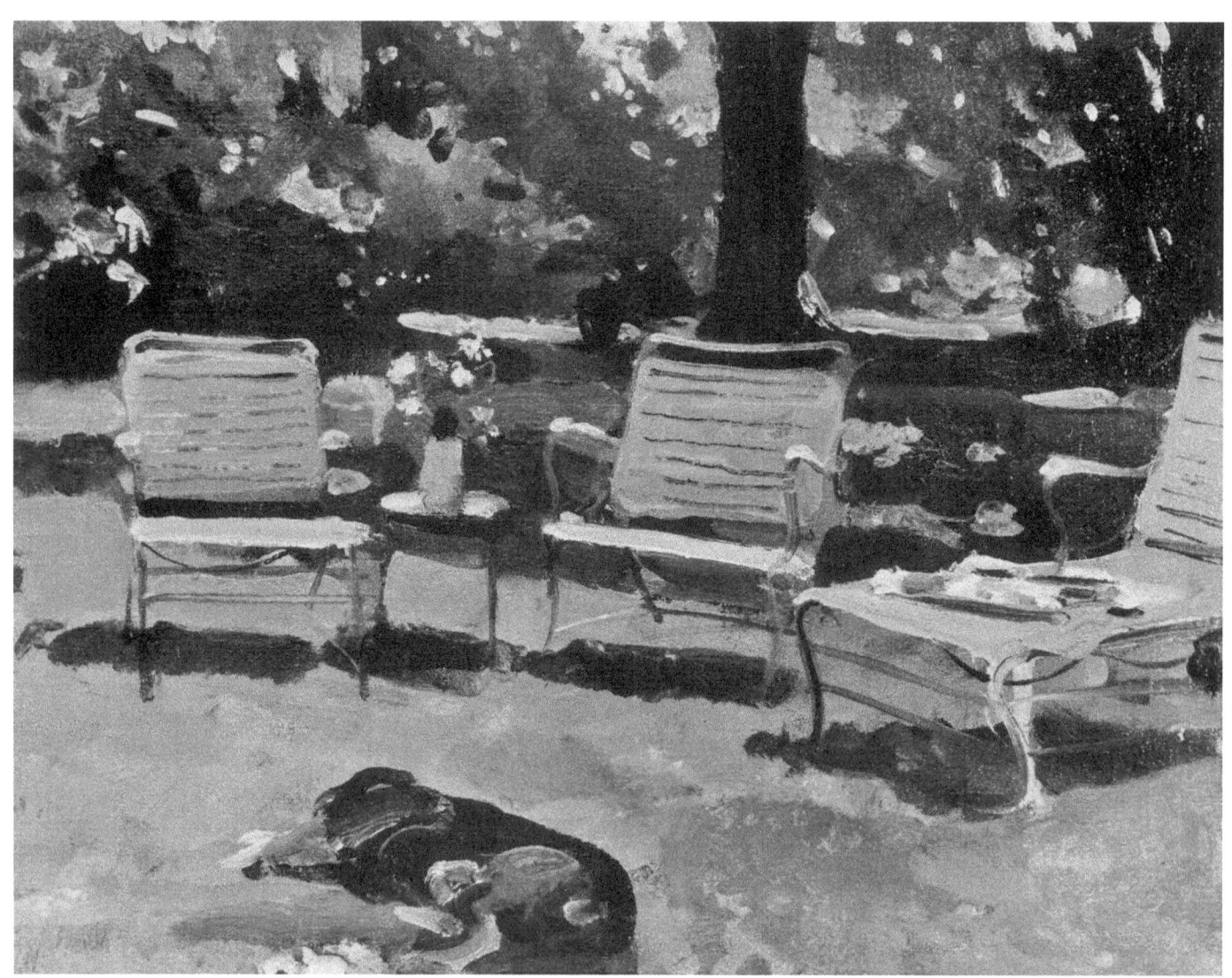

Sam. *12" x 14". This was painted over a failure; some of the colors from the original painting still show through. You often get color ideas from sections of old paintings that haven't been covered yet. Don't try to put acrylic gesso or any other acrylic paint over an oil painting, expecting to have a fresh surface to work on. Plastic paint can't be put over an oil-based paint—the gesso will peel off. If you don't like to work over another painting, get a new canvas or panel.*

PROJECT 12
COLOR MIXING

I've broken this project into two sections. In the first, I deal with lightening and darkening colors. In the second, I suggest methods of mixing greens and grays that you may like to try.

Darkening Colors. One of the most basic problems of color mixing is how to bring the various colors of oil paints, as they come from the tube, down to a darker value. The most obvious course is to add black. Unfortunately, this solution isn't always satisfactory. Black added to a color does darken it, but at the same time it often changes its hue. For example, black added to yellow makes a green—a nice green, but still green, not yellow. Black added to red makes a hue very similar to burnt sienna. (This is not necessarily a disadvantage; you may *want* to mix these hues.) The addition of black to a color will also change its intensity—that is, it will deaden or dull a bright color, in addition to darkening it. Here are various ways to darken your colors, including the many—and more interesting—alternatives to black.

Red. Starting with the lightest red, cadmium red light (some companies just call it cadmium red), adding black doesn't create any real change. Red is so strong that it keeps its intensity. But it does go warmer, resembling burnt sienna. Try adding alizarin crimson to darken the cadmium red. Notice that while this red darkens the cadmium red, it also makes it cooler. For a truly dark red, almost a black, add ultramarine blue or phthalo (short for phthalocyanine) blue to alizarin crimson.

Yellow. Adding black to yellow changes its hue radically. Yellow isn't as strong as red, so it can't dominate the black as the red does. Cadmium yellow pale and black make a lovely olive green that is great for painting foliage. (Also try cadmium yellow light and cadmium yellow medium with black.)

Another way to darken cadmium yellow pale is with yellow ochre. Again the hue changes, but the result is more of a yellow than when you use black. It's better to use yellow ochre to darken cadmium yellow pale, because if you use cadmium yellow medium (which is warmer), the hue will move toward orange. If you want a middle-value yellow, add yellow ochre to either cadmium yellow light or cadmium yellow medium to darken them just slightly. But once you want to go really darker, start with cadmium medium as a base rather than the cadmium yellow pale or light; it's the darkest cadmium yellow and will therefore keep it's intensity longer when other colors are added to it.

To mix a dark yellow, add raw sienna to cadmium yellow medium. For a still darker yellow, add raw umber to that combination. However, raw umber mixed only with cadmium yellow pale or only with cadmium yellow medium turns the yellow into olive green—you darken the yellow, but you also change the hue.

Orange. Adding black to cadmium orange results in a rather dull, dark orange. I don't use this combination because I don't like it, and I've seen some student paintings ruined by it. I normally darken my orange with raw sienna, tempered with cadmium red light. You get more of a burnt sienna look in the middle range; not really very "orangey," but mellow and rather nice. Then, at the dark stage, I'd use hardly any orange—mostly burnt sienna and burnt umber.

Green. Permanent green light is the lightest green on my palette. Black works well with it as a darkener—their mixture makes a nice, warm, dark green. Another way to darken permanent green light is to add viridian (a cooler dark green) or sap green (a warmer dark green). The result of combining viridian and permanent green light is a cooler color than the black and permanent green light mixture. A touch of cadmium red light or alizarin crimson will gray the combination. For a warmer dark green, you could try sap green in place of the viridian.

Blue. The lightest blue on my palette is cerulean blue, but there are other light blues, like manganese blue. I happen to be hooked on cerulean. When you add black, you get a very pleasant bluish gray. Try darkening cerulean blue with a succession of darker blues.

The middle-value blue that I use is cobalt blue. It's a bit warmer than cerulean. To get darker blue mixtures, I substitute cobalt blue for cerulean. To the cobalt, I add either ultramarine blue (a warm blue, going toward the purple), and/or phthalo blue (stronger, cooler, and darker than ultramarine). I painted for years without phthalo blue. I use it now, but I find it still dangerous; because of its strong tinting power, it can easily dominate a mixture. I suggest sticking with ultramarine blue as a darkener until you become fairly experienced. A touch of alizarin crimson will bring ultramarine down to a value equivalent to black.

Lightening Colors. There are fewer ways to lighten colors than to darken them. Once you get the lightest version of a certain color, it's hard to go farther without changing its hue or lessening its intensity, resulting in chalky colors. Take, for example, cadmium red light. The only way to lighten it is by adding orange (which changes the hue) or white (which gives you a chalky, weak pink). Here are some ways—in addition to adding white—to lighten your colors.

Red. When you add white to cadmium red light, you get pink. There might be times when you want such a pink, but alizarin crimson and white make a better one. Cadmium orange does lighten the red, but it makes it quite a bit warmer, too. Cut a hole in a small piece of paper to isolate all surrounding areas. Hold something red out in the light. Look through the hole, and you'll notice that the isolated red is about the value of cadmium red light as it comes from the tube. A piece of bright red cloth or a bright red flower doesn't become pink when exposed to light. It stays red. Your only choice is to surround the red with darks. If the light side of your red object doesn't look light, it's probably because you don't have enough darks around it or haven't made the shadows on your red object dark enough in contrast.

Yellow. Cadmium yellow medium is the darkest yellow on my palette. I can make it lighter by adding cadmium yellow pale, my lightest yellow. The cadmium yellow pale cools the cadmium yellow medium in addition to lightening it; that is, the hue starts to lean toward green. You can also add white to cadmium yellow medium and cadmium yellow light. This combination can be very useful in making warm white and off-white. As in the case of red, adding white to yellow doesn't actually make it lighter; it makes a yellowish, warm white.

Orange. Adding white to cadmium orange produces a situation similar to that of red and yellow. The white cools and makes the orange look chalky. Try lightening cadmium orange with the warmest yellow, cadmium yellow medium. This color will lighten the orange, but it will also make a yellow-orange rather than a pure orange. To go even lighter, your only choice is to use cadmium yellow pale, which takes the yellow-orange into a warm yellow.

Green. As I've said, permanent green light is my lightest green. Cadmium yellow-green would be lighter, but since cadmium yellow pale and permanent green make a mixture very close to cadmium yellow green, I feel that cadmium yellow-green isn't really necessary to have. Using white as a lightener, the permanent green light goes cooler. This lighter, cooler green is chalky, but can be useful in painting foliage—for example, ferns out in the light. It's important to remember that greens mixed only with yellow and blue, or with yellow and one of the "tube" greens, aren't sufficient. Painting with greens requires variety. You must be able to go from cool, chalky greens to warm, olive-brownish greens.

Also try mixing your lightest yellow, cadmium yellow pale, with permanent green light. This makes a very nice light green that's very useful. But never make your greens from only one mixture or your painting will be boring. (I discuss other ways to mix greens at the end of this project.)

Blue. Cerulean blue is the lightest blue I use. The only way to make cerulean blue lighter is by adding white. There's no color change. The white naturally makes the blue less intense. If you have a darker blue like phthalo blue or ultramarine, you can use either cobalt or cerulean blue to make them lighter. You can also add white to any of them. Lighten all your blues with white; then try lightening your dark blues first with cobalt, then cerulean. Experiment.

Mixing Greens. *Here are some of the combinations I use to create greens.*

A. Cadmium yellow pale and viridian, plus permanent green light

B. Cadmium yellow pale, plus cerulean and phthalo blues

C. All the colors in Swatches A and B plus white

D. Many colors plus white

E. Cadmium yellow pale, light, and medium, with black plus white and permanent green light

F. Sap green with any cadmium yellow (grayed with cadmium red light)

G. Ultramarine, burnt umber, burnt and raw sienna with cadmium yellow medium and pale

H. Cadmium yellow pale with cerulean and white

COLOR MIXING 113

Mixing Grays. *These swatches show some of the many color combinations that can make gray.*

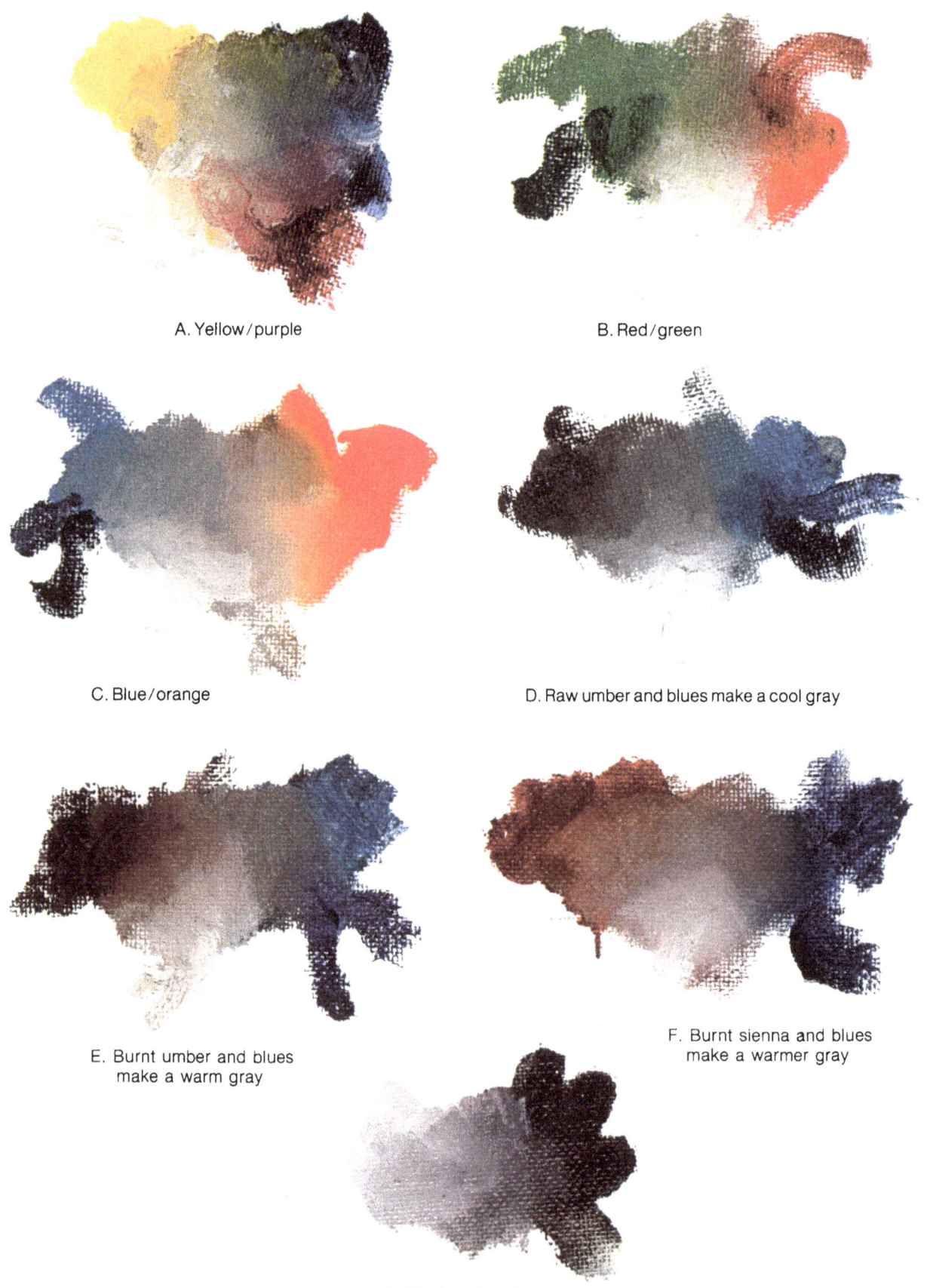

A. Yellow/purple

B. Red/green

C. Blue/orange

D. Raw umber and blues make a cool gray

E. Burnt umber and blues make a warm gray

F. Burnt sienna and blues make a warmer gray

G. Black and white

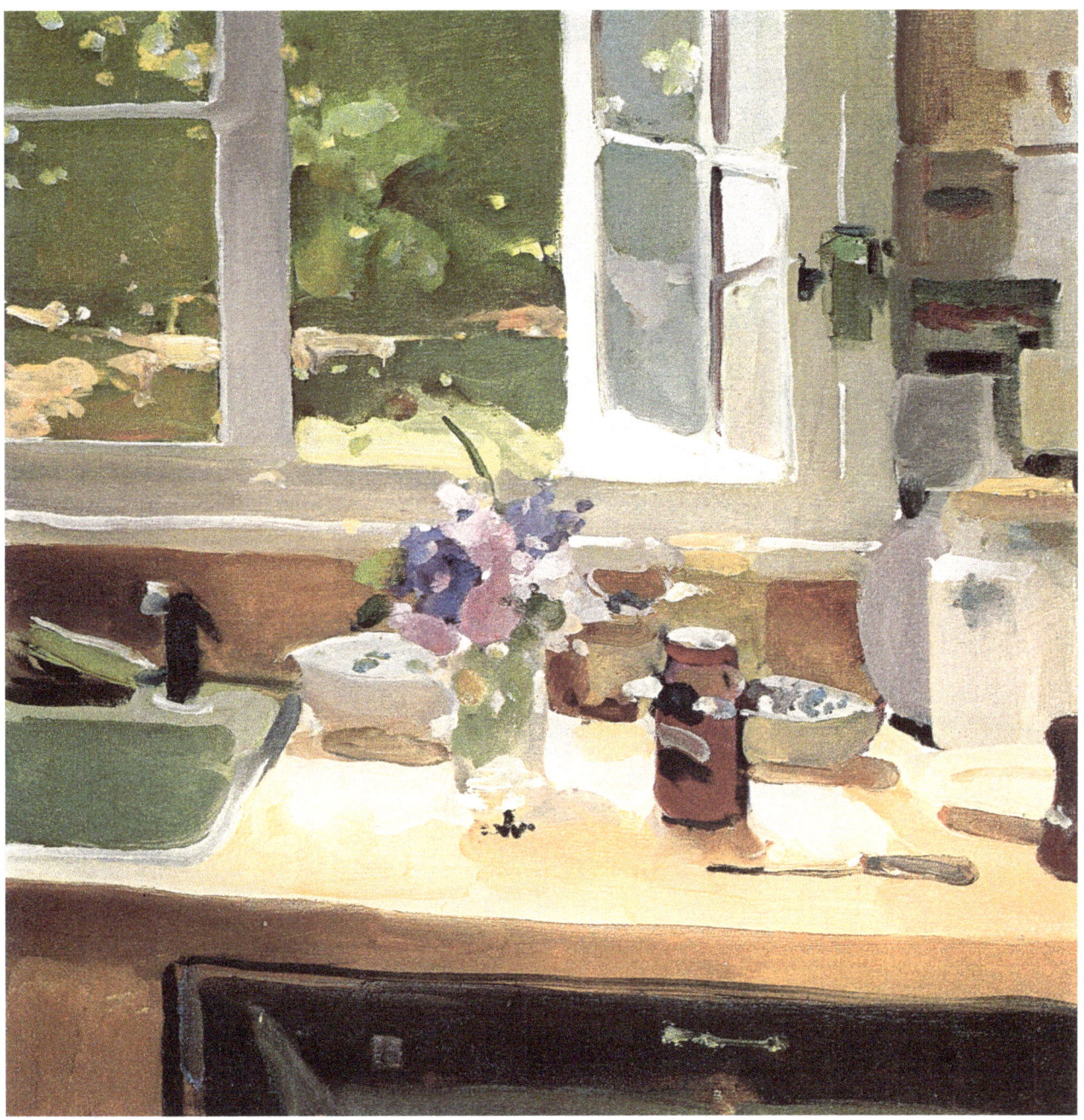

Kitchen Window. *Oil on canvas, 16" x 16". I painted this in my kitchen, in one sitting. The sunlight was beautiful that morning, and I wanted to catch the vibrancy of its light shining through the window. The trickiest part of painting both inside and outside at the same time is to balance value relationships carefully. If I made the trees and shadows as dark as they actually were, they wouldn't stay back. So instead I intensified the contrast of the values within the room. For example, I darkened the splashboard behind the flowers, lightened the white window frames, and treated the trees outside as just two simple values. For the greens in the background, I used a good deal of black mixed with white and cadmium yellow light. I also used some yellow ochre and cadmium red light along with the black. In the window frames, naturally, I used a great deal of white. I mixed grays with cerulean blue and cadmium orange, and also with alizarin crimson, cerulean blue, and cadmium yellow light (or yellow ochre).*

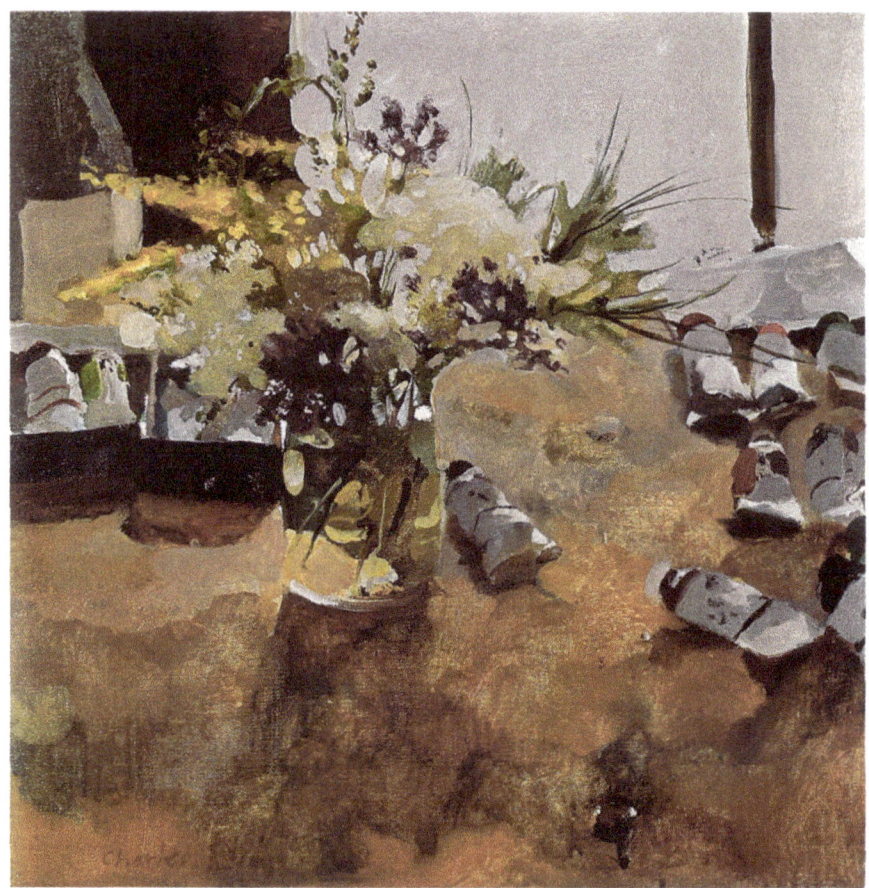

Flowers and Paint Tubes. *Oil on canvas, 16" x 16". For some reason, I very much like painting paint tubes, and have included them in many of my still lifes. For one thing, you tend to paint objects you like better than objects you're indifferent to. For another, I don't do well when I have a formal setup; in my studio it's very normal to find flowers among the brushes, paint tubes, and turpentine cans. The table here is a dull and unexciting brown. I include it in many paintings and must continually figure out ways to make it look less grim than it actually is. I painted thinly here, using burnt sienna, alizarin crimson, raw sienna, some cerulean blue, and white. I carried the colors in the vase right up into the flowers themselves. I used a good deal of muted purple in the flowers: cerulean blue plus alizarin crimson mixed with raw sienna.*

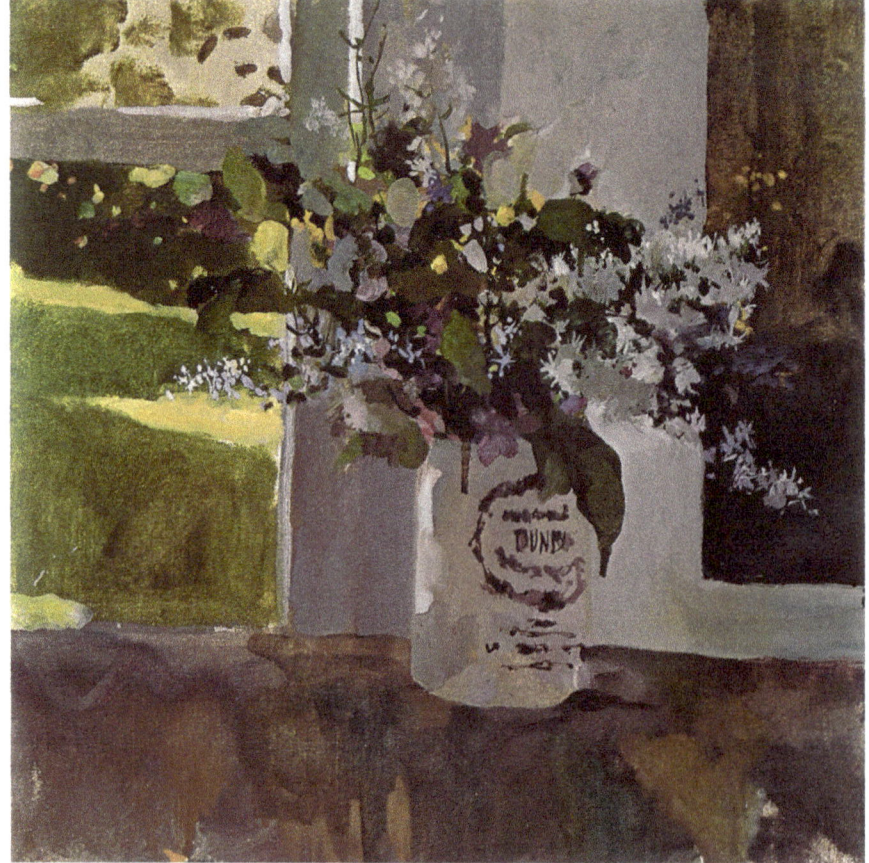

Studio Wildflowers. *Oil on canvas, 16" x 16". By using the same colors and more or less the same values in different areas of a painting—as I did in the greens of the background and the flowers—you can develop a pattern and cause the eye to actually flow through the painting. I also contrasted the small forms of the wildflowers with some rather large generalized areas. If there's an equal amount of detail throughout the painting, the result will probably look fussy and overly busy. So, as a general rule, place the greatest amount of detail at your focal point; that is, in the area where you want the most attention. In painting the table, I tried to come up with colors that gave the impression of a brown table but that had more excitement than just simply burnt umber or raw umber. Here I used cadmium red light, alizarin crimson, raw sienna, cobalt blue, cerulean blue, raw umber, and even a little cadmium orange.*

116 FLOWER PAINTING IN OIL

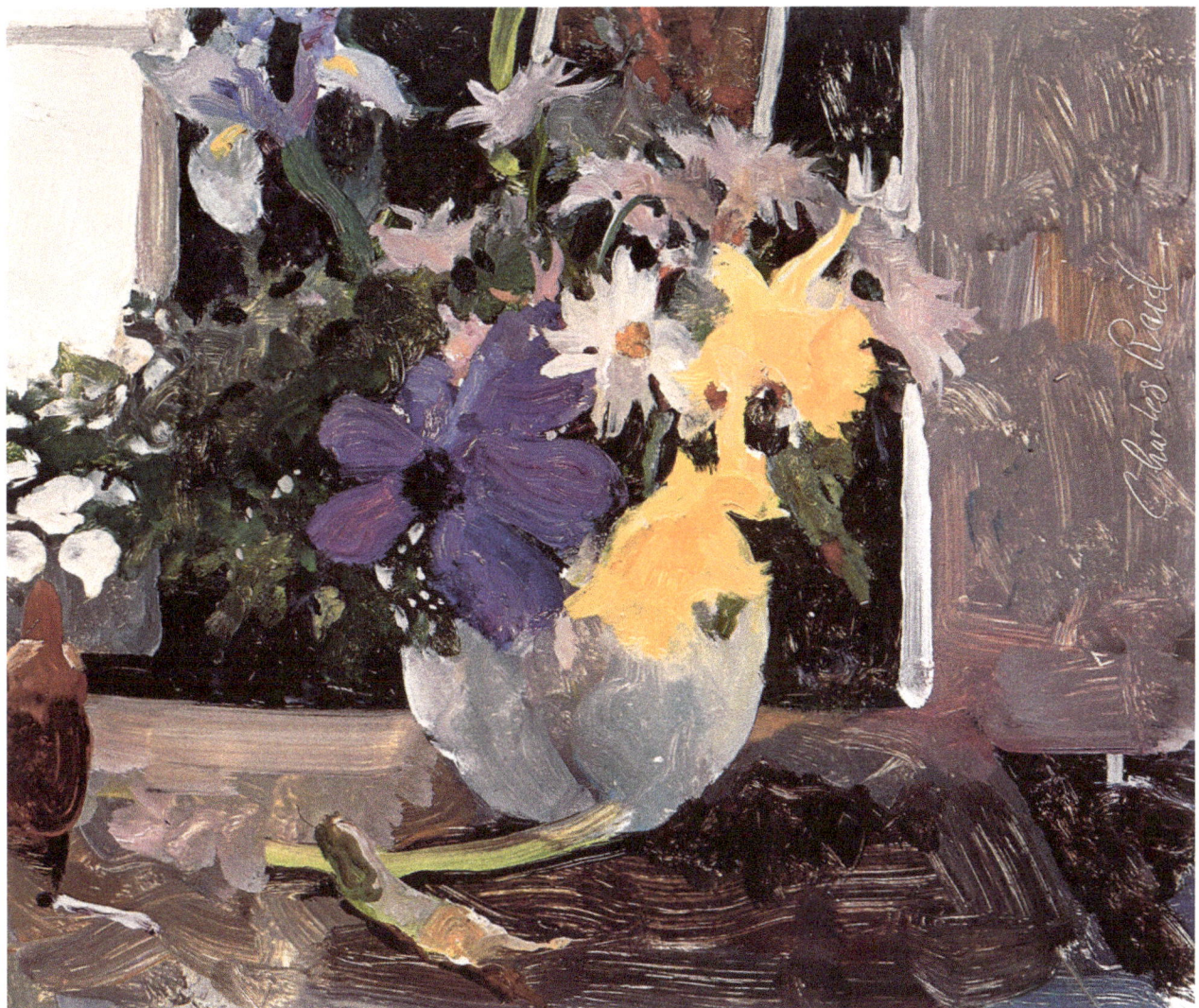

Flowers. *Oil on Masonite, 11' x 14". I started a larger oil painting of these flowers on canvas. But after working all day, I could see that the picture was labored and tired-looking. So I decided to start again. The second time, the painting was done quite quickly, in 3 or 4 hours, on the only support handy—a piece of Masonite. I find Masonite rather slippery, but still certainly preferable to canvas panels. (Canvas panels tend to be too absorbent. But you can always remedy that with a coat of gesso.) Notice the tie-ins of values in the various areas of this picture. The dark leaves in the bouquet relate very closely to the darks in the background. The flowers on the right-hand side all flow through one another and into the vase. Some value contrast between areas is of course very important, but along with value contrast you must have these areas of similar value and color, so that the eye will flow through the painting smoothly.*

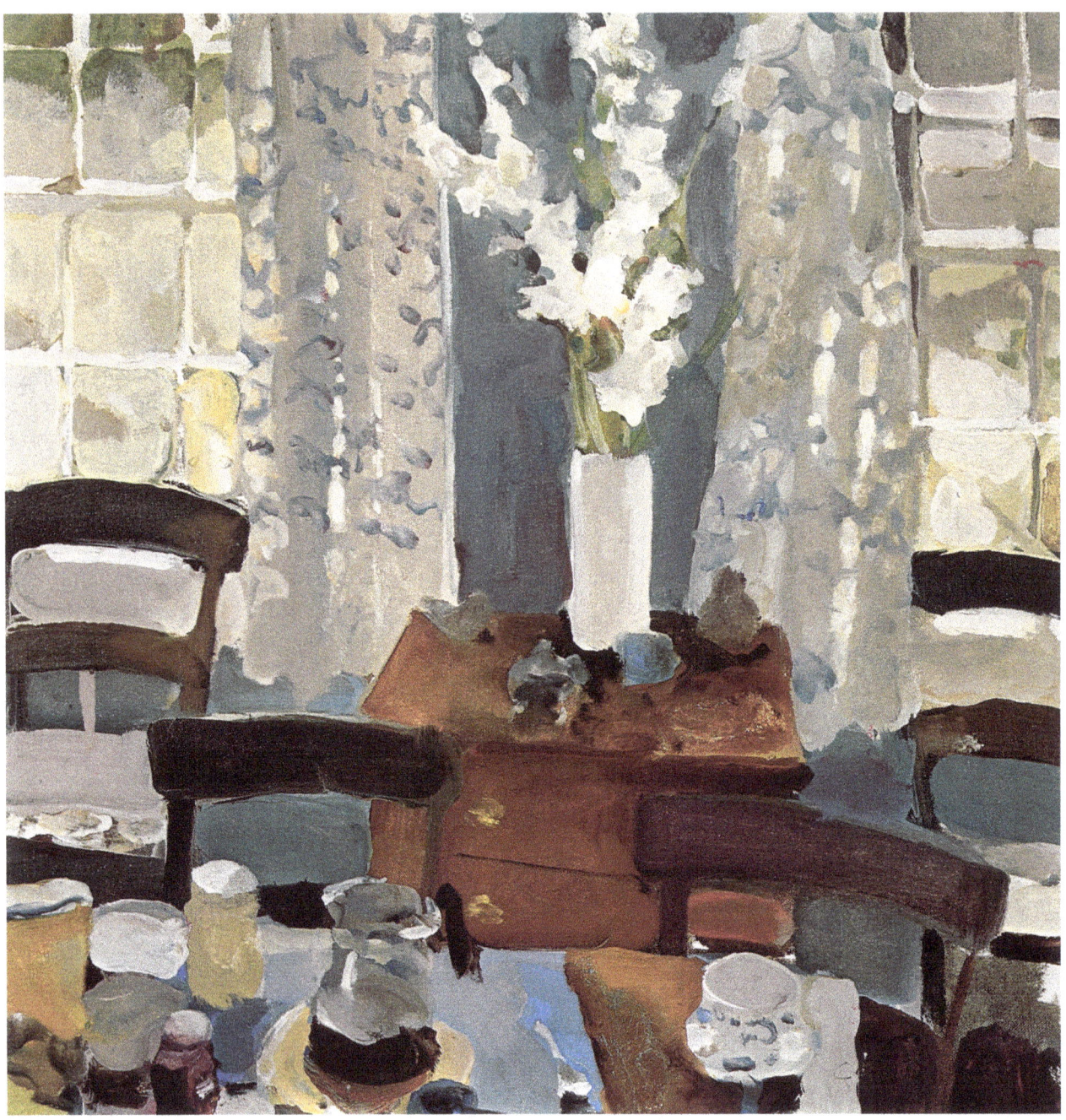

Breakfast Flowers. Oil on canvas, 18" x 18". I set up my canvas right after breakfast, leaving all the things on the table just as they were. This is actually a fairly dark room, so to get the feeling of luminosity and light that I wanted, I raised almost all the values. Notice the variety of blues that I used in the various areas: some are almost gray, while others are quite intense. I wanted the colors within the room to be stronger than those outdoors, so I also grayed the greens outside the windows a lot. Notice that the chairs are painted in a variety of colors and values. Never paint them a single color or value, even though at first glance they appear to be so. The flowers are a fairly insignificant part of this painting; but even so, they can add a great deal to any painting.

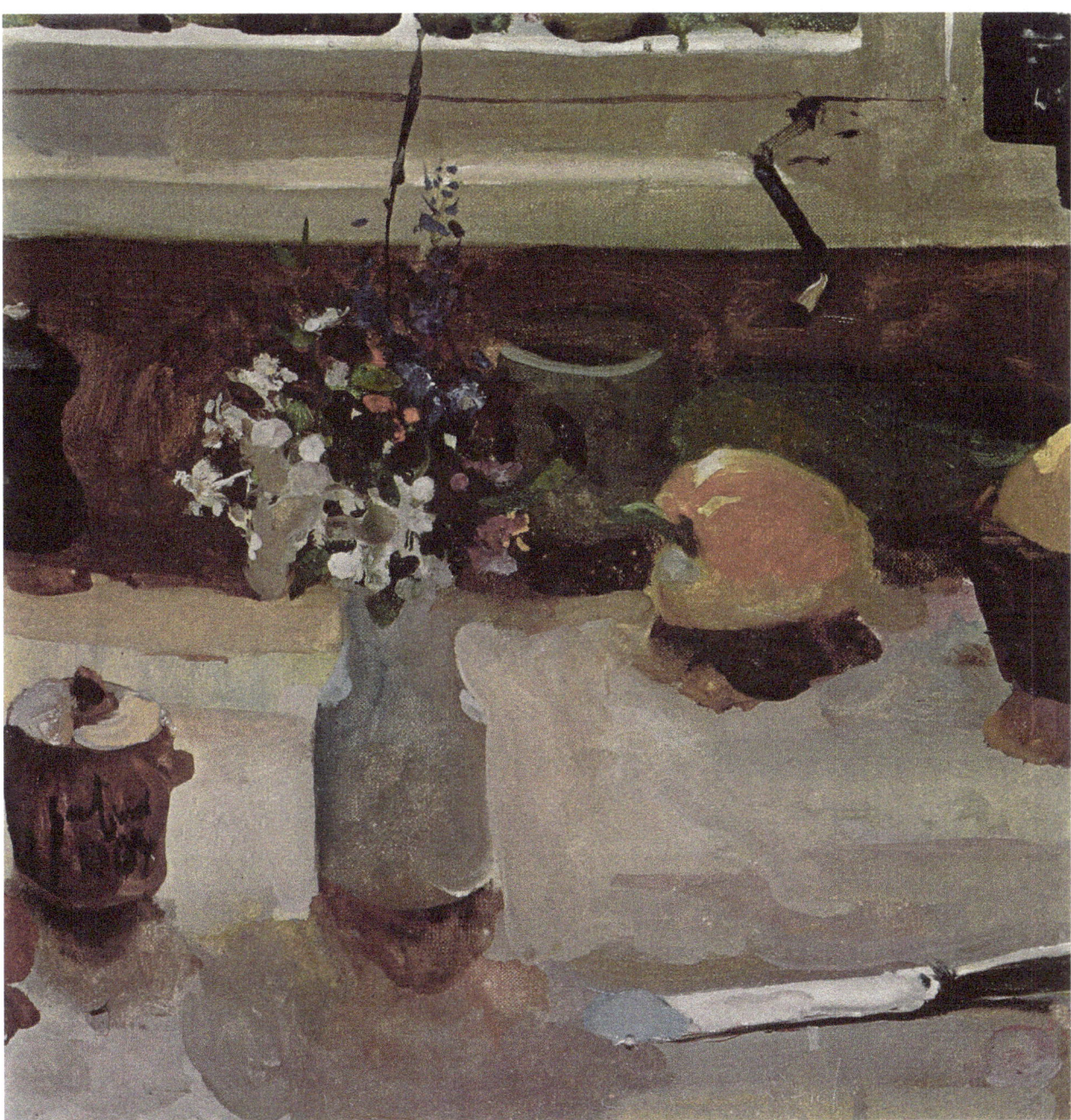

Spring Flowers. Oil on canvas, 16" x 16". Notice the edges in the painting: the various vegetables in shadow have soft edges compared with many of the edges out in the light. I want the vegetables to be apparent, but not detract from the subject of the painting, which is the small flower arrangement. The structure of this painting depends on the fairly dark strip that runs through the center. Notice how the values in this dark brown splashboard tie in with the values in the flowers. This is an example of comparing the difference between two areas by keeping color and value changes to a minimum. The use of almost pure color in shadow—here, alizarin crimson and cobalt blue—can be very exciting. Remember to keep your shadows fairly thin compared with your lights.

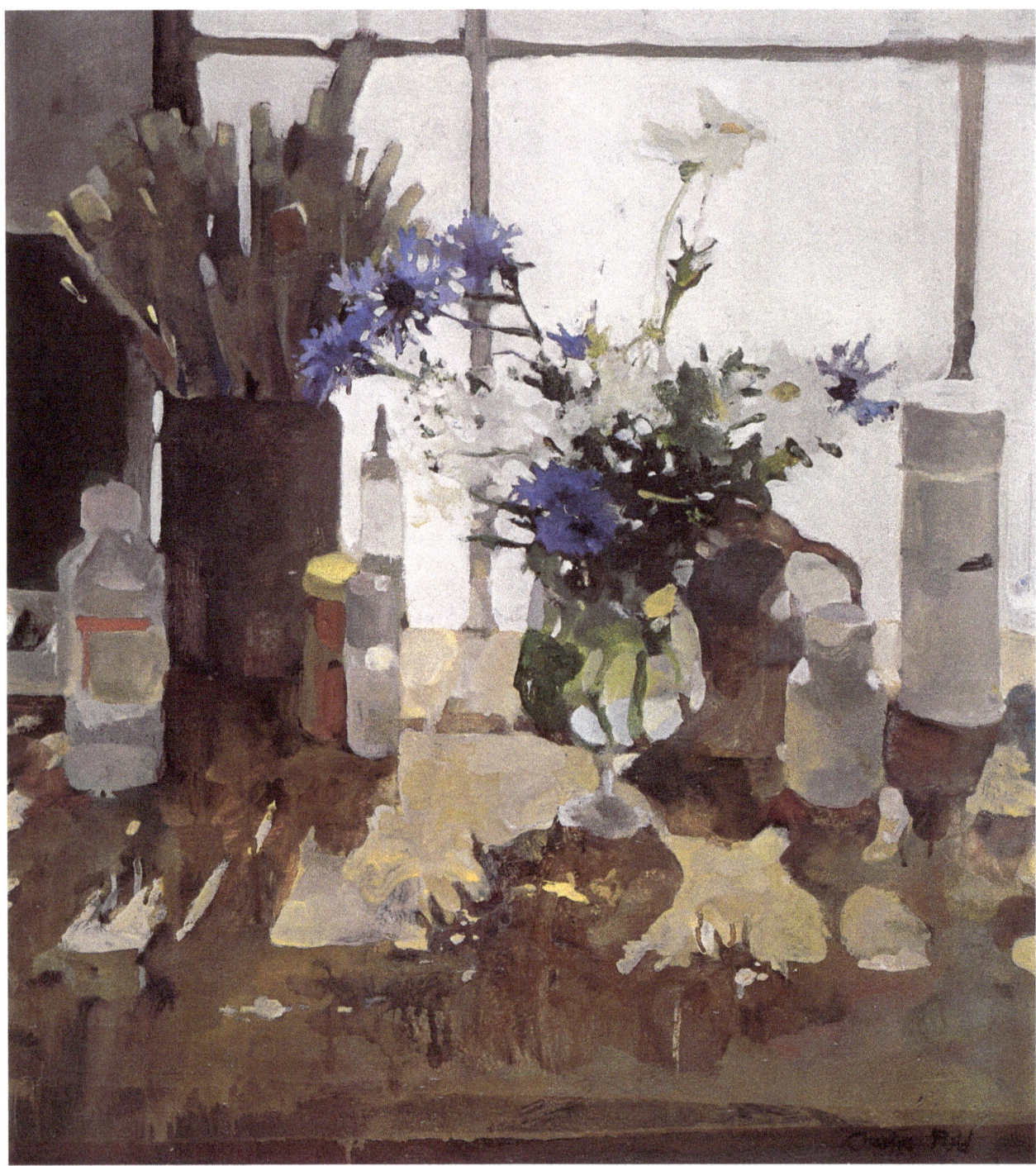

Flowers and Brushes. Oil on canvas, 20" x 22". This painting took a great deal longer than the others—about 15 or 20 hours over a period of a week. I like to work quickly on some paintings, but other subjects seem to demand more involvement. Because these subjects were in direct sunlight, their cast shadows were constantly changing. Where you decide to finally place the cast shadows really depends on your composition. One solution, of course, is to work just on the table area at a certain time of the day, and then, as the light changes, go on to another section (for example, the flowers themselves) that isn't so critically affected by the sun. In order to work on an area as involved as this mass of brushes, I squinted and tried to develop a sense of the overall mass; then I went back to certain sections and picked out a few details. Notice how the grayed mass of brushes stays in the background, while the intense blue flowers appear to advance toward the viewer, even though their values and color (blue) are the same. The most intense colors appear in or near the floral area, the center of attention.

Pointers on Mixing Color. You must learn the way each color behaves when you combine it with other colors. Obviously, some colors have much more tinting power than others. The strongest colors are the phthalo blues and greens, and alizarin crimson. Next come cadmium yellow, cadmium red light, and cadmium orange. On the weaker side are cerulean blue, permanent green, and the earth colors. You'll have to practice to determine the strength of the individual colors. Generally, you have to be very careful when mixing your light and middle values, but using strong color when you want darker values is usually desirable. In other words, you could use all the phthalo blue and alizarin crimson you want to make a rich, dark purple, without worrying about either color dominating the mixture.

If you're a beginner with oils and you want to mix a light value, I'd suggest you start by putting a glob of white on your palette. (Remember, do your color mixing out on the palette, not in your main color supply.) Then, with a fresh brush, add small portions of color to the white to see what happens. If you want to mix a purple, or a gray, or any other combination of color, be sure to clean off your brush each time before going to a new color on your palette.

Let's assume you're not using white to lighten a color but instead you're using a cadmium yellow light to make a light green. You plan to mix your cadmium yellow with some permanent green or cerulean blue. In the same way that you started with white, gradually adding color until you got the tint you wanted, when you use color to lighten color you must start with the weakest and add the stronger color to it. Because you realize that the yellow is the strongest of the colors that you're using here, you'll start off with your cerulean blue, or your permanent green, then slowly add your yellow.

Don't put out huge quantities of paint on your mixing surface. Even if you have one large light area to paint, don't try to mix enough paint for the whole area. That's why I feel you should do your mixing as you go, with a brush rather than a palette knife. You're not painting a big expanse, like a wall. Even in a large area that seems to be the same color or value, you'll want *minor* color and value changes; not enough to change the overall color or value, but enough to create subtle variations. I believe in the cowardly approach. I really disagree with the school of thought that requires lots of paint, both on the palette and on the painting.

When mixing, take a healthy brushful of paint out from the color supply into the mixing area. Wipe your brush off before you clean it in turpentine, then wipe it again. Then go on to a new color, and so on. In this color-mixing stage, when you're trying to get the right color and value, you'll be mixing fairly small portions of color on your palette. Once you have the general ratios of various color, you can start putting more paint out on your palette and your painting. It's interesting to look at experienced artists' palettes after or during the process of painting. The mixing area is covered with a wide assortment of very small amounts of mixed colors.

Mixing Greens. There are many varieties of green that come right out of the tube: viridian, sap green, permanent green, phthalo green, and several others. I usually have viridian and permanent green light on my palette, but I often use sap green too. I rarely use phthalo green but phthalo yellow-green is a lovely light green, just as it comes from the tube. In the color swatches on page 113, I've mixed some combinations which I often use to create greens (I seldom use a green as it comes directly from the tube). I break my greens down into cool and warm combinations.

Cool Greens. To make a cool green, you'd naturally go to cooler colors on the palette: viridian (a cool, darker green), permanent green light, and cooler blues like phthalo and cerulean blue which you mix with the cool yellows—cadmium yellow pale and lemon yellow. Cadmium yellow light is usually a bit warmer but would also be fine. For that matter, any of the yellows mixed with blues and viridian should make generally cool greens.

Swatch A. The first and simplest combination is cadmium yellow pale mixed with viridian. In the same swatch, I also added permanent green light. Notice that the permanent green adds a slightly warmer tone to the combination.

Swatch B. Here I stayed with cadmium yellow pale, but I used two cool blues: phthalo and cerulean. Phthalo is the coolest, darkest, and strongest blue, so when you use it, keep its strength in mind. Use very little phthalo; a little goes a long way. For a very dark green, you'd naturally try phthalo green. If you add lots of yellow, you can easily make a light green. Cerulean is lighter and not as strong.

Swatch C. In this next combination, I used all the colors I just mentioned: phthalo blue, cerulean blue, permanent green light, and viridian. I mixed these with cadmium yellow pale and added white, which of course lightens the swatch—but it also cools it even more. The chalky, milky green that is created is very useful, but beware of using too much white with yellows. If not properly used, it can result in a very chalky painting. I think you'll have trouble finding much difference between the greens resulting from the yellow and blue mixture and the greens resulting from the yellow and green mixture. Both are cool. But to be precise, I guess you'd say that the yellow-blue mixture is slightly cooler. Please notice that the green mixture in Swatch C isn't very pretty. It seems raw and forbidding. You really need another color, or colors, to mellow the green. Again, a bit of

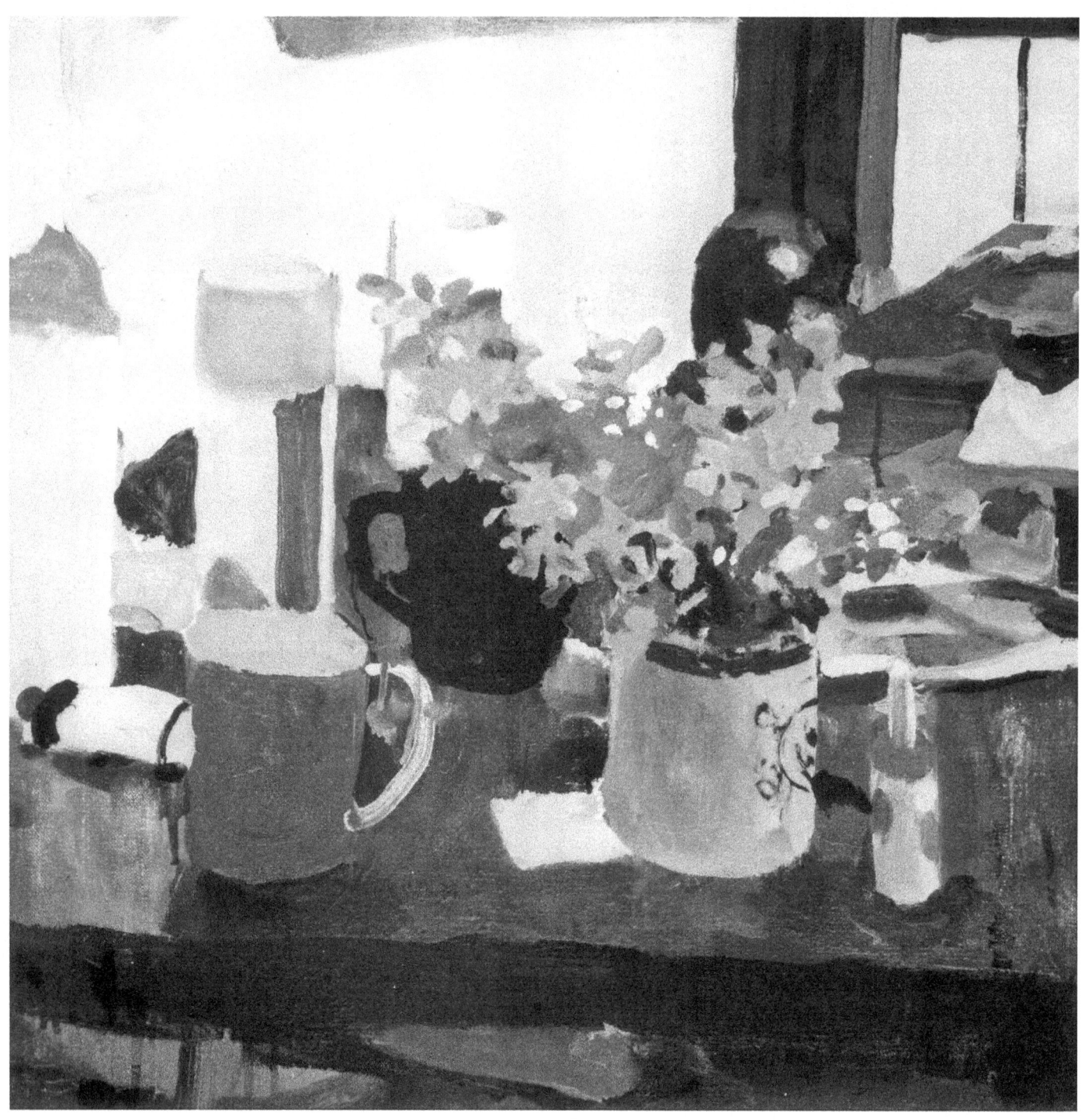

Bob's Table. 20" x 20". These flowers have been placed on a worktable containing various spray cans I use, along with coffee cups, a beer can, a paint tube, and Magic Marker. I really enjoy contrasting these objects with the flowers. I also like trying to make basically unattractive things look interesting.

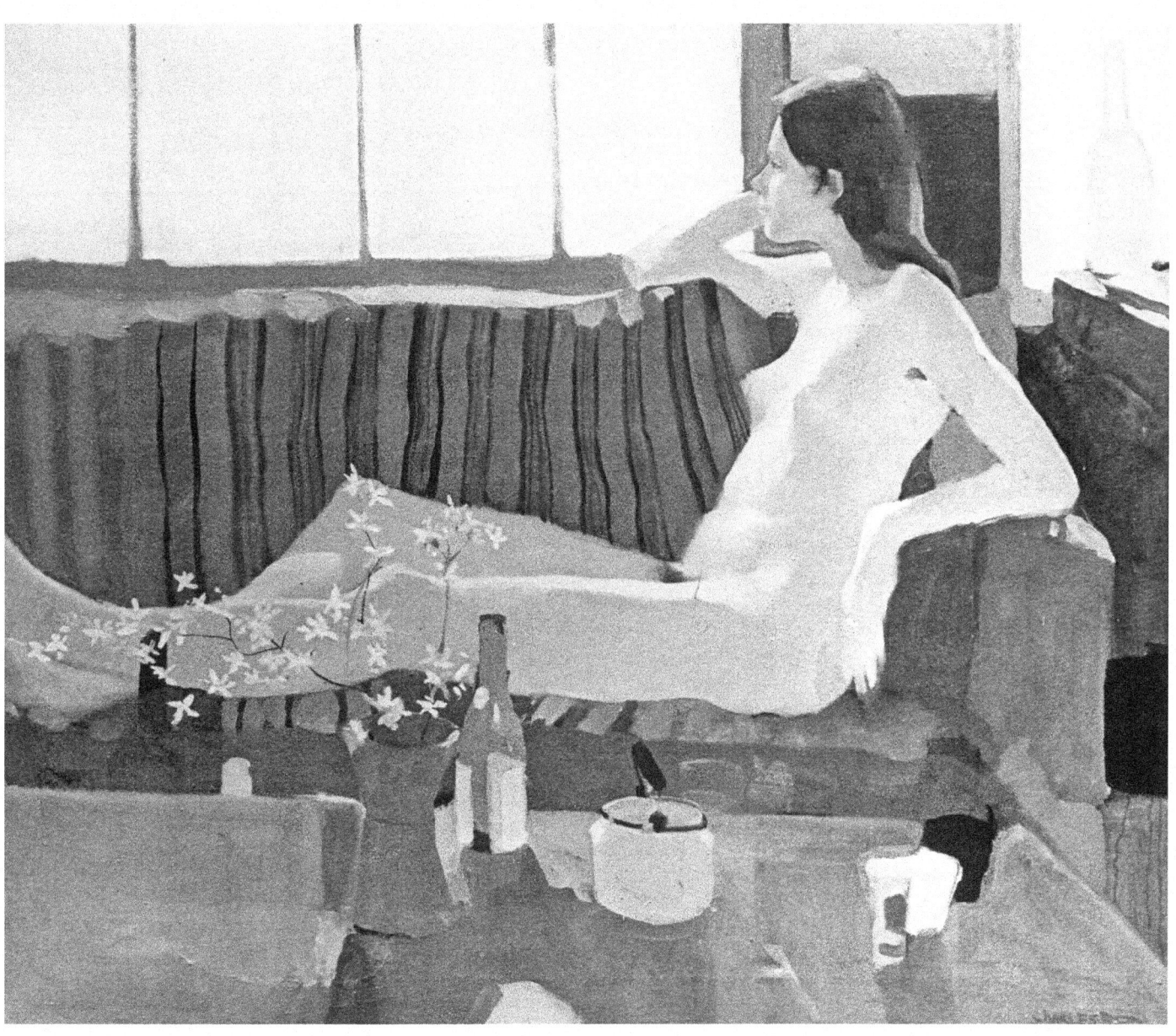

Chris with Forsythia. *30" x 45". More Chris than forsythia here. I wish I'd used more flowers and done a better job on the tabletop; it looks pretty sparse. I painted the figure first, but found that the legs looked clumsy. The painting seemed to need something in this area; so I added the flowers.*

this cold green can be fine, but you just can't settle down and paint a large green area with this combination alone.

Swatch D. Here I shot the works and added many of the colors I might use when painting the greens in a still life or landscape. Essentially, I warmed the rather chilly green combinations I've been talking about. I feel that the overall effect is still cool, but the warmer color I added gives a touch of mellowness that I find essential. Notice that I go from light to dark. Where the cadmium yellow pale and white dominates, there are lighter greens. I used cerulean blue and permanent green light. For warmth, I might add very small amounts of cadmium red light, cadmium orange, yellow ochre, or raw sienna. As I go darker, I still might use cadmium red light, but I also might try some alizarin crimson instead of orange, and some viridian green mixed with ultramarine blue. Finally, a little burnt sienna might be used. Naturally, you wouldn't necessarily use all of these colors, but the point is: greens are not simple to paint. The "tube" greens (viridian and permanent green light) alone and mixed with yellow and blue are seldom satisfactory.

Warm Greens. Now let's work on the warm greens. As you see from my color swatches, I used the same colors to create these greens that I did for the cool greens.

Swatch E. Black is very handy. Here, I mixed it with all my yellows—cadmium yellow pale, cadmium yellow light, and cadmium yellow medium. If you mix it with cadmium yellow pale, the result will be cooler. If you use cadmium yellow medium with black, you'll have a warmer green. If you need to go lighter, notice the nice, milky, subtle green which happens when white is added to these mixtures. Finally, try adding other greens, like permanent green, to your combinations.

Swatch F. Another basically warm green can be made with sap green, mixed with any or all of the three yellows. Naturally, the cadmium yellow pale will make a cooler mixture than a mixture made with cadmium yellow medium. Try adding some cadmium red light, if you wish to go even warmer. The red takes the green into a rather "earthy" brownish green.

Swatch G. Ultramarine blue is the warmest dark blue. Here, I mixed it with cadmium yellow medium and pale. (You should try adding each of the yellows to see what differences they make to the mixture.) I also used burnt sienna and raw sienna. This makes the brownest green. You could try adding viridian or sap green instead of the ultramarine blue.

Swatch H. For a nice, milky, cool light green, try cadmium yellow pale and cerulean blue, with white. This combination is very handy for light bluish greens, such as those you find in plants like ferns when they're out in the light.

As a final word, keep in mind that all these combinations are interchangeable. When actually painting, of course, you'll experiment. Try these combinations, but also paint any combination you can think of until you find your own "set" that suits you.

Mixing Grays. Black and white make the most neutral gray; that is, it has no particular hue. But usually I want more "color" in my gray, either warm or cool, so I go to complementary colors to mix grays. In the color swatches on page 114, I used several obvious complementary colors to make grays. Notice that in any pair of complementaries one is cool (blue, purple, green), while its opposite is warm (orange, yellow, red). Grays don't really show up as gray until you lighten them with white. Only when you add white do you start to see whether it's a warm or a cool gray. Without white, almost all the combinations I discuss would look simply like a dark value, without much color identity. If you mix more of the cool color, say blue, with less of its warm complement, orange, and then add white, you have a cool gray. On the other hand, if you mix less of the blue and more of the orange, then add your white, you get a warm gray. In my swatches, I suggest darker and lighter versions of the complementary colors. For example, I might use cerulean blue in my swatch, but I suggest that you also try a darker blue. Naturally, if you want a very dark gray, you'd use a darker blue like phthalo or ultramarine. I've also included some earth colors that make good grays when mixed with blues.

Complementary Colors. Here are the specific mixtures of complementary colors that make gray:

Yellow/Purple (Swatch A). You can use any yellow here, from cadmium yellow pale to cadmium yellow medium. For yellow's complement, purple, you might mix alizarin crimson with phthalo, ultramarine, or cerulean blue. You can also mix cadmium red light with any of these blues to make purple. As usual, you should try all the possibilities. In my swatch I used cadmium yellow pale with a purple that's mixed from phthalo blue and alizarin crimson, all cool colors. (Cadmium yellow pale is the coolest yellow, leaning toward green, and alizarin crimson is the coolest red, leaning toward purple.)

Red/Green (Swatch B). For a cooler gray, combine viridian with alizarin crimson and add white. For a warmer gray, substitute permanent green light, which is warmer than viridian, and cadmium red light, which is warmer than alizarin.

Blue/Orange (Swatch C). There's no substitute for cadmium orange, but you can try any of the blues, depending on the type of gray you want. In my swatch I mixed cerulean blue with cadmium orange. This gray tends to be a bit cooler than the gray mixed in the previous example.

However, if you use more orange and less blue, you can make quite a warm gray. As you see, the variations between the different complementary color combinations is slight. You can make a nice range of grays with just one combination, but I think it's important to try them all.

Earth Colors and Blue. Now to earth colors and blue. Although I prefer to use the complementary colors, I use these combinations quite often. Experiment with the following mixtures. There will be times when they'll be quite useful.

Cool Grays (Swatch D). I used raw umber and cerulean blue for the cool grays in my swatch. If you want a darker gray, use cobalt or, darkest of all, phthalo blue, with the raw umber.

Warm Grays (Swatches E and F). I used the warmer umber, burnt umber, and added ultramarine blue for the warmer grays in Swatch E. Remember, burnt umber has more of a suggestion of red, while raw umber tends toward the cooler green hues. Again, try your various blues with these earth colors. For an even warmer gray, Swatch F, I used the warmest earth color, burnt sienna, with ultramarine as my blue.

Black and White (Swatch G). Now look at the gray I got when I mixed black and white. This is the most neutral gray, and there will be times when this is just what you want.

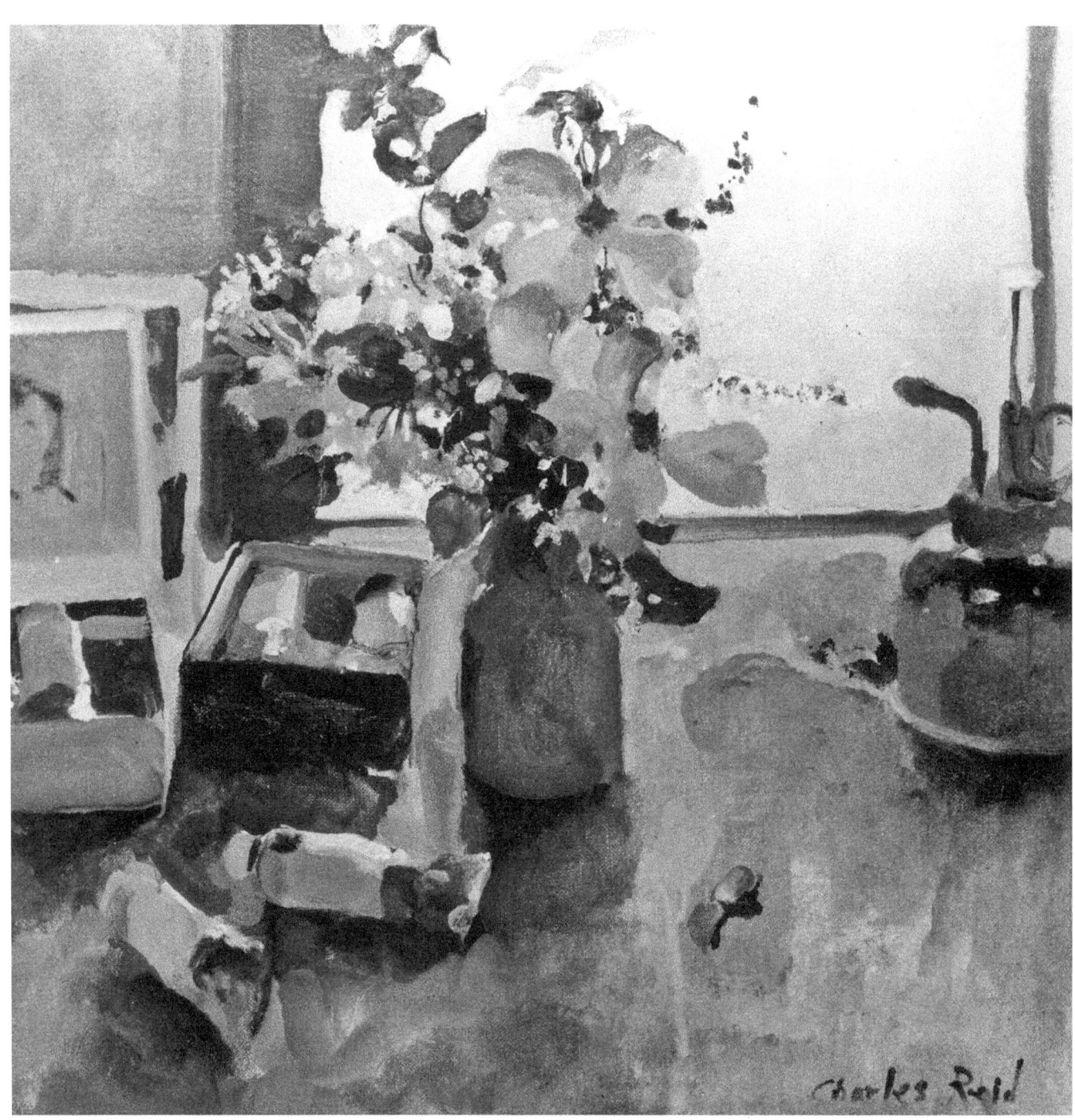

PROJECT 13
COMPOSITION

When you think of composition, you may think of it in terms of placing objects within the picture area. But placement of objects is only part of the story. Value and pattern also play a large role in composition. In this project we'll discuss object placement. In later projects, we'll discuss composition in terms of value and patterns.

When you arrange a bunch of flowers and place them on a table, floor, or whatever, you must first decide what shape and size canvas to use. Making a sketch may help. In fact, I suggest that you do make a sketch first. It's true that many artists just grab any canvas they can lay their hands on and start to paint. However, I think you should be fairly experienced before doing away with a preliminary drawing.

Boundaries. Assuming you're going to make a drawing, first make a square or rectangle corresponding in shape to the canvas you think you want to use (Figure 18). This is very important. Don't start out by just sketching flowers! It won't do any good in terms of composition. You must relate the flowers to the specific size and shape of your canvas.

Horizon. After establishing the shape of your compositional sketch by drawing a boundary, establish the "horizon" or eye level of your picture (Figure 18). If the flowers are on a table, decide where the table ends and the wall behind begins. (If you're looking down on the flowers, you may not even have a horizon line.) At any rate, give it careful thought. Try to vary the position of the horizon line from painting to painting. Place the flowers above eye level sometimes; at other times, place them below eye level.

Placement. In Figure 19, I've drawn three possible compositions for the same subject. Naturally, there are other possibilities. You might want to choose a placement somewhere in between sketches B and C; that's fine, too. The important thing is to decide on just how much picture area you wish your flowers to take.

Background. Your next question should be what to do with your background. Never underestimate the difficulty of backgrounds. Often, they're the hardest part of the picture to resolve. The example in Figure 19A is simple. The flowers take up so much room, you don't really need any other objects. I find the composition in Figure 19B the hardest. The main thing is the flowers, but you need something else to make the background interesting. There are many solutions. (Look through the illustrations in this book to see the way I solved the problem.) The important thing is to give it some thought. Don't start right in painting a bouquet without also considering what to do with the background. Think of the background first; or, at least, when painting the flowers.

Background as Subject. In Figure 19C, the same principle as in Sketch B applies, but there you're probably more concerned with the surroundings. The flowers are really only a bit

Dogwood. *14" x 14". If you cover up the flower sprayer, you'll see that almost everything else is massed in the left-hand side of the painting. Don't feel you must always group your objects in a perfectly balanced arrangement; try getting away with what may appear to be poor compositions. The main thing is to think and experiment, shifting objects until you find just the right placement. I often move troublesome objects three or four times during the course of a painting.*

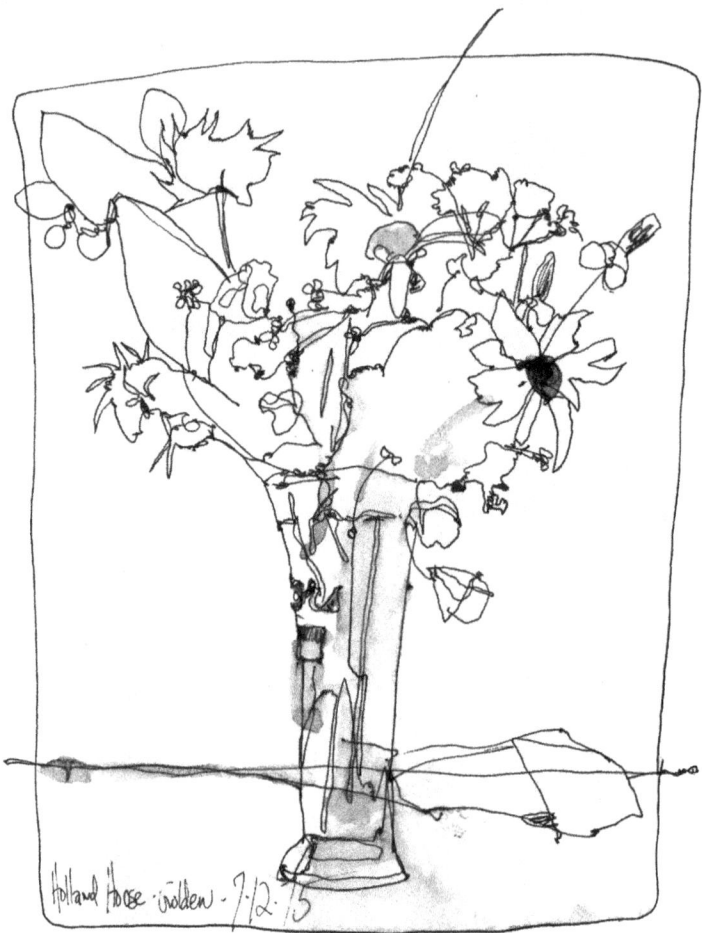

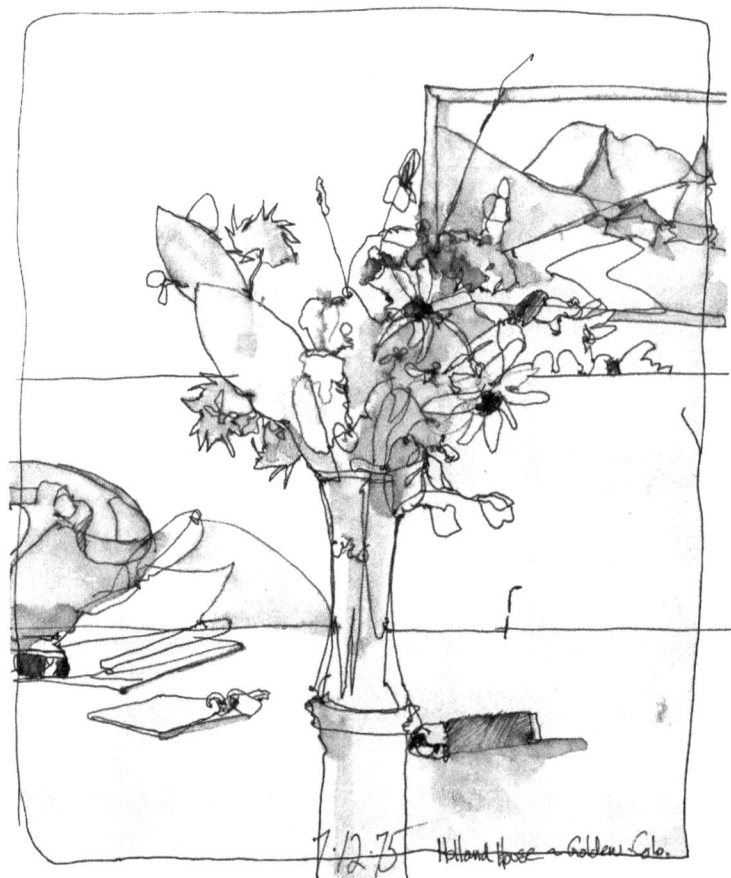

Figure 18. *This rectangle indicates the shape of the canvas I'll use. I established my horizon line near the bottom.*

Figure 19. *Three possible compositions for the same drawing: a closeup, showing the flowers as subject (Sketch A, top left); the flowers as subject, with the background subordinate (Sketch B, bottom left); and the background as subject, with the flowers subordinate (Sketch C, above).*

of flavoring for the composition; the surroundings are what the painting is all about. Naturally, you'll solve the problem of corners just as you would in any other composition. Before beginning to paint, you must decide how to handle corners, sides, top, and bottom of your painting, and plan the cutoff points.

Positioning Flowers. Once you decide just how big your flowers are going to be in relation to the picture area, place them in your composition. Also, decide if you want to include other objects in the picture, and, if so, where they'll be placed in relation to the flowers.

I'll explain how I usually place my flowers. I normally start with the flowers, find a container that seems to fit them, and then decide where I want them to be. I must admit that I'm very partial to windows, and whenever I can get away with it, I put the flowers in front of one. I usually keep the objects already on the table undisturbed. I see if they'll work in the painting.

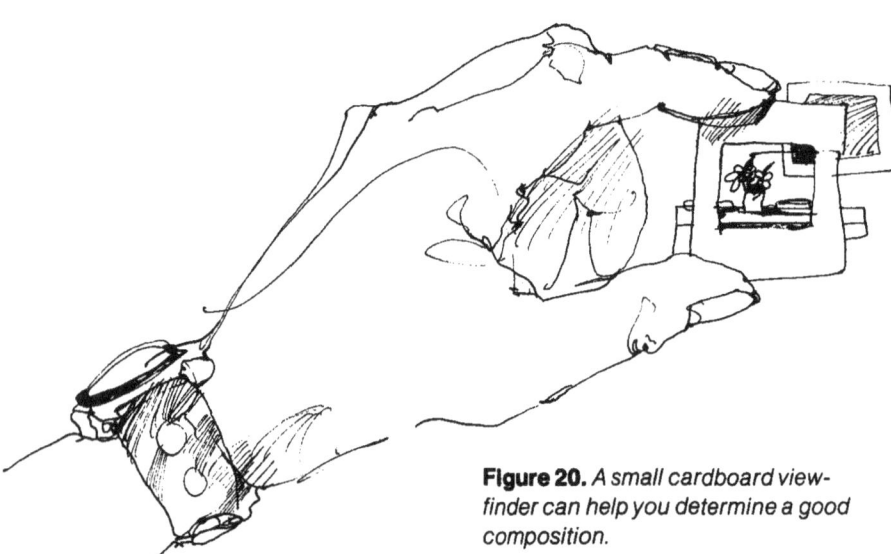

Figure 20. *A small cardboard viewfinder can help you determine a good composition.*

Viewfinder. My next step is to look through a viewfinder (Figure 20), first moving it closer to my arrangement, then back, trying to find a good composition. As you move the frame around, you'll see all kinds of possibilities. I've drawn a possible setup, and I've indicated with squares some of the sections I might choose for a painting. It's interesting to see how many possible paintings there can be with just this one setup.

Overlapping Objects. I then might switch some of the objects around to see if I can improve my arrangement. No one can tell you how to arrange your setup. You'll naturally bring your own tastes and feelings into the picture. Your setup is a very important part of your creative process and should be arranged with much care.

The only definite statement I would make is that you should be sure that at least some of the objects interlock and overlap. Don't have

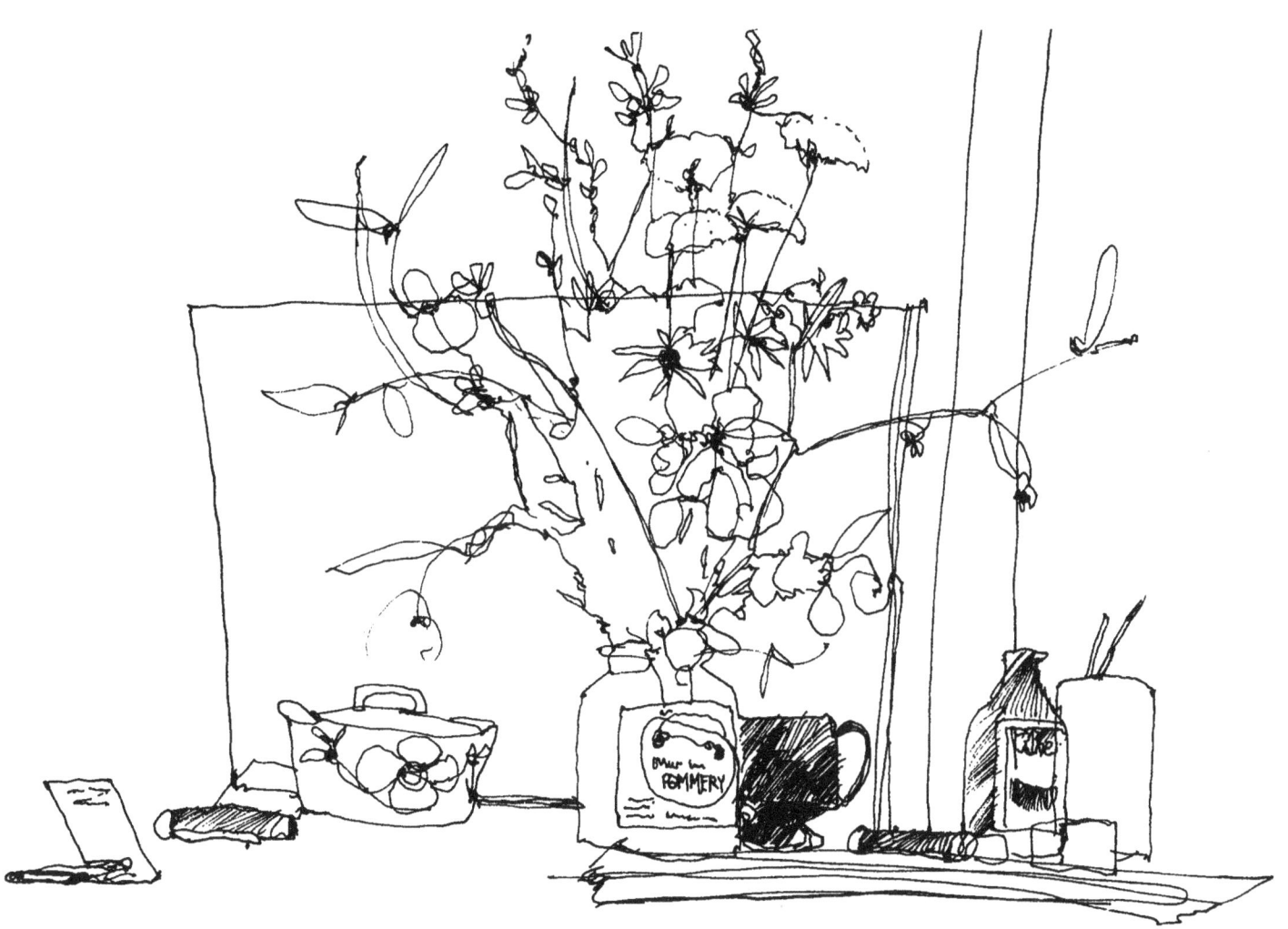

Figure 21. *A good "rule" for composition is to have two-thirds of an object overlap another, while the other third is separate.*

Figure 22. *In these two sketches, you see a vertical situation, where the eye has nothing to stop it from going up or down off the canvas (Sketch A, top); and a horizontal situation, where the eye goes right across the canvas (Sketch B, bottom).*

lots of separate pieces scattered about. On the other hand, don't bunch everything into a tight group. If I must make a rule (a rule you may break without a guilty conscience), it's this: try having two-thirds of your objects overlapping one another, while leaving the other third separated from the main grouping (Figure 21). Remember, this is the kind of a rule you may use as a starting point. Discard it as you become more adventurous in your compositions.

Compositional Direction. As you study the group of objects in front of you, try to forget for a moment that they're particular objects. In other words, forget that you have a vase, coffee cup, or ceramic elephant. Instead, think of them as shapes that are a part of a design. This is very important. It sounds easy, but it isn't. In the next projects, you'll be dealing with value and pattern, where you must think abstractly. So you might as well start now. Decide if the particular objects you're dealing with work well as shapes. When I say "work well," my first requirement would be whether the shapes help direct the eye through the picture. Your shapes should act as roadsigns for the eye. Avoid shapes that lead vertically or horizontally (Figure 22)—they're static. Instead, work for diagonals.

In order to have movement in a painting, you need the tension of forms working against one another. When all the shapes lead in the same direction, you generally get a static painting. So, when you arrange your objects, be sure that they help lead the eye through the picture and that they have contrast and interest, as in Figure 23.

Cutting Off Objects. Don't feel you must get every shape into your painting completely. It's often a good idea to have some objects partially out of your picture. Don't worry if your picture margin cuts an object in two (Figure 24A). This is much

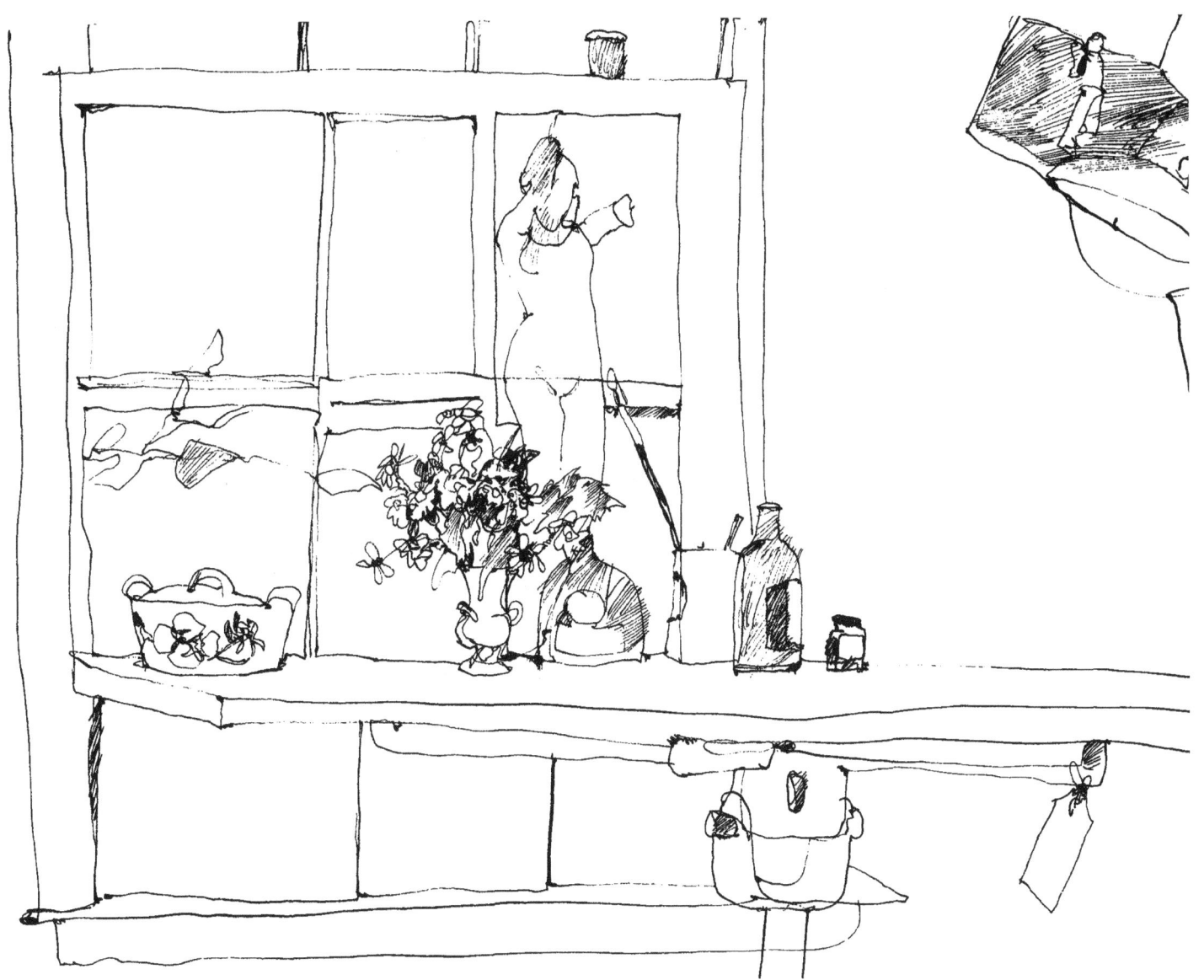

Figure 23. *This composition has both horizontal and vertical movement, but the eye stays within the picture.*

COMPOSITION 133

Figure 24. The borders of your painting are important. It's better to have objects cut off by the margin naturally (Sketch A, top) than to get a cramped feeling when they press against the borders (Sketch B, bottom).

134 FLOWER PAINTING IN OIL

better than having an edge of an object butting up against or sitting on a margin (Figure 24B).

Some Final Thoughts. I've suggested some things to avoid and some things to try, but I can't honestly state any rules of composition. Composition should be very personal, and as I sit here wondering how to finish this section, I'm glancing through a book on Morandi, an Italian who was born in 1890 and died in 1964. He's a favorite of mine, and he breaks just about every rule of composition that exists. He bunches his objects in the center of his pictures, and he's particularly fond of horizontal and vertical forms. He seems to avoid all the diagonals I just finished suggesting you should use. I guess when you paint as well as Morandi, you can bunch all your objects in the center of the picture, and you can use horizontals and verticals to your heart's content!

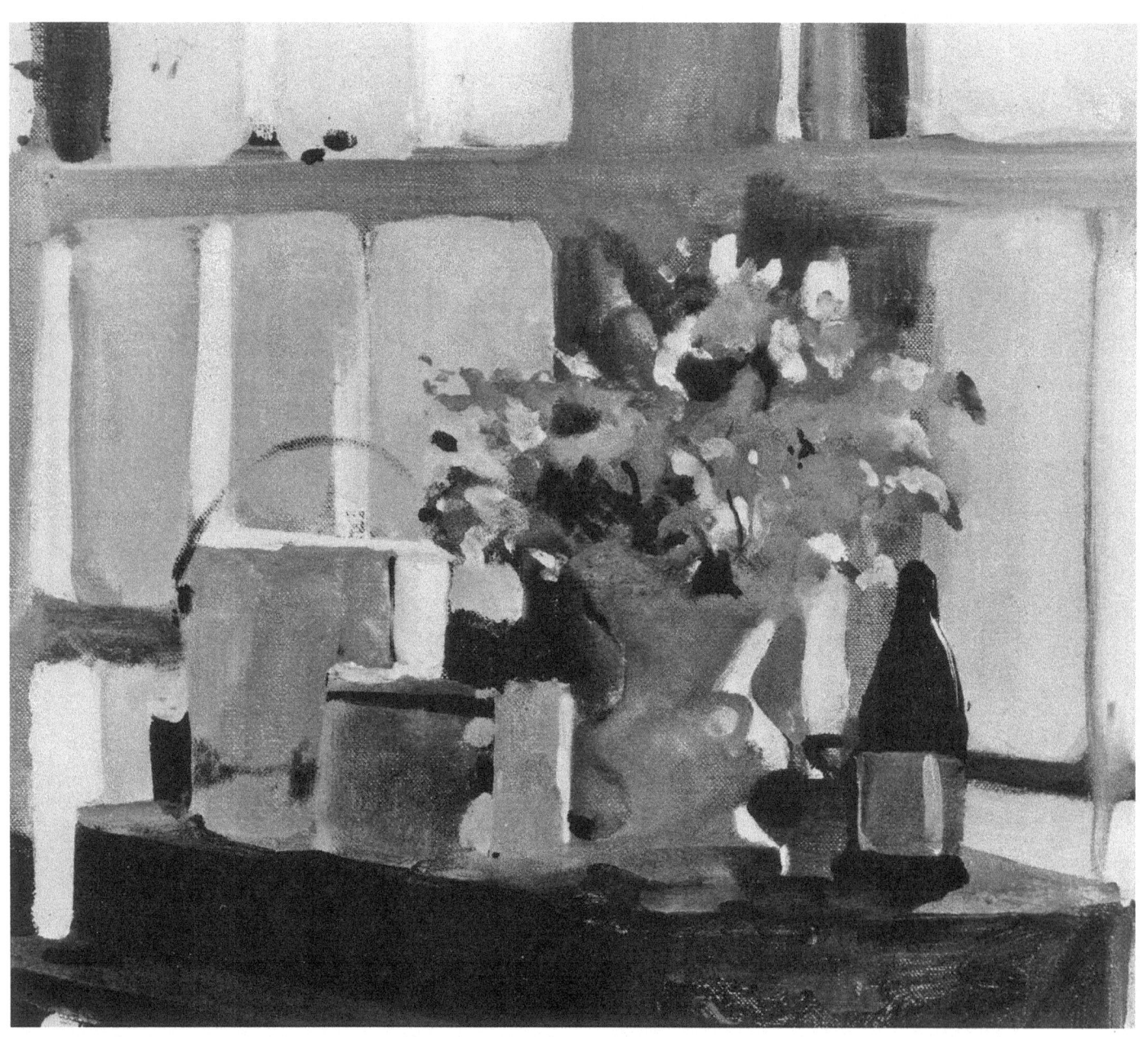

Allen. *(Detail) The flowers aren't really very important here, but they liven up this rather dull shelf. I didn't want to make this area of the painting too busy, so I allowed the flowers and other objects to remain mostly in shadow. Shadows are wonderful for tieing everything together.*

PROJECT 14
VALUES

I find the study of values fascinating. There can be no correct value for a particular object, just as there can be no correct color. Each artist will and should see values differently. Some artists like strong contrasts, so they make their darks darker and their lights lighter. Other artists see and paint in a high key where all values tend to be relatively light. Still others want a low-keyed, somber, darker value range.

We choose values depending on our tastes. We also choose certain values because they help us express a particular idea or feeling in a painting. When choosing values, I feel that many students tend to generalize. This is a shame, since one of the greatest pleasures, at least for me, is trying to find just the right value for a particular area. I can spend hours on a troublesome part, lightening and darkening it, trying to find the perfect balance with the other values in the painting.

Values are Relative. Nothing is light or dark unless it's compared with something else. In Figure 25 (left), I painted a gray square. It looks pretty dark compared to the white paper. In Figure 25 (right), I added a darker border. The value of the square is exactly the same, but notice how much lighter it seems compared with its dark border. The point is that you can't think of a value by itself. You must have another value next to it to compare it with. Also, you can't judge your values properly on white canvas. You must either tone your canvas first, or else, if you like working on white canvas, lay in some darks and middle lights right away.

Values in Diffused Light. Value is one of the hardest things to understand. The value of an object can be defined as the relative degree of lightness and darkness of the object in relation to other objects seen under the same lighting conditions. In other words, you can determine the actual values of objects under flat, diffused lighting conditions more easily then under more arbitrary conditions, where light and shade play a strong role.

Figure 25. *Notice how the value of the gray square seems to change in relation to its background.*

Figure 26. *Here we have a light object against a darker background, with no definite light source.*

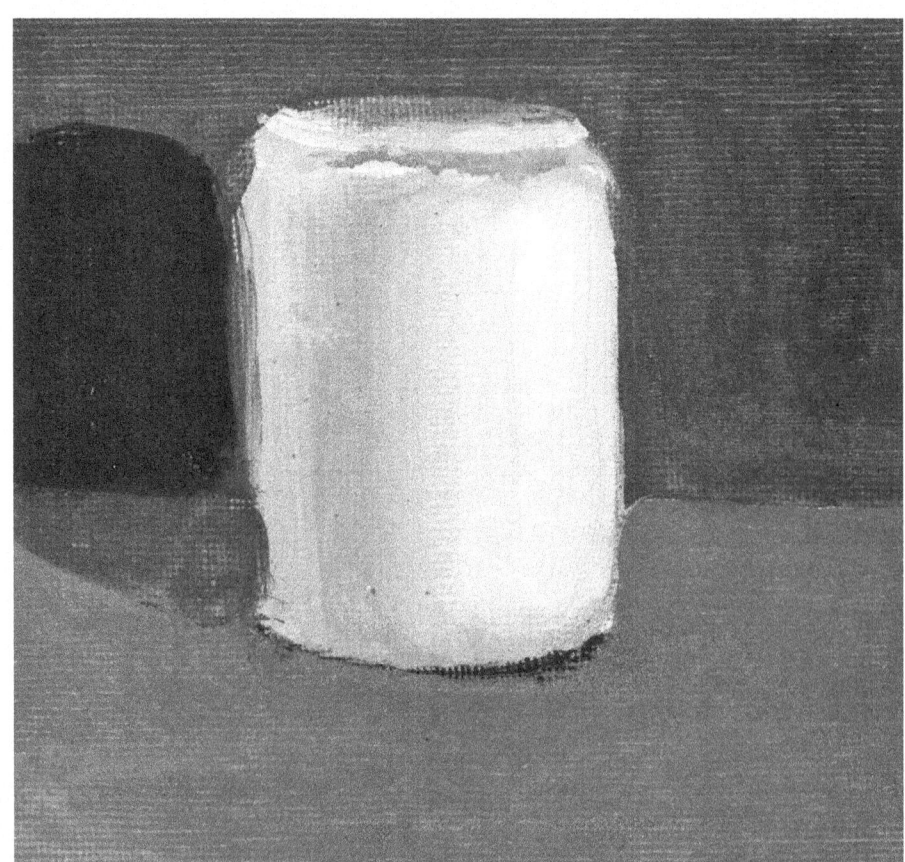

Figure 27. *I've thrown a single light from one definite direction on the white object, and it takes on form and depth.*

138 FLOWER PAINTING IN OIL

For example, in Figure 26 I made a flat diagram of a white object—in this case, a jar—placed against a fairly dark table and an even darker background, under diffused light. The comparative values of each area are obvious.

Values in Strong Light. I then put a single light on the jar (Figure 27). All the values in the light were lightened still further. The shadow side of these objects, however, remained constant. It appeared even darker because the areas in the light became even lighter by contrast. Returning to the objects in the light, notice that although the objects are all lightened, the difference between these areas in terms of value remains constant. In other words, they've all been lightened proportionately. The background, however, is still darker than the table; the table is still darker than the jar. (If the table were shiny, this, of course, wouldn't be so. You'd have strong highlights contrasting with the darker areas of the table.)

In other words, we have lightened each area several values, but no matter what we do, this darker table will never be as light as the jar. Because they're in the same light, there's always a tendency to make all areas the same value—but that's what makes washed-out paintings. If you look only at the table in the light, you'd probably think it was very light. If you didn't compare the table with the jar, you'd probably make the table as light as the jar. If you keep comparing values as you paint, you'll realize that the table, even though it's lighter, can never be as light as the jar. Don't paint what you know in your mind: that the objects are in the same light. Paint what you actually see with your eyes: that the jar is still darker than the table.

Values in Shadow. Now let's look at the shadow areas in Figure 27. You have a white jar. Compare the shadow on the white jar with the shadow on the table. The local value of the jar is lighter than the table.

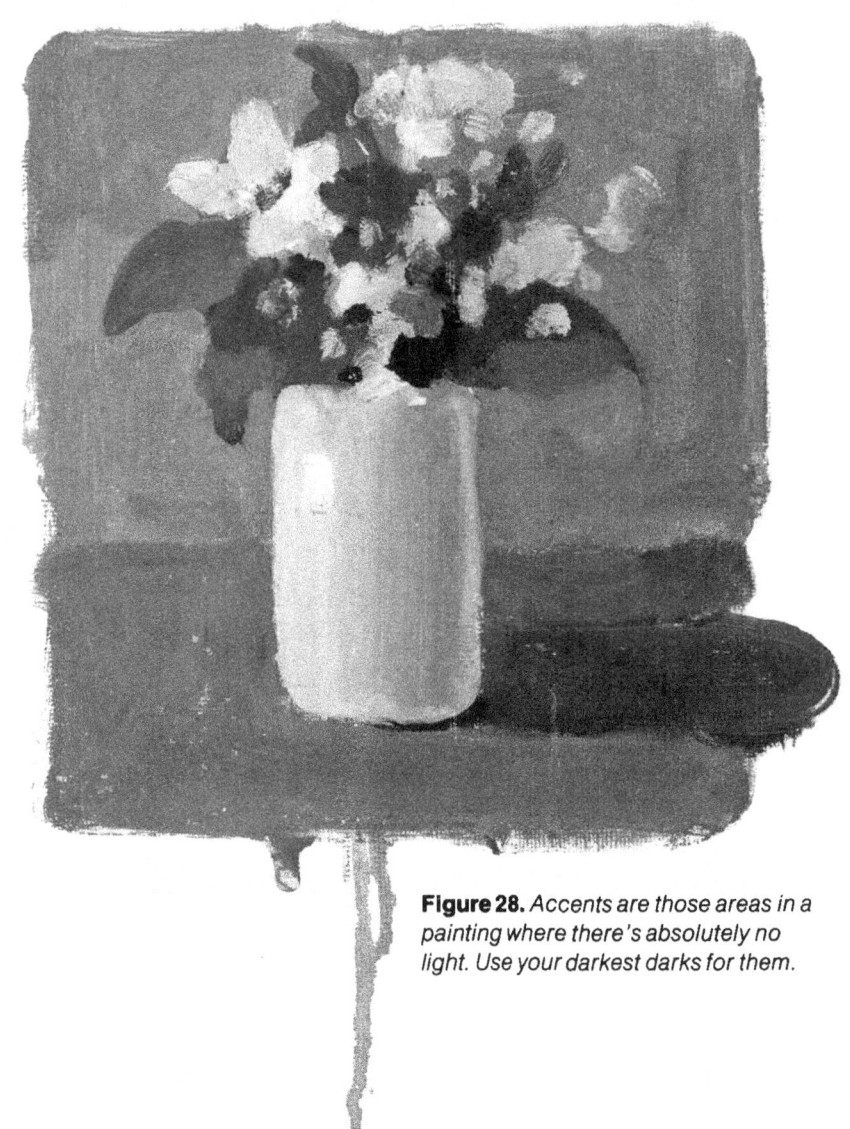

Figure 28. *Accents are those areas in a painting where there's absolutely no light. Use your darkest darks for them.*

VALUES 139

This means that the shadow values on the jar will always be lighter than the cast shadow values on the table. Now compare the cast shadow on the table with the cast shadow on the wall. Again you keep your value range constant. The cast shadow on the darker wall is darker than the cast shadow on the lighter table.

Accents. Accents exist in areas in a painting where there's absolutely no light. In Figure 28, there's an accent around the bottom of the jar and just above the lid of the jar under the flowers on the right-hand side. Accents are the only time you can use your darkest possible dark—in this case, black. This is a very important point. Never confuse accents with shadows. Compare the shadows on the table, leaves, and jar—the shadows are several different values, but none is as dark as the accent. Accents give shadows luminosity and depth. It's often a good policy to find one very small accent and put it in early in the painting stage. This accent will help you establish the proper value for shadow.

Highlights. Highlights are helpful, but they mustn't be overdone. Too many highlights destroy your values and make a picture look fussy and jumbled. Limit yourself to only one or two highlights, placed moments before finishing a picture—just about your final stroke.

Reflected Light. Never confuse reflected light with your main light area. Reflected light is the light that bounces into your shadows from surrounding objects. Since reflected light is actually part of your shadow, never let it be as light as the main light area (Figure 29).

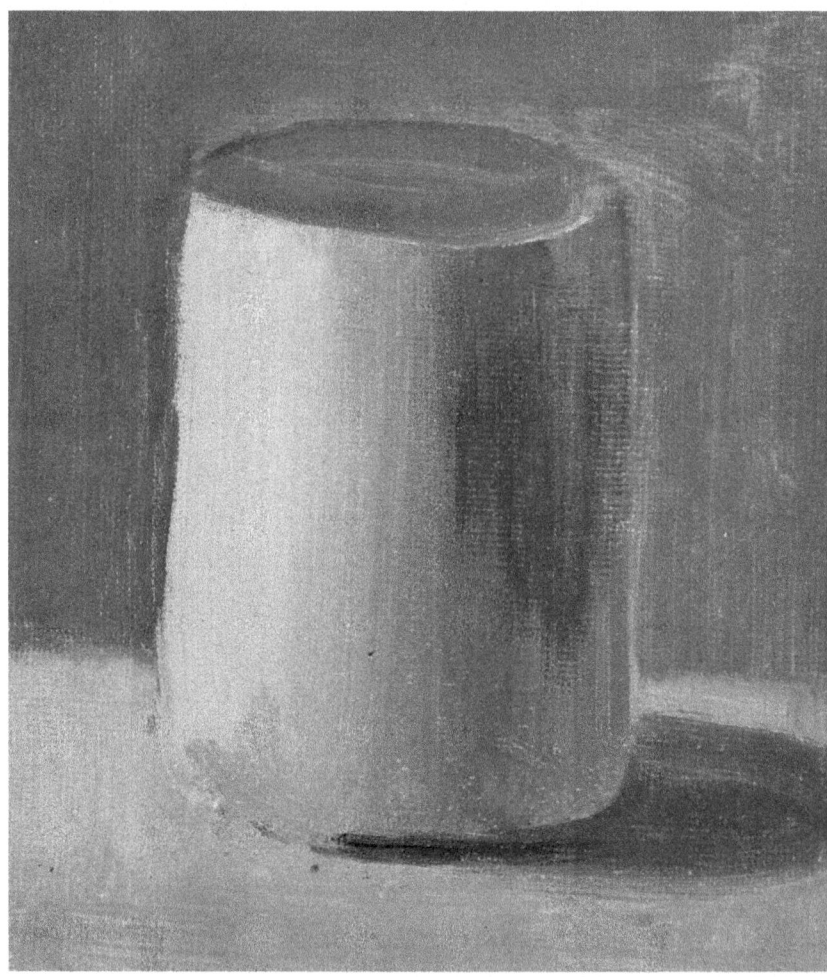

Figure 29. *The reflected light seen here bounces into shadow areas off surrounding objects that are in the light.*

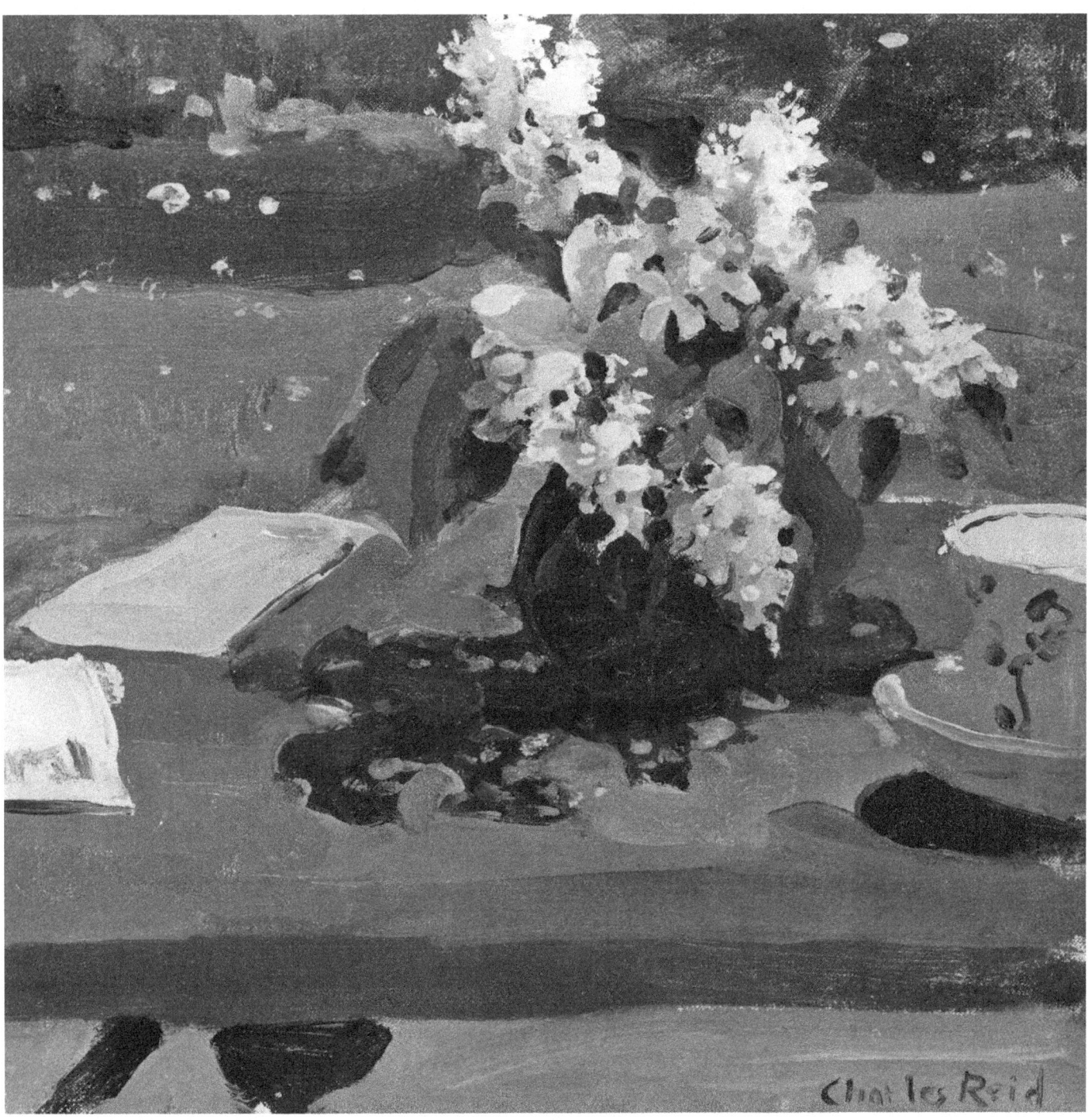

Lilacs. 12" x 12". It's fun to set up your flowers in a casual setting like this, with the only props being some mail and a coffee cup. Notice how dark the shadows on the table are. They all appear to be the same value. Actually there should be some difference in them. I should have selected one to be my darkest dark—probably the one at the base of the vase, my focal point—and made the others just a bit lighter.

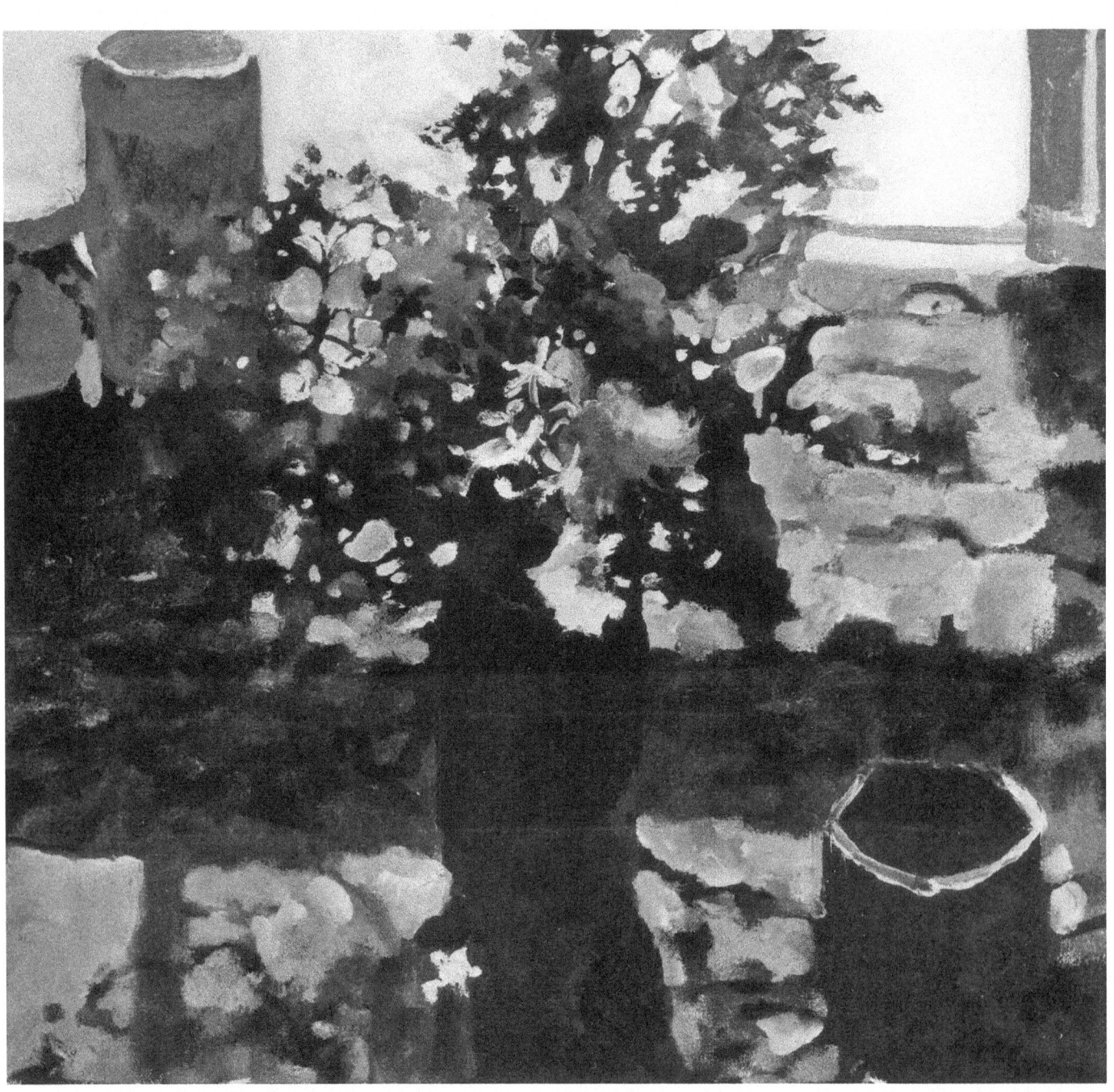

PROJECT 15
PATTERN

Blue Flowers. *14" x 18".*
These flowers were placed on a blue tablecloth. There was a strong light coming through the window. This picture gave me a terrible time, and seemed to take forever to finish. Part of my problem was that the pattern of the flowers competed for attention with the pattern on the tablecloth. In a case such as this you must decide which area should dominate, concentrate your greatest detail and range of colors and values there, and mass as many other sections as possible.

Now that I've discussed some of the basic points concerning values, I'd like to discuss its importance in establishing the foundation of a good painting. I've already established that you should not permit your light and shadow to destroy the relative value of your objects. If you put several objects of various colors and values on a table, turn on a light, and proceed to paint all areas in the light the same value and color, you'll destroy all contrasts of value and color in the objects, and ruin your chances for good pattern in your painting.

Abstract Design. Pattern is simply the careful arrangement of light and dark shapes and colors to create design in a picture. Take, for example, the pattern in a tablecloth. Even if it were composed of realistic, representational objects, it could also be seen as a series of abstract shapes of values and colors.

Pattern in Old Master Paintings. Unfortunately, most students don't think of realistic objects in terms of abstract pattern. But even the most realistic old master painting is essentially an abstract design that also happens to contain recognizable objects. Take a reproduction of a Rembrandt or Vermeer, for example, and turn it upside down. Rembrandt, especially, used to advantage the effect of a strong, concentrated light in his paintings. Seeing the paintings upside down makes the various objects more difficult to identify—and therefore forces you to see their design as an arrangement of abstract shapes and carefully selected colors. If you lose the local color and value of your objects, then you'll lose the pattern in the painting.

Start looking for patterns in every painting you see. Also, see if the artist retained the correct value of the various areas. Once you get involved with value and seeing pattern, you'll be hooked!

Value Studies. To understand the effect of value on pattern, it's necessary to make some value studies to see if you can develop pattern. In the demonstration that follows, I've decided to use felt-tip pens which come in a range of grays from very light gray to black. There are several different brands available. The grays usually come in cool or warm tones. Don't interchange them—select either a warm or a cool gray. In this case, I've selected cool gray in the following values: #2, #4, #7, and black. (The paper itself will represent white.) I suggest using felt-tip pens so you won't be able to "fudge" your values. If you used charcoal or pencil, you'd probably have a harder time being definite.

For the demonstration, I set up a simple still life with some obvious value contrasts: light, middle, and dark values. I used a fountain drawing pen with India ink (non-waterproof). I have bad luck with regular waterproof India inks; the pens always seem to get clogged.

Step 1. I only have three objects to worry about: the flowers and vase, a small ink bottle, and a 35mm cartridge box of film. I make a contour-type drawing, just simple boundaries. My sketch is 4" x 3" overall. Remember to consider the shape canvas you plan to paint on. The shape of your sketch should correspond with it.

Step 2. When I finish the sketch, I take my #2 felt-tip pen and fill in all areas except my obvious lights. In this case, I see some white flowers and a white vase. The values I'll be using in this demonstration are shown in the value chart at right.

WHITE #2 #4 #7 BLACK

Step 3. I look for my obvious darks: the ink bottle, some dark areas in the leaves, and the top of the film container.

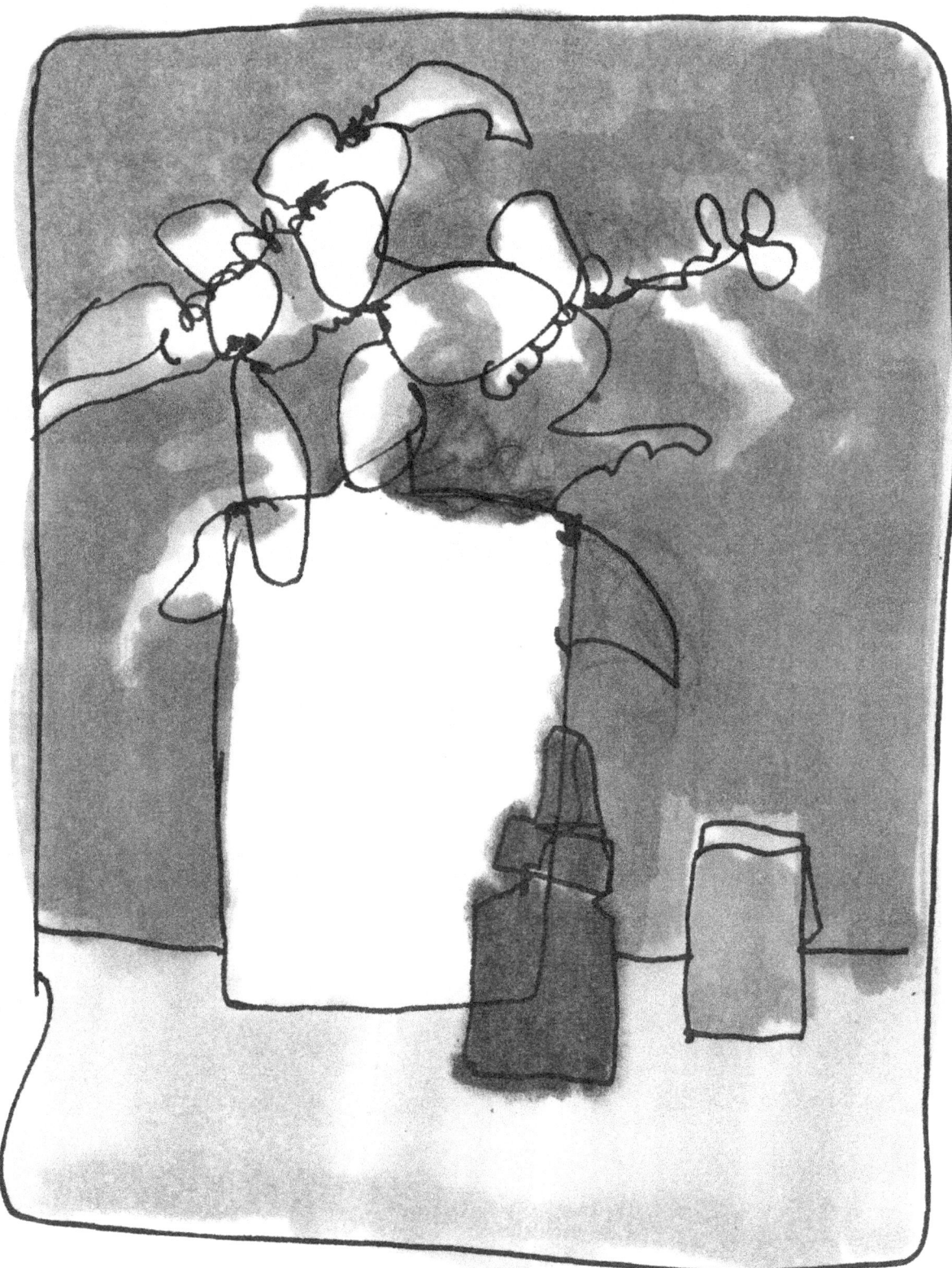

Step 4. Now for my middle values. The background is darker than I've indicated; so, using a #4 pen, I make it darker. Notice that I'm willing to lose boundaries here. I darken the leaves and background at the same time. This will be difficult for some of you who fear "lost drawing." Try to realize that this is just a sketch. You're just interested in abstract pattern now, and it won't matter if you lose some of your drawing.

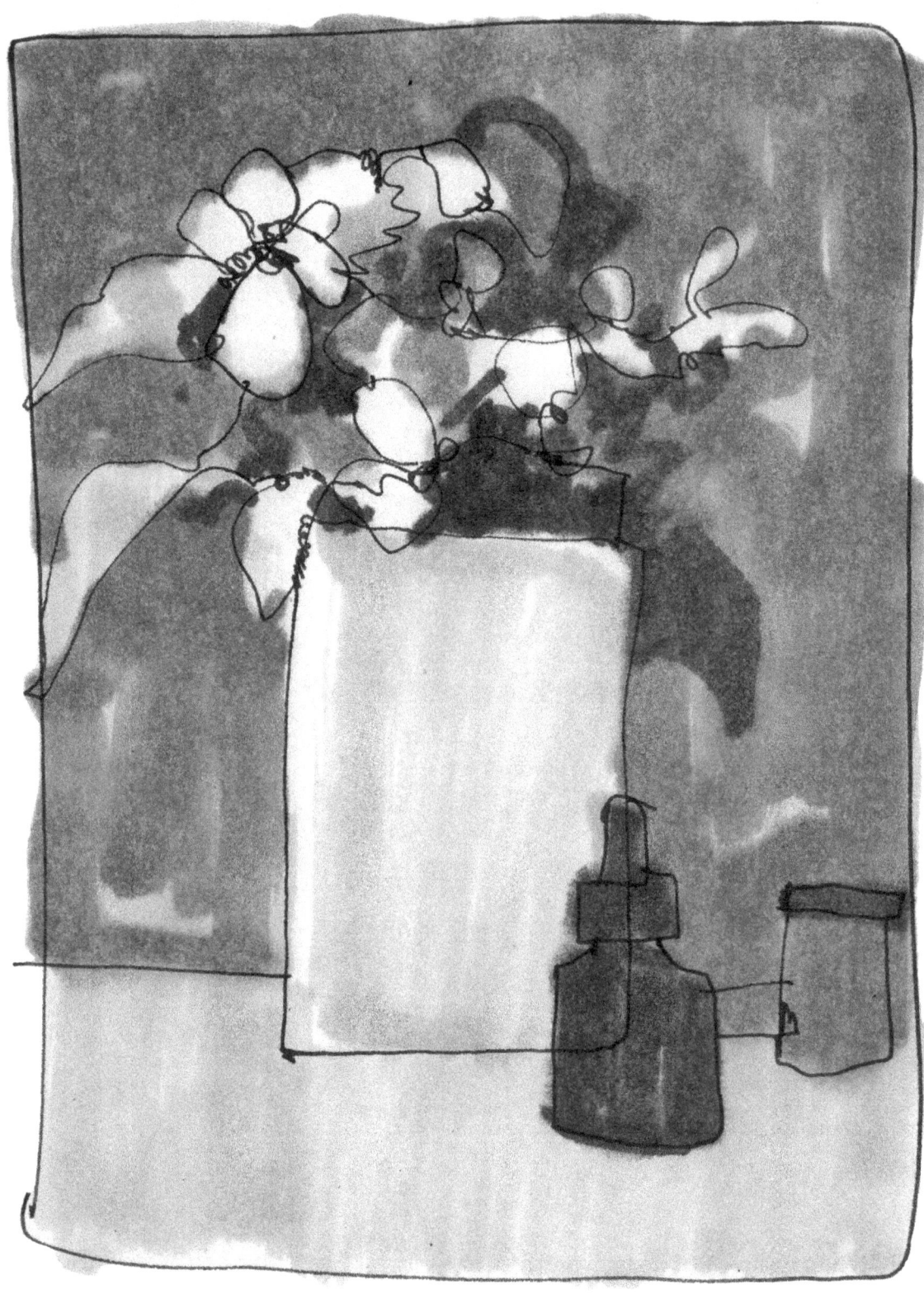

Step 5. I have a white vase which is in shadow, but still looks very light. I haven't touched it yet, but I see that it looks awkward as a white shape. It's too big and takes away from the flowers. I fill it in with a #2 pen so it's now the same value as the table. I now have a basic value sketch of my still life. It really doesn't matter if the felt pen drawing is accurate in terms of the actual drawing. What does matter is that I have some kind of pattern with clearcut lights and darks.

Directing the Eye. Once you put several different values on canvas, you have the beginning of a pattern. It might not be an effective pattern, but it's still a pattern. One of the major requirements of a good pattern is that it helps direct the eye through the painting. Naturally, color, as well as value, is a factor in directing the eye. Avoid a pattern that's spotty and fragmented (Figure 30). You shouldn't get a feeling of pieces, but rather a feeling that your colors and values are connected.

In each case, the color and the light and dark values should lead your eye through the picture. Pattern is, as I said before, a roadmap for the viewer's eye. But a good picture should never be an obviously designed one. A successful painting is one that says something without the viewer knowing, or caring, how it is being said.

Poor Pattern. In Figure 31, I've tried to point out some things which might make a poor pattern. The windowframe on the upper left forms a barrier for the eye. The eye tends to be contained within the square and there's no tie-in between the flowers and the window. The dark values in the bottle connect only with the dark values in the window. Again, you're not led from one area to another. The darker leaves within the flowers appear stationary. They go nowhere. The eye is not directed by the darks here; we have the feeling of unconnected, isolated pieces of dark.

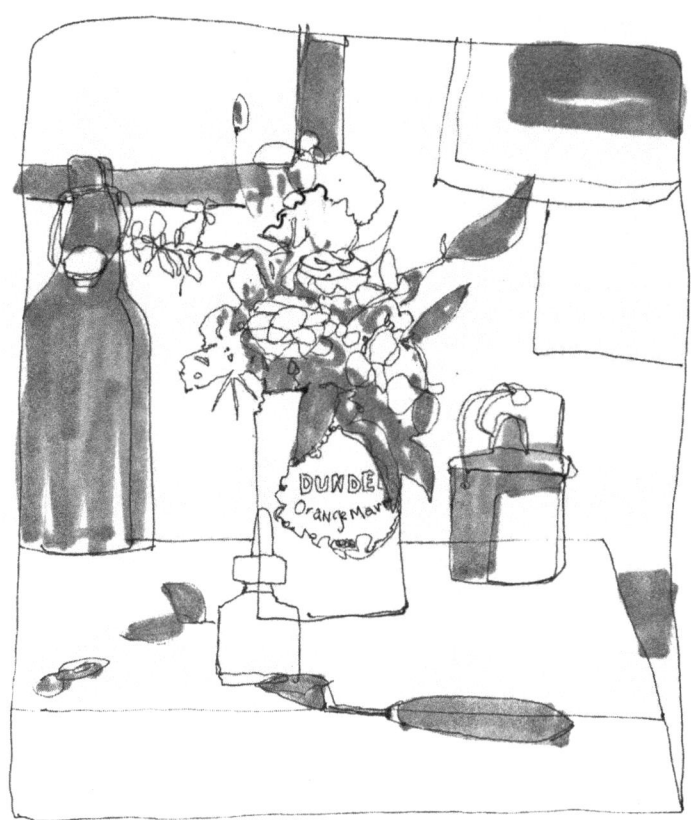

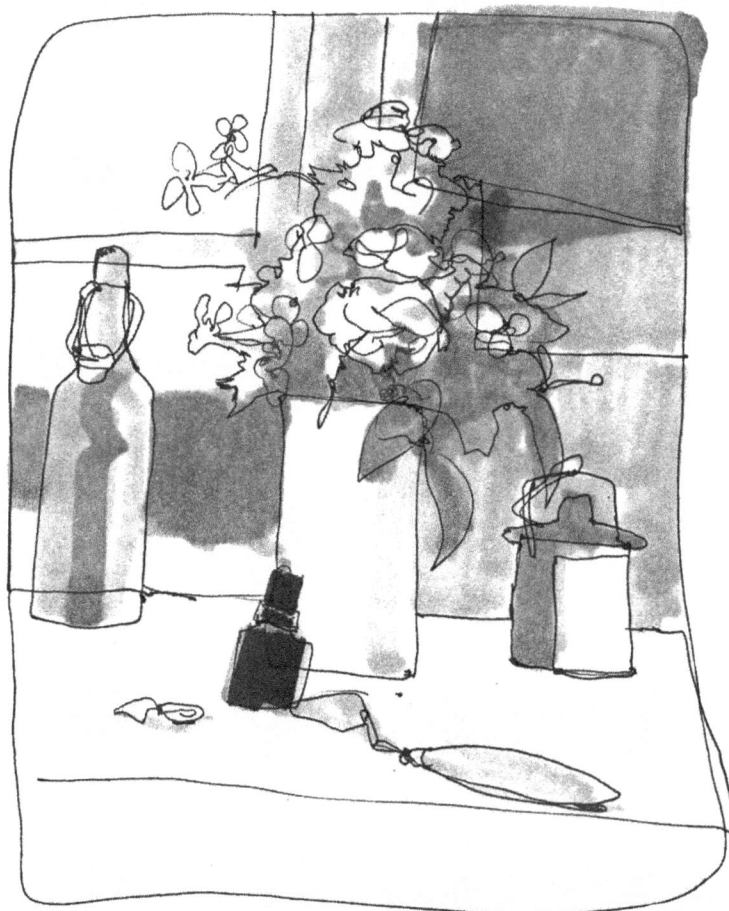

Figure 30. *(Top) Incorrect use of values gives this drawing a "spotty" pattern.*

Figure 31. *(Right) Here's an example of a drawing with a poor tonal pattern.*

Correcting Poor Pattern. Now let's try some first aid. I'd like to suggest the following alternatives you might use to correct Figure 31 without changing the composition. In Figure 32A I change some values and, especially, add some cast shadows. Notice how the cast shadows form a path through the picture. This is a case where darkening cast shadows can be a major way to save the composition. I then lighten the values in the windowframe and in the picture in the right-hand corner. These lighter values now draw less attention to these area; your eye is instead drawn to the darker values.

Still looking for tie-ins, in Figure 32B, I try using some of the darks outside. The hedge outside the studio is handy. This dark makes a nice connection between the bottle and the leaves of the still life. The ink bottle remains isolated, but because everything else is more or less connected, it poses no problem. The middle value of the wall also helps make a feeling of connection with the darker leaves.

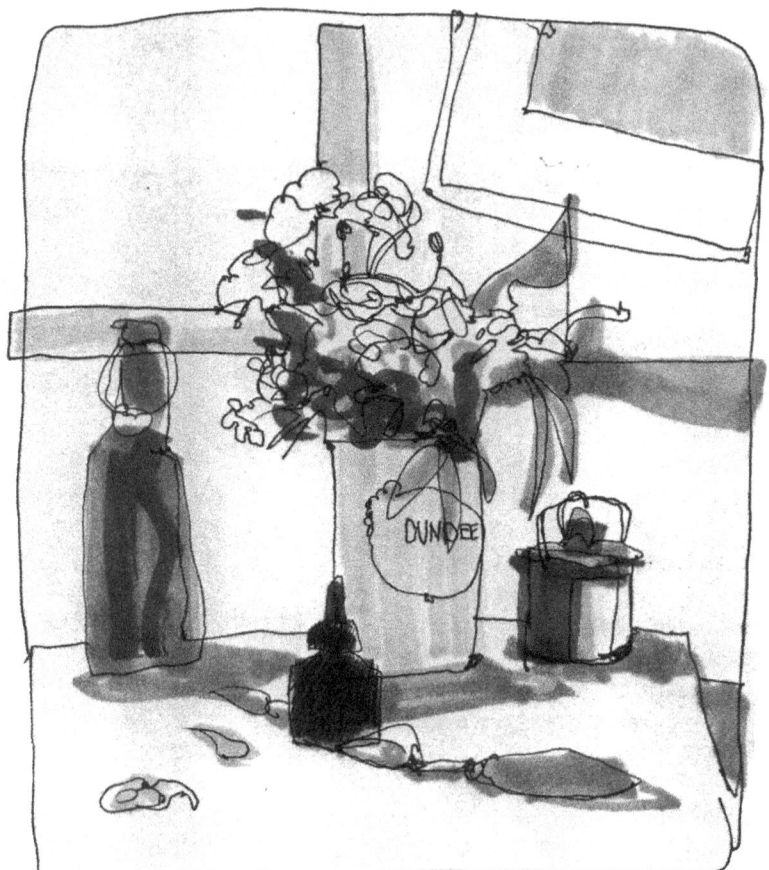

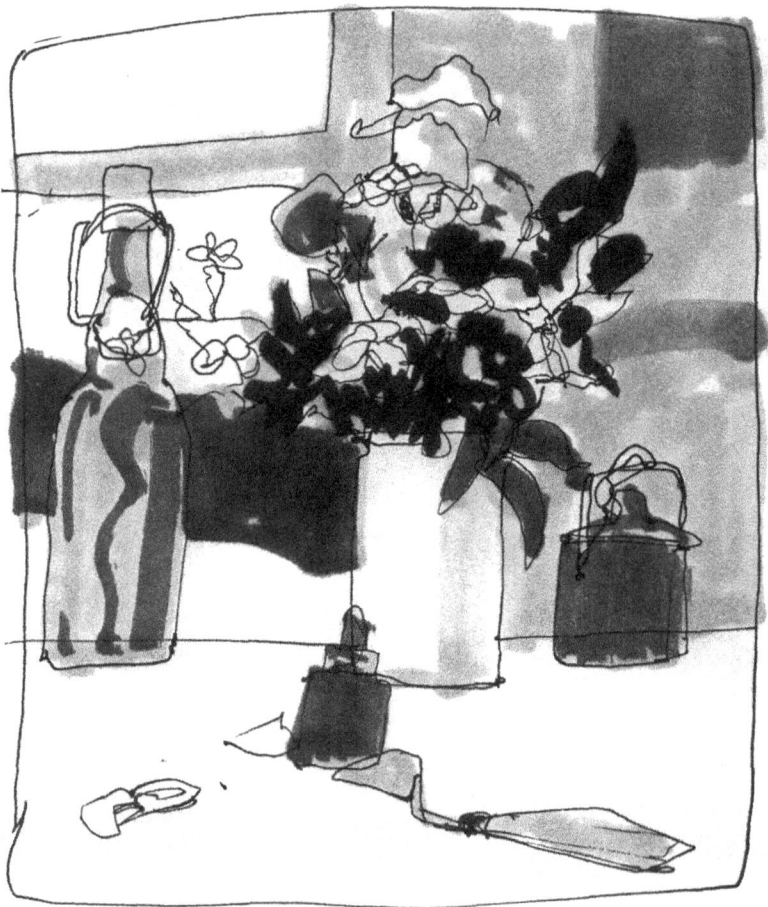

Figure 32. *I correct the poor value pattern of Figure 31 as follows: In Sketch A (top) I direct the eye through the drawing by the careful placement of cast shadows. In Sketch B (bottom) I structure the drawing by connecting the dark values outside the window with those in the bottle and leaves.*

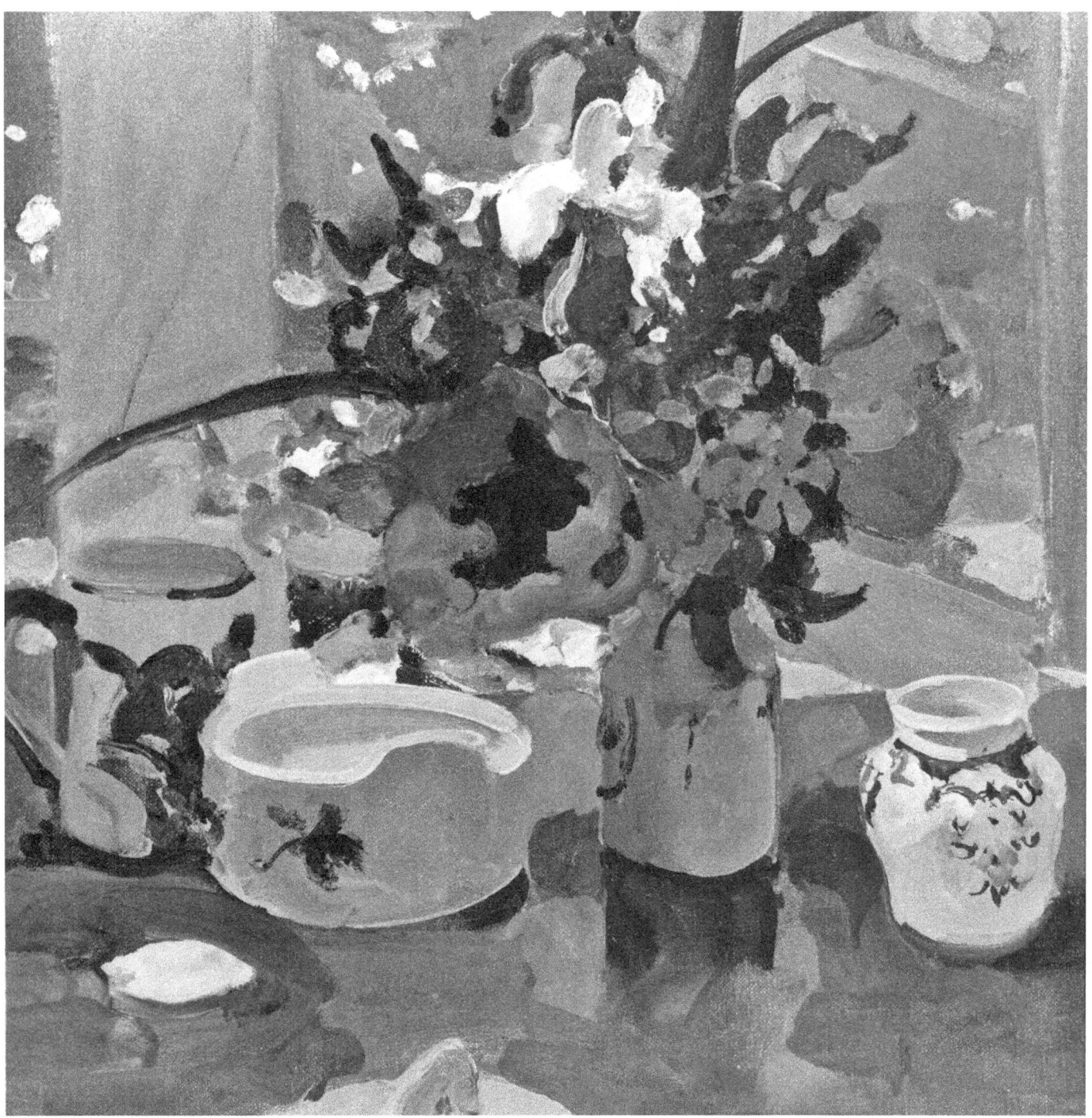

Poppy. 14" x 14". The huge Oriental poppy in this arrangement was a terrible struggle for me; I have trouble with bright reds and yellow. Happily, this reproduction is in black and white! I'm sure that it's possible to do a good painting of a poppy. I simply happen to have difficulty with exotic flowers, but they may turn out to be your favorite subject.

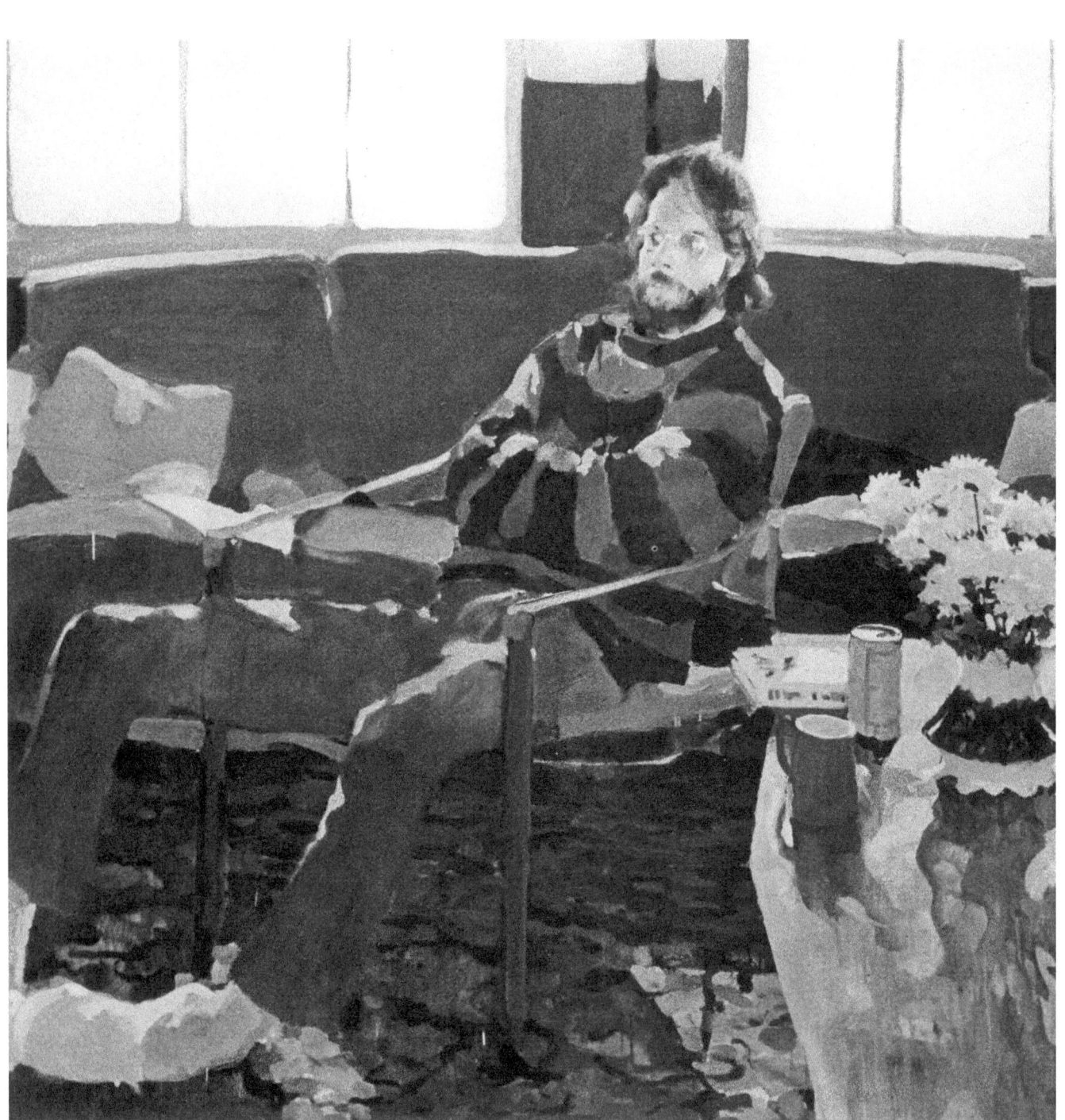

PROJECT 16
LIGHTING

In a painting, lighting can create problems—or solve them. If you light your subject with a single, strong light source, you'll get definite shadows and cast shadows that will form a foundation for the painting.

Lighting for Form. Simple, definite shadows and cast shadows describe the shape of your subject. If you use extreme lights and darks, you won't need all the subtle middle values that are necessary in a diffused lighting situation. Two sketches (Figure 33) help show what I mean. In Figure 33A, I used line alone, with almost no light and shade. Notice how much detail I need to identify these two marigolds. In Figure 33B I used only light and shade—really only two values—to describe the flowers. Considering the complicated marigolds, the sketch is pretty simple. The shadows on the flowers describe their bulk and mass, without having to use much detail.

Lighting for Composition. The strong cast shadows created by your lighting can be very important compositional elements. In Figure 34A I sketched a subject without cast shadows. In Figure 34B the arrangement was the same, but notice what a difference the addition of shadows and cast shadows makes. Because line isn't too important here, you become more aware of these shadow shapes. I hope you can see that in a strong light these shapes can become as important as any object.

To summarize, I feel lighting is important in making form. Strong lighting is also essential if you want strong shapes of shadows and cast shadows as part of your composition. On the other hand, the subject (flowers, in this case) is still the main thing. If you have some great flowers, by all means paint them—even if your lighting is poor!

Back Lighting. *40" x 50". Collection Mr. and Mrs. Hadley Ford. Notice the flowers and other objects reflected in the shiny surface of the table. I used a variety of edges and values and—though you can't see it—quite a bit of color. I purposely kept the flowers simple: just two values with no detail. When you paint a subject in back lighting, the value of the light-bathed areas remains constant, and you paint details mostly in the halftone or middle-value areas.*

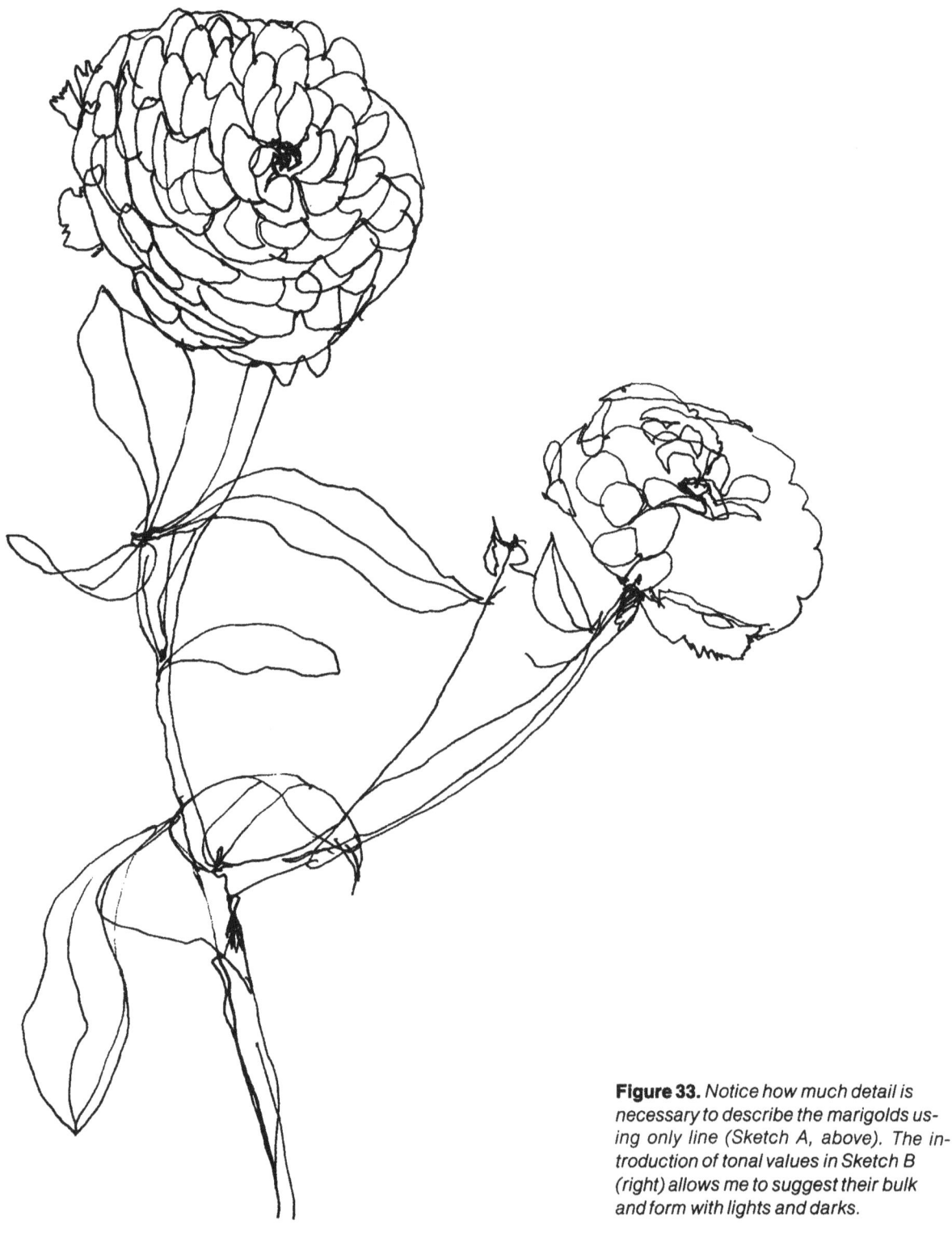

Figure 33. Notice how much detail is necessary to describe the marigolds using only line (Sketch A, above). The introduction of tonal values in Sketch B (right) allows me to suggest their bulk and form with lights and darks.

Figure 34. *In Sketch A (above) I used only line; the drawing lacks depth and form. In Sketch B (right) I added cast shadows (tonal values), and definition occurs instantly.*

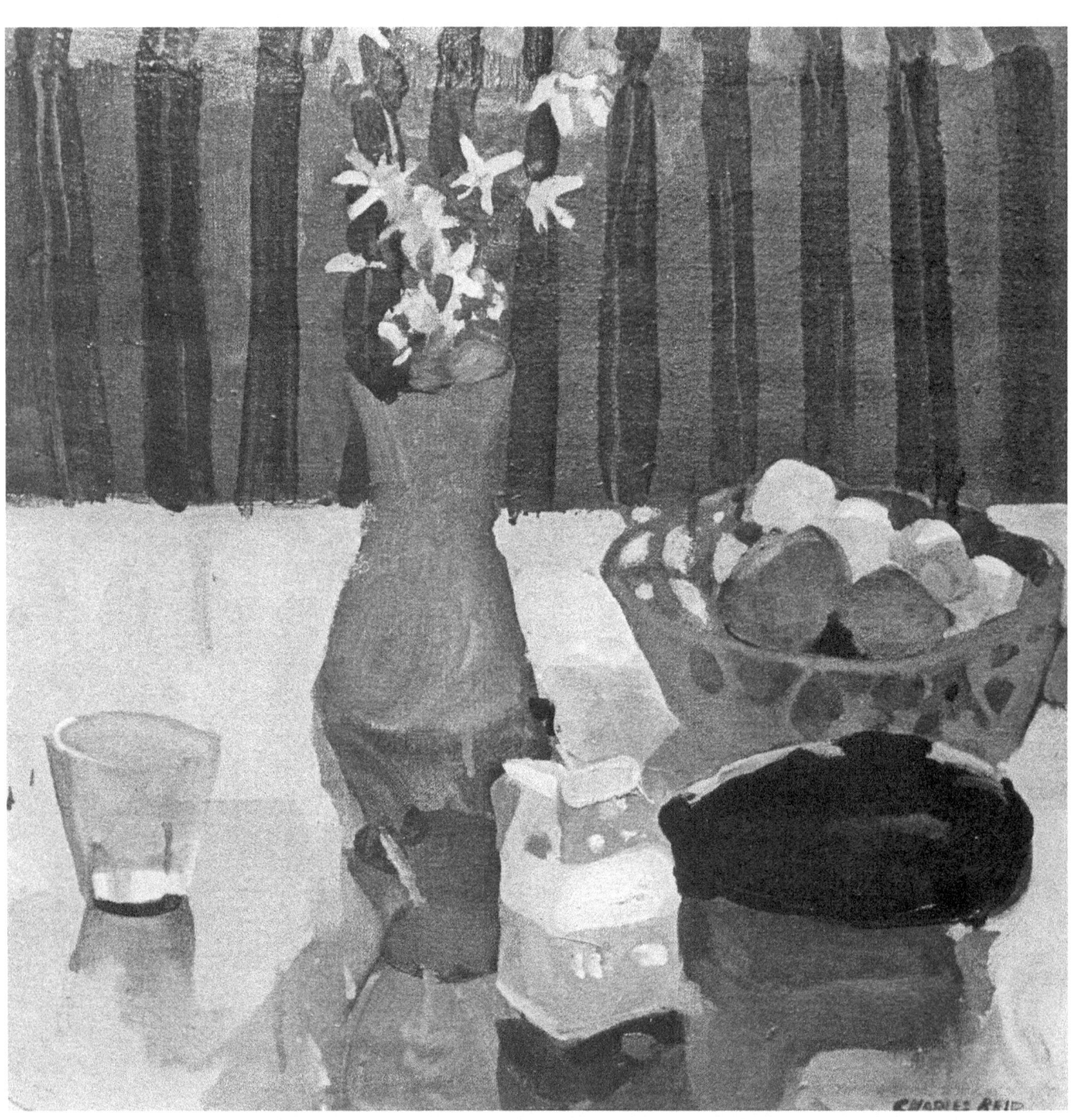

PROJECT 17
EDGES

Edges describe the boundaries of the objects you draw or paint. Usually you're so happy to create a decent drawing that you don't worry too much whether the edges of the drawing or painting are hard or soft. But good edges are important! Good edges, or good edge control (which is the same thing), often make the difference between a finished painting and an unfinished one.

Most of you hate to lose the preliminary drawing that you sweated over. This fear causes you to paint along the edges and boundaries of each object and fill in each area as a separate piece. You don't want to lose a boundary by "fudging" an edge, so you come up with a "paint-by-the-numbers" picture with each object cut out and separated from its surroundings.

Combine Hard and Soft Edges. In Figure 36 I painted a subject with only hard edges. Because of my style, it's hard for me to do a truly hard-edged picture. But this is a pretty good example of hard edges where they shouldn't be. The vase just doesn't appear three-dimensional: the value gradations don't produce shadows. Instead, the values look like dark patterns on the vase or as if sections have been cut out of it.

The rest of the sketch would pass. It has a strong, postery effect, with firm edges and strong contrasts between the lights, darks, and middle values. In other words, you could get away with *some* hard edges. But if you want objects to look round and have form, they can't have all hard edges. The trick is to have a combination of both hard and soft edges.

I'm assuming, of course, that you're interested in "traditional" painting. There's a school of contemporary painting built around using only hard edges. Hard-edged painting is valid, if that's what you're after. Hard edges become a problem only when they happen where you don't mean them to happen.

So, assuming that you're interested in making things look round, in Figure 35 I've painted a closeup of the same vase and flowers I used in Figure 36, where everything had firm boundaries, but here I carefully used both hard and soft edges. The accompanying diagram explains where and why.

Making a Hard Edge. Hard edges are easy to make. You simply put two pieces of paint directly next to one another, making sure that no blending occurs, and you have a hard edge (Figure 37A).

Making a Soft Edge. Making soft edges is a bit more difficult. At first, the process is the same as for making a hard edge. But then you must blend the two areas of paint (Figure 37B). After placing two areas of paint next to each other, clean your brush in turpentine or brush cleaner and wipe it dry with Kleenex, a paint rag, or whatever. Then, starting on either the dark or light side: (1) Draw your brush back and forth over the boundary between the two areas in a zigzag motion, working your way along as far as you want a soft edge.

Forsythia. *14" x 16". I like putting in objects that appear naturally in the area I'm painting. This was done after a lunch at our studio. The dark object is an uneaten eggplant. There was also a carton of cream; so I painted it, too. I feel that the stripes are too dominant and, again, I don't have enough flowers in the vase. More flowers would have helped.*

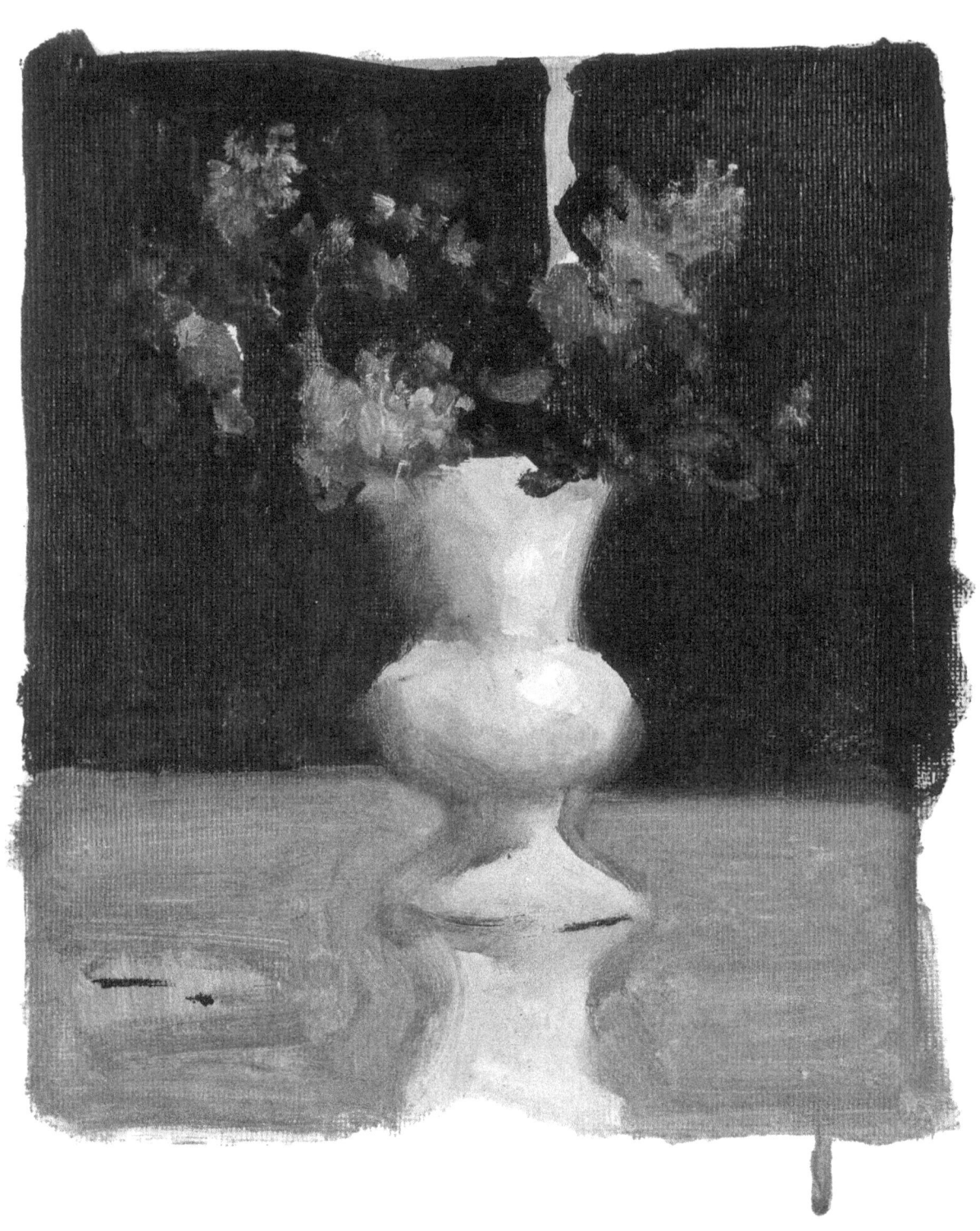

Figure 35. Painting the same subject as in Figure 36, but with softer edges, I achieved more believable shadows and tonal values. In the diagram at right you can see how the subject was lighted and how the direction of the light establishes the shadow patterns. The different types of shadow have different types of edges: the shadow side of the vase, for example, where the form turns away from the light, is soft-edged; the lighted side, contrasting sharply with the dark background, is hard-edged; and the cast shadow has a harder edge than the shadow side of the vase.

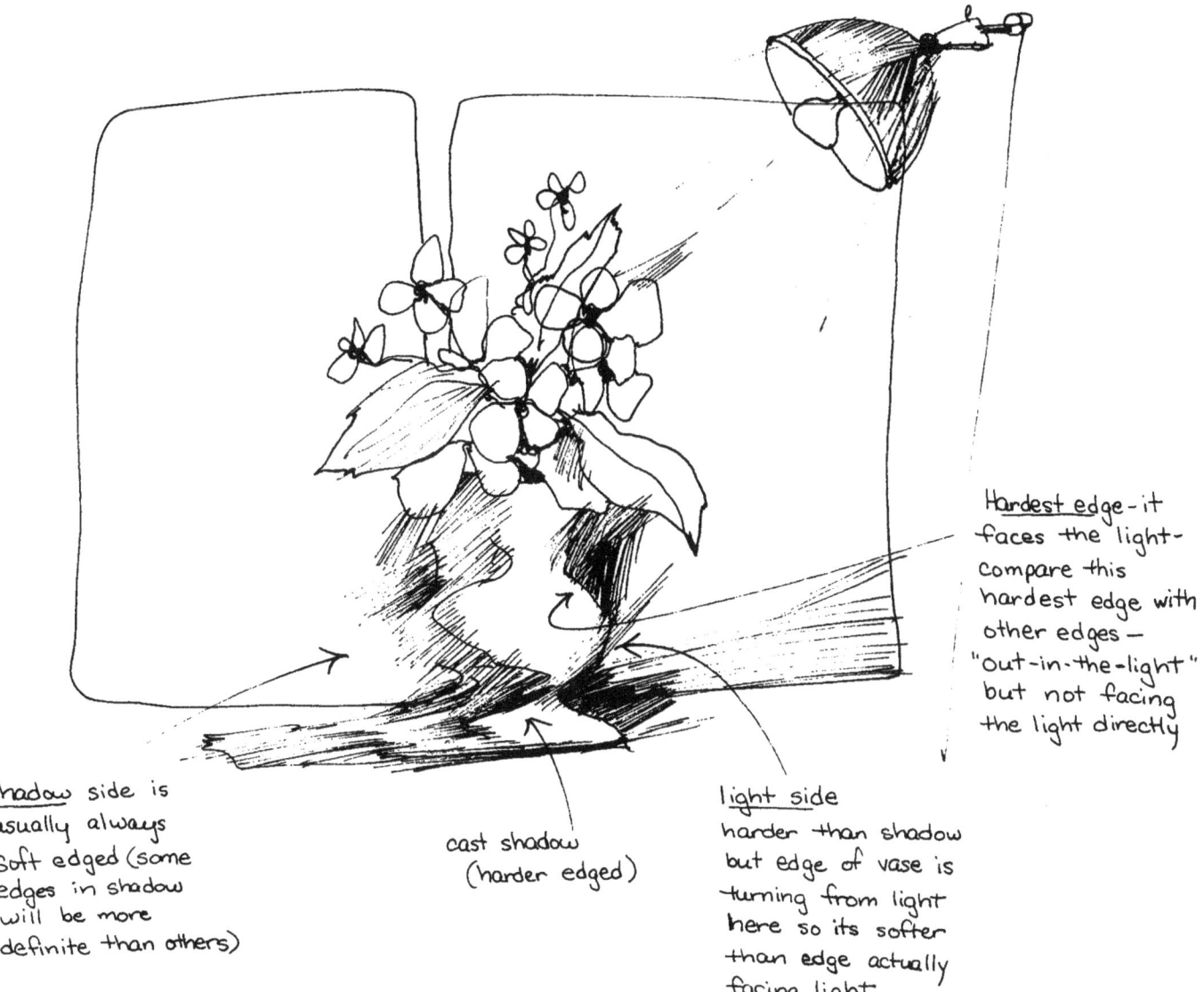

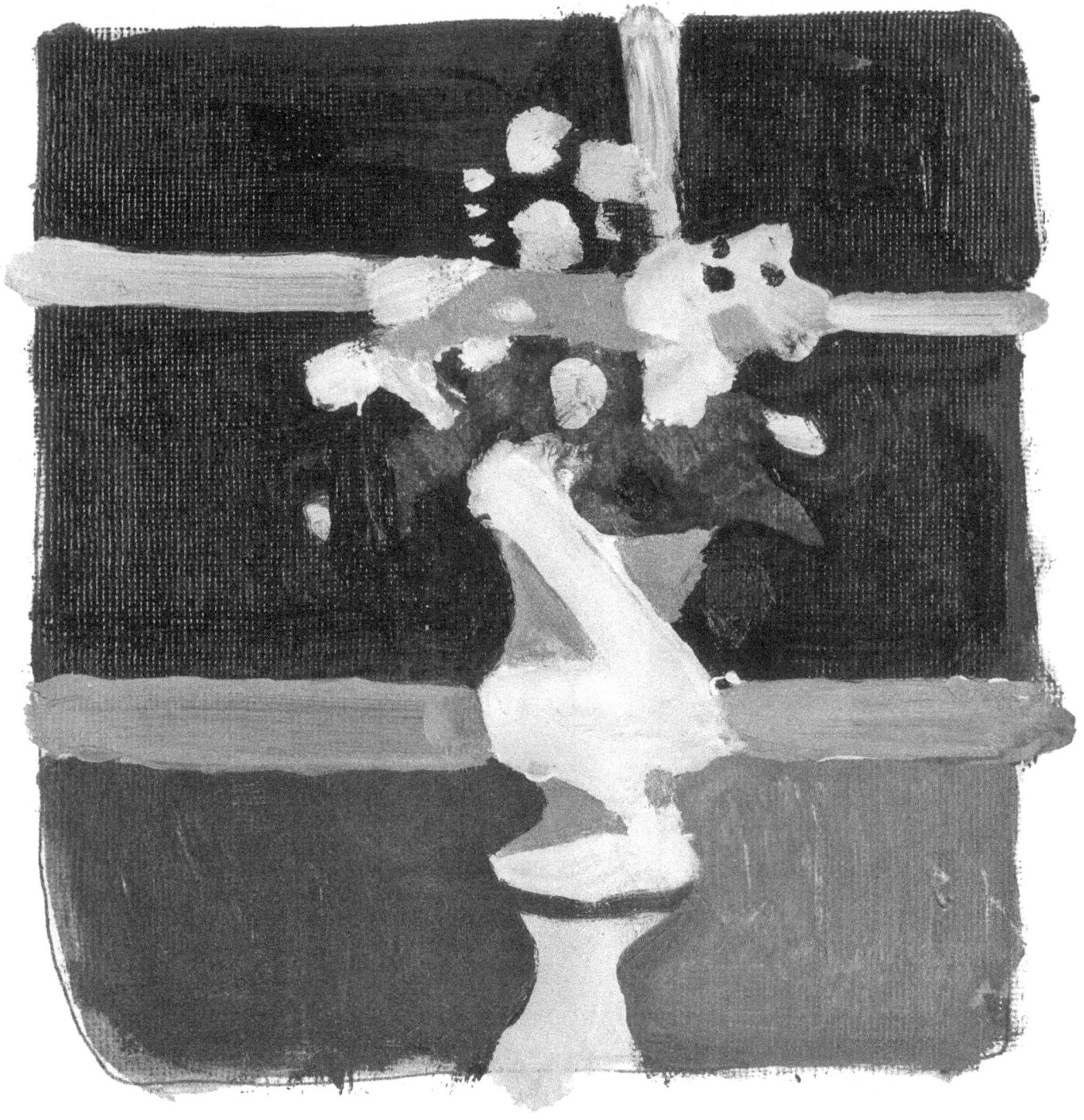

Figure 36. Here is the same subject as in Figure 35, but because I used hard, static edges in this painting, it lacks depth. I made light and dark patterns, not shadows.

Clean and wipe your brush. (2) Place your brush directly over the zigzag and brush up and down the length of the desired soft edge. *Don't* work the brush out into either the light or dark area of paint. Clean and wipe your brush again. (3) If there are still abrupt divisions anywhere, take a clean, wiped brush and repeat the up-and-down stroke (no more zigzagging should be necessary). You may have to clean and wipe your brush quite a few times. This is the only way to keep unwanted colors and values from creeping into other areas.

Edges for Emphasis and Form. It's important to realize that one of the best ways of emphasizing certain areas is through edges. Hard edges make things important; soft edges make them less important. An unwanted form can be made less bothersome with soft edges. By comparison, you can draw the viewer's attention to another area with harder edges. Hard and soft edges also help you make form. To bring something forward, give it a harder edge than another area that you wish to make recede.

Figure 37. *Two areas of paint placed side by side create a hard edge (Example A, left). You can make it soft by brushing back and forth across the edge with a zigzag stroke. (Example B, right).*

INDEX

Abstract design, 143
Accents, 83, 140
Accessories, 18-19
Acrylic gesso, 13, 19, 88
Afternoon, 106
Alla prima, brushes for, 12
Allen, 109; detail, 136
Anemones, 77; demonstrated, 88-89
Anemones, wood, 49; demonstrated, 50-52
Arrangement of objects and shapes, 130-133
Artist's Handbook of Materials and Techniques, The (Mayer), 11
Audubon, John James, 9

Background: comparing values to, 55, 61, 77, 90, 107; in composition, 127-130; to correct shape, 39; selection of, 75, 107; to show silhouette, 21; as subject, 127, 130
Back Lighting, 152
Basinette for holding supplies, 15
Beer Mug, 54
Black, 16; and white in mixing grays, 125
Blue Flowers, 142
Blues, 16; darkening, 112; and earth colors in mixing grays, 125; lightening, 112; and orange in mixing grays, 124-125
Bob's Table, 122
Bonnard, Pierre, 77
Bottle: how to paint, 101; demonstrated, 102-105
Boundaries, establishing, 127
Bouquet, drawing a, 21; illus., 22-23
Bouquet, painting a, 78; demonstrated, 90-91
Breakfast Flowers, 118
Bristle brush, 11-12, 18

Broad leaf forms, 35-37, 49
Broken color. *See* Drybrush
Browns, mixing, 75
Brush, how to hold, 27-32
Brush cleaner, 19
Brushes, 11-12, 18, 28; how to clean, 19, 32
Brushstrokes, types of, 27-32, 35-37

Canvas, 12-13; shape of the, 127, 144
Center of interest, 61
Changing light, painting in a, 76, 80
Chip, 42
Christy with Flowers, 20; detail, 53, 100
Chris with Forsythia, 123
Chrysanthemums, 55
Cleaning brushes, 19, 32
Cleaning the palette, 15, 18
Close-value painting, 107
Color, impression of strong, 77
Color demonstrations, 73-96
Color mixing, 69, 75, 76, 111-125
Colors, palette of, 15-16
Color swatches, 95, 113, 114
Combining hard and soft edges, 159
Compact forms, 43; demonstrated, 44-46
Compatibility of oils and acrylics, 13
Complementary colors for mixing grays, 124-125
Composition, 52, 84, 86, 90, 127-135
Compositional direction, 132
Containers, glossy opaque, 97; demonstrated, 98-99
Containers, glossy transparent, 101; demonstrated, 102-105
Contrast and forms, 61, 77, 107
Controlled brushstrokes, 32
Conventional brushstrokes, 28
Cool grays, mixing, 124-125

Cool greens, mixing, 121, 124
Copal painting medium, 16
Correcting poor pattern, 150
Cotton canvas, 12
Cutting off objects, 132, 135

Daffodils, 43
Daisies and Brushes, 75; demonstrated, 84-85
Darkening colors, 111-112
Darkest darks, placement of, 83, 140
Darks, adding, 71
Degas, Edgar, 75
Delphinium, drawing a, 21; illus., 24
Demonstrations, color, 73-96
Design. *See* Composition
Details: brushstroke used for, 32; using, 9, 21, 43, 65
Diffused forms, 49; demonstrated, 50-52
Diffused light, values in, 137-138
Directing the eye: with shapes, 132; with values, 72, 149
Dogwood, 61; demonstrated, 62-65
Dogwood, 6
Drawing: losing the, 84, 159; preliminary, 94, 127
Drawing a bouquet, 21; illus., 22-23
Drawing individual flower shapes, 21; illus., 24-25
Dried Flowers, 74; demonstrated, 81-83
Drybrush, 28

Earth colors, 16; and blue in mixing grays, 125
Easels, 13
Edges, 159-163; for emphasis and form, 163; varying the, 105, 159
Equipment, 11-19
Evening primrose, 21; illus., 25
Exercises in drawing flowers, 21-25

Fechin, Nicholi, 32
Ferns, palette for, 79, 112
Filler, in paints, 15
Flowers, 117
Flowers, learning about, 21-25
Flowers and Brushes, 120
Flowers and Paint Tubes, 116
Forms, simplifying, 9, 21, 43. *See also* Massing forms
Forms, types of: broad leaf, 35-37; compact, 43-46; diffused, 49-52; massed, 55-59; open, 61-65; see-through, 67-71; slender leaf, 39-41
Forms and contrast, 77, 107-108
Forsythia, 158
French easel, 15

Gel (for oils), 16, 88
Gesso; acrylic, 13, 19, 88; traditional, 18
Glass palette, 15, 18
Glazing, brushes for, 12
Glossy containers. *See* Containers, glossy
Goldenrod, 21
Greens, 16
Greens, mixing, 121, 124; darkening, 112; for foliage, 76, 77, 78, 80; lightening, 112; and red in mixing gray 124
Grounds, 13, 18

Hard edge, making a, 159
High-contrast painting, 107
Highlights, 105, 140
Homer, Winslow, 78
Horizon, establishing the, 127
Housepainter's brush, 18

Impatience Plant, 34
Impressionist exhibit, 78
Iris, 60
Irises, 61

Joe Pye weed, 21

Kitchen Daisies, 48
Kitchen Flowers, 76; demonstrated, 86-87
Kitchen Window, 115

Learning about flowers, 21-25
Light: how to show, 87; painting in a changing, 76; using a diffused, 137-138; using a strong, 138
Lighting, 153-157: for composition, 153; for drawing, 121; for form, 153
Lilacs, 141
Linen canvas, 12-13
Linseed oil, 16
Liquitex acrylic gesso, 13, 19, 88
Loaded brush, using a, 28, 39

Making edges, 159
Marigolds, 153
Marmalade Jar, 47

Masonite: as a palette, 15; as a support, 13
Massed forms, 55; demonstrated, 56-59
Massing forms, 9, 21, 43, 67, 74, 86, 90, 94
Materials, 11-19
Matisse, Henri, 77
Mayer, Ralph, 11
Media for drawing exercises, 21
Media for value studies, 143; demonstrated, 144-148
Medium: homemade, 16; prepared, 16, 17; use of, 27-28, 32, 81
Methods of holding brushes, 27-32
Milk Carton, 38
Miller, Henry, 9
Mineral spirits, 19
Mixing colors, 15-16, 111-125
Mixing grays, 124-125; illus., 114
Mixing greens, 121, 124; illus., 113
Morandi, Giorgio, 134

Narcissus, 26

Objects, cutting off, 132, 135
Old master paintings, pattern in, 143
Opaque surfaces, 97; demonstrated, 98-99
Open forms, 61; demonstrated, 62-65
Orange, 15; and blue in mixing grays, 124; darkening, 112; lightening, 112
Orchids, 80; demonstrated, 94-96
Order of procedure, 73
Outside shape. *See* Shapes, positive and negative
Overlapping objects, 130-132
Oxhair brush, 28

Paintboxes, 15
Painting knives, 15, 18
Painting mediums, 16, 17
Palette for color demonstrations, 74-80
Palette of colors, 15-16
Palettes, 15; how to clean, 15, 18
Panels, 13
Paper: for cleanup, 18; as a palette, 15; as a support, 13
Pattern, 143-150; of light and dark, 61; in old master paintings, 143; treatment of, 92, 142
Persian Rug and Daisies, 79; demonstrated, 92-93

Pigments. *See* Colors, palette of
Plexiglas palette, 15
Placement: of objects, 130–132; of subject, 127–129
Pointers on mixing color, 121
Pointillist-type brushstrokes, 32
Poor pattern, 149; correcting, 150
Poppy, 151
Porcelain, 97; demonstrated, 98–99
Positioning flowers, 52, 130
Preliminary drawing, 94, 127; losing the, 84, 159
Prepared canvas, 12
Priming supports, 13, 19
Primrose, 21; illus., 25
Purple and yellow in mixing grays, 124

Queen Anne's Lace, 21, 67; demonstrated, 68–71
Queen Anne's Lace, 66

Rags, for cleaning palette, 15, 18
Razor blades, 15, 18
Reds, 15; darkening, 111; and green in mixing grays, 124; lightening, 112
Reflected light, 46, 89, 140
Regular brushstrokes, 28
Relative values, 137
Rembrandt van Rijn, 28
Res-in-gel, 16
Rose, 21, 42; illus., 25

Sable brushes, 11–12
Sam, 110
Sandpaper, in priming supports, 18
Sarah in the Yard, 72
Schulz, Sigrid, 78
Scraper, 15, 18
Scumbled brushstrokes, 32
See-through forms, 67; demonstrated, 68–71

Shadows: in composition, 153; for making form, 153; values for, 139-140
Shape of the canvas, 127, 144
Shapes: developing, 39; for directing the eye, 132; of individual flowers, 21-25; positive and negative, 21, 40; of shadows, 45
Sigrid's Flowers, 78; demonstrated, 90-91
Silhouettes. *See* Shapes, positive and negative
Simplifying forms, 21-25, 43, 67, 70, 74
Slender leaf forms, 39; demonstrated, 40-41
Soft edge, making a, 150
Sony with Narcissus, 17
Spring Flowers, 119
Squint, when to, 74, 86-87
Still life, background for, 75
Strokes: dark, 37; light, 37; short, abrupt, 36; short, feathered, 50; thinner, 36. *See also* Brushstrokes
Strong light, values in, 138
Studio Wildflowers, 116
Subject: background as, 127, 130; selecting a, 75
Supplies, 11-19
Supports, 12-13
Surface textures: glossy, opaque, 97-99; glossy, transparent, 101-105; matte, 97
Swatches of grays, 124-125; illus., 114
Swatches of greens, 121, 124; illus., 113

Taubes' copal painting medium, 16
Textures. *See* Surfaces, how to paint
Textures of canvas, 12-13
Thistles, 21
Tightening up, 82, 85, 96
Tomatoes and Flowers, 33
Toned canvas, 50, 68

Toulouse-Lautrec, Henri de, 75
Traditional gesso, 18
Transparent surfaces, 101; demonstrated, 102-105
Transparent washes, 27
Tulip, 43
Turpentine: for cleaning brushes, 19; effect of plastic, 15; as a medium, 16; for washy brushstrokes, 27

Unprimed supports, 12, 13
Using the brush, 27-32
Utrecht Linens, Inc., 13

Values, 137-140; for backgrounds, 107-108; comparing, 45, 77, 137, 139; and composition, 90; control of, 91; for directing the eye, 149; in painting massed forms, 55; in painting open forms, 61; in painting see-through forms, 71
Value studies, 143; demonstrated, 144-148
Vellum, 13
Viewfinder, 130

Warm grays, mixing, 124-125
Warm greens, mixing, 124
Washy brushstrokes, 27
Water lily, 43; demonstrated, 44-46
White, 16, 69; and black in mixing grays, 124-125
Wildflowers, 21-25, 49
Win-Gel, 88
Winton painting medium, 16
Wood anemones, 49; demonstrated, 50-52
Wooden palette, 15

Yellow, 16; darkening, 111; lightening, 112; and purple in mixing grays, 124

Zinnias, 55

We hope you enjoyed this title from Echo Point Books & Media

Before Closing this Book, Two Good Things to Know

Buy Direct & Save

Go to www.echopointbooks.com (click "Our Titles" at top or click "For Echo Point Publishing" in the middle) to see our complete list of titles. We publish books on a wide variety of topics—from spirituality to auto repair.

Buy direct and save 10% at www.echopointbooks.com

DISCOUNT CODE: EPBUYER

Make Literary History and Earn $100 Plus Other Goodies Simply for Your Book Recommendation!

At Echo Point Books & Media we specialize in republishing out-of-print books that are united by one essential ingredient: high quality. Do you know of any great books that are no longer actively published? If so, please let us know. If we end up publishing your recommendation, you'll be adding a wee bit to literary culture and a bunch to our publishing efforts.

Here is how we will thank you:

- A free copy of the new version of your beloved book that includes acknowledgement of your skill as a sharp book scout.
- A free copy of another Echo Point title you like from echopointbooks.com.
- And, oh yes, we'll also send you a check for $100.

Since we publish an eclectic list of titles, we're interested in a wide range of books. So please don't be shy if you have obscure tastes or like books with a practical focus. To get a sense of what kind of books we publish, visit us at www.echopointbooks.com.

If you have a book that you think will work for us, send us an email at editorial@echopointbooks.com

www.ingramcontent.com/pod-product-compliance
Lightning Source LLC
Chambersburg PA
CBHW041919180526
45172CB00013B/1335